SUH YONGSUN
2008 → 2011

작업 WORKS 2008 → 2011

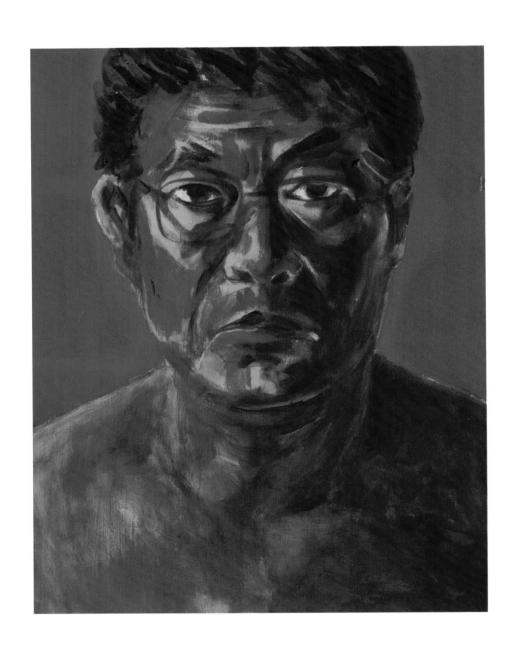

자화상 SELF-PORTRAIT
53 × 41 CM
ACRYLIC ON CANVAS
2008

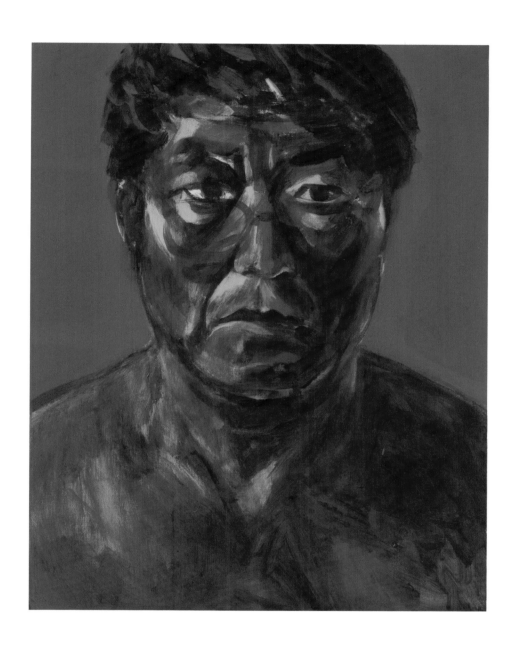

자화상 SELF-PORTRAIT
53 × 41 CM
ACRYLIC ON CANVAS
2008

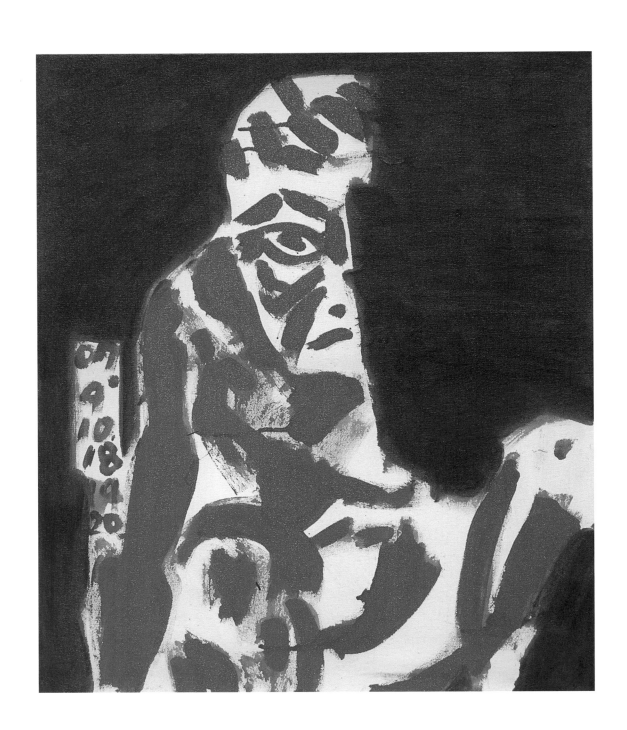

자화상 SELF-PORTRAIT
73 × 60.5 CM
ACRYLIC ON CANVAS
2007, 2008

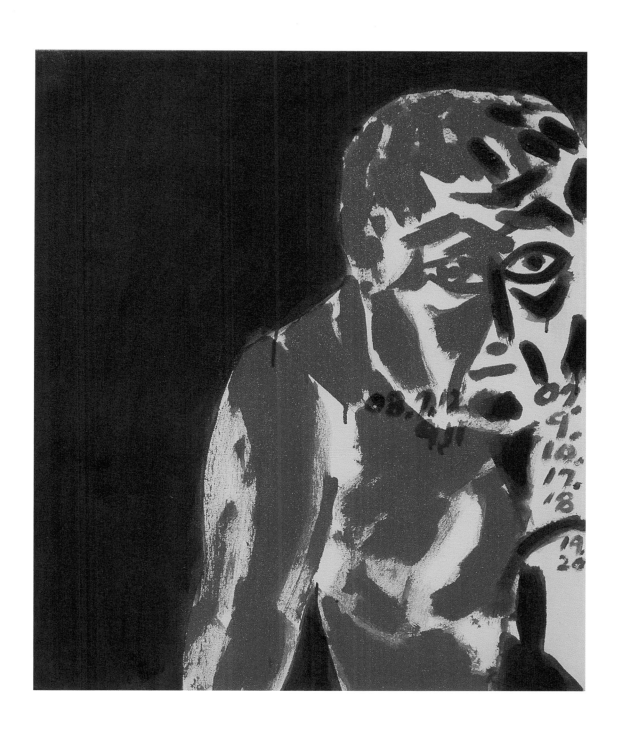

자화상 SELF-PORTRAIT
73 × 60.5 CM
ACRYLIC ON CANVAS
2007, 2008

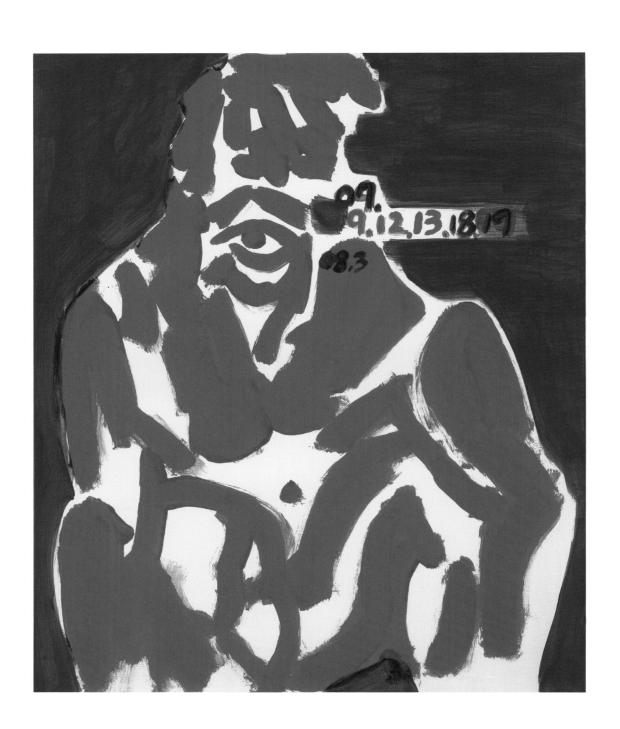

자화상 SELF-PORTRAIT
73 × 60.5 CM
ACRYLIC ON CANVAS
2007, 2008

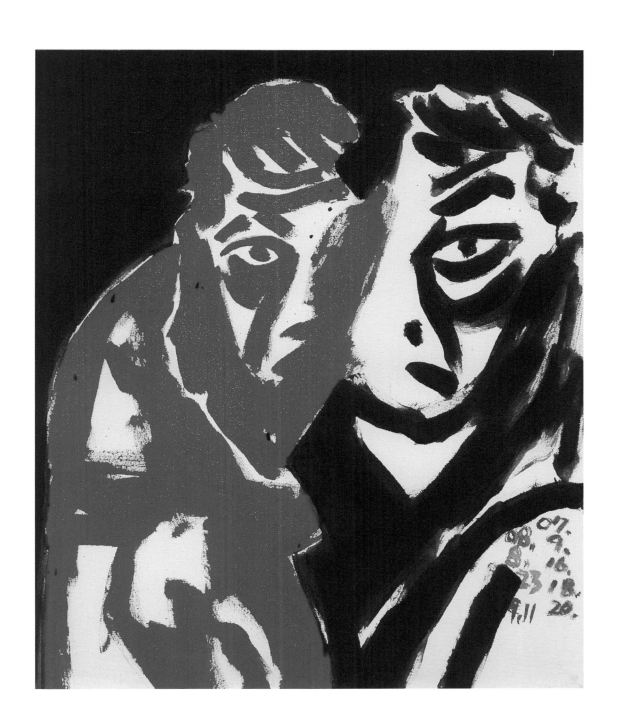

자화상 SELF-PORTRAIT
73 × 60.5 CM
ACRYLIC ON CANVAS
2007, 2008

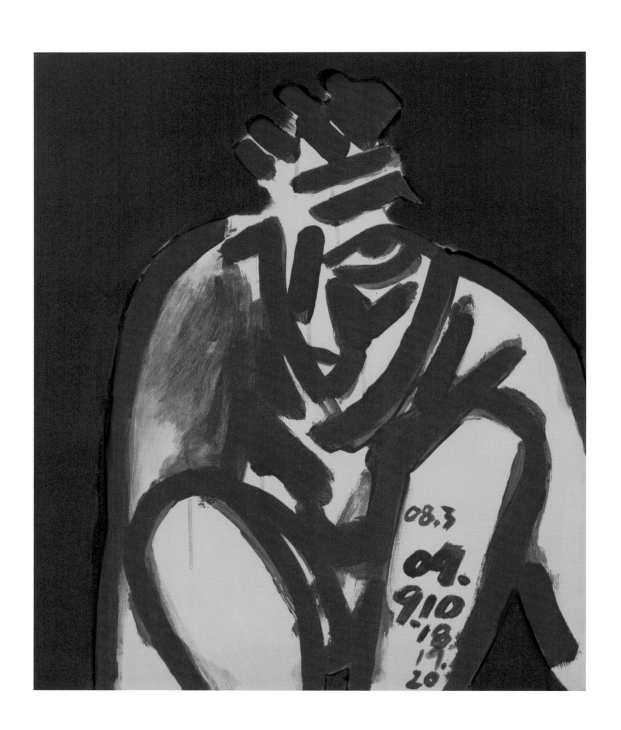

자화상 SELF-PORTRAIT
73 × 60.5 CM
ACRYLIC ON CANVAS
2007, 2008

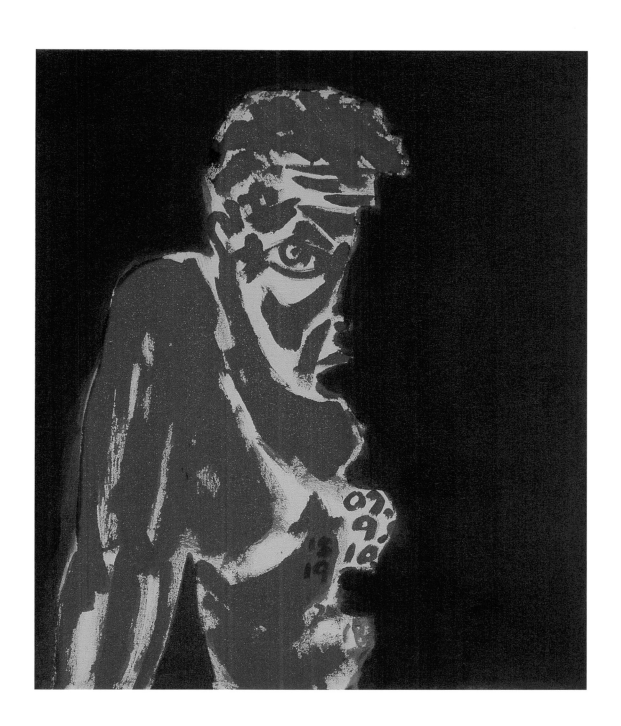

자화상 SELF-PORTRAIT
73 × 60.5 CM
ACRYLIC ON CANVAS
2007, 2008

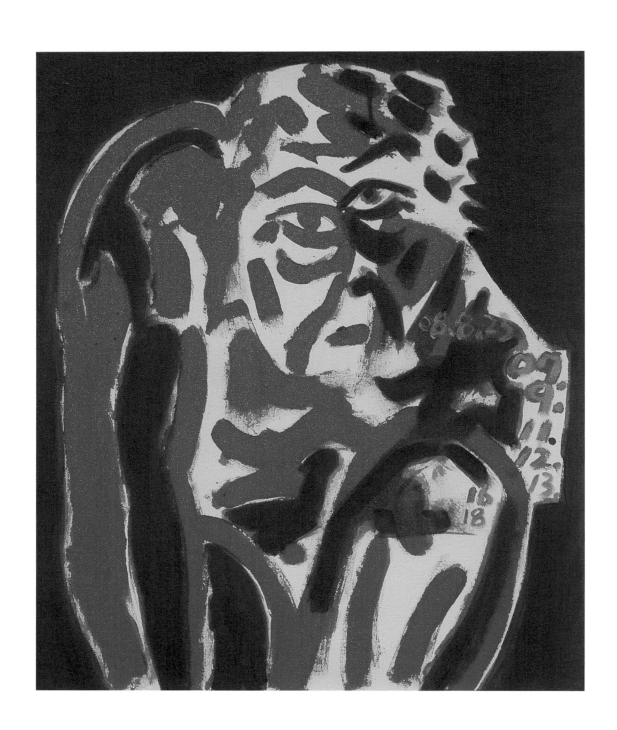

자화상 SELF-PORTRAIT
73 × 60.5 CM
ACRYLIC ON CANVAS
2007, 2008

자화상은 실제로 그리는 순간 실패하는 그림이에요.
선을 긋는 순간부터 안 닮아요. 자기가 생각하는 자기의
모습은 절대 안 나와요. 그래서 화가로서 가장 비극적인
그림 중의 하나가 자화상인 거죠. 그런 점에서는 시지프스
신화와 같은 점이 있어요. 실패를 반복하면서 어떻게든 계속
그려나가는 거죠. 그래도 먼저 그린 그림과 다음에 그린
그림은 차이가 있어요. 그것 때문에 하는 거예요. 그리고
부분적으로 조금씩 뭔가가 담겨 나가는 느낌이 있어요.

　　이영희,『화가 서용선과의 대화』(좋은땅, 2020),
　　55~56쪽.

Self-portraits are paintings that fail the moment
you begin to draw. From the instant you draw a line,
the image loses its resemblance. The image one
conceives of oneself is never realized. And thus,
self-portraits are one of the most tragic art forms an
artist can produce. In that sense, it is like the myth
of Sisyphus. You anyhow continue to draw despite
repeated failures. Still, there is indeed a difference
between the picture you painted before and the one
you painted after. And this is what keeps you going.
Moreover, there is also a feeling that something is
partially and gradually being embodied.

자화상 SELF-PORTRAIT
89 × 130 CM
ACRYLIC ON CANVAS
2007, 2008

90°

자화상 SELF-PORTRAIT
89 × 146 CM
ACRYLIC ON CANVAS
2007, 2008

90°

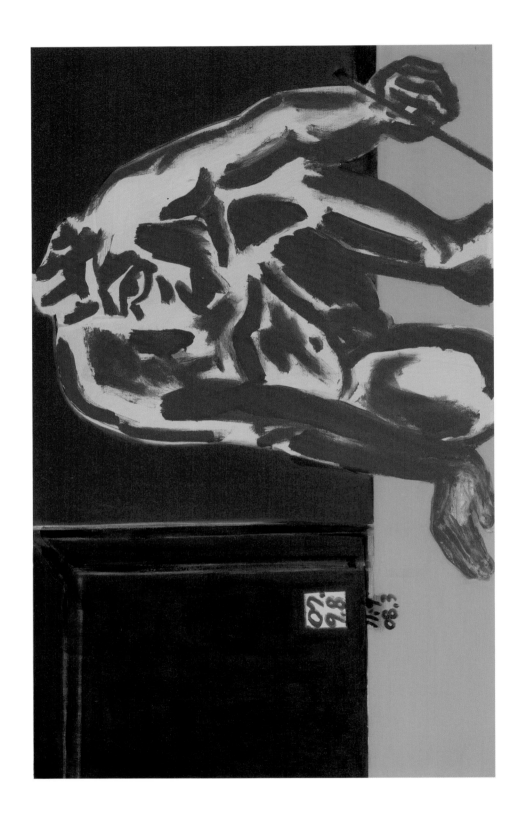

자화상 SELF-PORTRAIT
89 × 146 CM
ACRYLIC ON CANVAS
2007, 2008

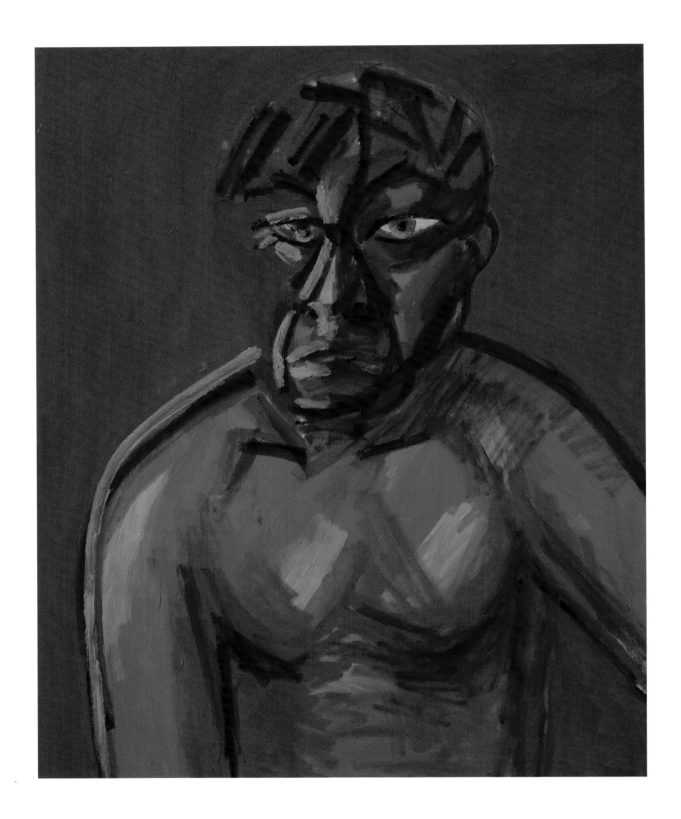

자화상 SELF-PORTRAIT
163 × 130 CM
OIL ON CANVAS
2008

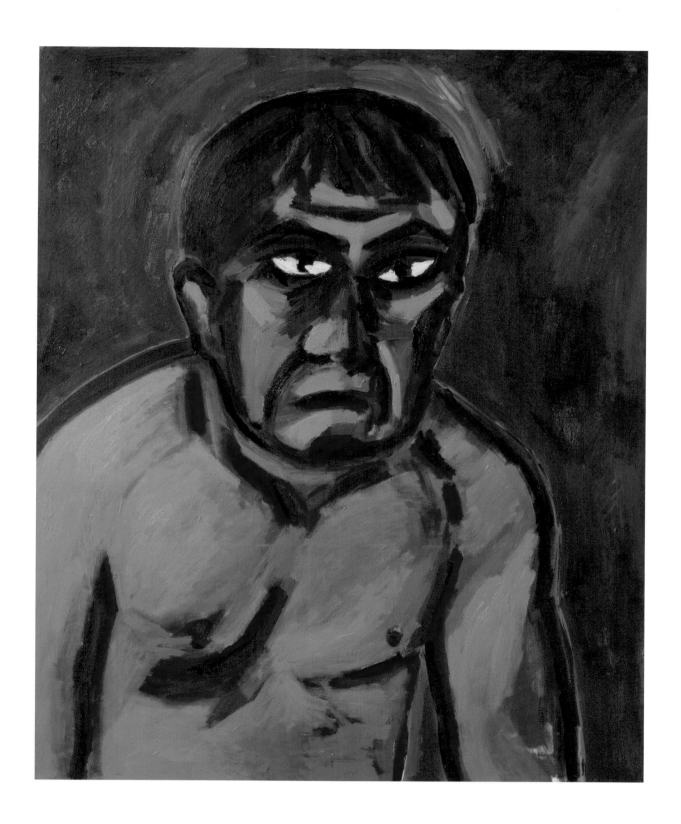

자화상 SELF-PORTRAIT
163 × 130 CM
OIL ON CANVAS
2008

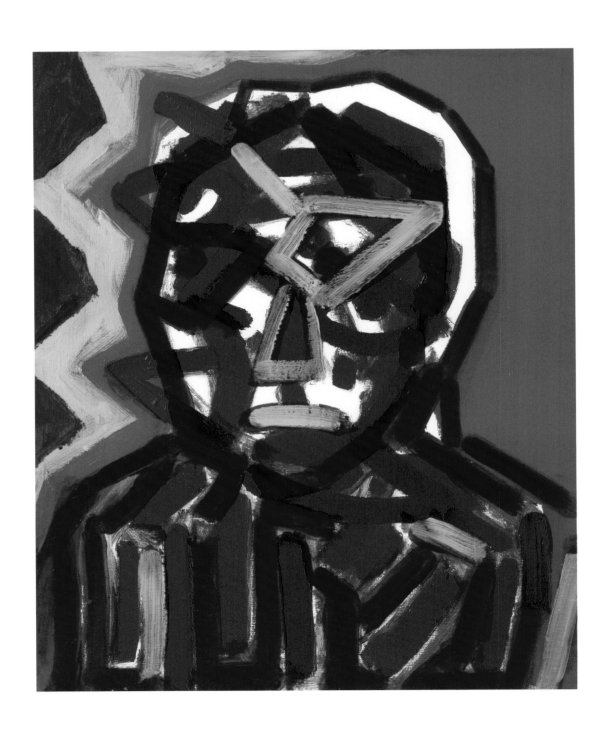

생각하는 사람 PERSON WHO THINKS
73 × 60.5 CM
ACRYLIC ON CANVAS
2008

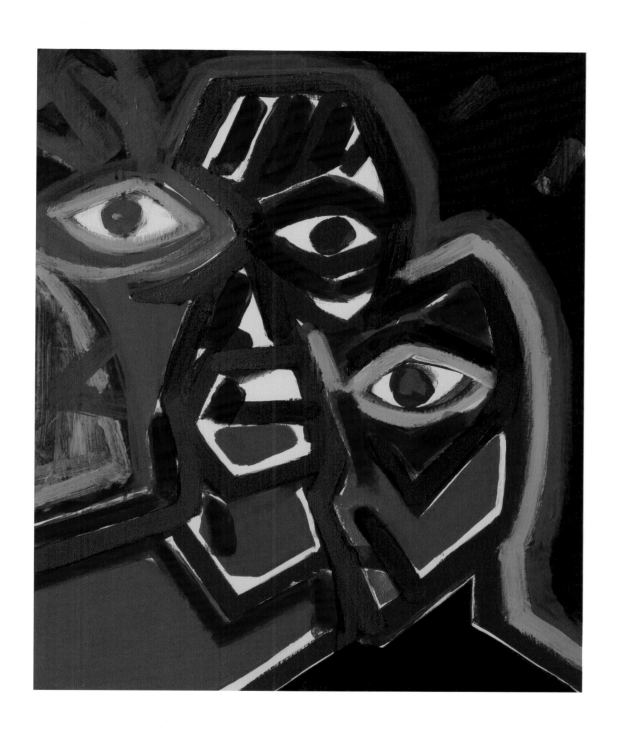

느끼는 사람 PERSON WHO FEELS
73 × 60.5 CM
ACRYLIC ON CANVAS
2008

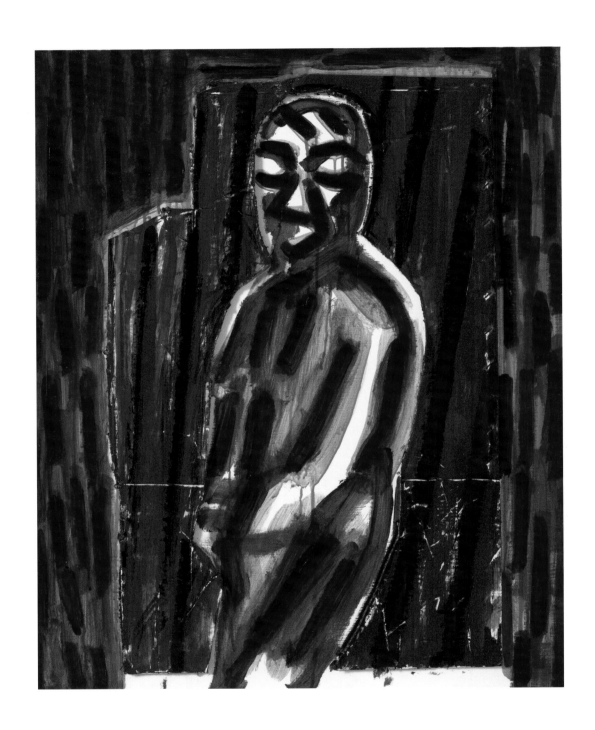

기다리는 사람 PERSON WHO WAITS
91 × 72.5 CM
ACRYLIC, PAPERBOARD BOX COLLAGE ON CANVAS
2008

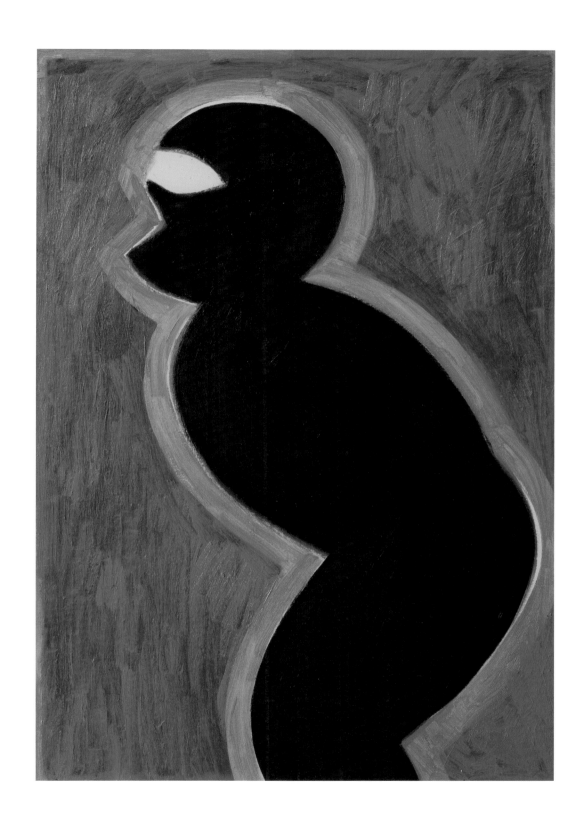

소리치는 사람 PERSON WHO SHOUTS
131 × 90 CM
ACRYLIC ON CANVAS
2008

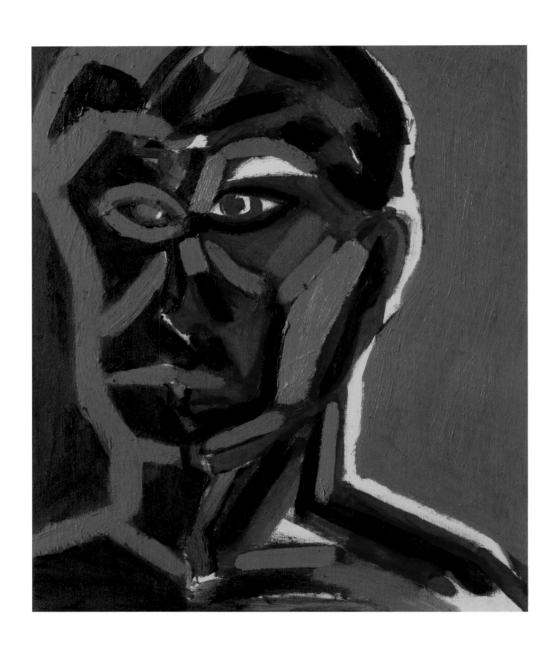

이중성격 DUAL PERSONALITY
53 × 45.7 CM
OIL ON CANVAS
2008

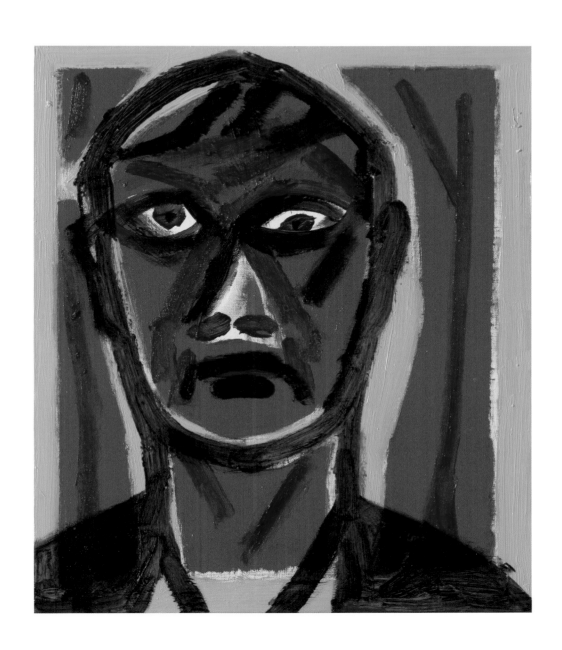

얼굴 THE FACE
54 × 45.4 CM
OIL ON CANVAS
2008

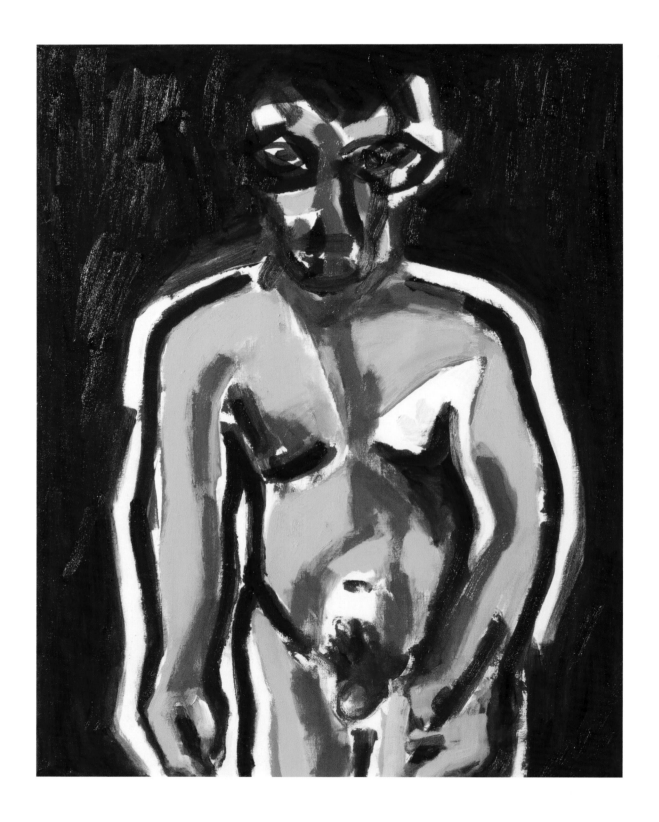

남자 ① MAN ①
116.7 × 90 CM
OIL ON CANVAS
2008

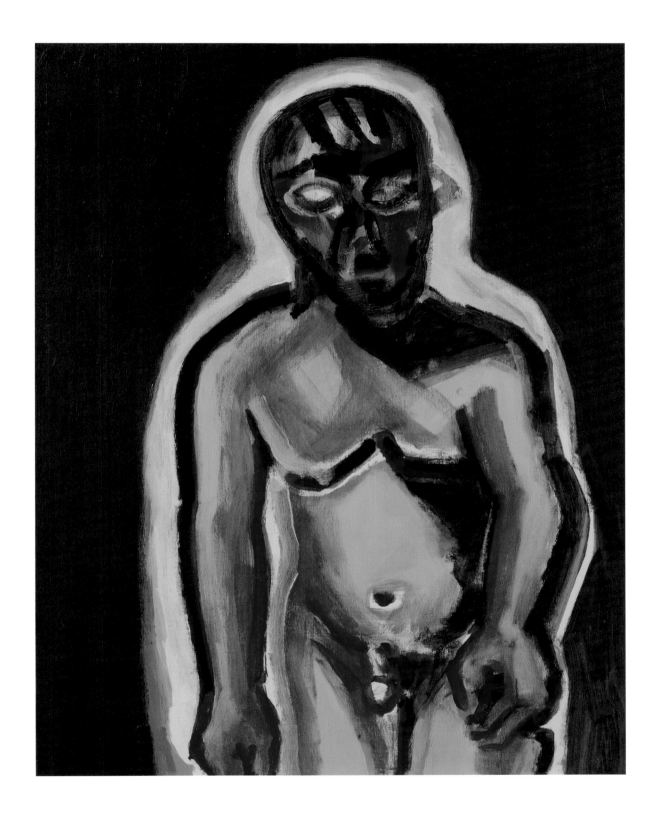

남자 ② MAN ②
116.7×90 CM
OIL ON CANVAS
2008

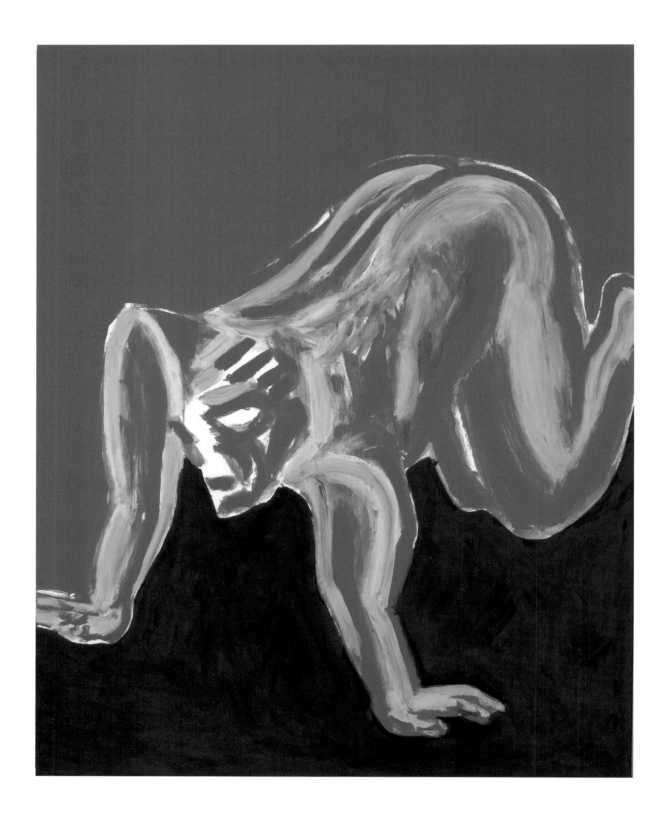

개사람 ① GAESARAM (CANINE MAN) ①
163 × 130 CM
ACRYLIC ON CANVAS
2008

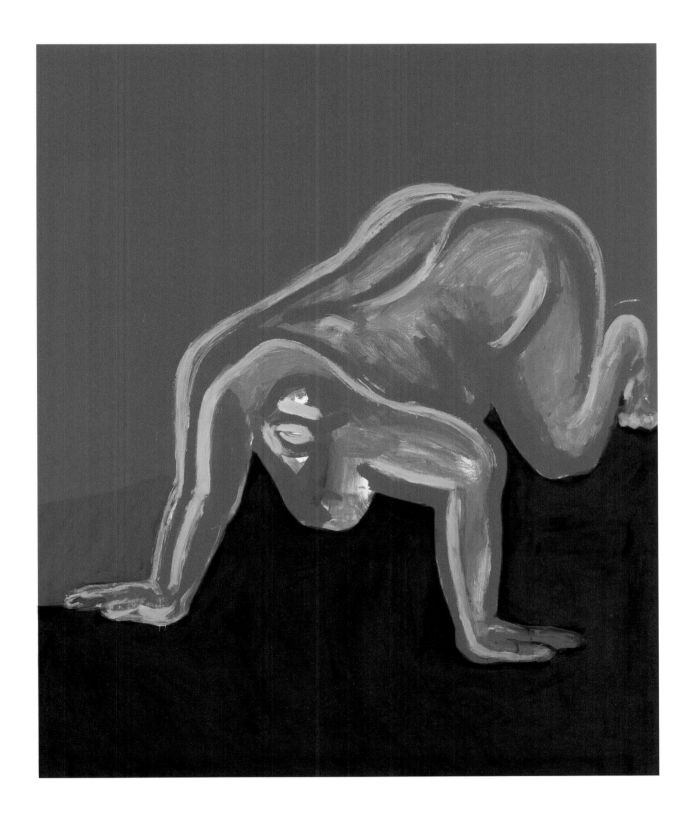

개사람 ② GAESARAM (CANINE MAN) ②
163 × 130 CM
ACRYLIC ON CANVAS
2008

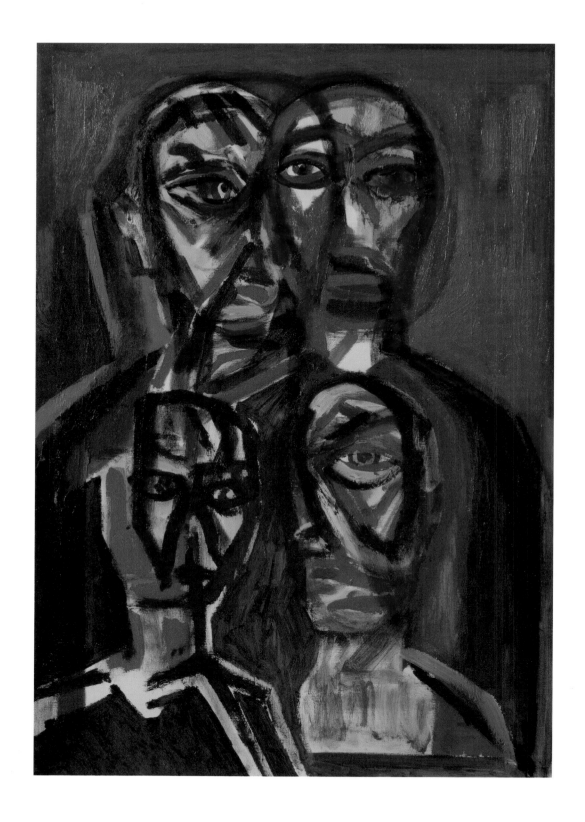

관계 RELATION
130 × 89 CM
OIL ON CANVAS
2008

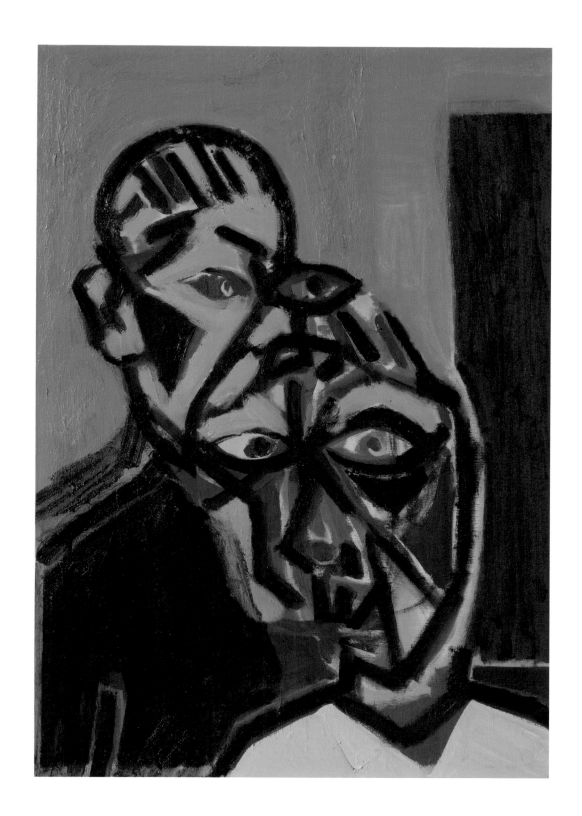

사람들 PEOPLE
131 × 90 CM
OIL ON CANVAS
2008

생각 **THINKING**
73 × 60.5 CM
OIL ON CANVAS
2007, 2008

깊은 생각 DEEP THINKING
91 × 117 CM
ACRYLIC ON CANVAS
2008

90°

작업 중 41번지 AT WORK #41
91 × 117 CM
ACRYLIC ON CANVAS
2008

90°

34가 작업 중 AT WORK 34TH ST.
168.5×153 CM
ACRYLIC ON CANVAS
2006, 2007, 2008

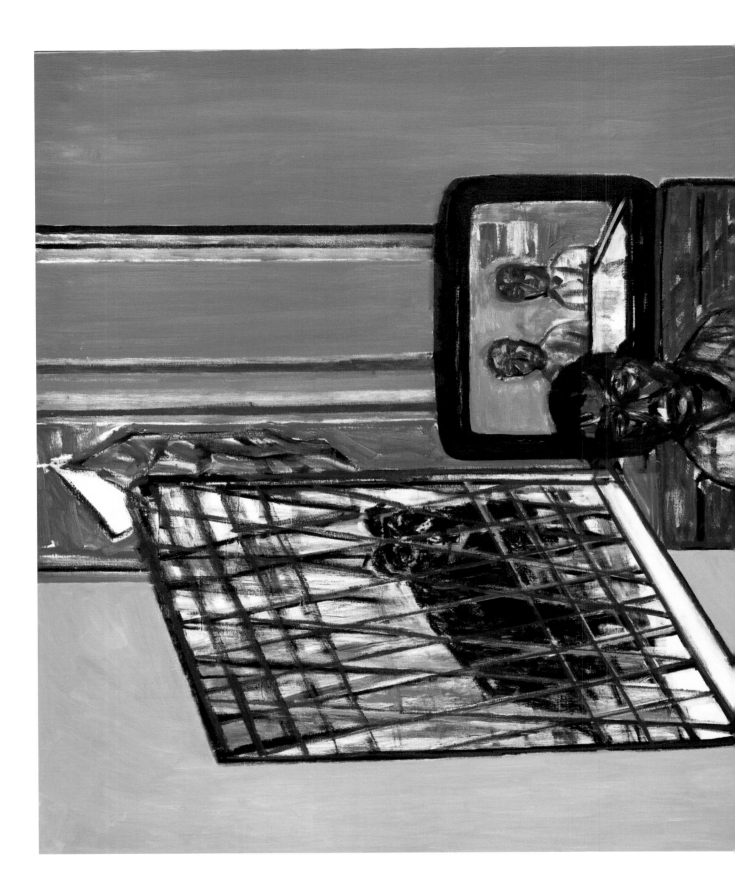

들여다보는 개 A DOG PEEKING INTO THE ROOM
259 × 194 CM
ACRYLIC ON CANVAS
2008

소리치다 SHOUTING
194 × 259 CM
OIL ON CANVAS
2008

카페에서 AT THE CAFÉ
72.7 × 60.6 CM
OIL ON CANVAS
2008

엘리베이터 ELEVATOR
117 × 91 CM
ACRYLIC ON CANVAS
2008

기다림 WAITING
100 × 80 CM
OIL ON CANVAS
2008

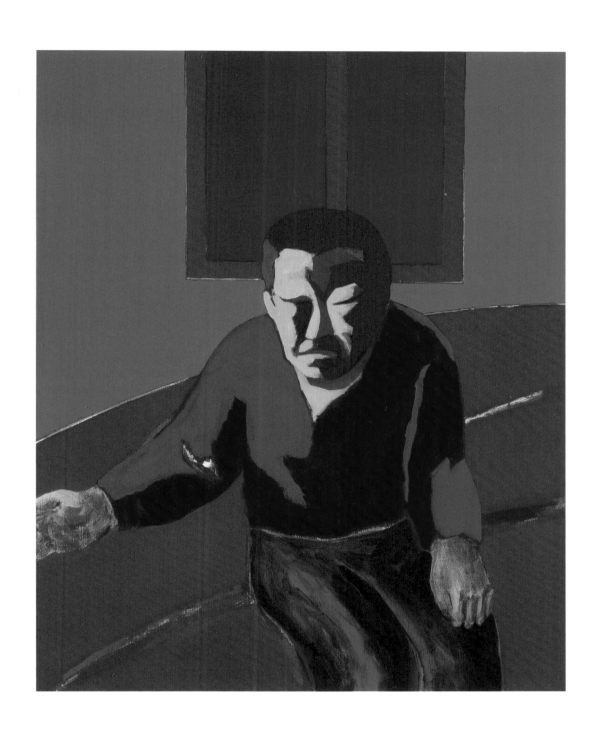

대화 CONVERSATION
100 × 80 CM
ACRYLIC ON CANVAS
2008

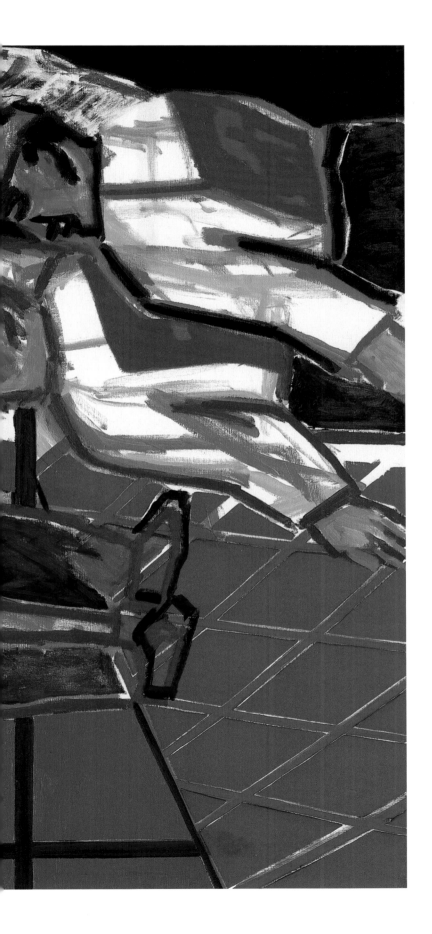

선거 ELECTION
259 × 194 CM
OIL ON CANVAS
2008

화합 UNITY
220 × 360 CM
OIL ON CANVAS
2008

버티기 HOLDING ON
145 × 89.5 CM
OIL ON CANVAS
2008

광차 MINECART
116.5 × 91 CM
OIL ON CANVAS
2008

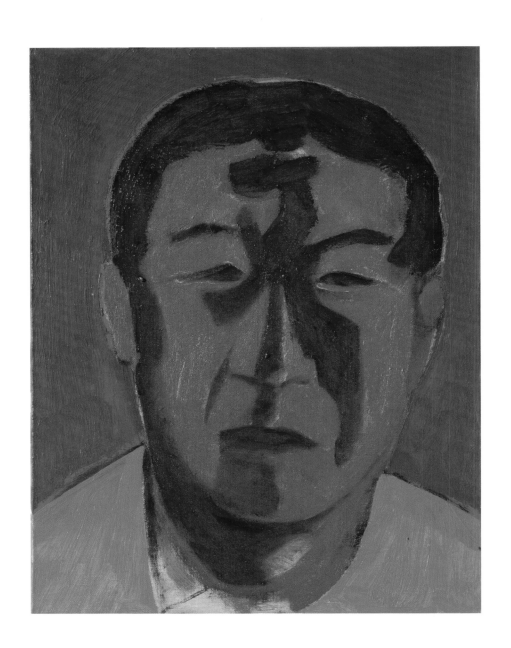

건축가 주소장 ARCHITECT JU
54.5 × 41 CM
OIL ON CANVAS
1997, 2008

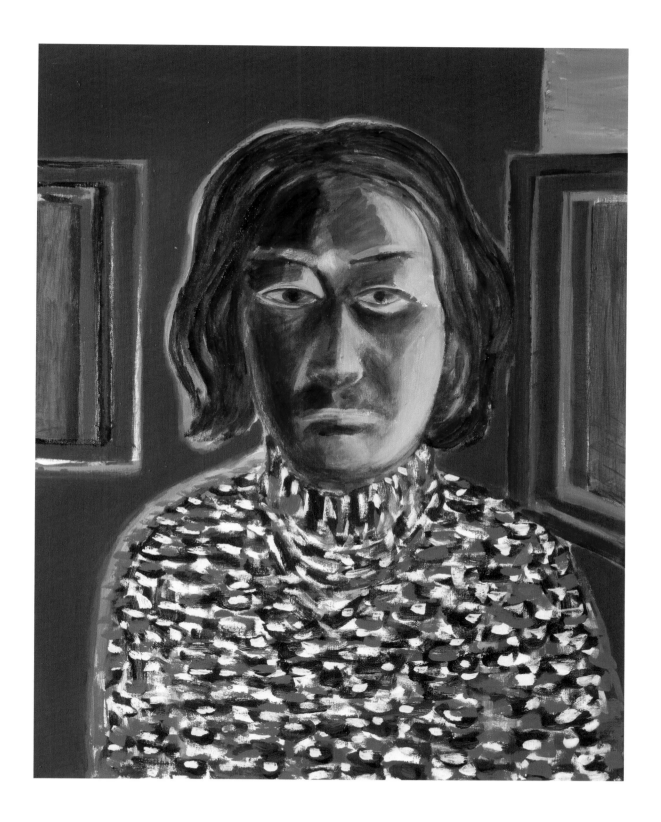

장성아 JANG SUNGAH
116.5 × 91 CM
ACRYLIC ON CANVAS
2008

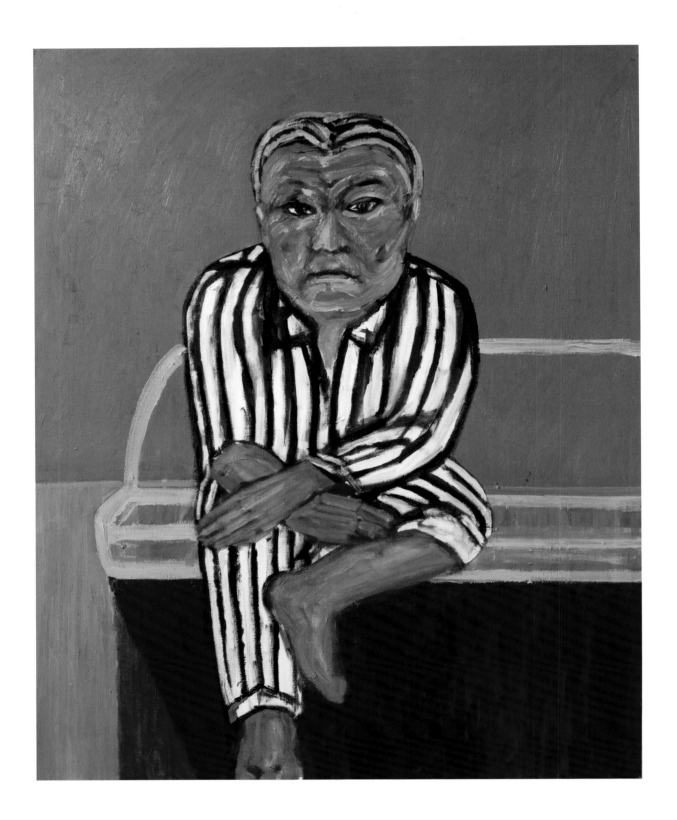

앉아있는 사람 SITTING MAN
162 × 130 CM
OIL ON CANVAS
2008

기차로 유럽 여행을 하는 도중 침대 칸에서 만난 한 남자의
모습이다. 그는 잠옷으로 바꾸어 입고 잠을 잤다. 여행자인
나는 잠자리에서 일어난 한 남자의 모습에서 건강한
일상생활을 느꼈다. 우리의 생활은 하루하루가 다르기도
하지만 또한 영원한 반복이기도 하다. 그가 잠을 자고
깨어나서 다시 받아들이는 새로운 세상뿐 아니라, 그를
바라보는 나의 시선과 감각에 관한 그림이기도 하다.
　　작가 노트, 2013· 4· 23

This is an image of a man I've met in a sleeping
compartment when I was traveling Europe by train.
He changed into his pajamas and went to bed. As a
traveler, I recalled something of a healthy everyday
life from the appearance of a man who just got out
of his bed. One's life is different day to day, but
it also repeats eternally. This picture is not only
about a new world a man takes in again after waking
up from his sleep, but also of my gaze and senses
looking at the man.

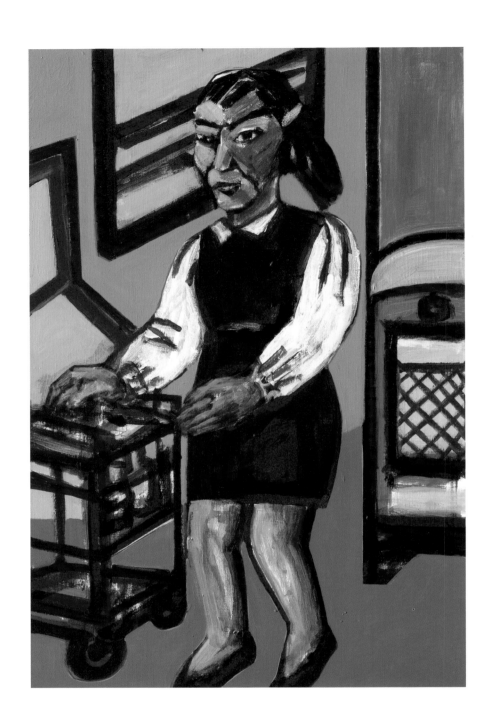

스튜어디스 FLIGHT ATTENDANT
91 × 60.5 CM
ACRYLIC ON CANVAS
2008

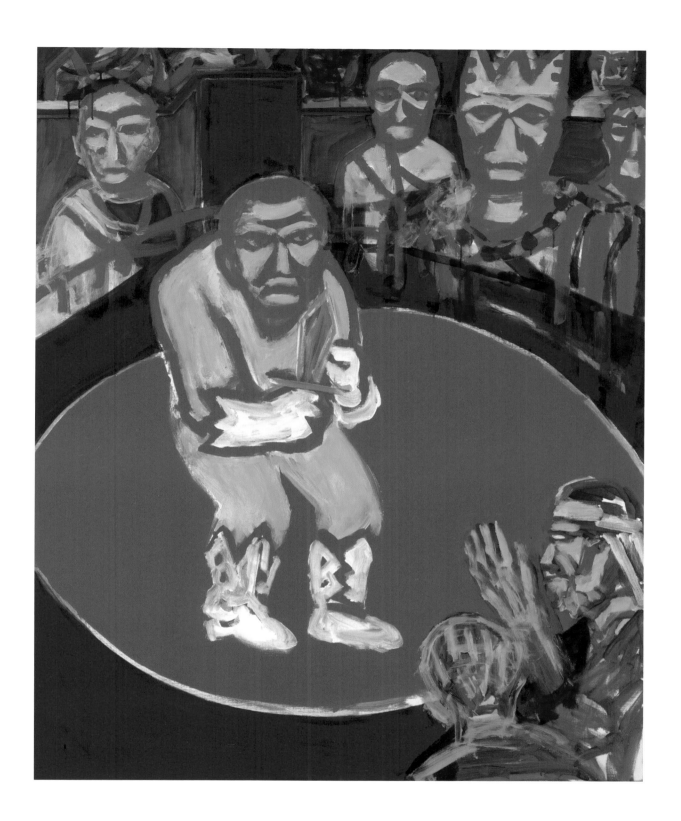

검투사 GLADIATOR
163 × 130 CM
ACRYLIC ON CANVAS
2008

베를린 지하철 BERLIN SUBWAY
73 × 154 CM
ACRYLIC ON CANVAS
2006, 2007, 2008

90°

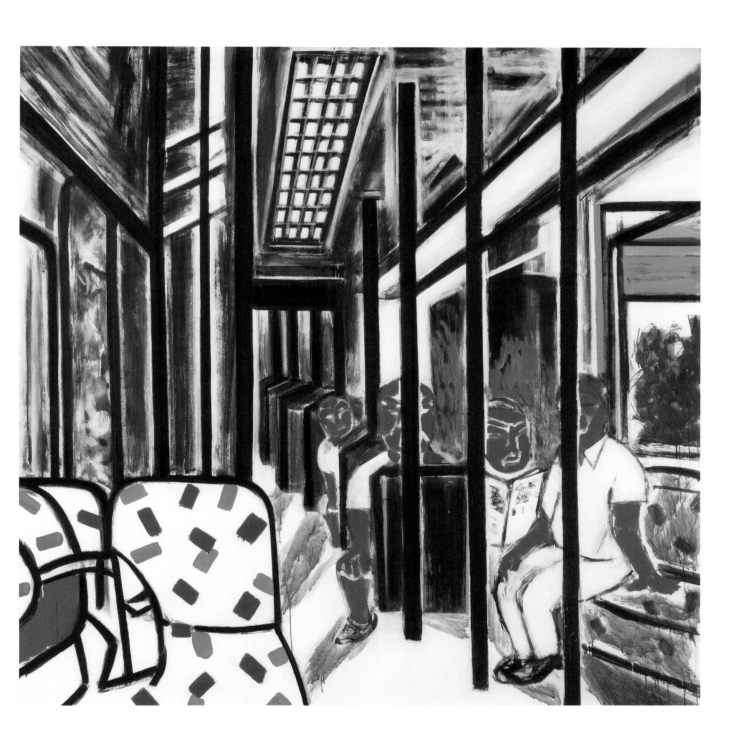

S-BAHN, 베를린 S-BAHN, BERLIN
200 × 200 CM
ACRYLIC ON CANVAS
2008

베를린 레오폴드플라츠 정거장
LEOPOLDPLATZ STATION, BERLIN
205 × 415 CM
ACRYLIC ON CANVAS
2006, 2007, 2008

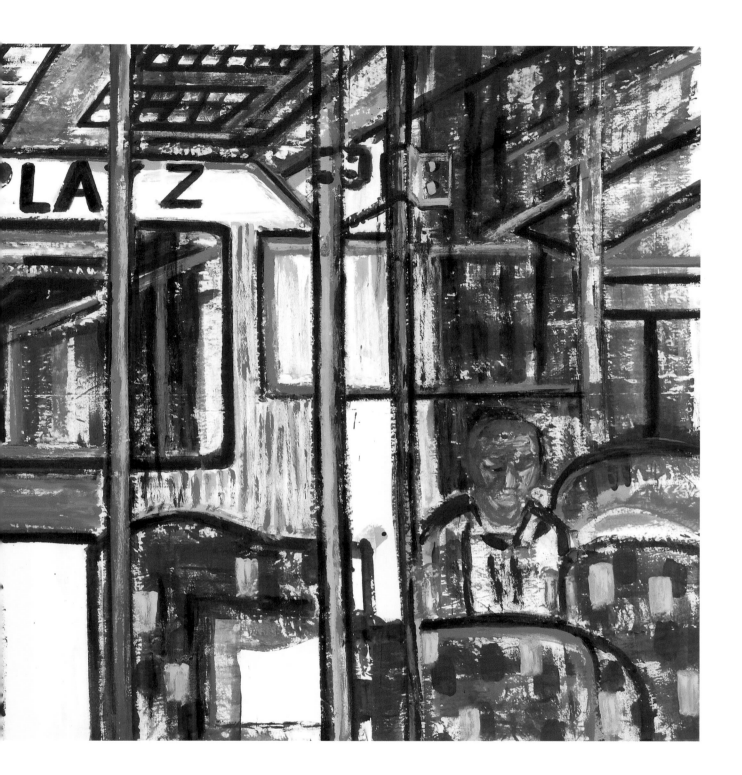

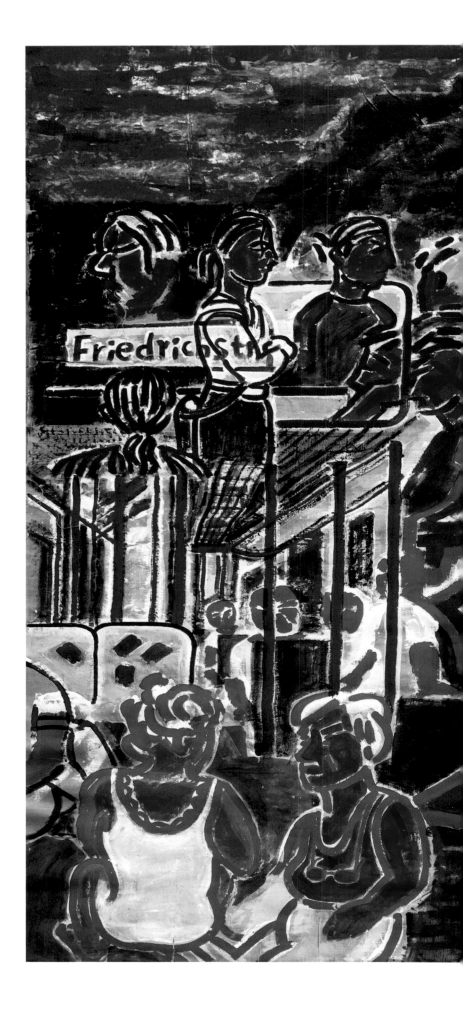

비스마르크 BISMARCK
408 × 447 CM
ACRYLIC ON LINEN
2006, 2008

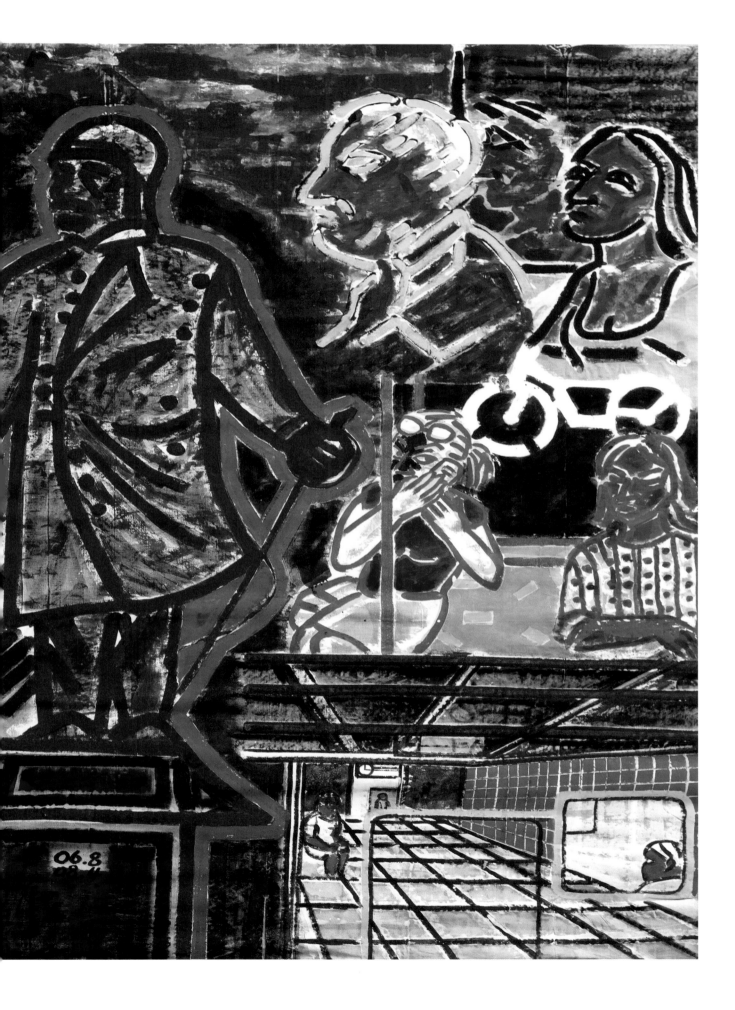

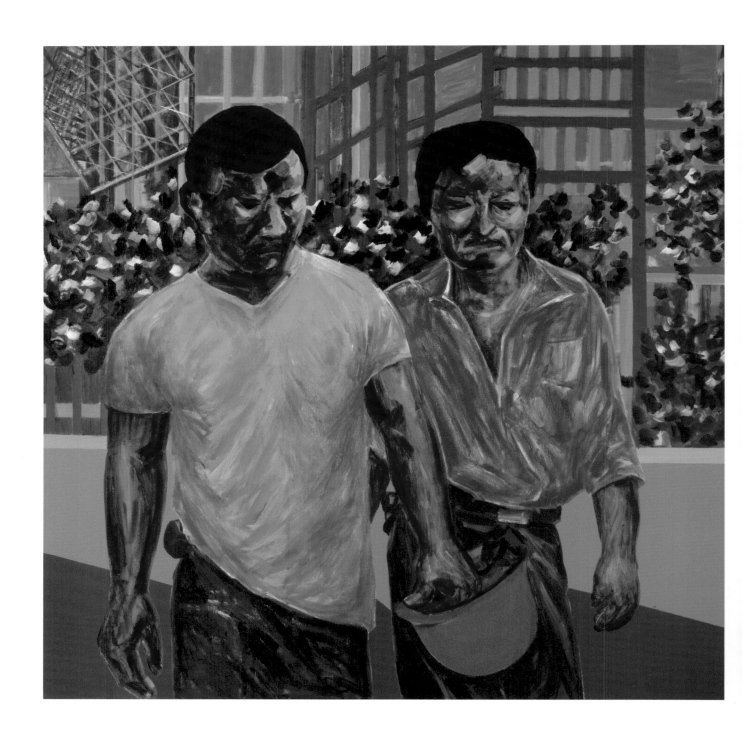

퇴근 – 추이거좡(崔各庄)에서 LEAVING WORK – FROM CUIGEZHUANGXIANG
200 × 200 CM
ACRYLIC ON CANVAS
2007, 2008

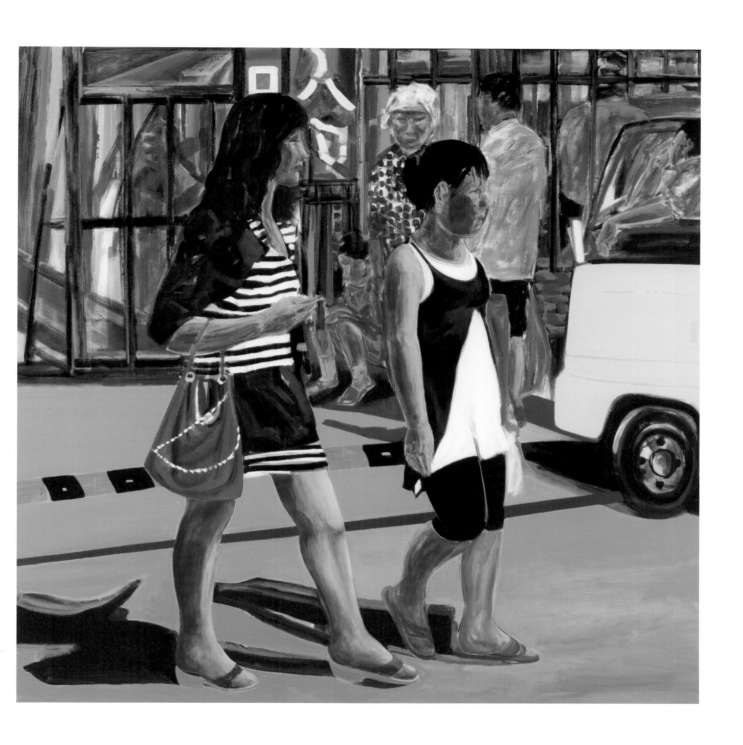

라이광잉(來廣管) LAIGUANGYING
200 × 200 CM
ACRYLIC ON CANVAS
2007, 2008

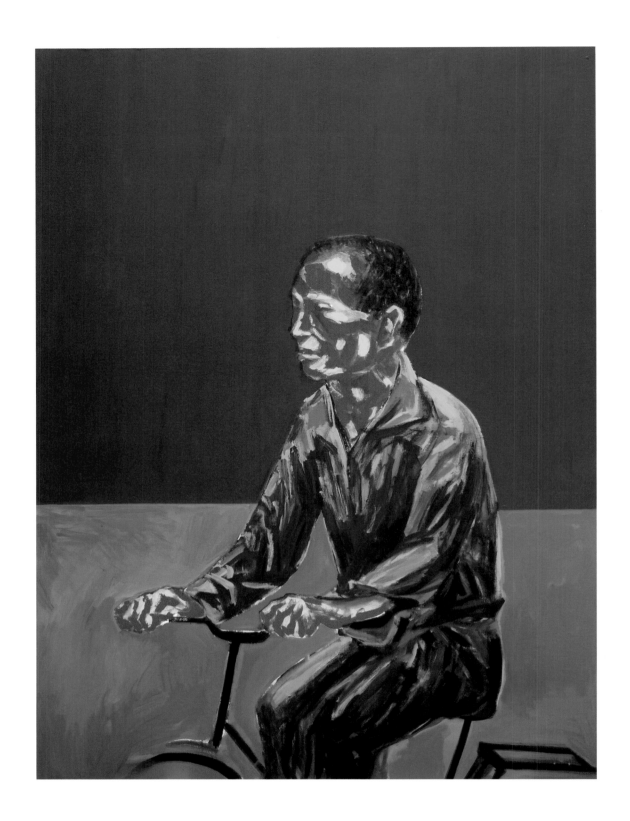

자전거 타는 사람 MAN ON BICYCLE
200 × 150 CM
ACRYLIC ON CANVAS
2007, 2008

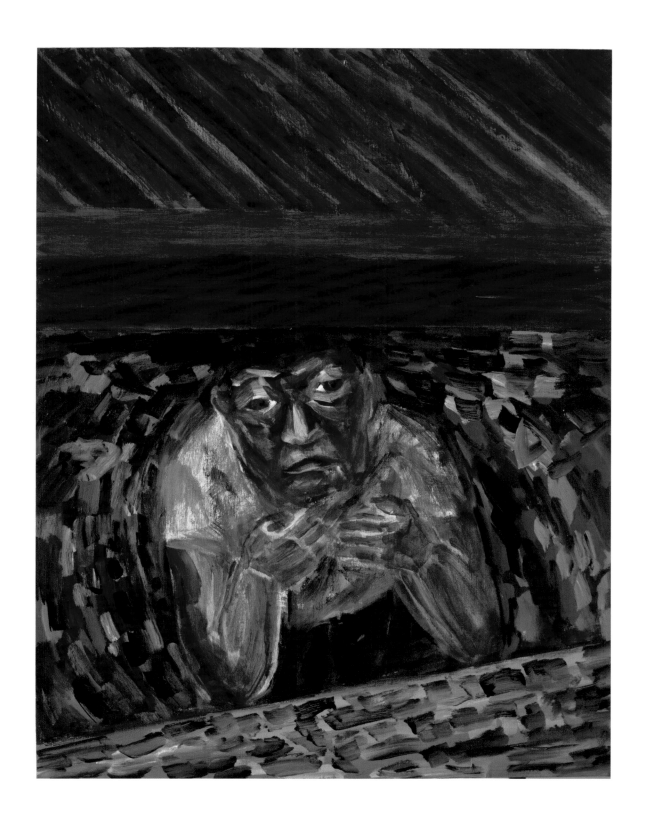

아버지-엄마의 이야기 FATHER-MOM'S STORY
117 × 91 CM
ACRYLIC ON CANVAS
2008

동학, 승천 DONGHAK UPRISING, ASCENSION
200×150 CM
ACRYLIC ON CANVAS
2008

동학, 미륵의 달 DONGHAK UPRISING, MOON OF MAITREYA
99 × 99 CM
ACRYLIC ON CANVAS
2008

계유년 GYEYUNYEON
193 × 130 CM
ACRYLIC ON CANVAS
1992, 2008

시 쓰는 매월당 MAEWEOLDANG WRITING POETRY
130 × 97 CM
OIL ON CANVAS
2008

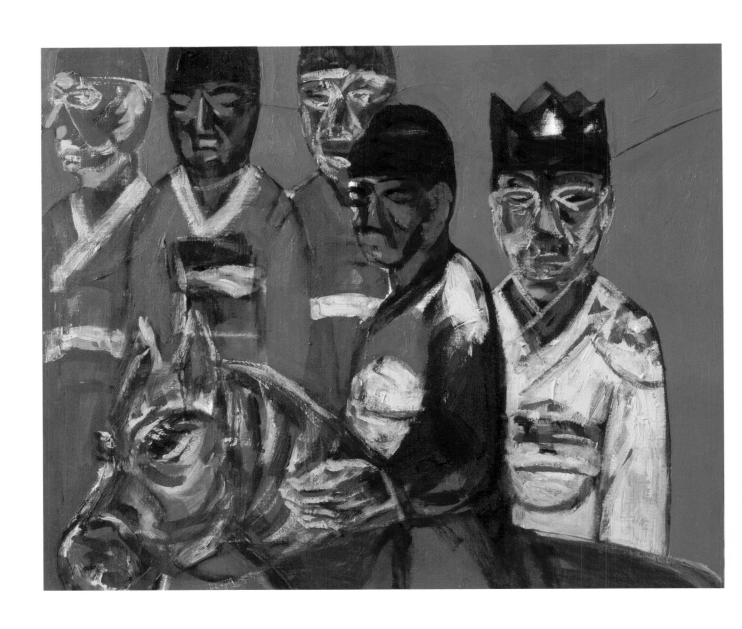

노산군, 세조 NOSANGUN, KING SEJO
60.6 × 72.7 CM
OIL ON CANVAS
2008

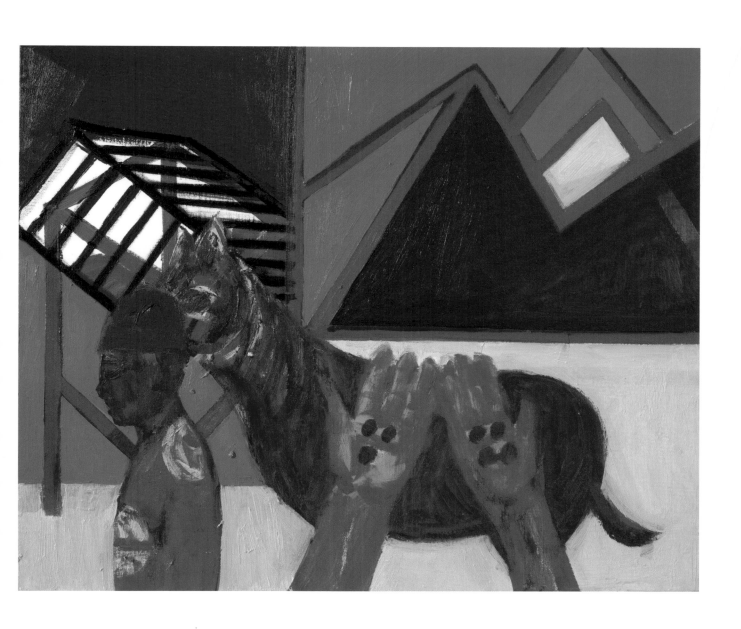

추악한 손 UGLY HANDS
60.6 × 72.7 CM
OIL ON CANVAS
2008

전등사 ① *JEONDEUNGSA TEMPLE* ①
71.4 × 54 CM
ACRYLIC ON KOREAN PAPER
2008

전등사 ② *JEONDEUNGSA TEMPLE* ②
71.4 × 54 CM
ACRYLIC ON KOREAN PAPER
2008

신화 MYTH
119.7 × 110 CM
ACRYLIC, WRAPPING PAPERBOARD COLLAGE ON CANVAS
2008

신화 그림은 상상의 산물이거든요. 신화 속에 등장하는 존재들도 모두 상상적인 형태들이죠. 인간과 비슷한 형상인데 날개가 있거나 머리가 몇 개이거나. 이런 것들을 그림으로 그리는 작업이 나에게 굉장한 자유를 줘요. 제가 그린 그림들이 색을 과장하고 형태를 왜곡하기는 했지만, 결국 눈앞에 보이는 현실의 틀을 벗어나지는 않았거든요. 그런데 신화를 그림으로 그리는 작업은 초현실의 세계에 대한 이야기예요. 그런 초현실의 세계를 상상하는 것이 나를 자유롭게 만든 것 같아요.

이영희, 『화가 서용선과의 대화』(좋은땅, 2020), 51쪽

Paintings on mythology are products of imagination. Characters that appear in the myths are also imaginary, resembling human beings but with wings or with multiple heads. Working on such figures gives me a great freedom. This is probably because, although the things I have painted are exaggerated in color and distorted in form, they have never crossed the boundaries of visible reality. By the way, painting on various myths is related to telling a story of a surreal world. The act of imagining the world of the surreal, I believe, has liberated me in a way.

천제 RITUAL TO HEAVENLY GODS
182 × 227.5 CM
ACRYLIC ON CANVAS
2008

구와우 GUWAWU VILLAGE
45.5 × 53 CM
ACRYLIC ON CANVAS
2008

금강골 GEUMGANGGOL
45.7 × 54 CM
ACRYLIC ON CANVAS
2008

명달리 ② MYEONGDAL-RI ②
60.8 × 91 CM
ACRYLIC ON CANVAS
2008

팔당 ① PALDANG ①
80 × 100 CM
OIL ON CANVAS
2004, 2008

서 있는 사람들 ① STANDING PEOPLE ①
277.5 × 56 × 57 CM
ACRYLIC ON WOOD BOARD
2008

서 있는 사람들 ② STANDING PEOPLE ②
273 × 58 × 61.5 CM
ACRYLIC ON WOOD BOARD
2008

서 있는 사람들 ③ STANDING PEOPLE ③
273 × 58 × 85 CM
ACRYLIC ON WOOD BOARD
2008

서 있는 사람들 ④ STANDING PEOPLE ④
168.5 × 55 × 25 CM
ACRYLIC ON WOOD BOARD
2008

서 있는 사람들 STANDING PEOPLE
158 × 44 × 64 CM
ACRYLIC ON WOOD BOARD
2008

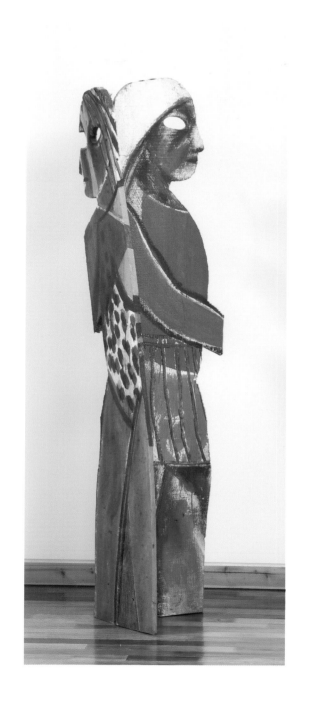

여자들 WOMEN
168.5×38×49 CM
ACRYLIC ON WOOD BOARD
2008

팔 들고 있는 사람 PERSON RAISING AN ARM
458 × 87 × 68 CM
ACRYLIC ON WOOD BOARD
2008

서 있는 사람들 STANDING PEOPLE
449 × 80 × 70 CM
ACRYLIC ON WOOD BOARD
2008

갇힌 사람들 THE CONFINED MEN
247 × 243 × 19 CM
WIRE NET, ACRYLIC ON WOOD BOARD
2008

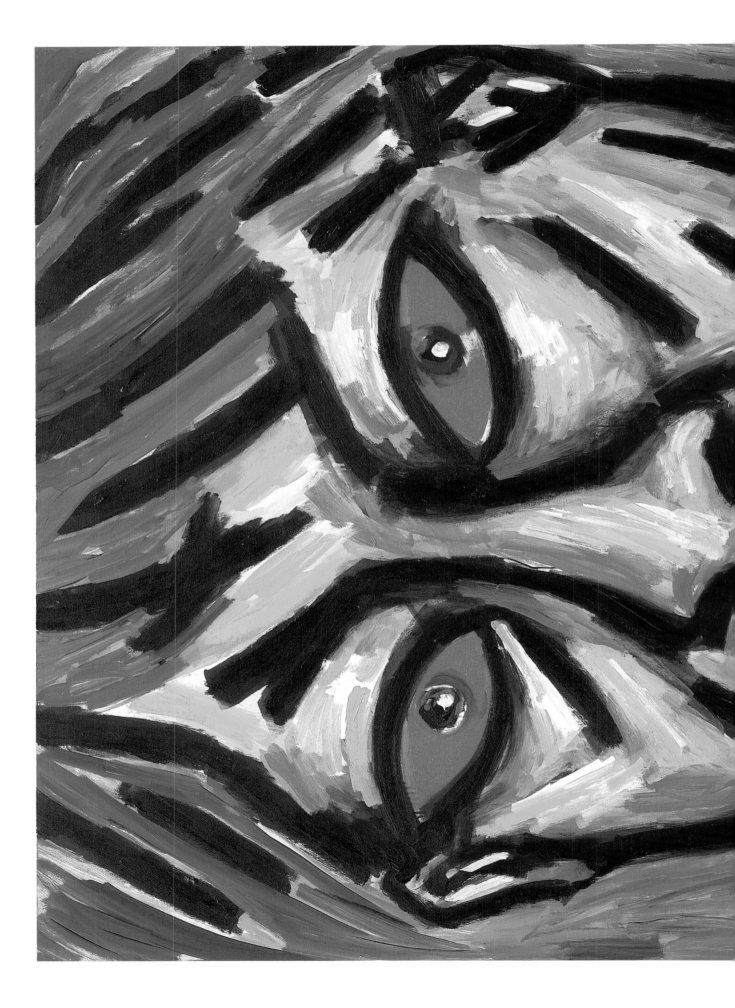

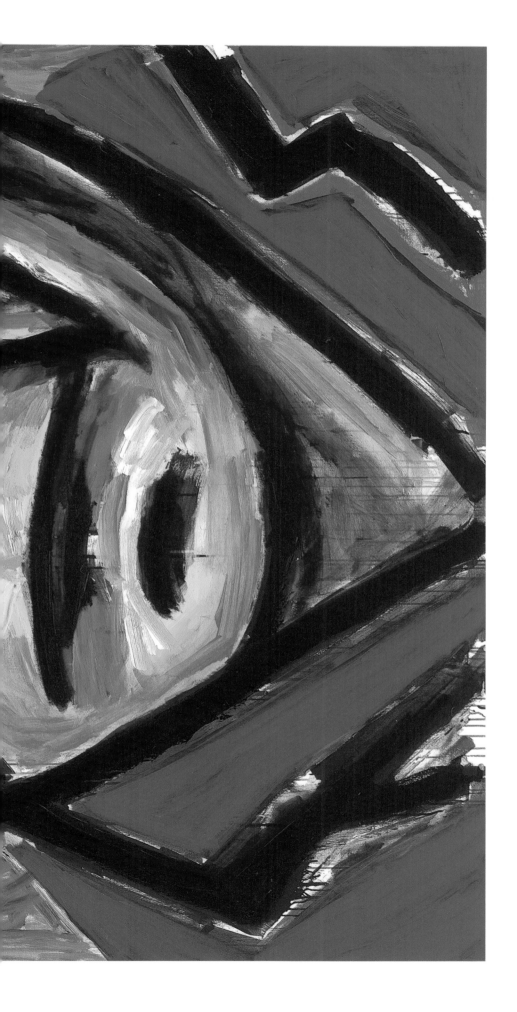

빨간 눈의 자화상 SELF-PORTRAIT WITH RED EYES
259 × 194 CM
ACRYLIC ON CANVAS
2009

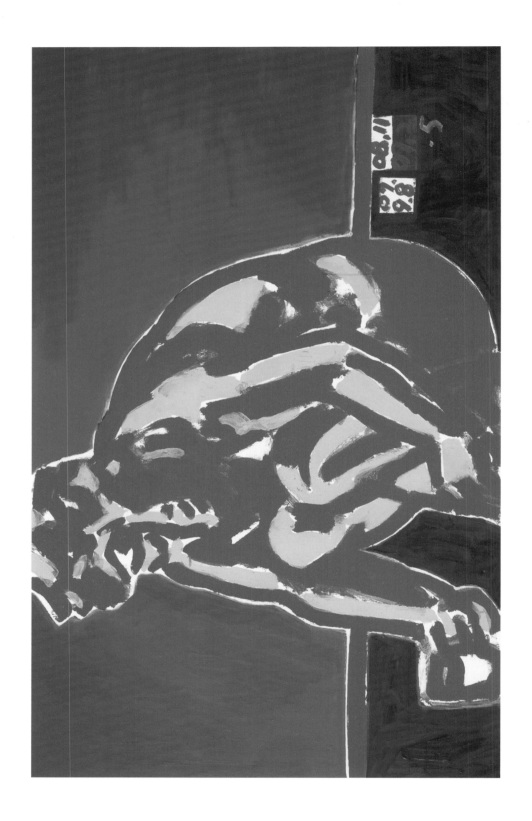

자화상 SELF-PORTRAIT
89 × 145 CM
ACRYLIC ON CANVAS
2009

90°

왠지 저는 빨간색이 감각적으로 굉장히 투명하게
느껴집니다. 눈으로 보는 투명성보다도 심리적으로 그런 것
같고요. 그렇게 다른 사람과는 다른 감각을 적용해서
그냥 더 빨갛게 그린 거죠. 90년대에 그런 특징이 있었을
거예요. 그래서 오해도 좀 받고 했습니다. 말도 안 되는
그런 얘기로 '왜 빨간색을 거부감을 느끼게 쓰냐'는 반응을
보이는 사람도 있었습니다. 1982~83년부터 더 의식적으로
빨간색을 쓰기 시작했는데, 그 당시 한국성이라는 걸
대상으로 생각했습니다. 동양화는 수묵화와 같이 무채색이
주를 이루잖습니까. 그런데 나중에 생각해보니까 불교미술
같은 거는 또 그렇지도 않아요. 붉은색을 많이 쓰죠.
그러니까 오방색이 있기는 하지만, 사실 저는 오방색을
의식해본 적은 없습니다. 그리고 제가 대학 다닐 때
화단에서 주목받는 작가들은 미니멀 계열의 작가들로
단색의 회색조, 흰색조가 거의 주된 것이었기 때문인지
뭔가 그림에 원색이 들어가면 주변 사람들이 거부감을
느끼더군요. 당시 화단 분위기가 그랬습니다. 거부감을
드러내는 평론가도 있었습니다. 그와 달리 어디선가
'한국미술에서 색이 죽어간다'라고 그렇게 썼던 글을 본
기억도 있습니다. 그런 분위기도 있었지만, 저한테는
그보다는 대학을 졸업할 즈음, 젊은 나이에 가질 저항
의식 같은 게 있었던 거죠. 우아함, 고상함과 대비되는
사회구조에 대한 분노 같은 것이었다고 생각합니다.

박춘호(대담, 정리), 「서용선 선생님과의 대화」,
『김종영미술관 소식지』21호(김종영미술관, 2020),
12~21쪽

To me, the color red is sensually received as greatly
transparent. For me, that transparency is rather
psychological than visual. To understand this issue
in terms of such senses different from others, I just
ended up painting more in red . Such was the feature
displayed mostly in the '90s. And this has invited
some misunderstandings. It is absurd, but there
were also those who complained why I had used red
in such a way to cause resistance.
I came to use red more consciously from around
1982 to 1983, considering on the idea of 'Koreanness.'
Aren't oriental paintings mainly monochrome as in
ink-and-wash paintings? But as I thought about it
again afterwards, it was not so in those works like
Buddhist paintings. They rather use red a lot. There
are five cardinal colors of obangsaek, but I have
never been aware of them. When I was in college,
those artists who acquired much attention from the
art circle all worked in a minimalistic style using
mostly monochrome shades of gray and white.
And therefore, people around me felt somewhat
discomforted when seeing primary colors in a
painting. It was a general tendency of the art circle
at the time. There were also a number of critics who
more plainly revealed their resistance against colors.
But on the one hand, I also remember encountering
a writing that wrote 'color is dying in Korean art.'
There indeed existed such views. But for me, it
was more about a spirit of resistance typical of a
young man getting ready to graduate from college.
I think it was something like a fury against the social
structure, contrasted from grace or elegance.

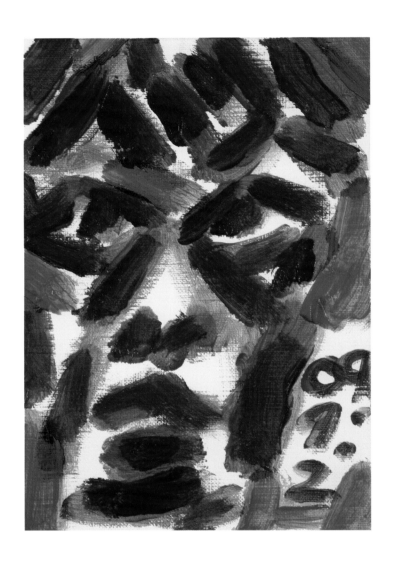

자화상 SELF-PORTRAIT
26×18 CM
ACRYLIC ON CANVAS
2009

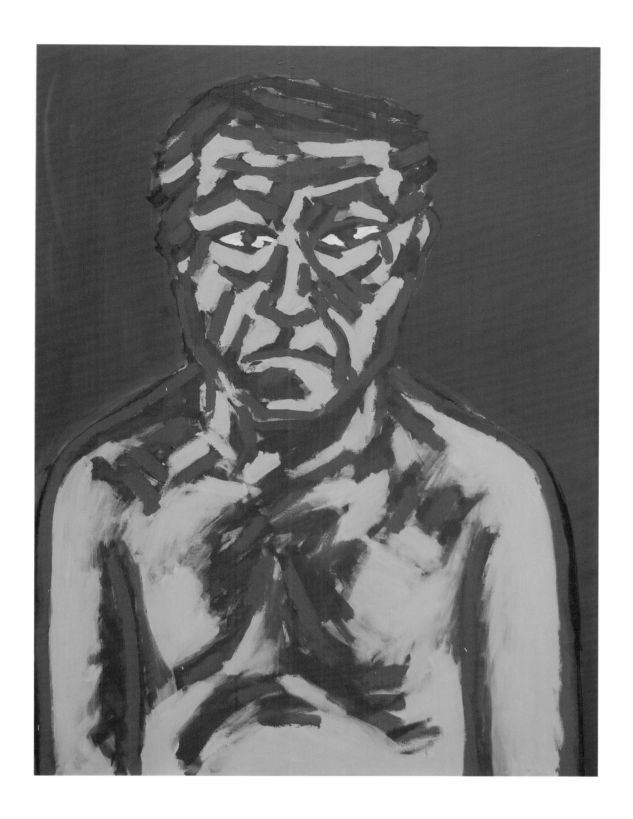

자화상 SELF-PORTRAIT
200 × 150 CM
ACRYLIC ON CANVAS
2009

그림 그리는 남자 THE MAN WHO PAINTS
161.6 × 116.6 CM
ACRYLIC ON CANVAS
2009

겨울 WINTER
134 × 117 CM
ACRYLIC ON CANVAS
2009

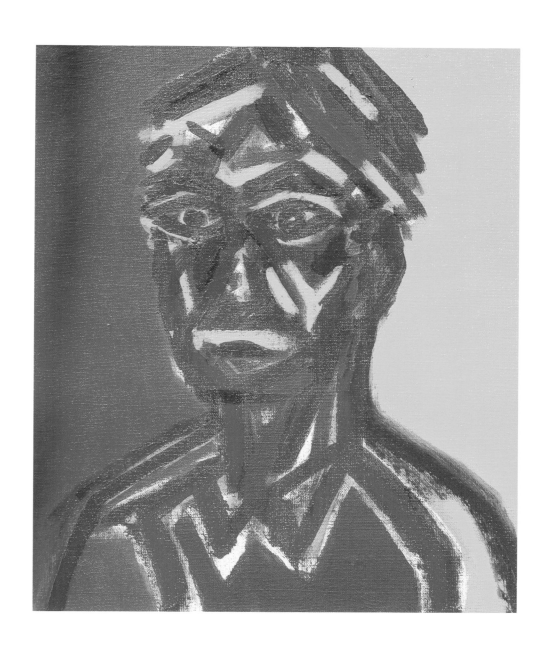

남자 ONE MAN
60 × 50 CM
ACRYLIC ON CANVAS
2009

앉아 있는 남자 SITTING MAN
100 × 80 CM
ACRYLIC ON KOREAN PAPER
2000, 2009

남자 ONE MAN
100 × 80 CM
ACRYLIC ON KOREAN PAPER
2000, 2009

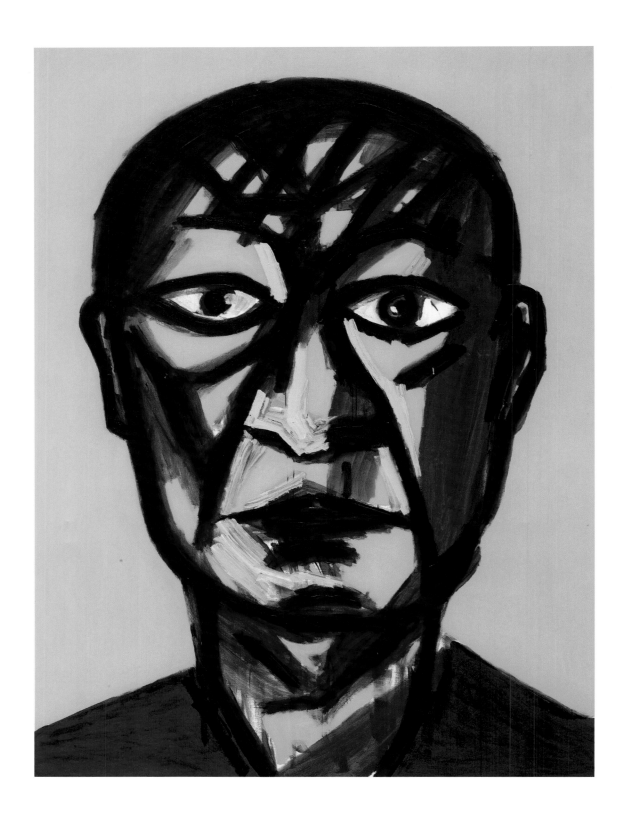

얼굴 ① THE FACE ①
259 × 194 CM
ACRYLIC ON CANVAS
2009

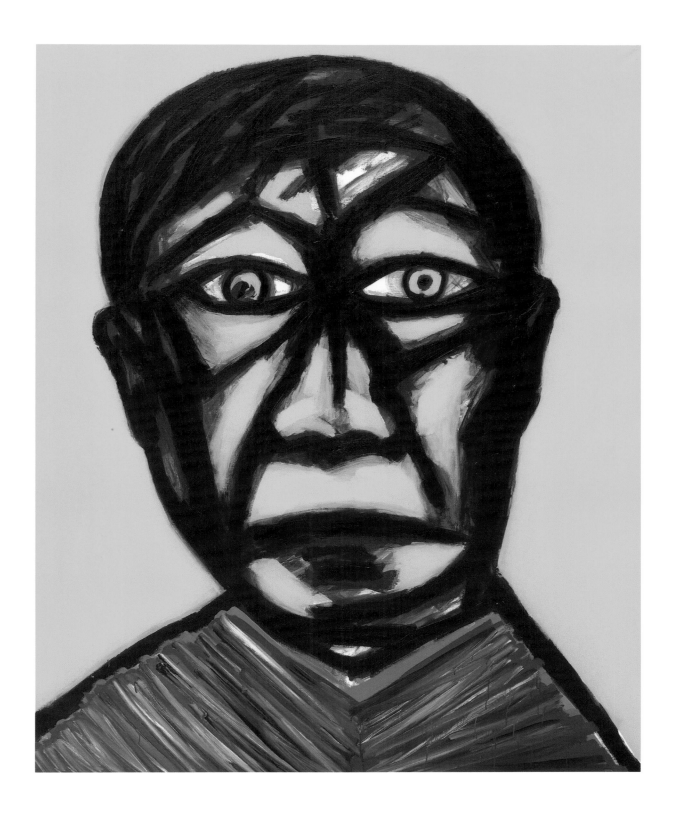

얼굴 ② THE FACE ②
249.5×200 CM
ACRYLIC ON CANVAS
2009

광부 ① MINER ①
259 × 194 CM
ACRYLIC ON CANVAS
2009

광부 ② MINER ②
259 × 194 CM
ACRYLIC ON CANVAS
2009

수줍음 SHYNESS
117 × 91 CM
ACRYLIC ON CANVAS
2007, 2009

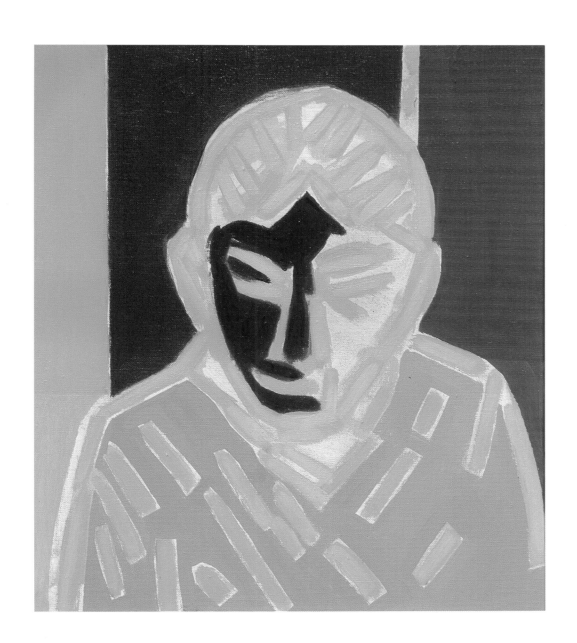

진예 JINYE
53 × 41 CM
ACRYLIC ON CANVAS
2009

김진희 ① KIM JINHEE ①
117 × 91 CM
ACRYLIC ON CANVAS
2009

김진희 ② KIM JINHEE ②
117 × 91 CM
ACRYLIC ON CANVAS
2009

주대관 **JU DAEGWAN**
53 × 41 CM
OIL ON CANVAS
1997, 2008, 2009

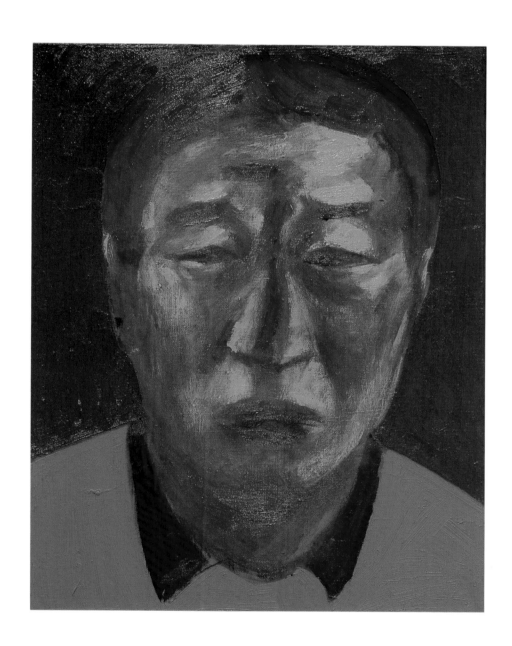

주대관 ② JU DAEGWAN ②
53 × 41 CM
OIL ON CANVAS
1997, 2008, 2009

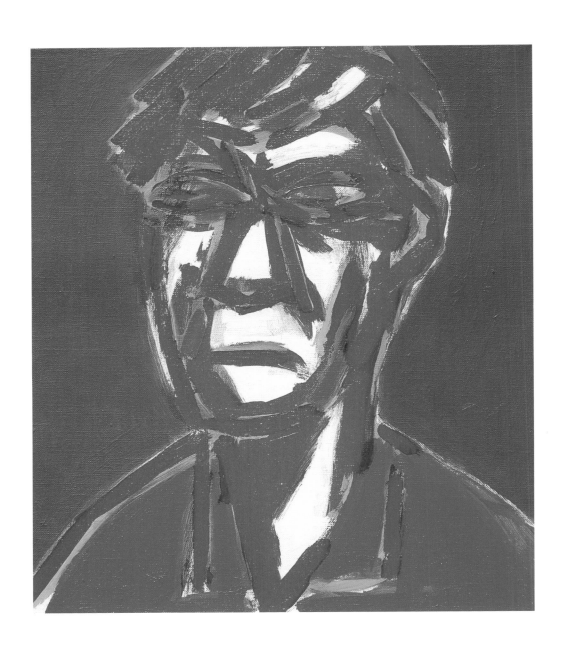

한승호 HAN SEUNGHO
53 × 41 CM
ACRYLIC ON CANVAS
2009

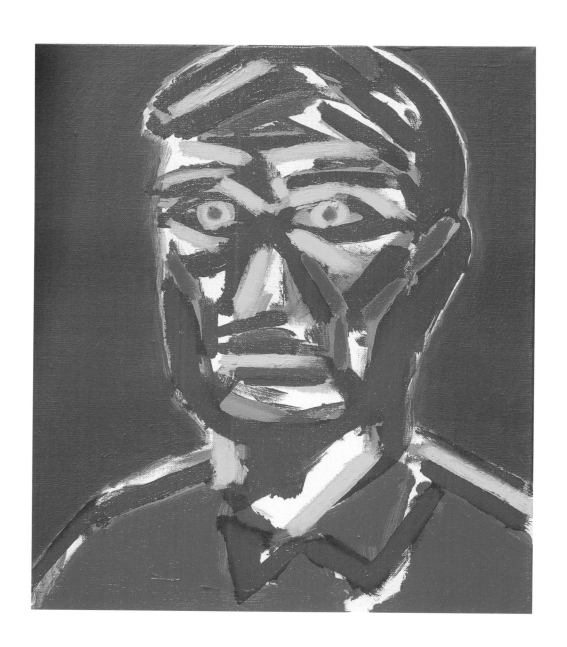

황종수 HWANG JONGSOO
53 × 41 CM
ACRYLIC ON CANVAS
2009

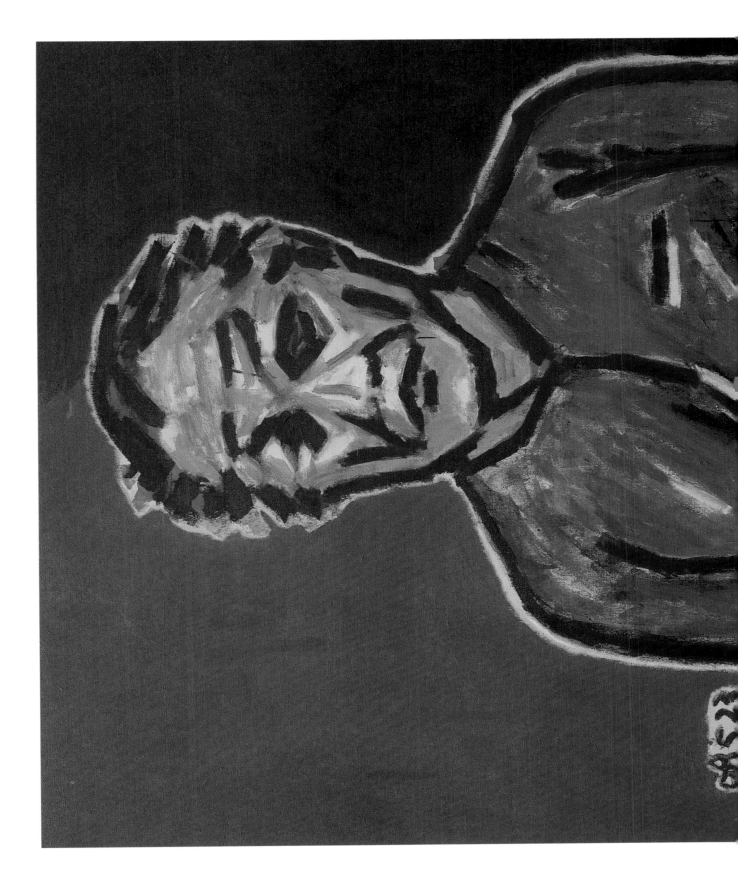

류광운 RYU GWANGWOON
333 × 218 CM
ACRYLIC ON CANVAS
2008, 2009

이가영 LEE GAYOUNG
200×150 CM
ACRYLIC ON CANVAS
2009

의자 CHAIR
162 × 97 CM
ACRYLIC ON CANVAS
2009

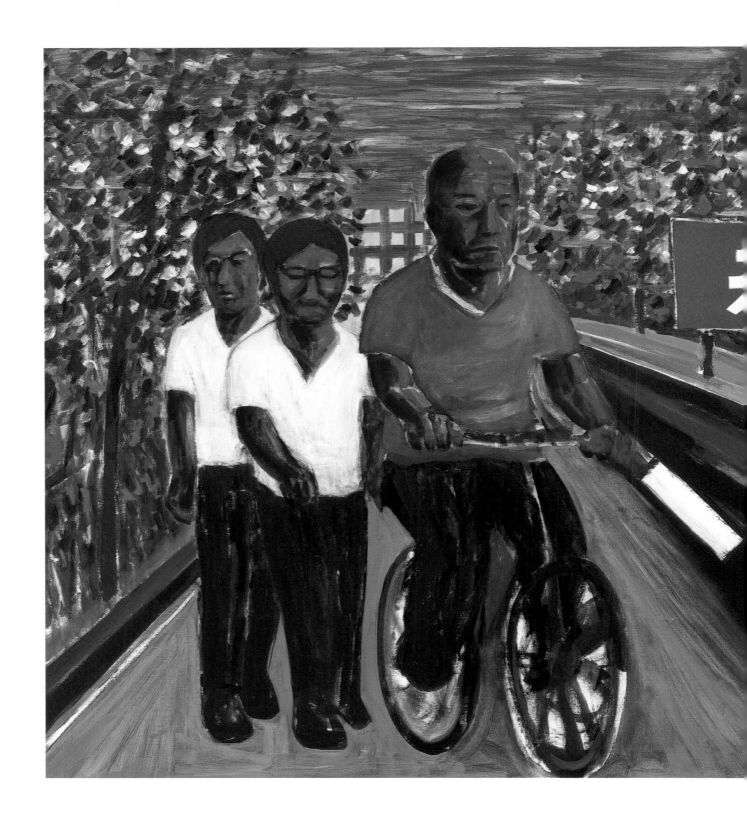

베이징 ① BEIJING ①
200 × 300 CM
ACRYLIC ON CANVAS
2007, 2008, 2009

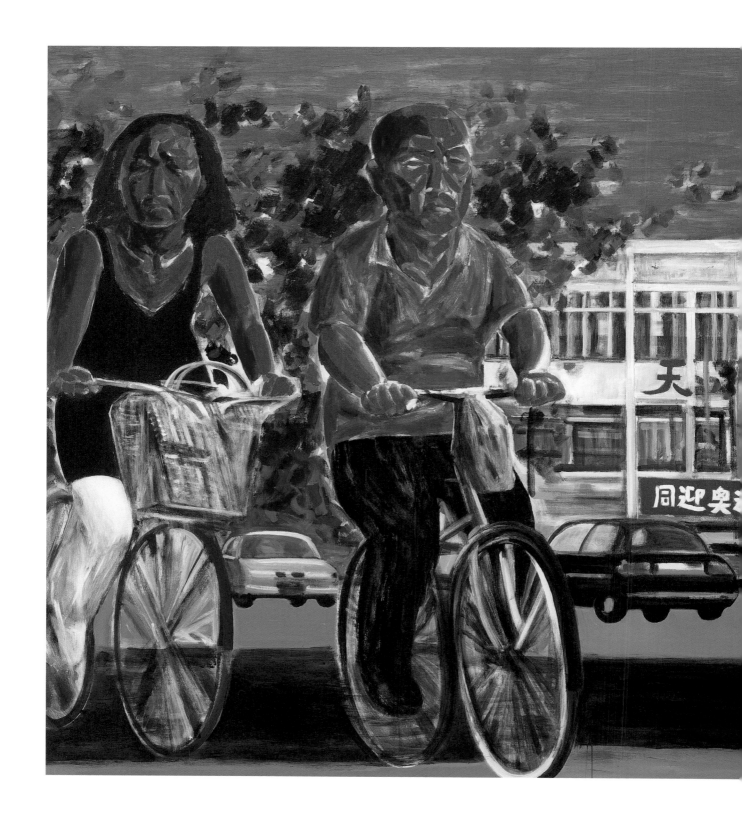

베이징 ② BEIJING ②
200 × 300 CM
ACRYLIC ON CANVAS
2007, 2008, 2009

베이징 ③ BEIJING ③
200×300 CM
ACRYLIC ON CANVAS
2007, 2008, 2009

베이징 ④ BEIJING ④
200 × 300 CM
ACRYLIC ON CANVAS
2007, 2008, 2009

걸어가는 남자 - 라이꽝잉(來廣管) WALKING MAN -
LAIGUANGYING
200 × 150 CM
ACRYLIC ON CANVAS
2007, 2009

北京 버스, 라이광잉（來廣營）BEIJING BUS, LAIGUANGYING
300×200 CM
ACRYLIC ON CANVAS
2008, 2009

베이징 버스 ① BEIJING BUS ①
300 × 200 CM
ACRYLIC ON CANVAS
2008, 2009

베이징 버스 ② BEIJING BUS ②
300 × 200 CM
ACRYLIC ON CANVAS
2008, 2009

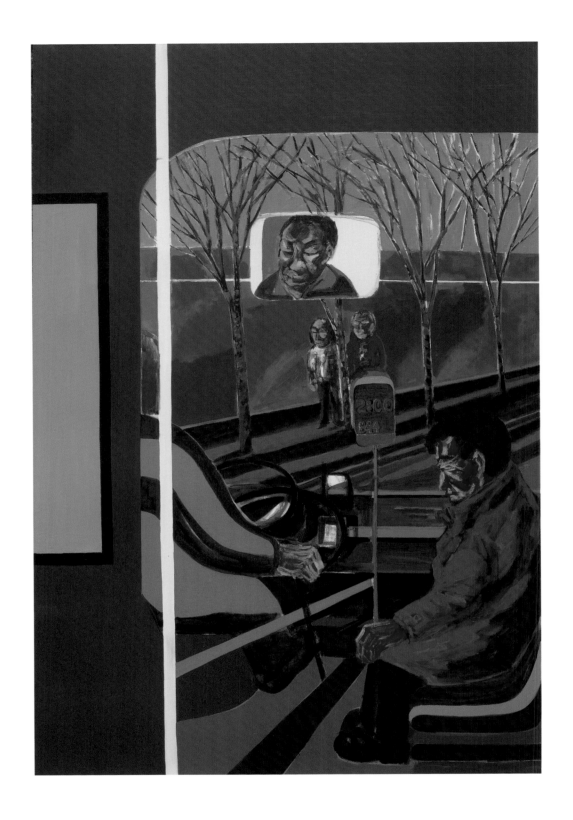

베이징 버스 ③ BEIJING BUS ③
300 × 200 CM
ACRYLIC ON CANVAS
2008, 2009

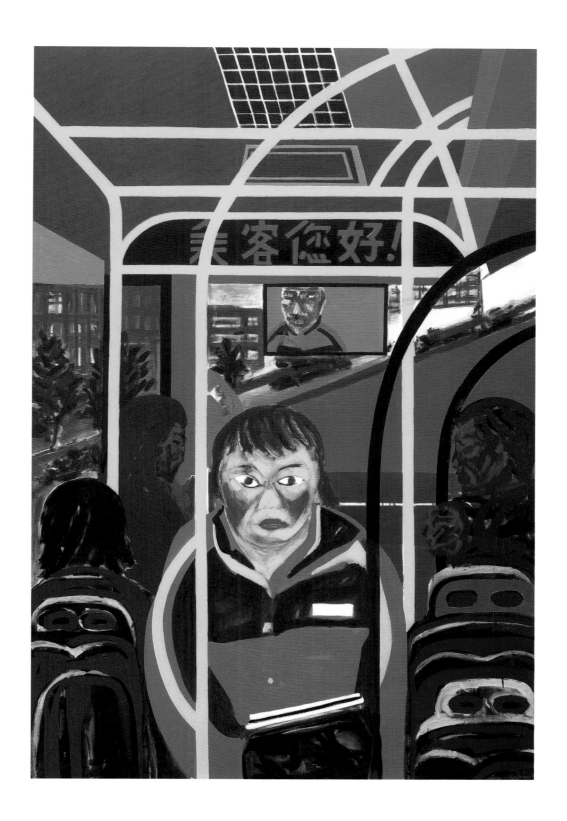

베이징 버스 ④ BEIJING BUS ④
300 × 200 CM
ACRYLIC ON CANVAS
2008, 2009

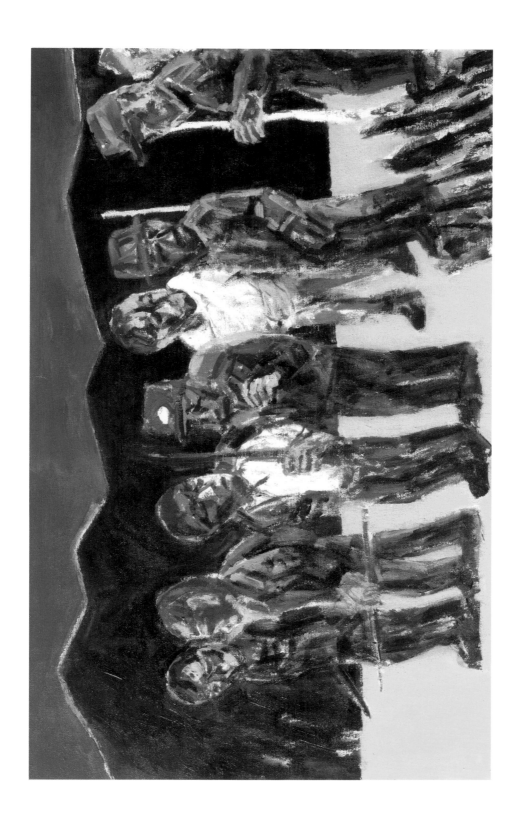

남녘 사람, 북녘 사람 MEN FROM THE SOUTH,
MEN FROM THE NORTH
80.4 × 130 CM
ACRYLIC ON CANVAS
2009

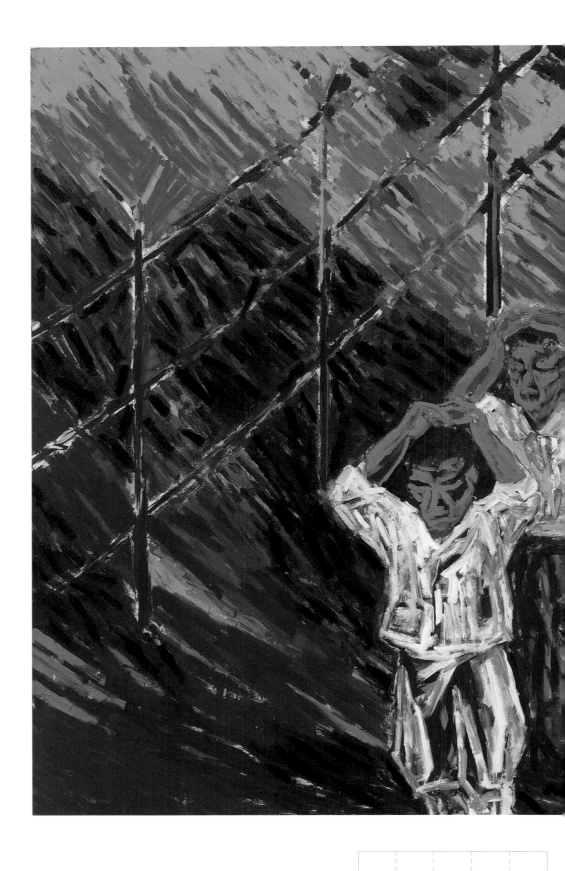

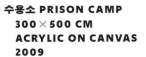

수용소 PRISON CAMP
300 × 500 CM
ACRYLIC ON CANVAS
2009

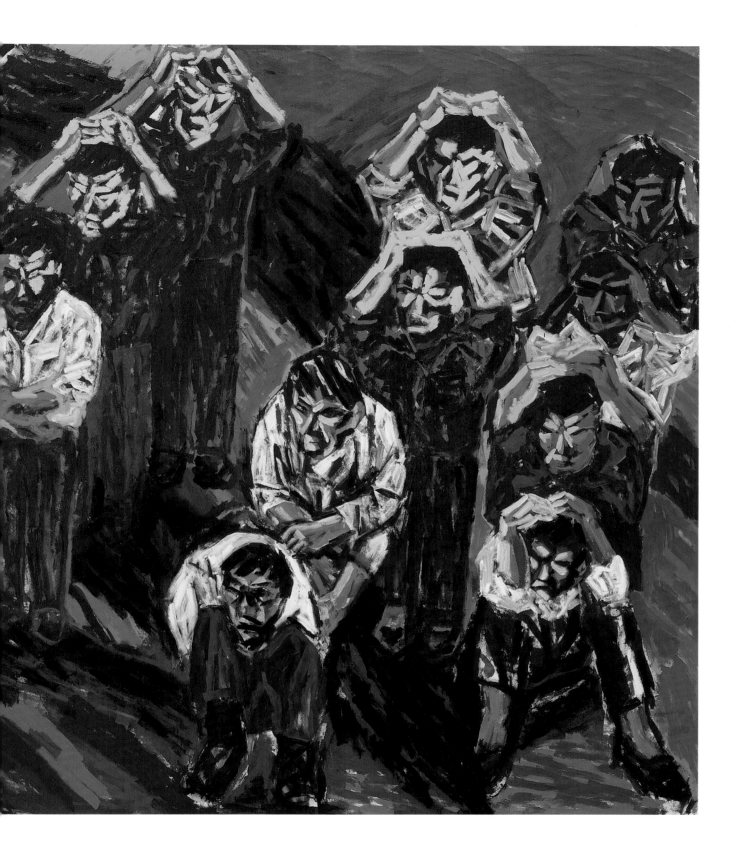

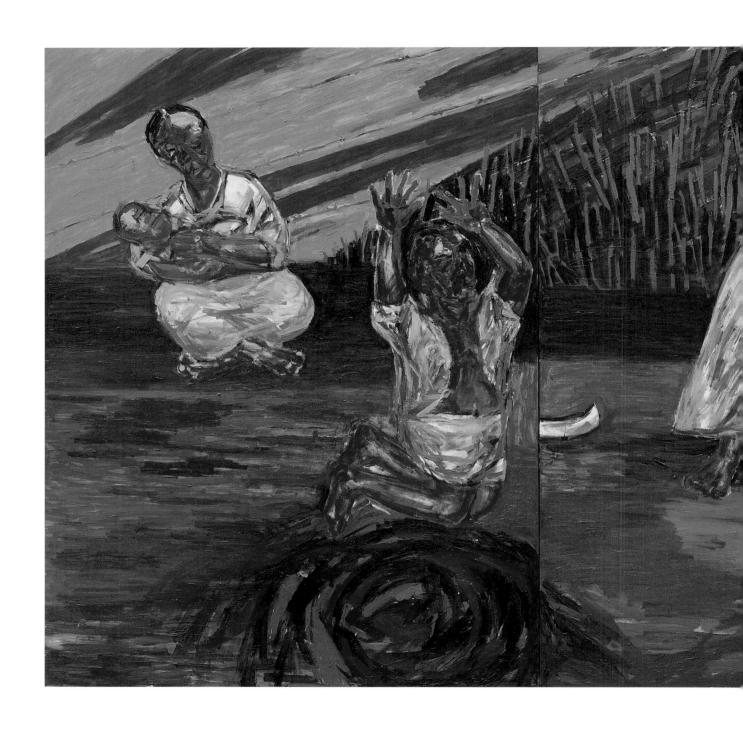

희생 CASUALTIES OF WAR
260 × 580.5 CM（3P）
OIL ON CANVAS
2009

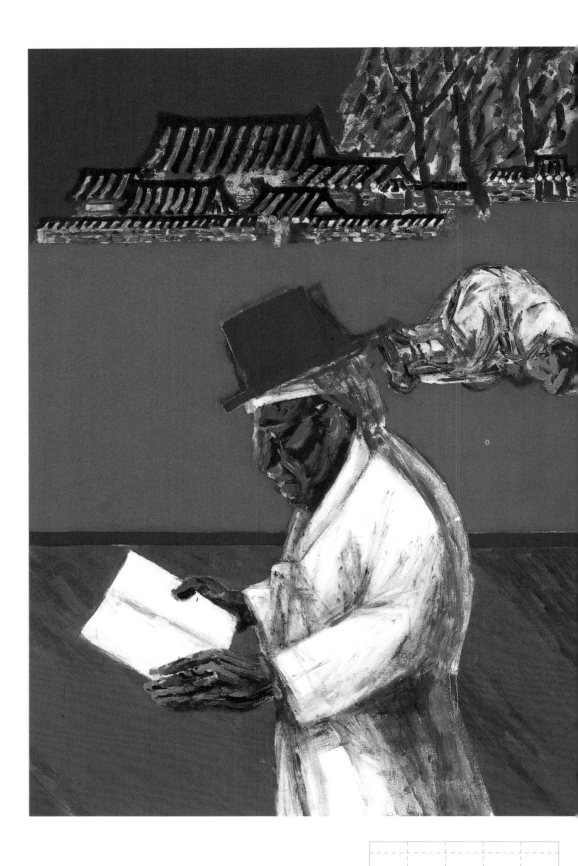

계유년 GYEYUNYEON
330 × 500 CM
ACRYLIC ON CANVAS
2009

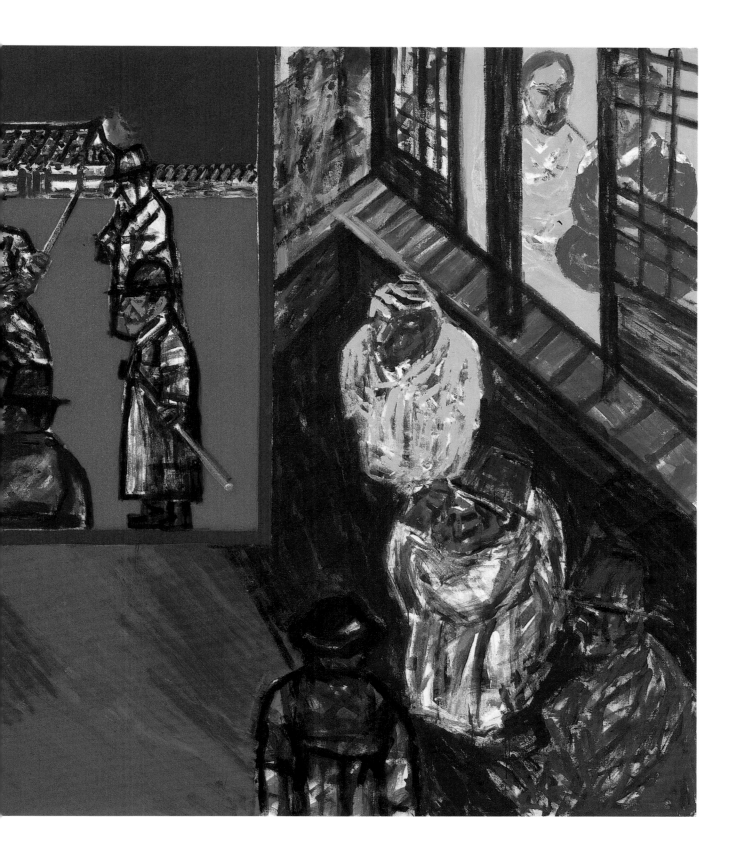

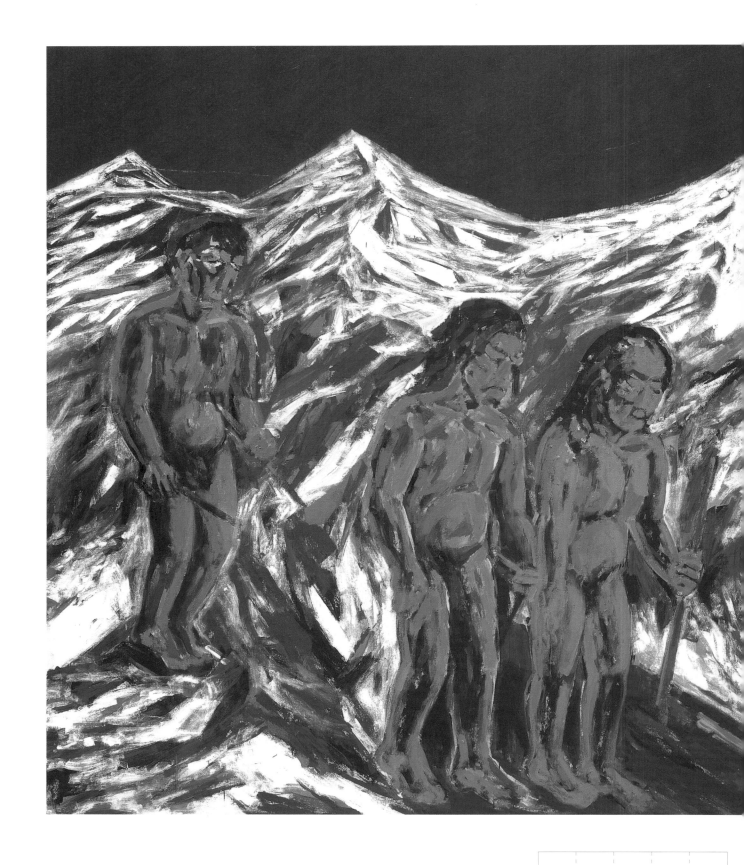

마고성 사람들 THE PEOPLE OF MAGO CASTLE
300 × 500 CM
ACRYLIC ON CANVAS
2009

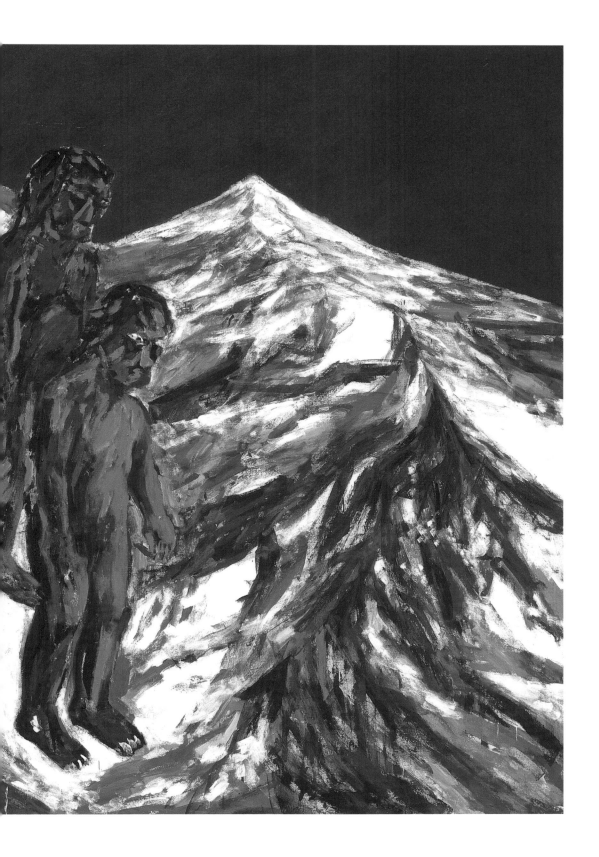

마고성 사람들 THE PEOPLE OF MAGO CASTLE
800 × 30 CM
ACRYLIC ON WOOD AND STEEL SUPPORT
2009

마고성 사람들 (부분) THE PEOPLE OF MAGO CASTLE (DETAIL)
800 × 30 CM
ACRYLIC ON WOOD AND STEEL SUPPORT FIXTURE
2009

마고성 사람들(부분) THE PEOPLE OF MAGO CASTLE (DETAIL)
800×30 CM
ACRYLIC ON WOOD AND STEEL SUPPORT FIXTURE
2009

마고성 사람들 (부분) THE PEOPLE OF MAGO CASTLE (DETAIL)
800 × 30 CM
ACRYLIC ON WOOD AND STEEL SUPPORT FIXTURE
2009

마고성 사람들 (부분) THE PEOPLE OF MAGO CASTLE (DETAIL)
800 × 30 CM
ACRYLIC ON WOOD AND STEEL SUPPORT FIXTURE
2009

마고성 사람들 (부분) THE PEOPLE OF MAGO CASTLE (DETAIL)
800 × 30 CM
ACRYLIC ON WOOD AND STEEL SUPPORT FIXTURE
2009

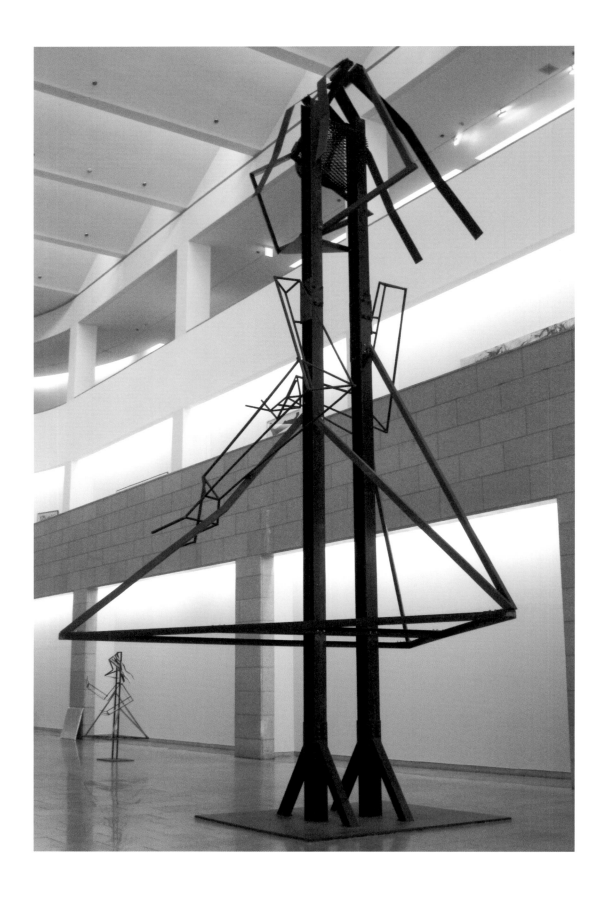

마고 ① MAGO ①
800 × 500 × 330 CM
STEEL
2009

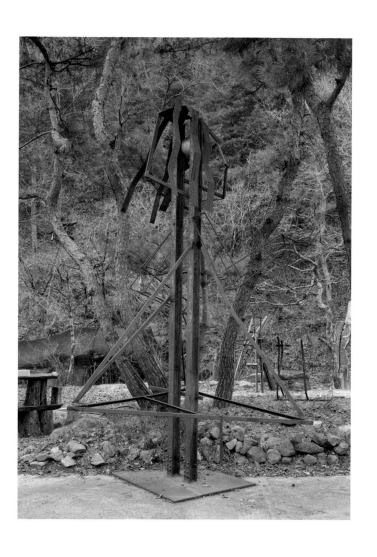

마고 ② MAGO ②
420 × 243 × 212 CM
STEEL
2009

마고 ③ MAGO ③
203 × 122 × 130 CM
STEEL
2009

마고 MAGO
162.5 × 130.5 CM
ACRYLIC ON CANVAS
2009

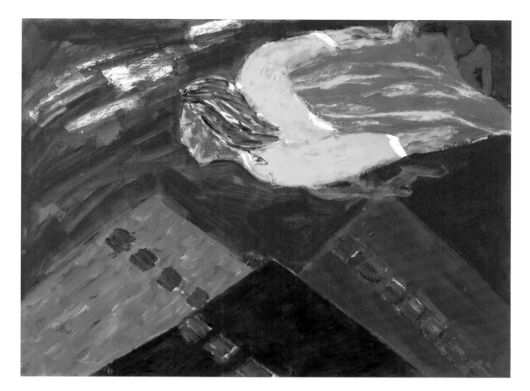

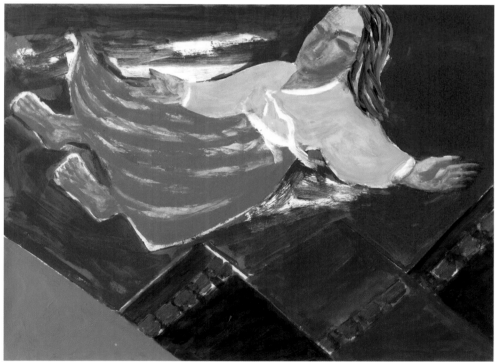

↑
마고 ① MAGO ①
54 × 72 CM
ACRYLIC ON KOREAN PAPER
2009

↓
마고 ② MAGO ②
54 × 72 CM
ACRYLIC ON KOREAN PAPER
2009

이른 봄, 한 화랑 주인의 도움으로 지리산 묵계에 머물 기회를 갖게 되었다. 4일간 쌍계사, 화엄사, 청학동, 하동 평사리, 노고단을 돌아다니며 맘껏 풍경을 그렸다. 혼자 밥을 해 먹으며 원묵계의 한 중턱에서 지리산을 한껏 즐길 기회를 가진 것이다. 마지막 날 청학동 골짜기에서 얼핏 '마고성'이라는 푯말을 보게 되었다. 마고성이라! 매달 한 번씩 찾아가는 태백행 길목의 함백산 바로 밑자락에 위치한 마고할미 신당이 생각났다. 아울러 중국 돈황의 한 협곡에서(천불동이었을 것이다) 서왕모 사당을 봤던 생각도 났다. 그리고 부도지를 읽어 보았다. 박제상의 부도지의 근거는 무엇일까? 중국 통일 이전의 고대사회와 한민족은 어떤 관계인가? 지리산도 그 열쇠의 일부를 쥐고 있는 듯하다.

작가 노트(지리산 답사기), 2009·3·8

In early spring, I had an opportunity to stay in a town called Mukgye near the Jirisan Mountain in courtesy of a gallery owner. During the four-day period, I wandered around the nearby locations of Ssangyesa Temple, Hwaeomsa Temple, Cheonghakdong, Pyeongsa-ri, and Nogodan and painted their beautiful scenery as much as I wished to. It was a chance for me to enjoy the Jirisan Mountain to the utmost on a mountainside in Wonmukgye, travelling alone and cooking for myself. On the last day, I came across a signpost that said 'Magoseong.' Magoseong! The name reminded me of a mago halmi (a crone from a myth who is known to have long nails that resembles birds' talon) shrine I encountered on my monthly visit to Taebaek that stood right under the Hambaeksan Mountain. The name also conjured up a memory of seeing the temple of the goddess Xi Wang Mu in a valley (probably the valley of Thousand Buddha Caves) in Dunhuang, China. And then, I read through the book Budoji (translator's note: Budoji is the first volume of Jingsimrok which writes of an ancient history of the Korean people. The book begins with a genesis mythology also known as 'Mago Myth' that takes place in a castle called Magoseong. The book is known to have been written by Park Jaesang from Shilla.) What would have been the basis for Park Jaesang's Budoji? How were the ancient society that existed before the unification of China and the Korean people related? It seems that the Jirisan Mountain also holds one piece of that puzzle.

지리산 원묵계 ① JIRISAN (MT.) WONMUKGYE ①
91 × 117 CM
ACRYLIC ON CANVAS
2009

지리산 원묵계 ② JIRISAN （MT.） WONMUKGYE ②
60.5 × 72.5 CM
ACRYLIC ON CANVAS
2009

지리산 원묵계 ③ JIRISAN (MT.) WONMUKGYE ③
60.5 × 72.5 CM
ACRYLIC ON CANVAS
2009

지리산 성삼재 JIRISAN (MT.) SEONGSAMJAE
50 × 72.5 CM
ACRYLIC ON CANVAS
2009

지리산 상월 JIRISAN (MT.) SANGWOL
50 × 72.5 CM
ACRYLIC ON CANVAS
2009

쌍계사 ① SSANGGYESA TEMPLE ①
72.5 × 116.5 CM
ACRYLIC ON CANVAS
2009

쌍계사 ② SSANGGYESA TEMPLE ②
50 × 72.5 CM
ACRYLIC ON CANVAS
2009

화엄사 연기암 HWAEOMSA TEMPLE YEONGIAM
60.5×72.5 CM
ACRYLIC ON CANVAS
2009

하동 평사리 PYEONGSA-RI, HADONG
50 × 73 CM
ACRYLIC ON CANVAS
2009

→ ↑
낙산사 ② NAKSANSA TEMPLE ②
72.5 × 91 CM
ACRYLIC ON CANVAS
2009

→ ↓
낙산사 ① NAKSANSA TEMPLE ① 낙산사 ③ NAKSANSA TEMPLE ③
45.5 × 53 CM 72.5 × 91 CM
ACRYLIC ON CANVAS ACRYLIC ON CANVAS
2008, 2009 2009

정선 JEONGSEON
53 × 45.5 CM
ACRYLIC ON CANVAS
2008, 2009

굴암리 GYULAM-RI
45.5 × 53 CM
ACRYLIC ON CANVAS
2008, 2009

정선군 고한 ① GOHAN, JEONGSEON-GUN ①
50 × 73 CM
ACRYLIC ON CANVAS
2008, 2009

정선군 고한 ② GOHAN, JEONGSEON-GUN ②
50 × 73 CM
ACRYLIC ON CANVAS
2009

구와우 ① GUWAWU VILLAGE ①
72.5 × 117.5 CM
ACRYLIC ON CANVAS
2008, 2009

90°

구와우 ② GUWAWU VILLAGE ②
116.5 × 72.5 CM
ACRYLIC ON CANVAS
2008, 2009

구와우 ③ GUWAWU VILLAGE ③
53 × 72 CM
ACRYLIC ON CANVAS
2008, 2009

구와우 ④ GUWAWU VILLAGE ④
61 × 72.5 CM
ACRYLIC ON CANVAS
2007, 2009

구와우 ⑤ GUWAWU VILLAGE ⑤
61 × 72.5 CM
ACRYLIC ON CANVAS
2007, 2009

명달리, 양평 MYEONGDAL-RI, YANGPYEONG
60.8 × 91 CM
ACRYLIC ON CANVAS
2008, 2009

다릿골 ① DARIGOL ①
50 × 60.8 CM
ACRYLIC ON CANVAS
2008, 2009

다릿골 ② DARIGOL ②
61 × 72.5 CM
ACRYLIC ON CANVAS
2008, 2009

다릿골 닥나무 ① DARIGOL MULBERRY ①
130.5 × 162.5 CM
ACRYLIC ON CANVAS
2009

다릿골 닥나무 ② **DARIGOL MULBERRY** ②
130.5 × 162.5 CM
ACRYLIC ON CANVAS
2009

금강골 GEUMGANGGOL
60.7 × 50 CM
ACRYLIC ON CANVAS
2009

용소골(덕풍계곡) YONGSOGOL (DEOKPUNG VALLEY)
53 × 72 CM
ACRYLIC ON CANVAS
2009

소나무 풍경 LANDSCAPE WITH PINE TREES
60.5×72 CM
ACRYLIC ON CANVAS
2009

소나무 PINE TREES
117 × 91 CM
ACRYLIC ON CANVAS
2009

해운대 HAEUNDAE
60.5 × 91 CM
ACRYLIC ON CANVAS
2006, 2009

태종대 신선바위 TAEJONGDAE, SINSEON BAWI ROCK
60.5 × 91 CM
ACRYLIC ON CANVAS
2006, 2009

둔황 가는 길 - 섬서성 ①
ROAD TO DUNHUANG - SHAANXI ①
132 × 162 CM
ACRYLIC ON CANVAS
2009

둔황 가는 길 – 섬서성 ②
ROAD TO DUNHUANG – SHAANXI ②
132 × 162 CM
ACRYLIC ON CANVAS
2009

뭉치 **MOONGCHI**
130 × 89.3 CM
ACRYLIC ON CANVAS
2006, 2009

주시 KEEPING AN EYE
550 × 200 × 20 CM
STEEL
2009

체포된 사람들 ① ② ③ ⑥ ⑦ **ARRESTED** ① ② ③ ⑥ ⑦
약 122.5 × 54.5 × 55 CM
ACRYLIC ON WOOD PANEL, BOLT
2009

감시 *SURVEILLANCE*
250 × 120 × 40 CM
REINFORCED STYROFOAM
2009

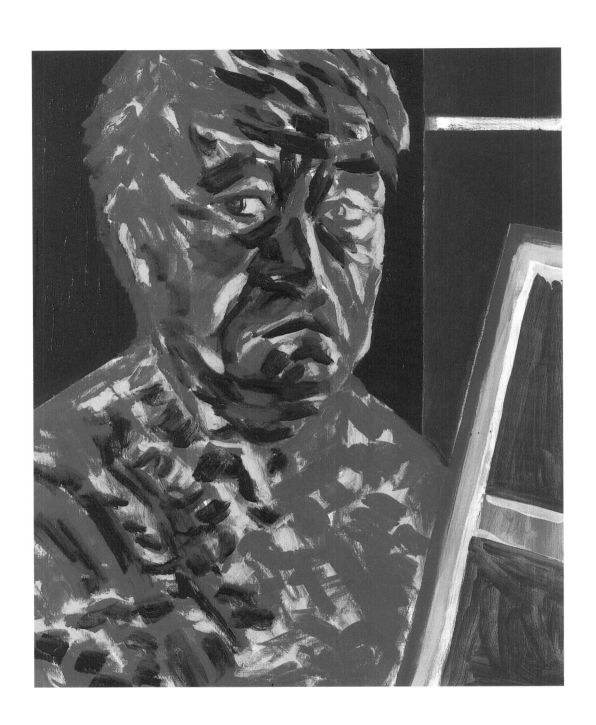

자화상 SELF-PORTRAIT
91×73 CM
ACRYLIC ON CANVAS
2010

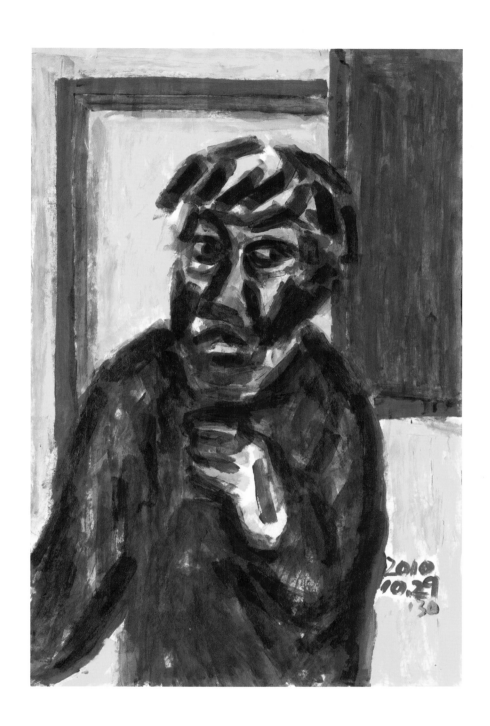

그림 그리는 남자 THE MAN WHO PAINTS
96 × 62.5 CM
ACRYLIC ON DAKPAPER
2010

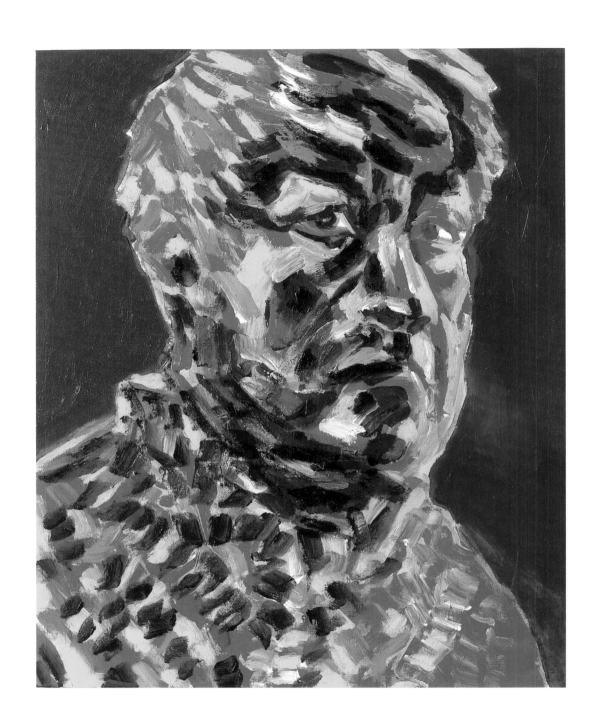

자화상 SELF-PORTRAIT
91 × 73 CM
ACRYLIC ON CANVAS
2009, 2010

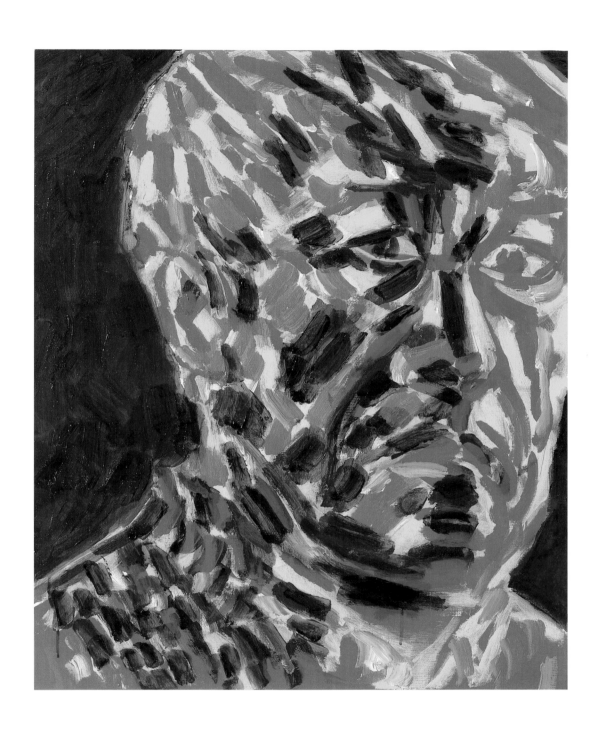

자화상 **SELF-PORTRAIT**
91 × 73 CM
ACRYLIC ON CANVAS
2009, 2010

자화상 SELF-PORTRAIT
91 × 73 CM
ACRYLIC ON CANVAS
2009, 2010

자화상 SELF-PORTRAIT
91 × 73 CM
ACRYLIC ON CANVAS
2009, 2010

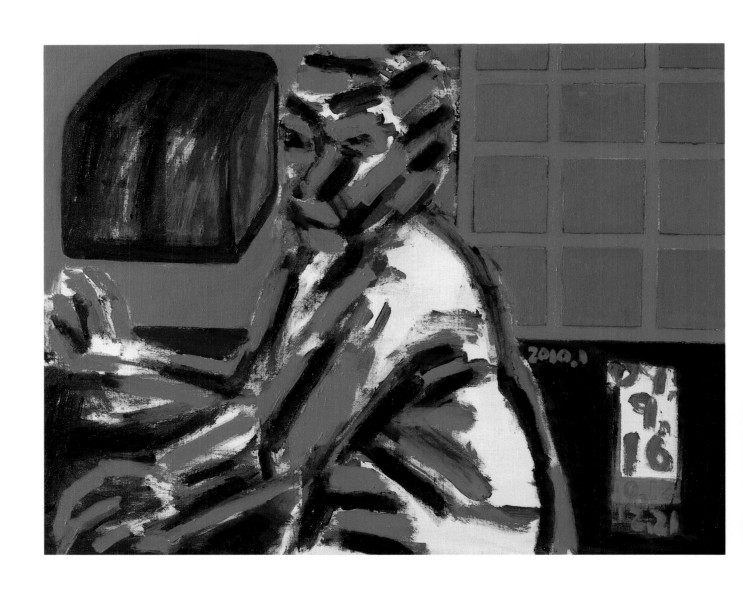

그림 그리는 남자 ① THE MAN WHO PAINTS ①
91 × 116.5 CM
ACRYLIC ON CANVAS
2009, 2010

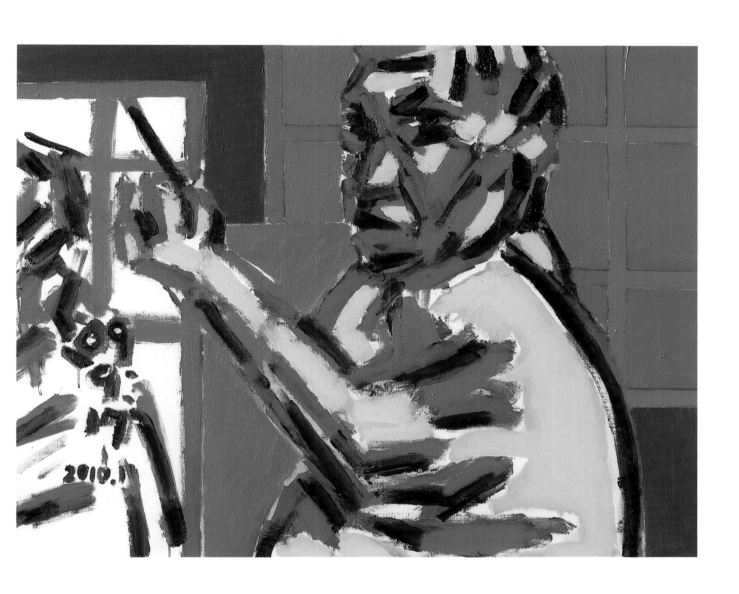

그림 그리는 남자 ② THE MAN WHO PAINTS ②
91 × 116.5 CM
ACRYLIC ON CANVAS
2009, 2010

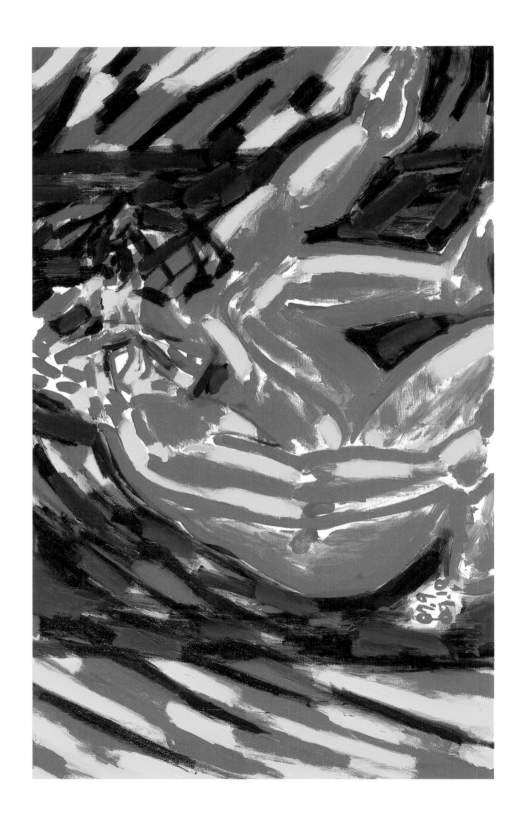

그림 그리는 남자 THE MAN WHO PAINTS
89×145.5 CM
ACRYLIC ON CANVAS
2007, 2010

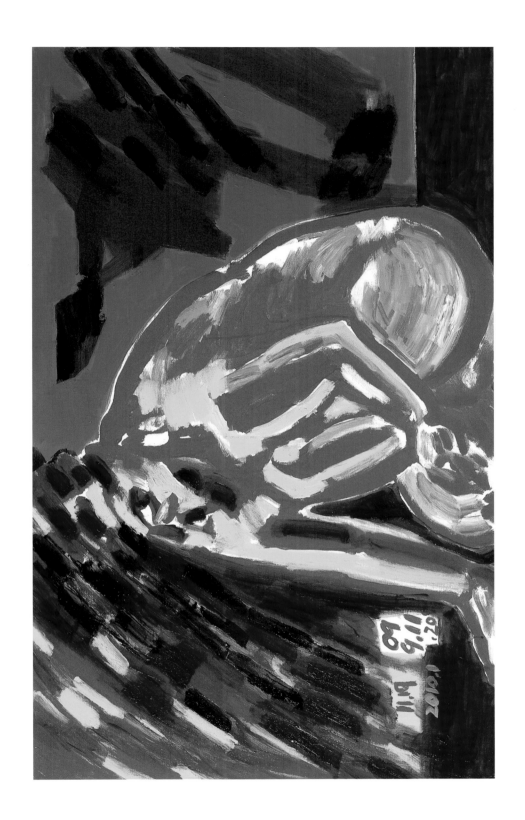

잠에서 깨어나기 WAKING UP
89 × 145 CM
ACRYLIC ON CANVAS
2009, 2010

90°

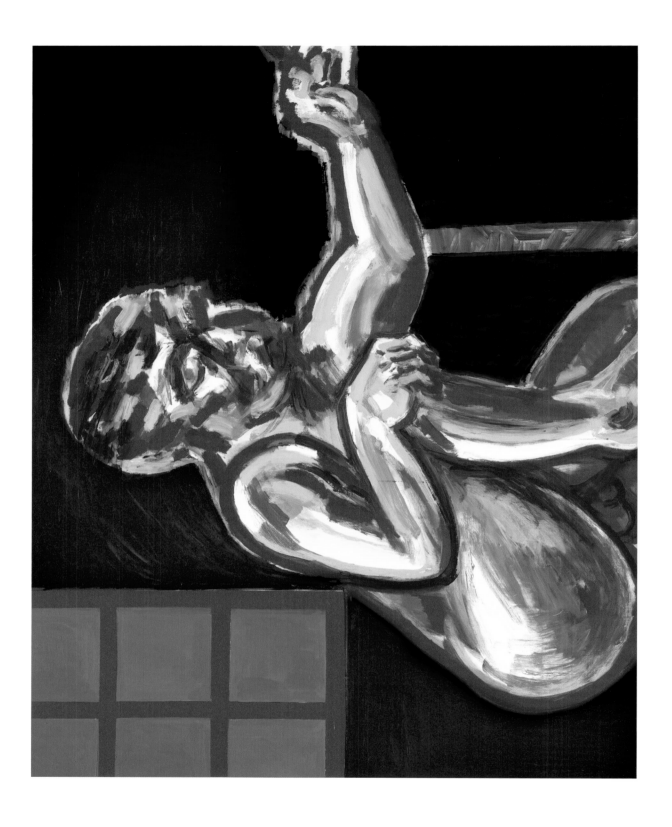

그림 - 아침 PAINTING IN THE MORNING
130.5 × 162 CM
ACRYLIC ON CANVAS
2010

90°

제가 한창 많이 자화상을 그릴 때 그렇게[아침에 기상하자마자 바로 자화상을 그리는 것을] 했습니다. 최대한 의식이 깨어나지 않은, 즉 의식과 무의식 사이에서 그림을 그리면 어떨지 생각했어요. 그래서 자기 전에 침대 옆에 거울도 가져다 놓고, 물감과 종이도 준비해 놓는 등, 바로 자화상을 그릴 수 있도록 해놓고, 아침에 눈 뜨자마자 침대에서 굴러 떨어지듯이 일어나서 드로잉을 했어요.

심은록, 『사람에 대한 환원적 호기심 – 서용선과의 대화』(교육과학사, 2016), 25쪽.

In the period when I ardently painted self-portraits, I had that routine [of painting a self-portrait right after getting out of bed in the morning]. I was interested in drawing in between consciousness and unconsciousness, at the most semiconscious state possible. This is why I prepared everything needed to draw a self-portrait before going to bed — placing a mirror beside my bed along with paints and paper. And as soon as I opened my eyes in the morning, I would literally roll out of my bed and started to draw.

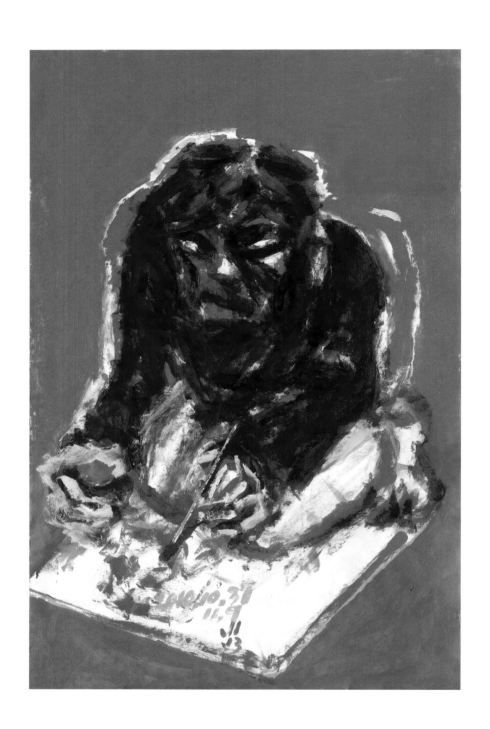

그림 그리는 남자 ① THE MAN WHO PAINTS ①
96 × 62.5 CM
ACRYLIC ON DAKPAPER
2010

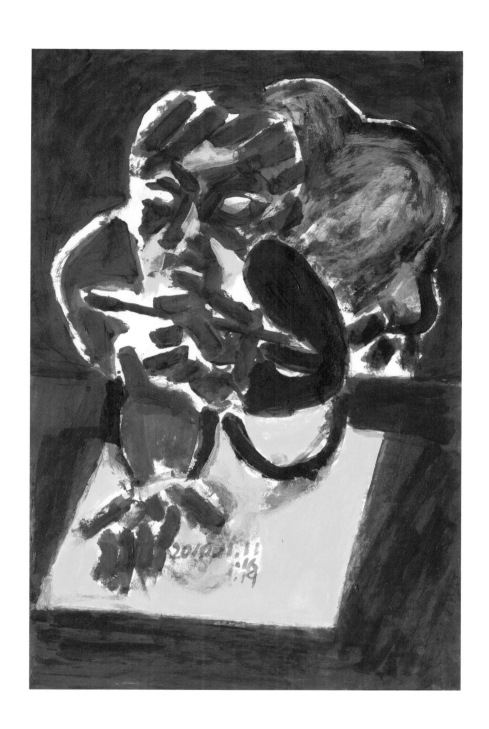

그림 그리는 남자 ② THE MAN WHO PAINTS ②
96 × 62.5 CM
ACRYLIC ON DAKPAPER
2010

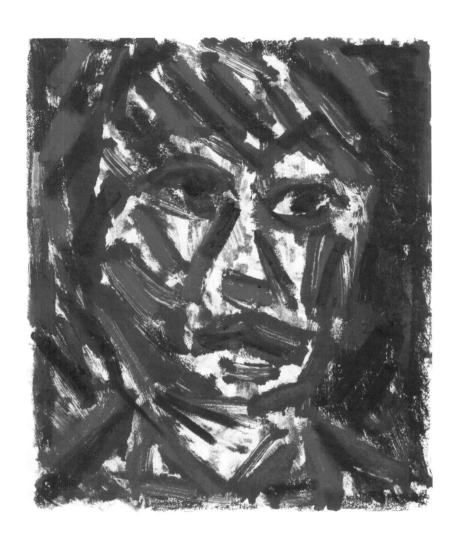

자화상 SELF PORTRAIT
31.5 × 21 CM
MONOPRINT
2010

→
들여다보는 개 A DOG PEEKING
INTO THE ROOM
258.5 × 193.5 CM
ACRYLIC ON CANVAS
2010

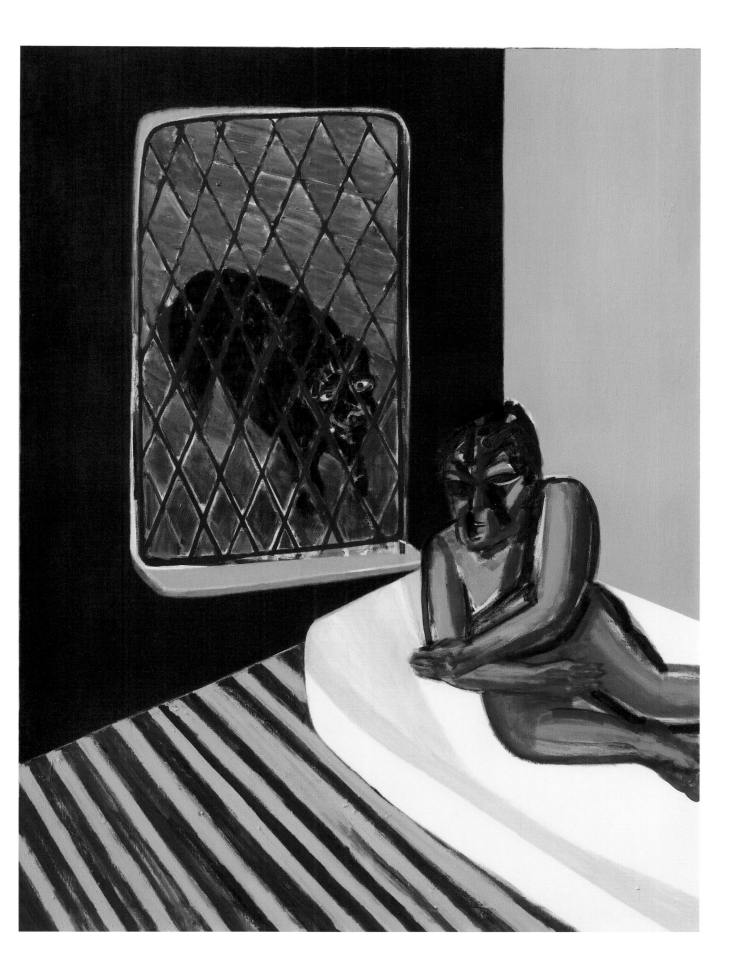

남자 ONE MAN
51 × 40.5 CM
ACRYLIC ON PAPER
2010

이상(李箱) ① LEE SANG ①
82 × 54 CM
ACRYLIC ON PAPER
2010

머리 ① ONE HEAD ①
65 × 45.5 CM
ACRYLIC ON CANVAS
2010

머리 ② ONE HEAD ②
65 × 45.5 CM
ACRYLIC ON CANVAS
2010

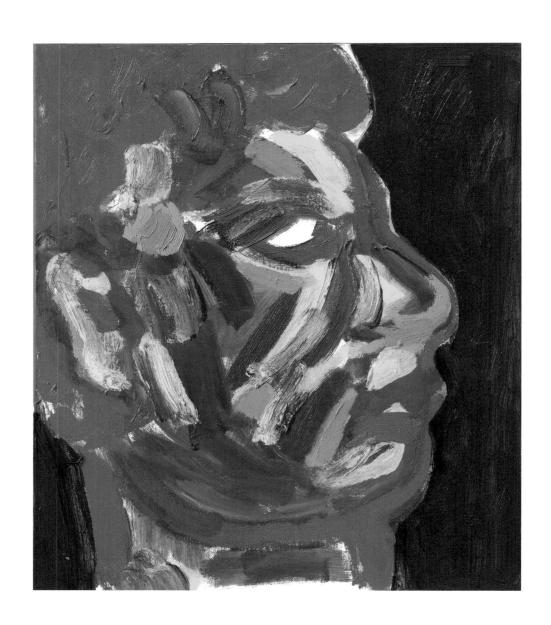

흑인 남자 BLACK MAN
53 × 45.5 CM
OIL ON CANVAS
2010

여자 ONE WOMAN
50 × 45 CM
OIL ON CANVAS
2010

김진희 ① KIM JINHEE ①
162 × 130 CM
ACRYLIC ON CANVAS
2010

김진희 ② KIM JINHEE ②
116 × 90.5 CM
ACRYLIC ON CANVAS
2010

거리의 사람들 ② PEOPLE ON THE STREET ②
141.5 × 76.5 CM
ACRYLIC ON DAKPAPER
2010

두 여자 TWO WOMEN
96 × 62.5 CM
ACRYLIC ON DAKPAPER
2010

거리, 자전거 타는 사람 STREET, A MAN ON BICYCLE
200 × 150 CM
ACRYLIC ON CANVAS
2007, 2010

23가 출구 23RD ST. EXIT
197 × 124.7 CM
ACRYLIC ON CANVAS
2010

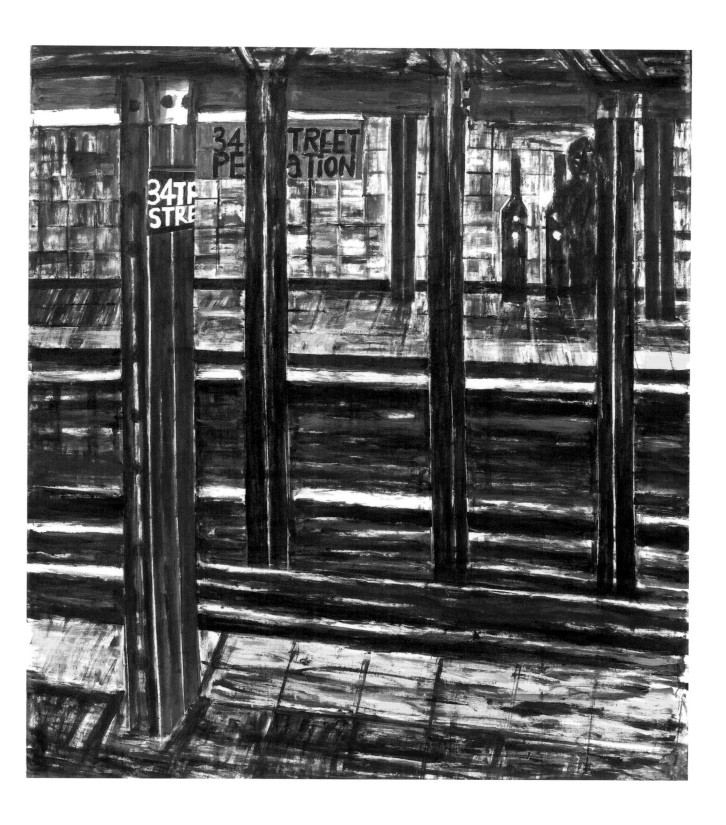

34가 34TH ST.
200 × 175 CM
ACRYLIC ON CANVAS
2010

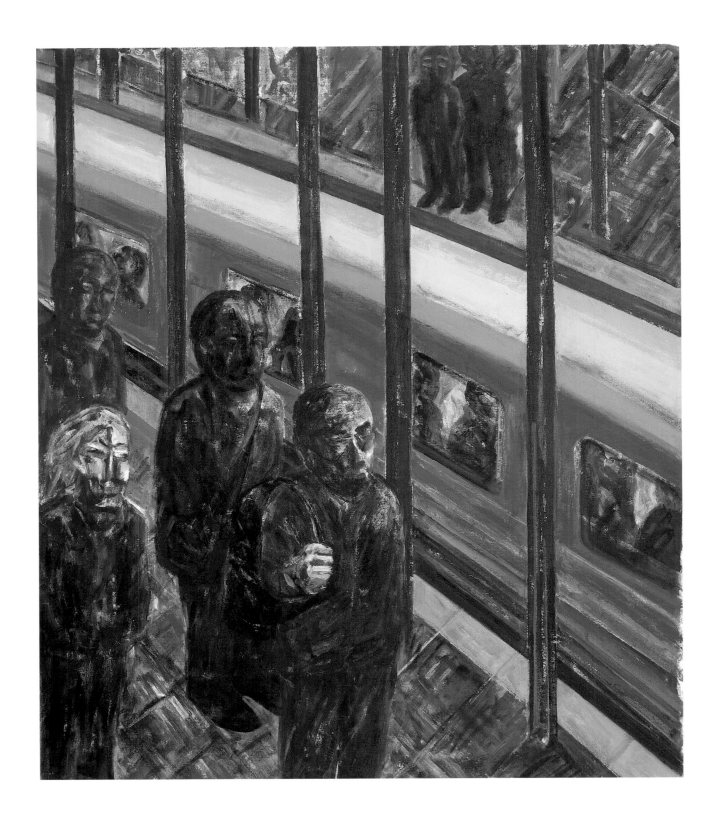

지하철 – 다운타운행 SUBWAY TO DOWNTOWN
163 × 138 CM
ACRYLIC ON CANVAS
2010

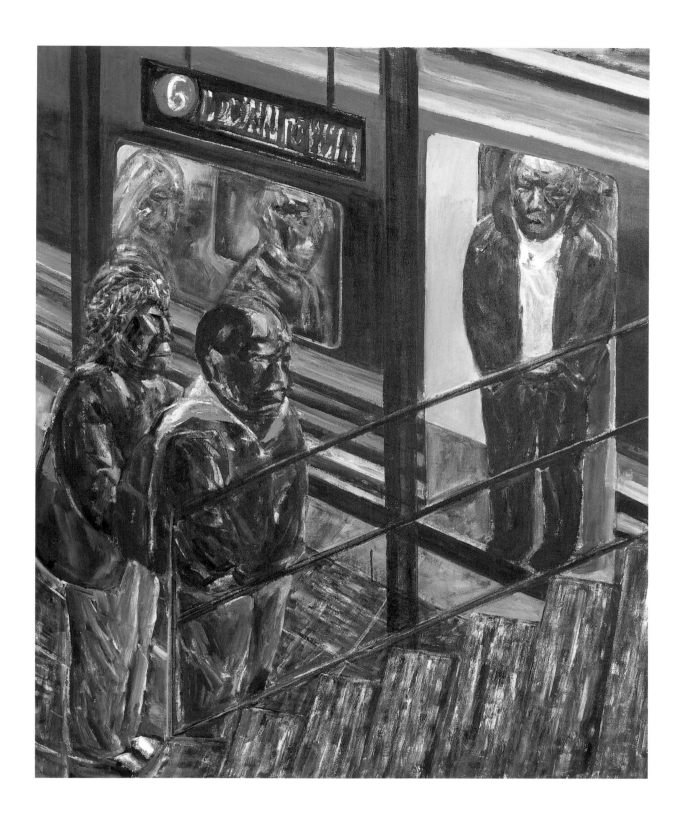

지하철－다운타운운행 SUBWAY TO DOWNTOWN
172×140 CM
ACRYLIC ON CANVAS
2010

지하철은 현대인에게 공간 체험을 새롭게 하였다. 각기 다른
목적과 장소를 마음에 품고 이동하지만 한 공간에 있어야
하는 승객으로 일시 변형된 인간 존재는 서로의 인간 관계
같은 것은 일시 보류할 수밖에 없다. 각자의 가치체계조차도
거기서는 보류함이 권장된다. 모르는 사람과 마주보고
있어야 하는 우리들은 무언극의 연극배우들이다. 누구나
자기 대본을 준비해야 한다. 신문을 읽거나 광고를 보는
척하거나 핸드폰을 들여다보거나 혹은 옆 승객에 피해를
주지 않으려 애쓰며 대화를 한다. 밀폐된 공간 속에서의
행동은 불특정 다수를 상대로 하는 매우 조심스런 심리
반응을 동반한다. 그것은 워커 에반스의 사진에서 보이는
서로의 시선을 애써 피한 채 허공을 바라보는, 자신을
잠시나마 잊어보려는 행위다.
　　작가 노트 2010·10·31

Subways have renewed the experience of space
for today's people. Human beings temporarily
transform into passengers who travel with different
purposes and destinations but are driven into a
same space. As a such being, one cannot but at
least temporarily put off things like one another's
personal relationships. One's system of values
are also recommended to be pushed aside. Having
to come face to face with strangers, we become
something like an actor in a silent drama. Everyone
has to prepare one's own script. One may read a
newspaper or pretend to look at advertisements,
or look into their mobile phones, or converse
with one another trying not to annoy neighboring
passengers. An action done in such an enclosed
space accompanies much cautious psychological
reaction against many and unspecified persons. And
such is like the one that could be found in Walker
Evans' photographs, of staring into the air in an
effort to avoid one another's gaze, an action that
tries to forget oneself at least for a while.

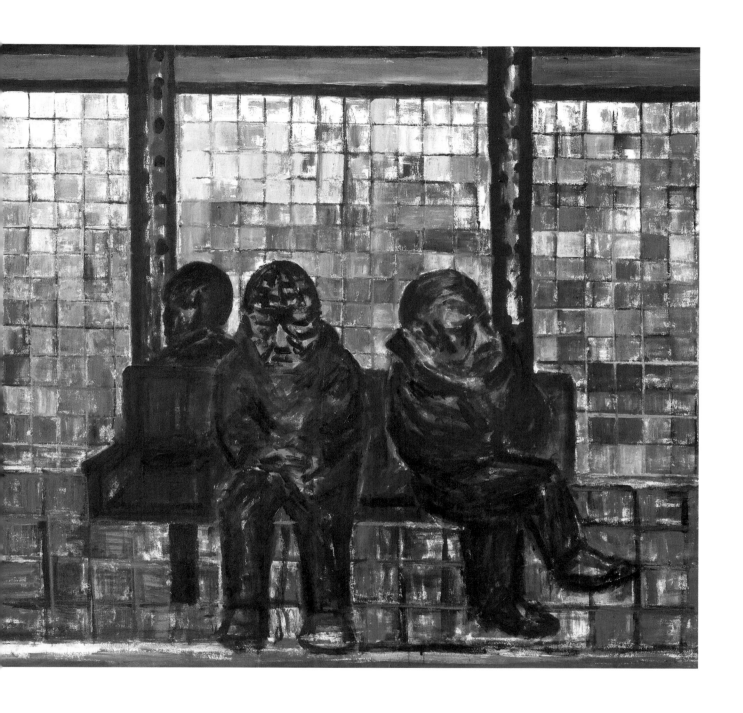

14가 지하철 정류장, 기다리는 사람
14TH ST. STATION, PEOPLE WAITING
143.5 × 230.5 CM
ACRYLIC ON CANVAS
2010

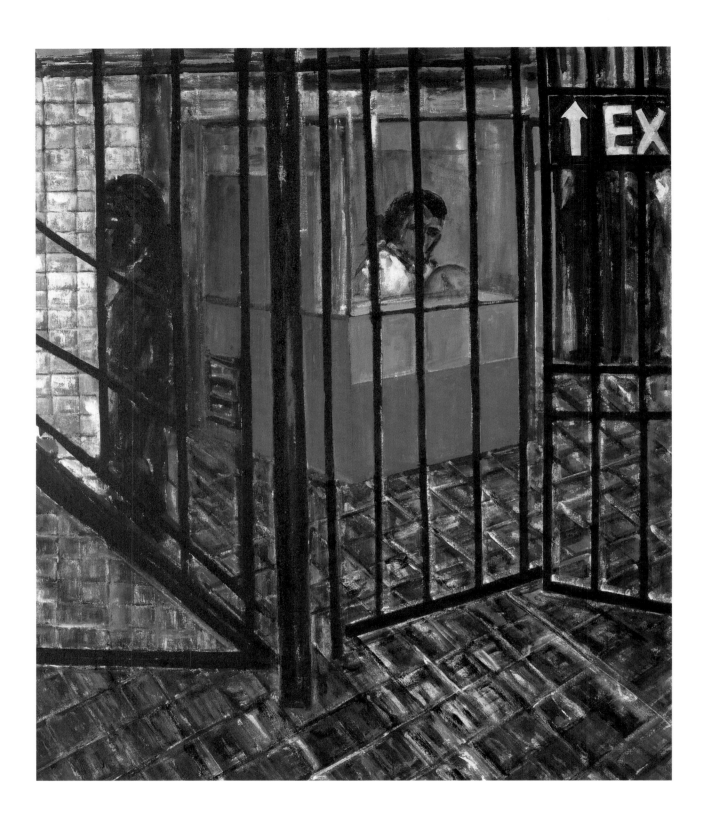

14가 출구 14TH ST. EXIT
172 × 141 CM
ACRYLIC ON CANVAS
2010

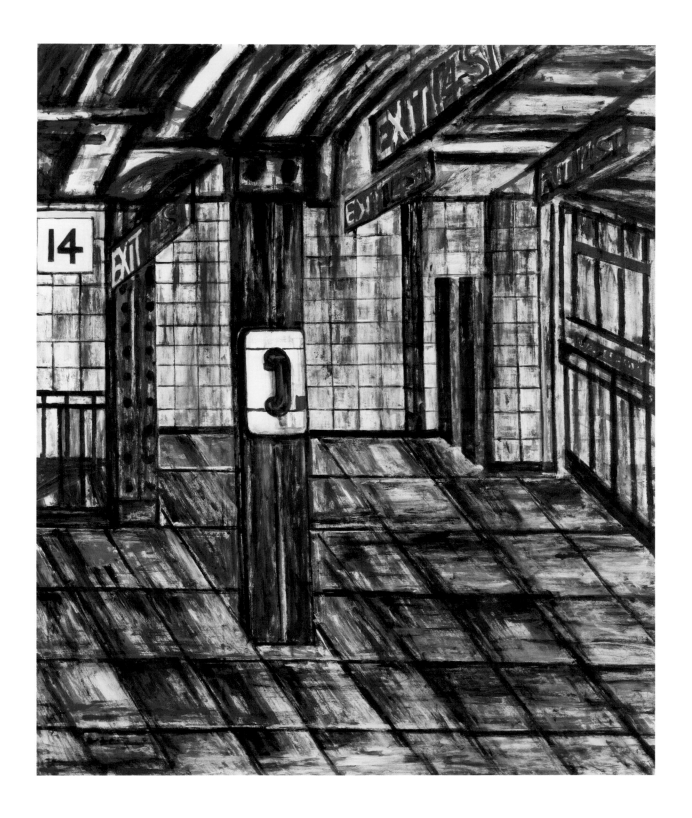

14가 출구 14TH ST. EXIT
213 × 175 CM
ACRYLIC ON CANVAS
2010

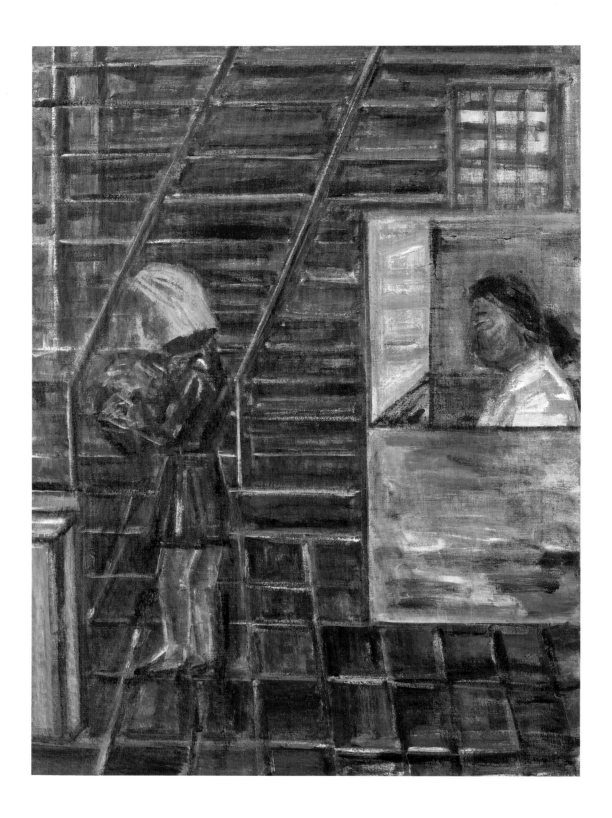

지하철 표 찾는 여자 WOMAN LOOKING FOR SUBWAY TICKET
140 × 97 CM
ACRYLIC ON CANVAS
2010

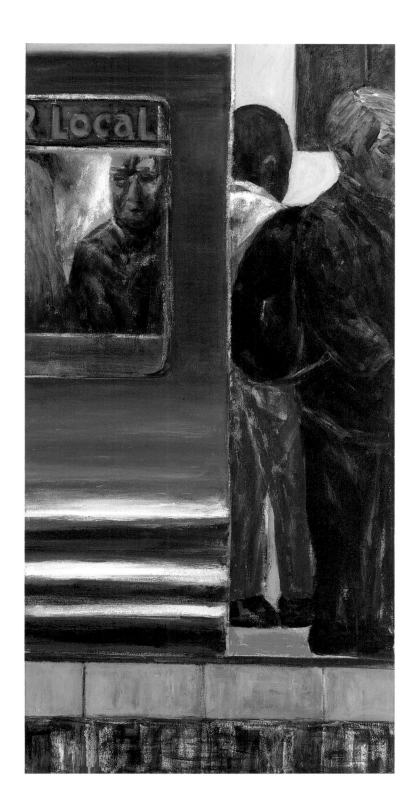

지하철 정거장 SUBWAY STATION
142.5 × 69.5 CM
ACRYLIC ON CANVAS
2010

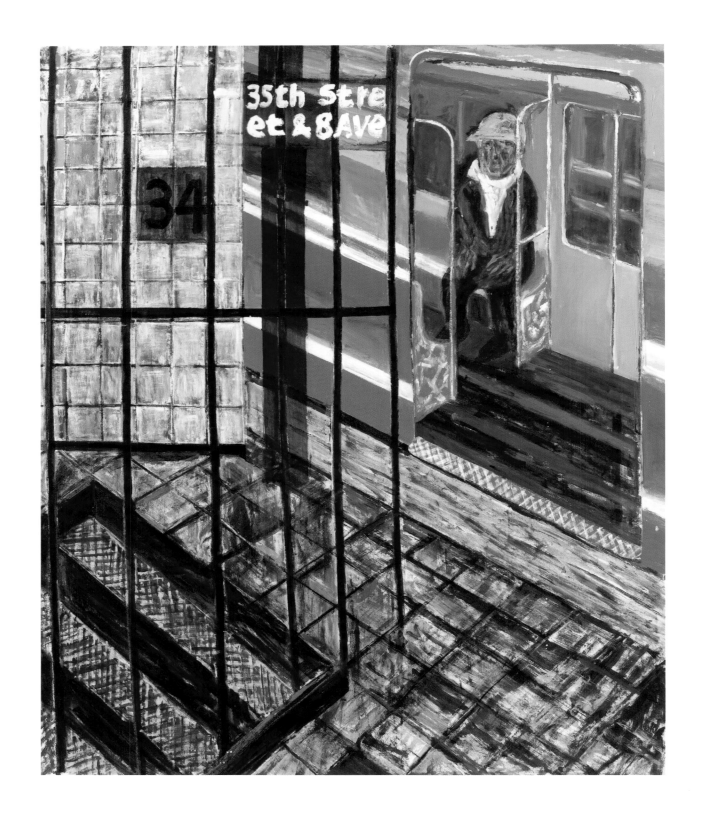

25가 출구 코너 CORNER OF THE 25TH ST. EXIT
215 × 175 CM
ACRYLIC ON CANVAS
2010

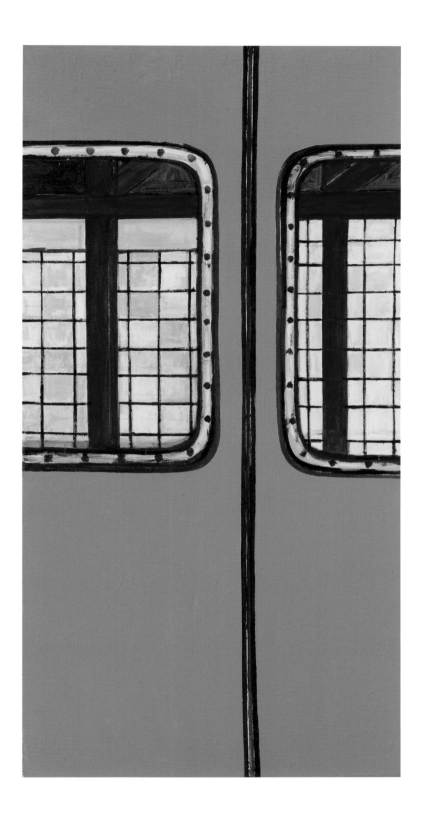

지하철 문 NY SUBWAY DOOR
179 × 90 CM
ACRYLIC ON CANVAS
2010

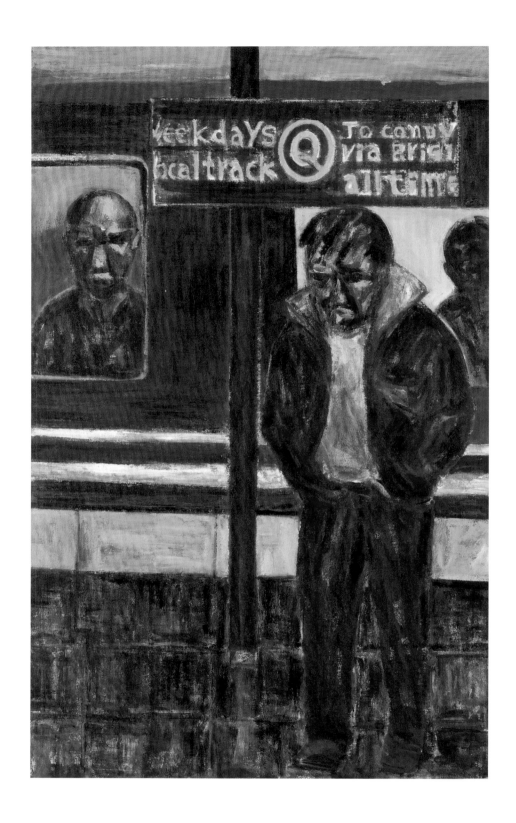

코니 아일랜드 행 TO CONEY ISLAND
145.5 × 89.3 CM
ACRYLIC ON CANVAS
2010

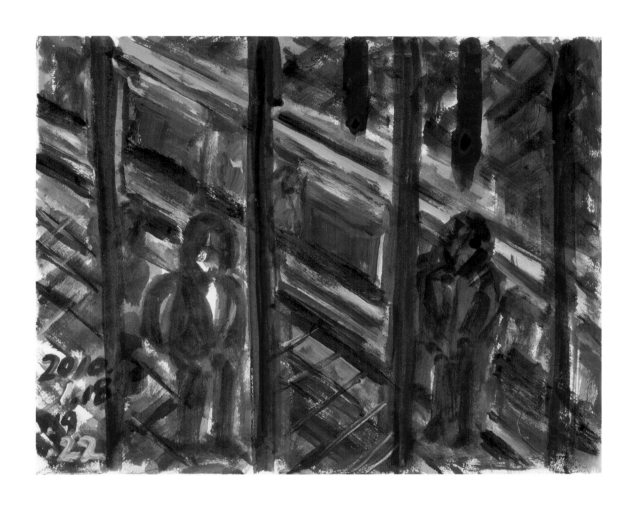

NY 지하철 NY SUBWAY
41 × 51 CM
ACRYLIC ON PAPER
2010

스완슨 지하철 SWANSON METRO
141.5 × 76.5 CM
ACRYLIC ON DAKPAPER
2010

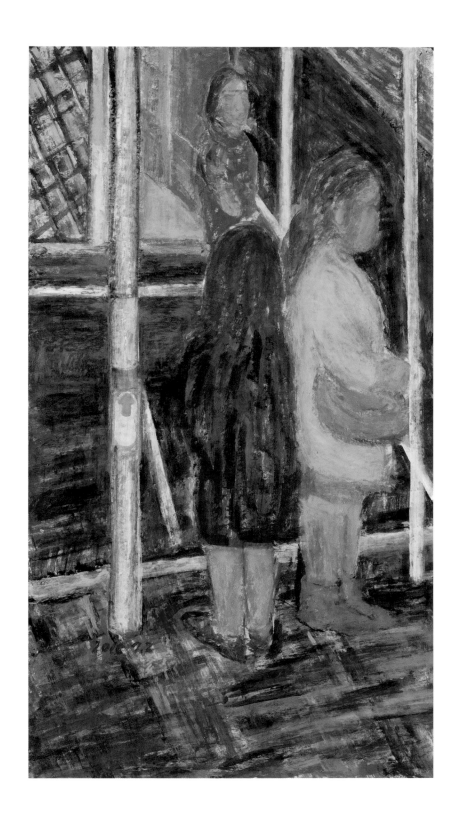

스완슨 거리 ① SWANSON STREET ①
141.5 × 76.5 CM
ACRYLIC ON DAKPAPER
2010

스완슨 거리 ② SWANSON STREET ②
141.5 × 76.5 CM
ACRYLIC ON DAKPAPER
2010

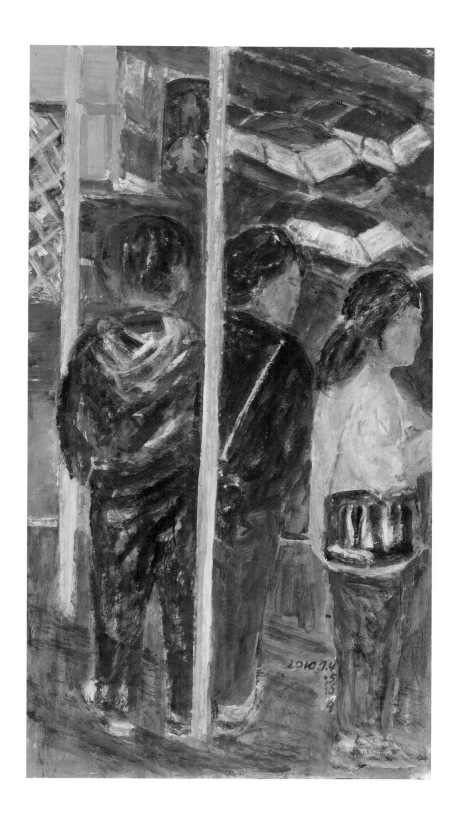

스완슨 거리 ③ SWANSON STREET ③
141.5×76.5 CM
ACRYLIC ON DAKPAPER
2010

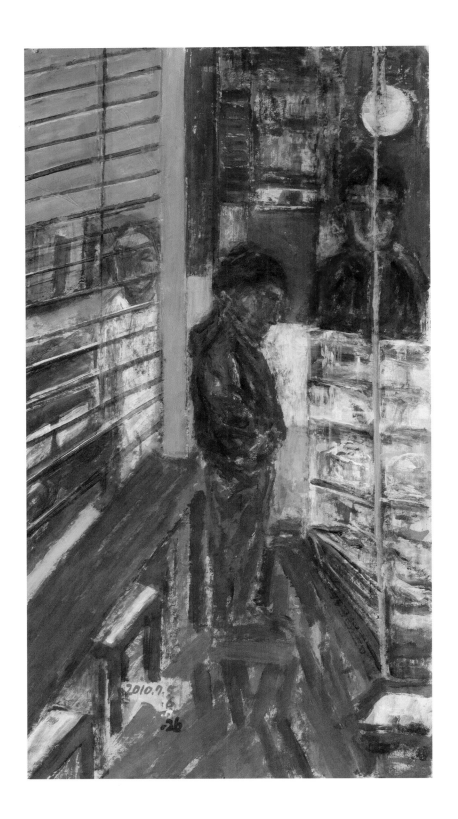

케이크 고르는 남자 A MAN CHOOSING CAKES
141.5 × 76.5 CM
ACRYLIC ON DAKPAPER
2010

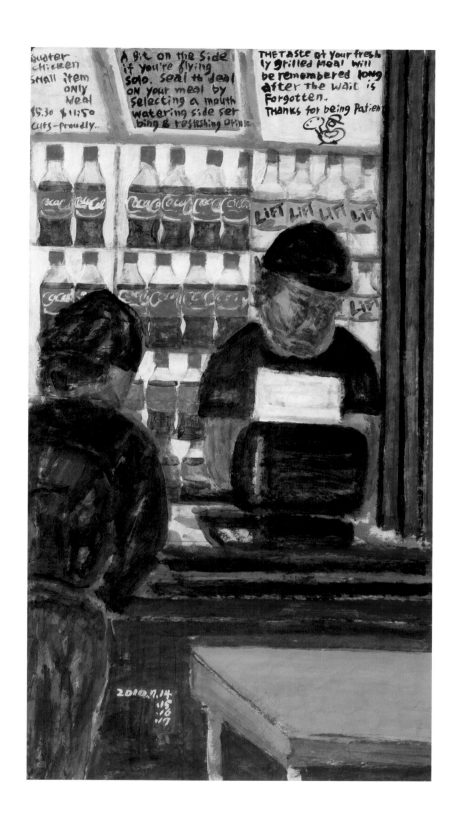

남미계 식당 HISPANIC RESTAURANT
141.5 × 76.5 CM
ACRYLIC ON DAKPAPER
2010

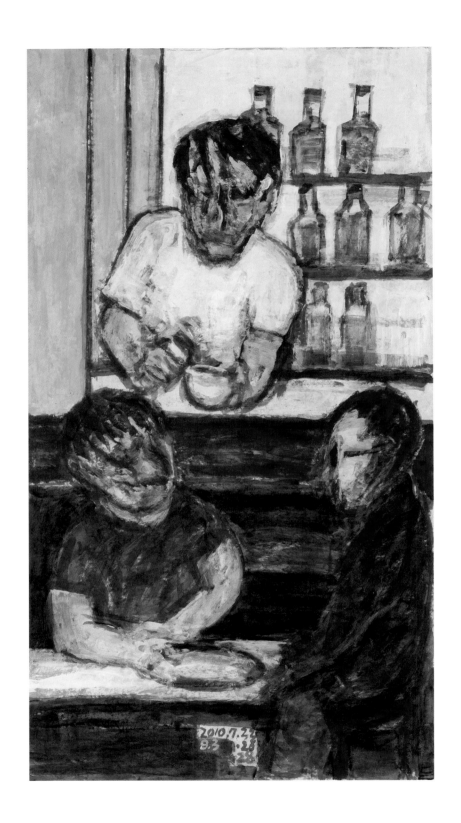

카페에서 AT THE CAFÉ
141.5 × 76.5 CM
ACRYLIC ON DAKPAPER
2010

호텔 앞 IN FRONT OF THE HOTEL
141.5 × 76.5 CM
ACRYLIC ON DAKPAPER
2010

포스터 POSTER
141.5 × 76.5 CM
ACRYLIC ON DAKPAPER
2010

시장 입구 – 라이광잉（來廣管）베이징
MARKET ENTRANCE – LAIGUANGYING BEIJING
200 × 300 CM
ACRYLIC ON CANVAS
2008, 2010

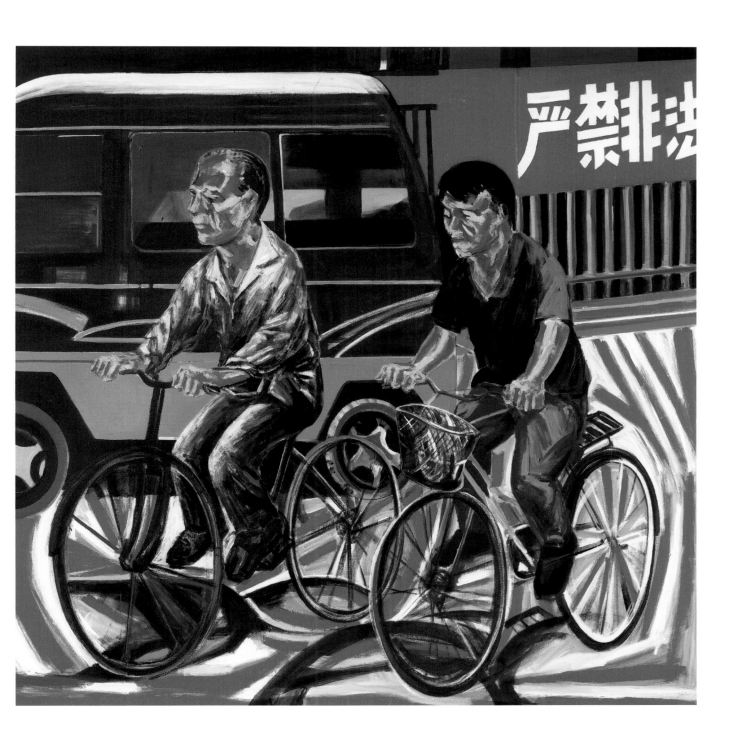

엄금비법(嚴禁非法) PROHIBITING ILLEGAL ACTIVITIES
200 × 200 CM
ACRYLIC ON CANVAS
2007, 2010

전기의자 ELECTRIC CHAIR
160 × 130 CM
ACRYLIC ON CANVAS
2010

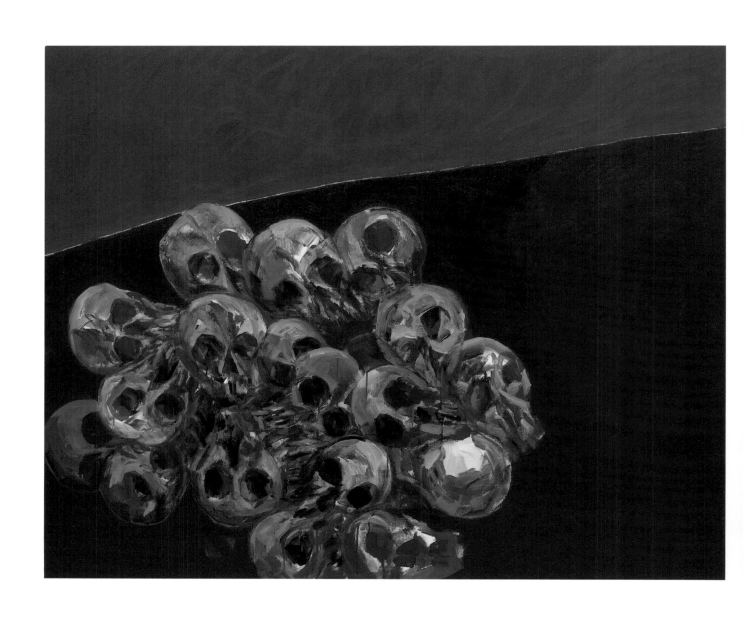

이름 없는 죽음들 NAMELESS DEATHS
131 × 162 CM
ACRYLIC ON CANVAS
2010

전쟁과 여인 A WOMAN IN THE WAR
130.3 × 161.7 CM
ACRYLIC ON CANVAS
2010

한글 만들기 MAKING HANGEUL
162 × 130 CM
ACRYLIC ON CANVAS
2010

고명(顧命) **KING'S TESTAMENT**
162 × 130 CM
OIL ON CANVAS
2010

단종 KING DANJONG
51.5 × 41 CM
ACRYLIC ON PAPER
2010

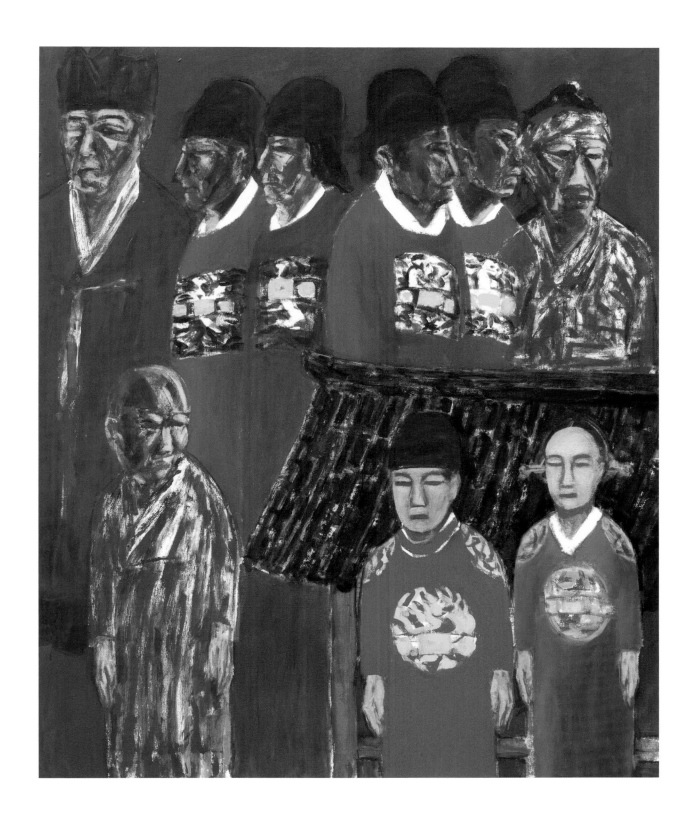

단종 KING DANJONG
175 × 143 CM
OIL ON CANVAS
2010

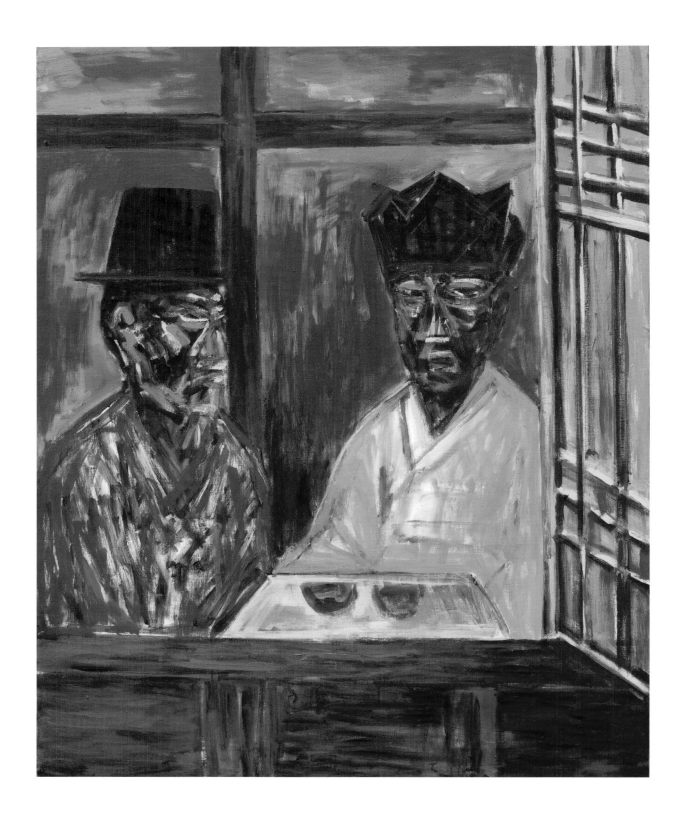

밀담 SECRET CONVERSATION
160 × 130 CM
ACRYLIC ON CANVAS
2010

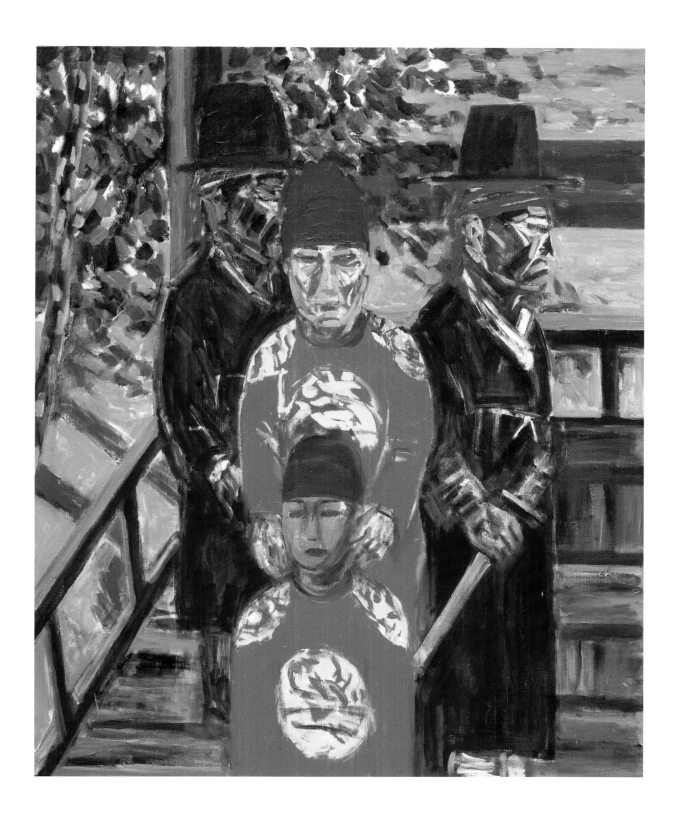

선위 ABDICATION
162 × 130 CM
ACRYLIC ON CANVAS
2010

과거의 이야기를 그림으로 표현한 작품을 보고 사람들이
그것을 역사화라고 말합니다. 그럴 때, 그렇게 보는
사람들의 관점을 수용하는 태도와, 역사화가 가진 내용과
형태에 의문을 가지는 태도가 나에게는 공존하는 것 같아요.
처음에는 역사화를 잘 몰랐어요. 대표적으로 노산군 단종에
대한 이야기를 토대로 작업을 시작했어요. 시간이 흘러서
정립된 사실을 그리는 것을 보통 역사화라고 하는데,
나에게는 역사적 사실보다는 이야기 자체가 중요했던 거죠.
어떻게 보면 문학적 접근이라고 볼 수도 있어요. 이 문제는
이야기를 문학과 역사로 구분할 수 있는가 하는 문제로
이어지는데 인간이 세상을 이해하는 관점과 시대적 흐름의
변화에 따라서 다양한 해석이 가능하다고 생각해요.

이영희, 『화가 서용선과의 대화』(좋은땅, 2020), 33쪽

When people see my work depicting stories from
the past, they call it a history painting. In regard
to such response, an attitude acquiescing to such
perspective and an attitude that questions the
content and form of a history painting coexist in
me. At first, I did not know much about historical
paintings. For one, when I painted the series on
Nosangun Danjong, I began from the stories of the
King. While the term 'history painting' generally
implies that a work is depicting historical facts that
have been established with time, for me, it is a story
that is more significant than a historical truth. In a
way, this could be understood as a kind of a literary
approach. This issue is followed by another question
of whether one can classify stories into literature
and history, and in this regard, I believe a variety of
interpretations are possible according the changes
in people's view of the world as well as the time.

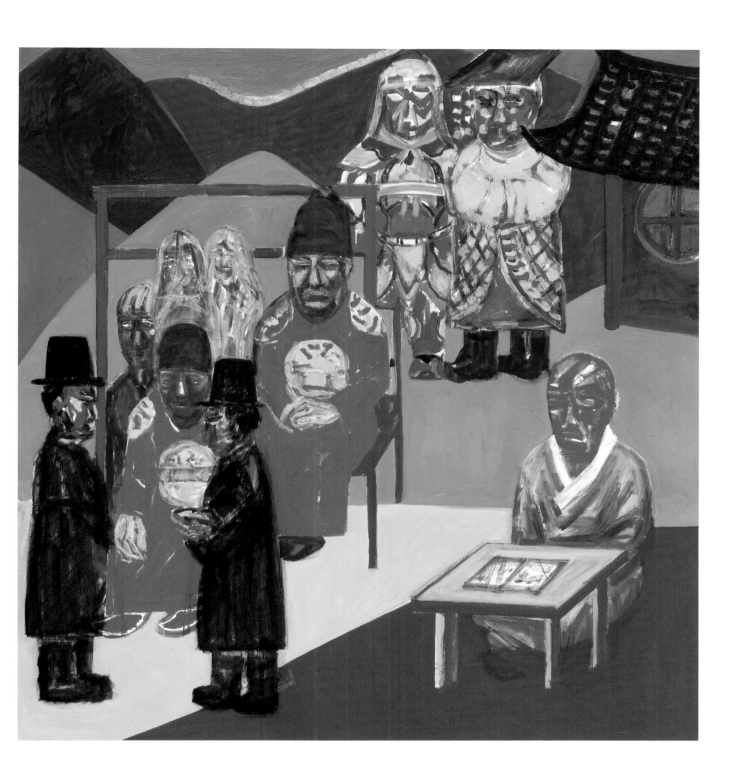

상황 SITUATION
219.5 × 210 CM
OIL ON CANVAS
2010

노산군 PRINCE NOSANGUN
259 × 193.5 CM
OIL ON CANVAS
2010

백성들의 생각, 노산군 THOUGHTS OF THE PEOPLE, NOSANGUN
259 × 193.5 CM
OIL ON CANVAS
2010

모의 CONSPIRACY
330.3 × 218 CM
ACRYLIC ON CANVAS
2010

세조 **KING SEJO**
193.5×259 CM
ACRYLIC ON CANVAS
2010

청령포, 송씨부인 CHEONGNYEONGPO, MADAME SONG
162 × 130 CM
ACRYLIC ON CANVAS
2010

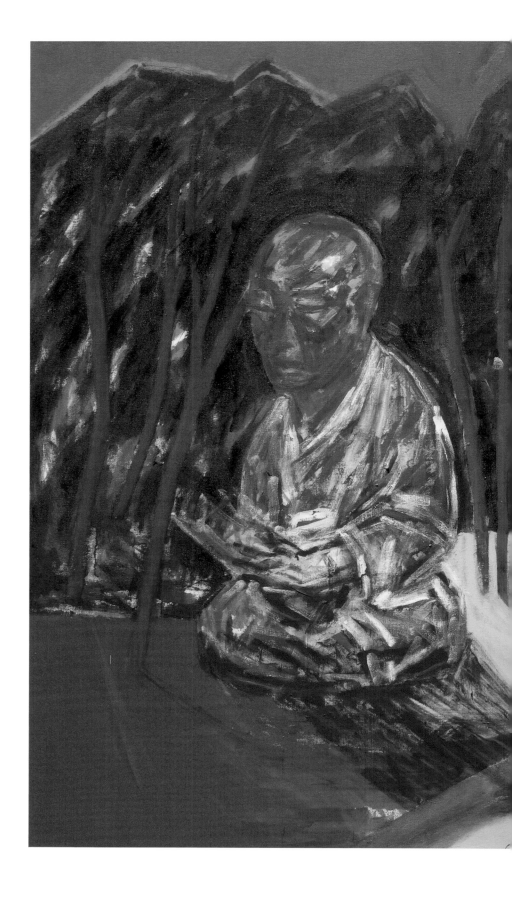

매월당 MAEWEOLDANG
218 × 330.3 CM
ACRYLIC ON CANVAS
2010

매월당 MAEWEOLDANG
172×140 CM
ACRYLIC ON CANVAS
2010

↑
청령포 CHEONGNYEONGPO
91 × 116.7 CM
OIL ON CANVAS
2010

↓
청령포 CHEONGNYEONGPO
91 × 116.7 CM
OIL ON CANVAS
2010

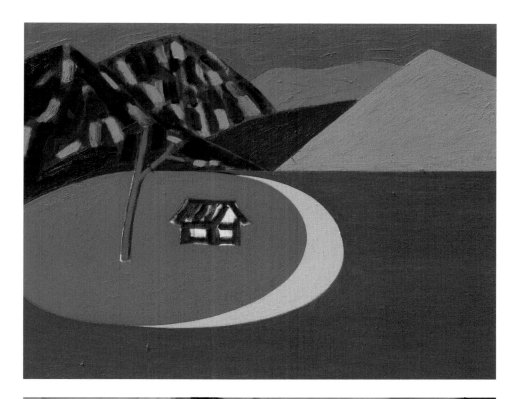

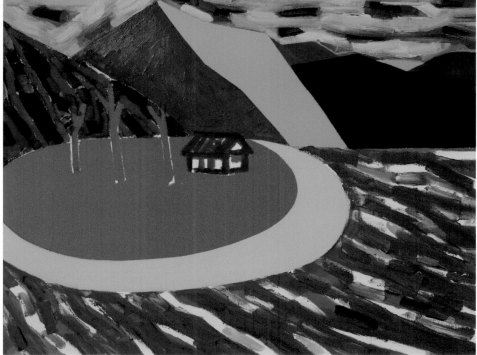

↑
청령포 CHEONGNYEONGPO
90 × 116 CM
OIL ON CANVAS
2010

↓
청령포 CHEONGNYEONGPO
90 × 116 CM
OIL ON CANVAS
2010

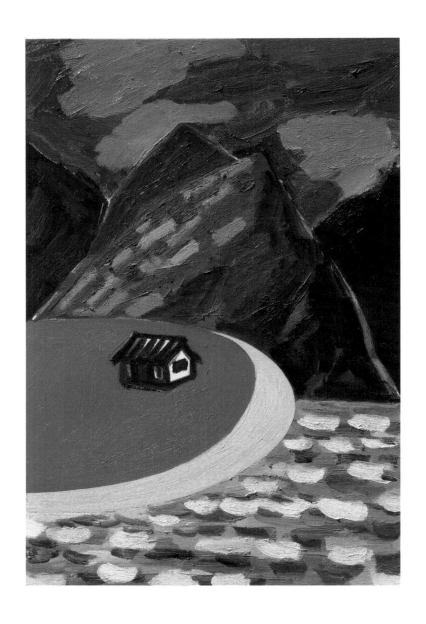

청령포 CHEONGNYEONGPO
91 × 60.8 CM
OIL ON CANVAS
2010

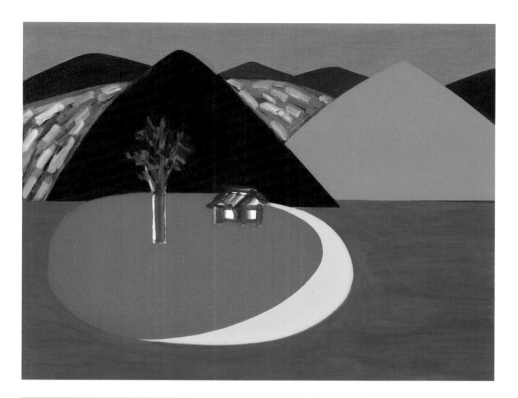

청령포 CHEONGNYEONGPO
131.5×162 CM
ACRYLIC ON CANVAS
2010

청령포 CHEONGNYEONGPO
130.5×162 CM
ACRYLIC ON CANVAS
2010

출항 ① SETTING SAIL ①
259 × 194 CM
ACRYLIC ON CANVAS
2010

출항 ② SETTING SAIL ②
259 × 194 CM
ACRYLIC ON CANVAS
2010

이동, 마고 사람 MOVING, PEOPLE OF MAGO
116.5 × 91 CM
ACRYLIC ON CANVAS
2010

철암천변 ① CHEORAM RIVERSIDE ①
45.5 × 53 CM
ACRYLIC ON CANVAS
2008, 2010

철암천변 ② CHEORAM RIVERSIDE ②
45.5 × 53 CM
ACRYLIC ON CANVAS
2010

철암 삼방동에서 AT SAMBANG-DONG, CHEORAM
45.5 × 50 CM
ACRYLIC ON CANVAS
2008, 2010

철암 삼방동 SAMBANG-DONG, CHEORAM
45.5 × 53 CM
ACRYLIC ON CANVAS
2007, 2010

철암 석탄공사 입구 CHEORAM COAL CORPORATION
ENTRANCE
46 × 53 CM
ACRYLIC ON CANVAS
2007, 2010

태백 황지동 HWANGJI-DONG, TAEBAEK
50.3 × 61 CM
ACRYLIC ON CANVAS
2010

구와우 GUWAWU VILLAGE
61 × 91 CM
ACRYLIC ON CANVAS
2010

도계 DOGYE
130 × 162 CM
ACRYLIC ON CANVAS
2010

태백산맥 도계 TAEBAEK MOUNTAINS, DOGYE
61 × 91 CM
ACRYLIC ON CANVAS
2009, 2010

만항재에서 AT MANHANGJAE
60.8 × 91 CM
ACRYLIC ON CANVAS
2010

청송 CHEONGSONG
91 × 117 CM
ACRYLIC ON CANVAS
2010

청송 주산지 CHEONGSONG JUSANJI
91 × 117 CM
ACRYLIC ON CANVAS
2010

주왕산 JUWANGSAN（MT.）
116.5 × 91 CM
ACRYLIC ON CANVAS
2010

숭어바위 SUNGEO BAWI (MULLET ROCK)
91 × 60.5 CM
ACRYLIC ON CANVAS
2007, 2010

동해 EAST SEA
45 × 53 CM
ACRYLIC ON CANVAS
2010

→
목포 거리 STREET IN MOKPO
162 × 130.5 CM
ACRYLIC ON CANVAS
2010

강진 도암면 DOAM-MYEON, GANGJIN
61 × 73 CM
ACRYLIC ON CANVAS
2010

백련사에서 AT BAEKRYEONSA TEMPLE
60.8 × 73 CM
ACRYLIC ON CANVAS
2010

강진만 GANGJINMAN BAY
130 × 162 CM
ACRYLIC ON CANVAS
2010

강진 백련사 동백꽃
CAMELLIA FLOWER IN BAEKRYEONSA TEMPLE, GANGJIN
130 × 162 CM
ACRYLIC ON CANVAS
2010

거제 ① GEOJE ①
91 × 117 CM
ACRYLIC ON CANVAS
2010

거제 ② GEOJE ②
91 × 117 CM
ACRYLIC ON CANVAS
2010

거제도 GEOJEDO ISLAND
23.5 × 31.5 CM
OIL PASTEL ON PAPER
2010

제주, 현대미술관에서
AT JEJU MUSEUM OF CONTEMPORARY ART
23.5 × 31.5 CM
OIL PASTEL ON PAPER
2010

다릿골 치과집 DARIGOL DENTIST'S HOUSE
53.5 × 65 CM
ACRYLIC ON CANVAS
2008, 2009, 2010

다릿골 치과집 DARIGOL DENTIST'S HOUSE
53 × 65 CM
ACRYLIC ON CANVAS
2008, 2009, 2010

다릿골 DARIGOL
50.3 × 61 CM
ACRYLIC ON CANVAS
2008, 2010

41번지 #41
61 × 93 CM
ACRYLIC ON CANVAS
2008, 2010

호랑이 ① TIGER ①
53 × 45 CM
ACRYLIC ON CANVAS
2010

호랑이 ② TIGER ②
53 × 45 CM
ACRYLIC ON CANVAS
2010

이와미 사람들 IWAMI'S PEOPLE
ACRYLIC ON WOOD
2010

11

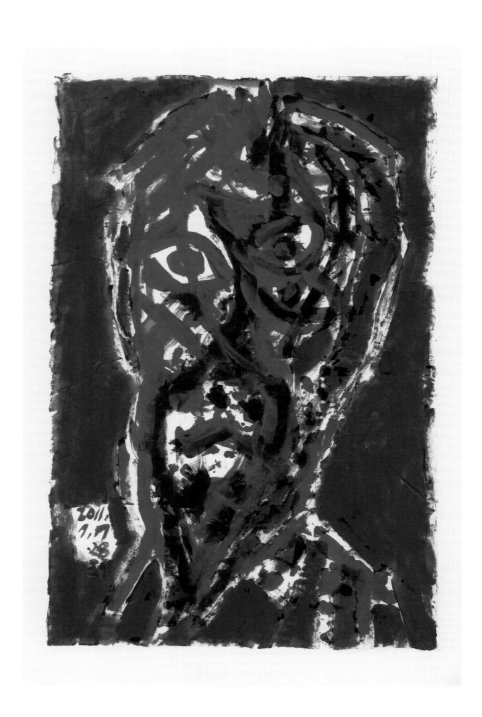

자화상 ② SELF-PORTRAIT ②
96 × 62.5 CM
ACRYLIC ON DAKPAPER
2011

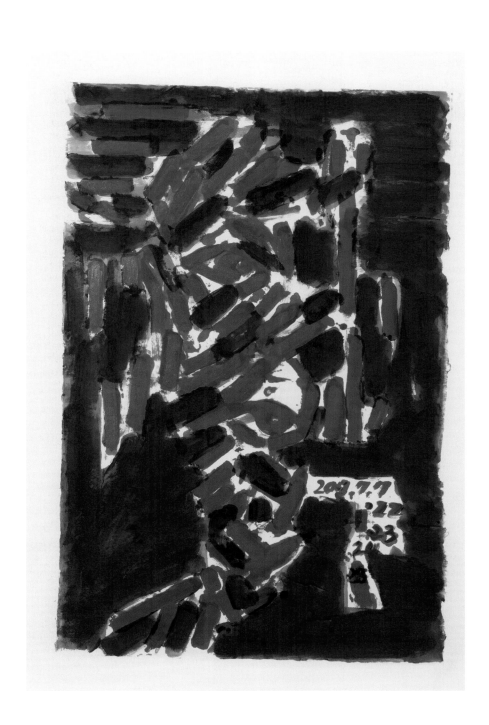

자화상 ③ SELF-PORTRAIT ③
96 × 62.5 CM
ACRYLIC ON DAKPAPER
2011

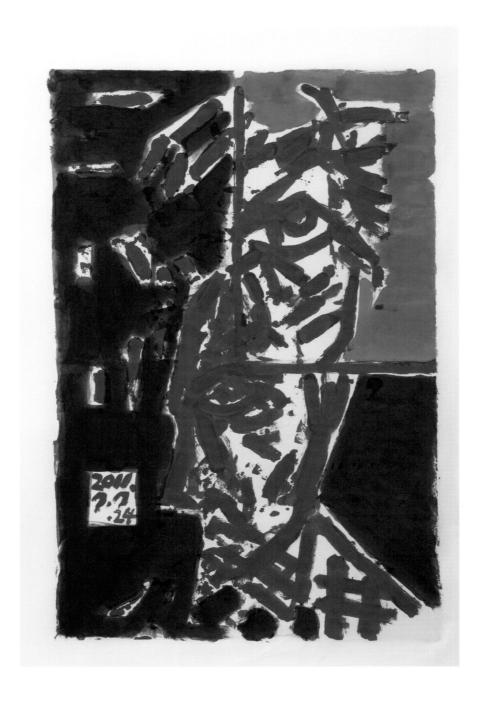

자화상 ④ SELF-PORTRAIT ④
96 × 62.5 CM
ACRYLIC ON DAKPAPER
2011

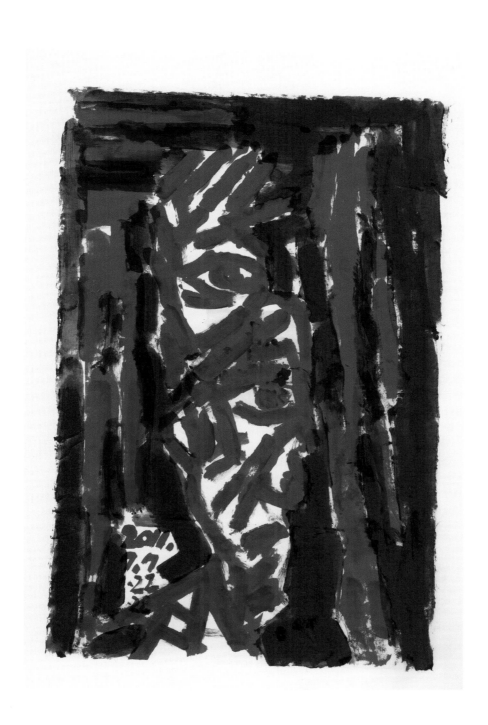

자화상 ⑤ SELF-PORTRAIT ⑤
96 × 62.5 CM
ACRYLIC ON DAKPAPER
2011

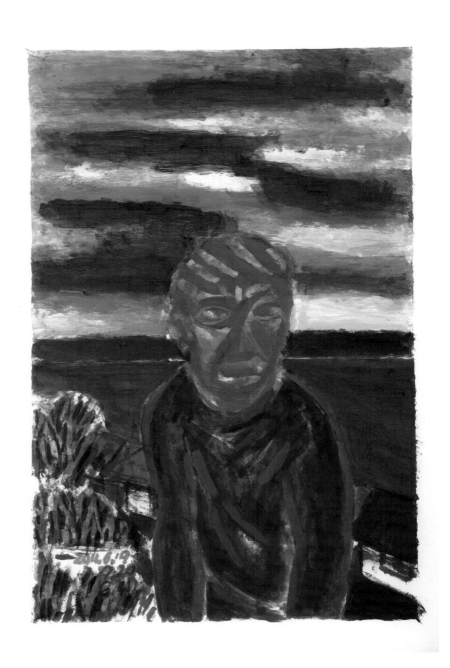

시애틀 자화상 SEATTLE, SELF-PORTRAIT
96 × 62.5 CM
ACRYLIC ON DAKPAPER
2011

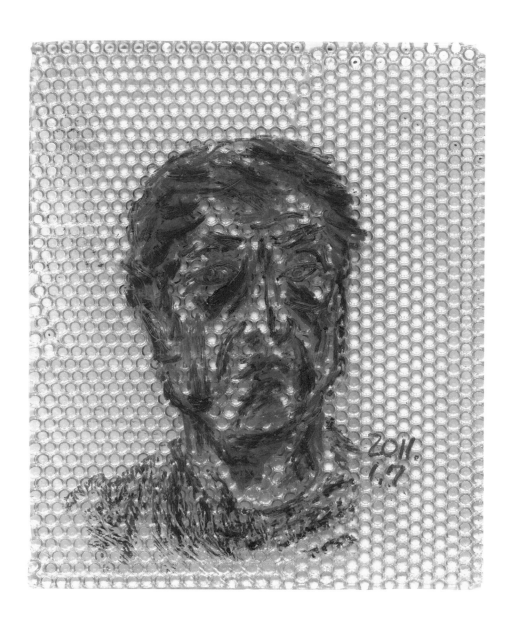

자화상 SELF-PORTRAIT
53.5 × 43 CM
OIL PASTEL ON ACRYLIC PANEL
2011

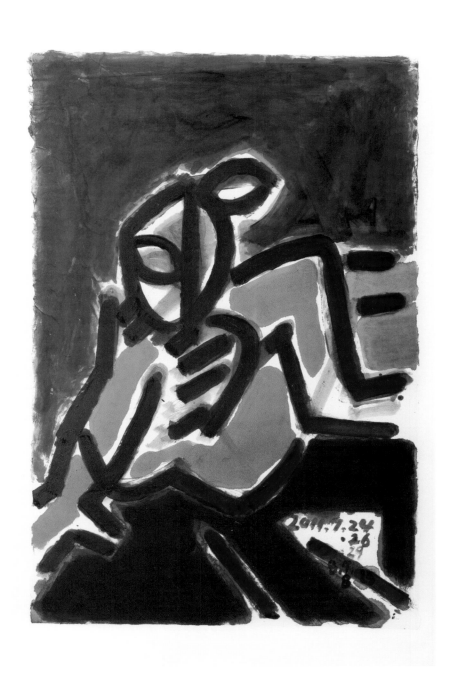

그림 그리는 남자 ① THE MAN WHO PAINTS ①
96 × 62.5 CM
ACRYLIC ON DAKPAPER
2011

그림 그리는 남자 ② THE MAN WHO PAINTS ②
96 × 62.5 CM
ACRYLIC ON DAKPAPER
2011

그림 그리는 남자 ③ THE MAN WHO PAINTS ③
96 × 62.5 CM
ACRYLIC ON DAKPAPER
2011

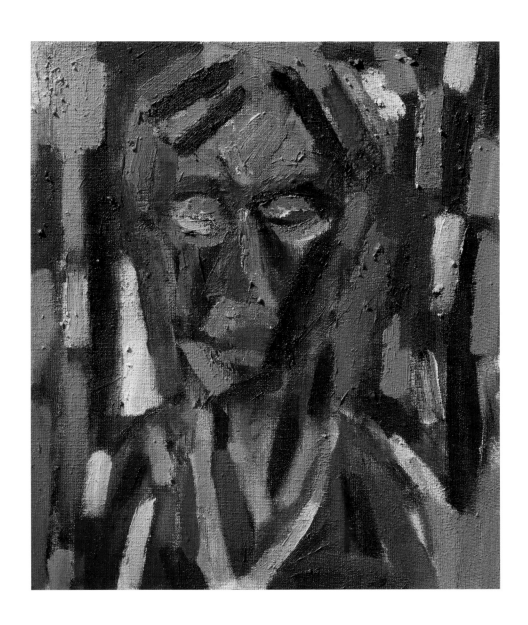

머리 ③ ONE HEAD ③
60.7×50.2 CM
OIL ON CANVAS
2009, 2011

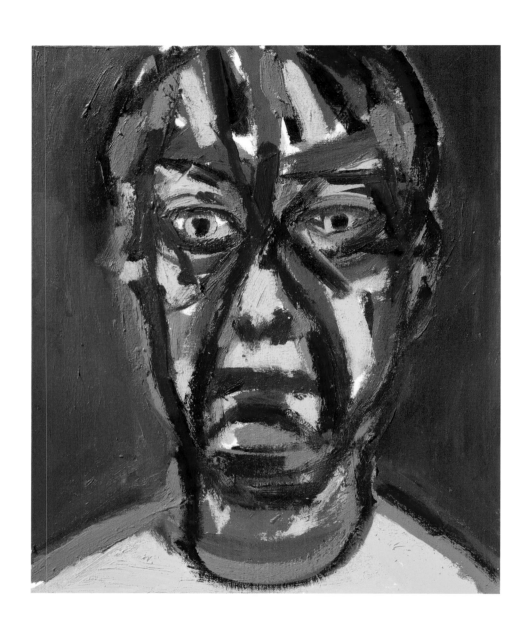

머리 ④ ONE HEAD ④
61 × 50 CM
OIL ON CANVAS
2008, 2011

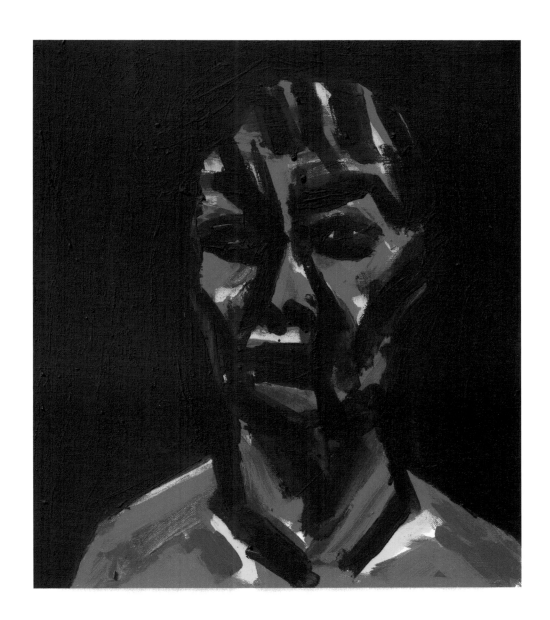

머리 ⑤ ONE HEAD ⑤
53 × 45.5 CM
ACRYLIC ON CANVAS
2009, 2011

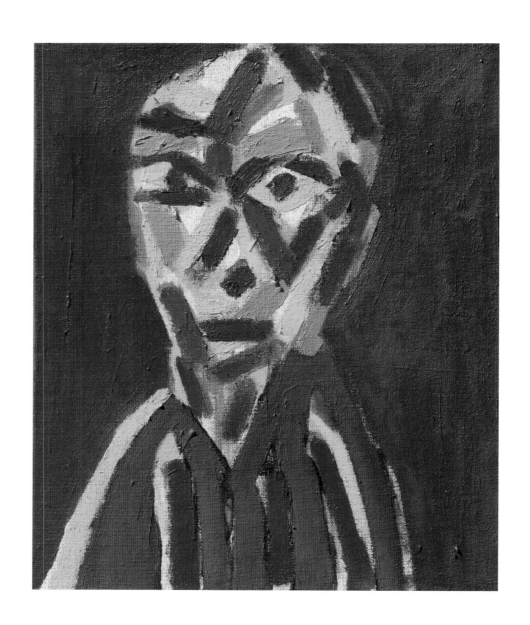

머리 ⑥ ONE HEAD ⑥
60.5×50 CM
OIL ON CANVAS
2011

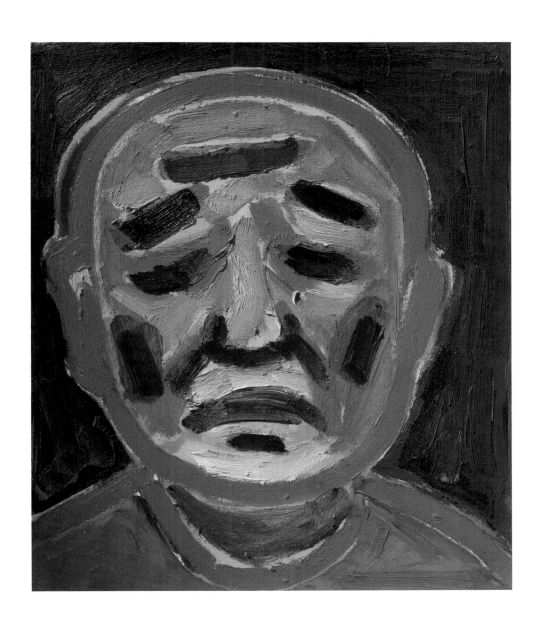

머리 ⑦ ONE HEAD ⑦
53 × 45.5 CM
OIL ON CANVAS
2002, 2011

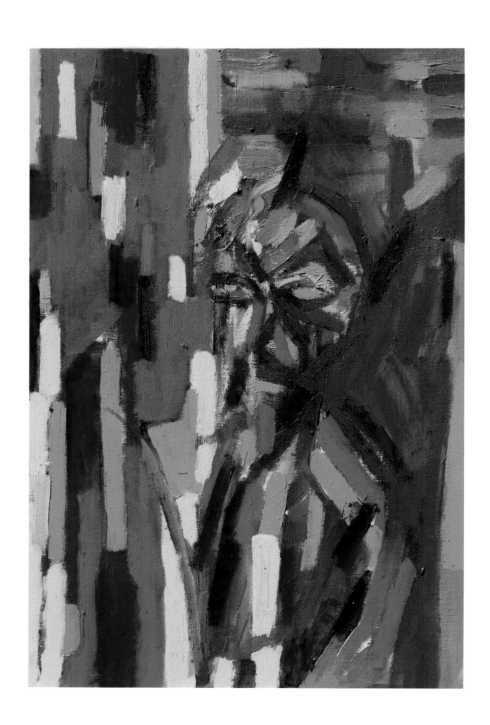

복잡한 생각 ① COMPLEX IDEA ①
91 × 61 CM
OIL ON CANVAS
2011

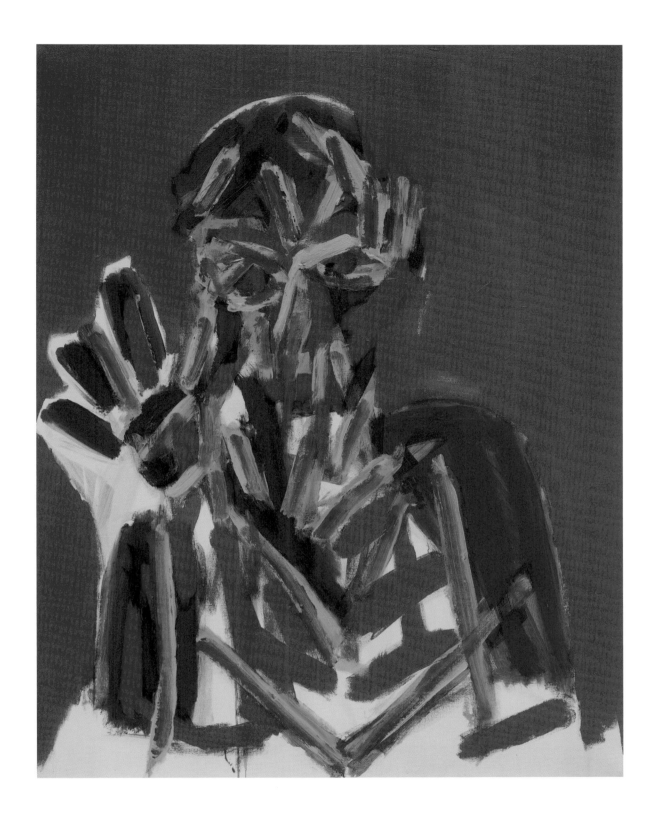

복잡한 생각 ② COMPLEX IDEA ②
116.5 × 91 CM
ACRYLIC ON CANVAS
2011

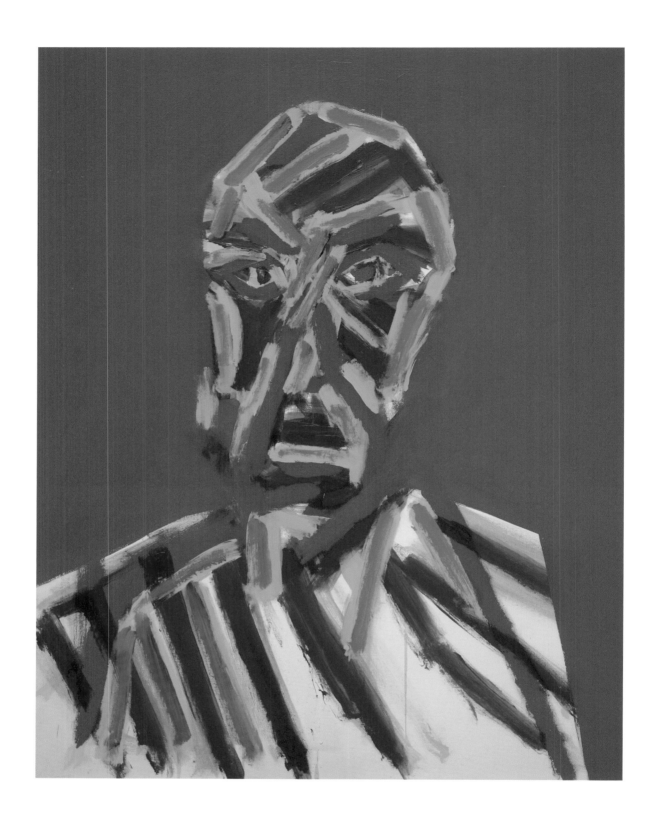

다른 생각 DIFFERENT IDEA
116.5 × 91 CM
ACRYLIC ON CANVAS
2011

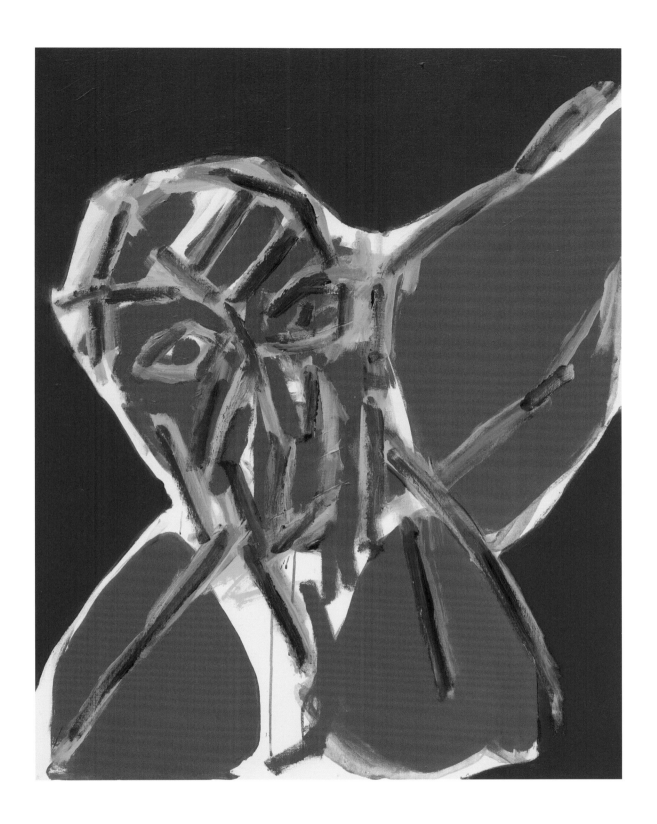

회의 DOUBT
116.5 × 91 CM
ACRYLIC ON CANVAS
2011

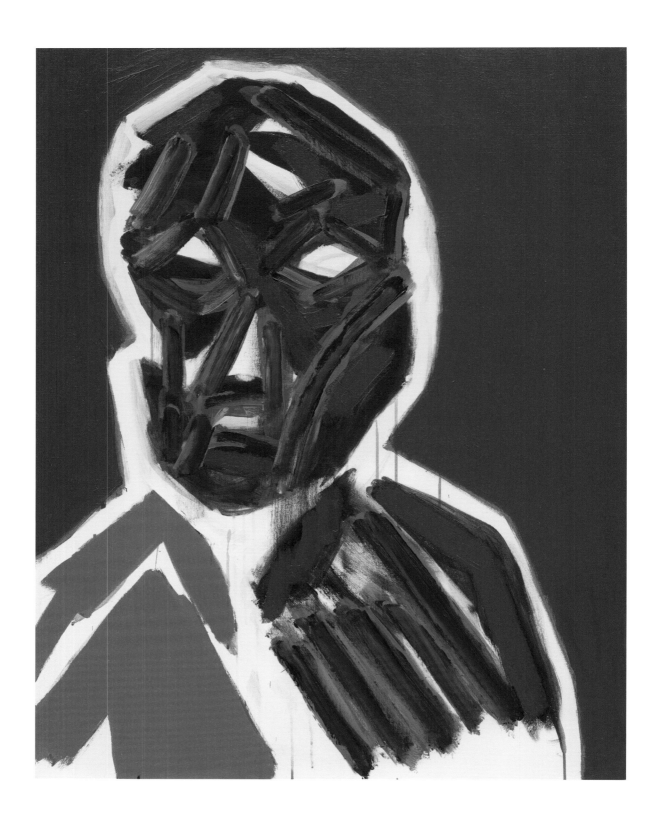

외면하는 **LOOKING AWAY**
116.5 × 91 CM
ACRYLIC ON CANVAS
2011

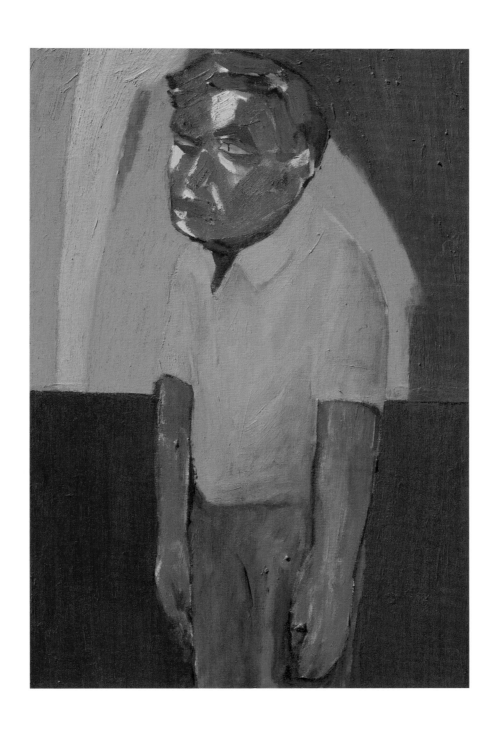

힘 빠진 남자 DEPRESSED MAN
90.8 × 60.8 CM
OIL ON CANVAS
2011

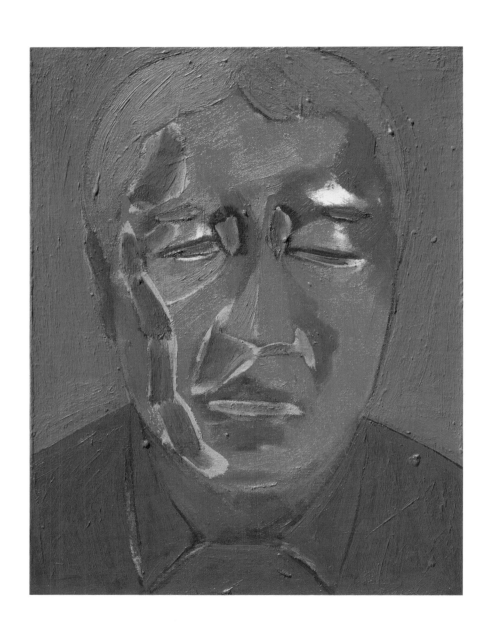

주대관 ① JU DAEGWAN ①
53 × 41 CM
OIL ON CANVAS
1997, 2008, 2011

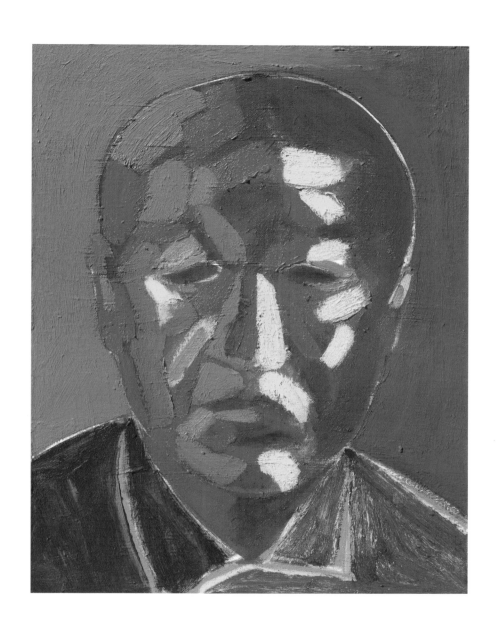

주대관 ② JU DAEGWAN ②
53 × 41 CM
OIL ON CANVAS
1997, 2008, 2011

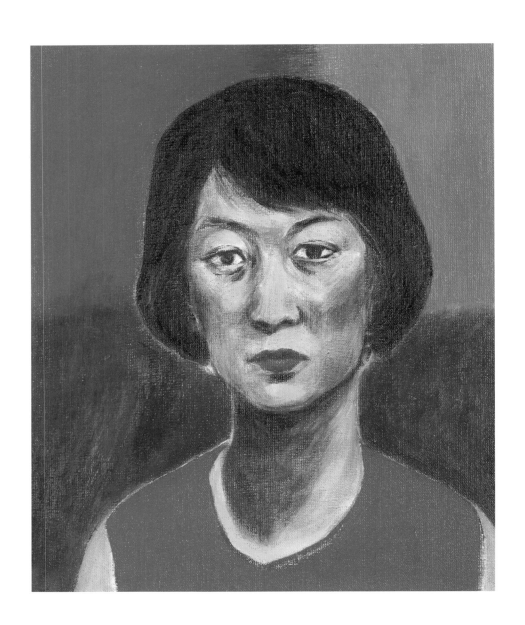

이영희 LEE YOUNGHEE
60.5 × 50 CM
ACRYLIC ON CANVAS
2010, 2011

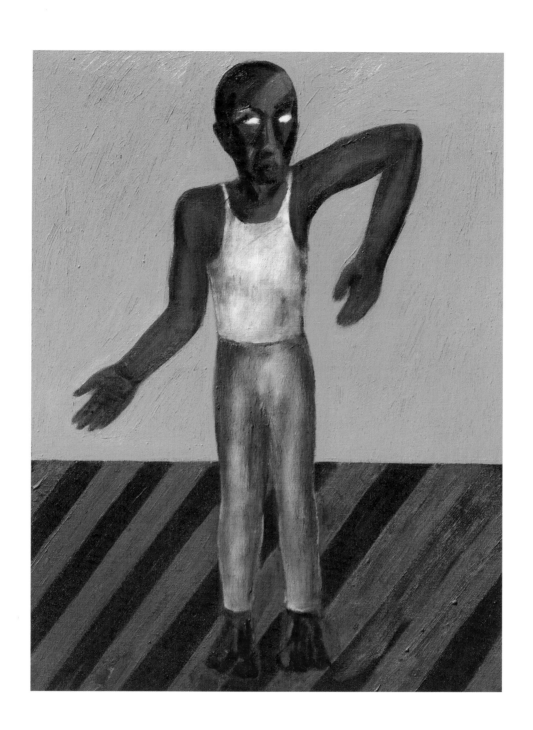

캐냐 무용수 KENYAN DANCER
91 × 61 CM
OIL ON CANVAS
2008, 2011

세 사람, 이와미 사람들 THREE MEN, IWAMI PEOPLE
62.5 × 96 CM
ACRYLIC ON DAKPAPER
2011

도농역 DONONG STATION
71.5 × 78 CM
ACRYLIC ON DAKPAPER
2010, 2011

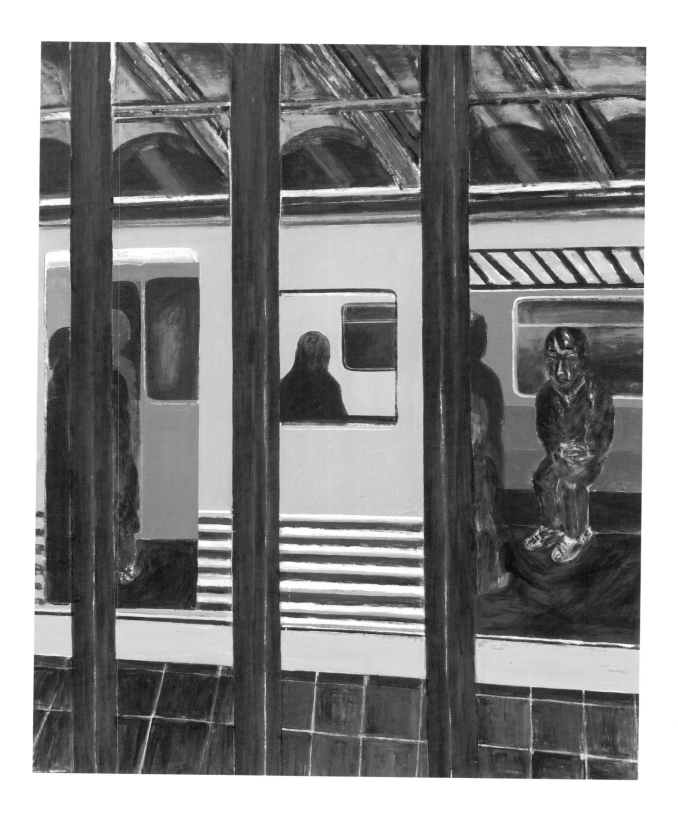

지하철 정거장 ② SUBWAY STATION ②
217 × 178 CM
ACRYLIC ON CANVAS
2011

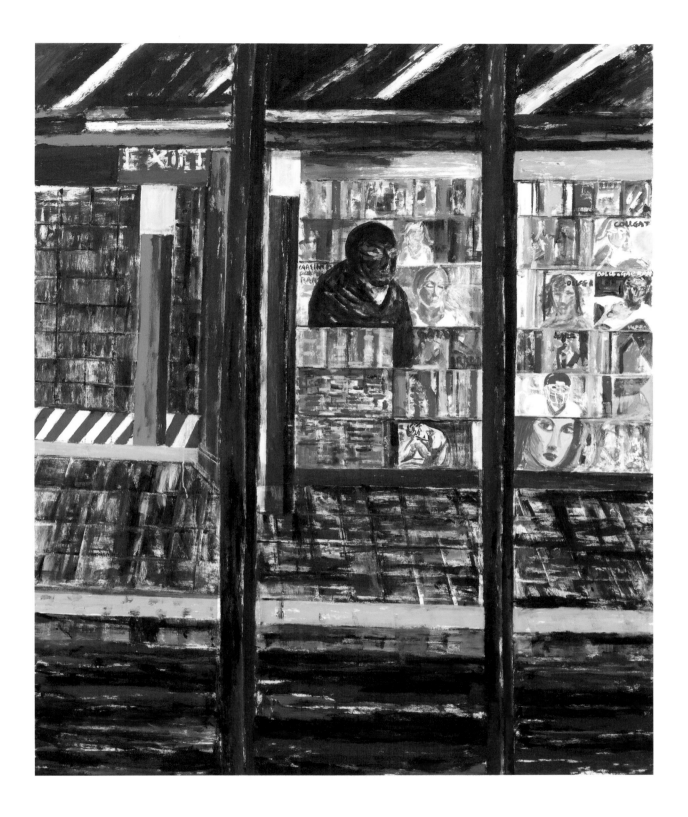

매점 NEWSSTAND
213 × 175 CM
ACRYLIC ON CANVAS
2010, 2011

뉴욕 지하철 NEW YORK SUBWAY
244 × 600 CM
ACRYLIC ON CANVAS
2010, 2011

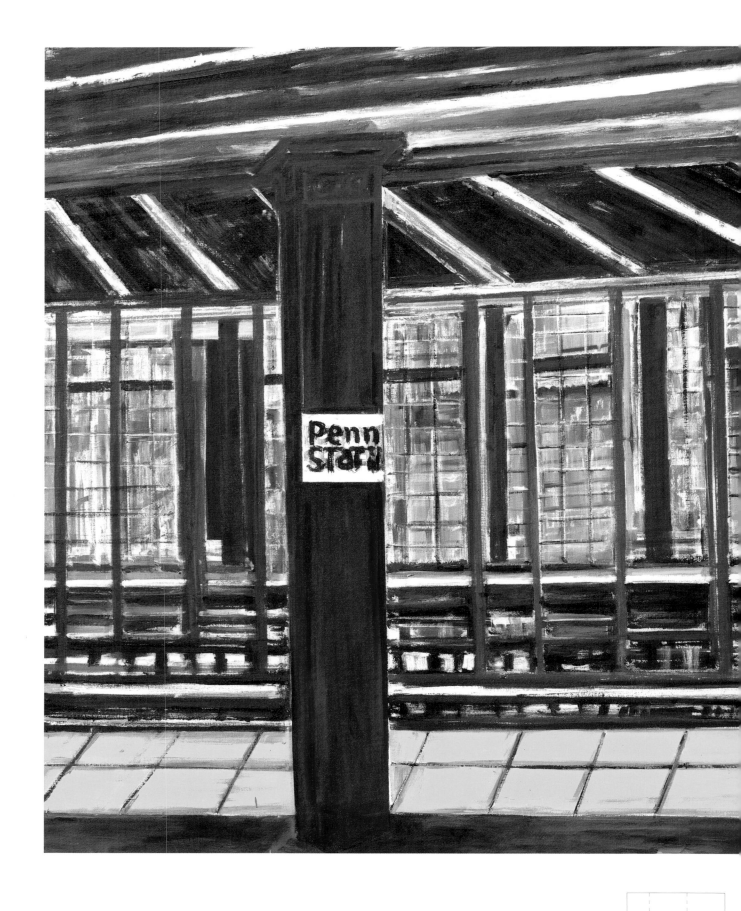

펜 스테이션 PENN STATION
193.5 × 259 CM
ACRYLIC ON CANVAS
2011

베를린 성당 **BERLIN CATHEDRAL**
400 × 500 CM
ACRYLIC ON LINEN
2006, 2011

후퇴 THE REFUGEES
121 × 91 CM
ACRYLIC ON CANVAS
2011

선물 – 사가모어 힐 GIFT – SAGAMORE HILL
175 × 214 CM
ACRYLIC ON CANVAS
2011

금대암에서 AT GEUMDAEAM
60.6 × 72.7 CM
ACRYLIC ON CANVAS
2011

지리산 금대암 JIRISAN（MT.）GEUMDAEAM
71 × 71 CM
ACRYLIC ON CANVAS
2011

세진대에서 AT SEJINDAE
72.3 × 91 CM
ACRYLIC ON CANVAS
2011

세진대 SEJINDAE
42.6 × 64 CM
ACRYLIC ON CANVAS
2011

천왕봉 중산리에서 ① IN CHEONWANG-BONG JUNGSAN-RI ①
72.5 × 90.7 CM
ACRYLIC ON CANVAS
2011

천왕봉 중산리에서 ② **IN CHEONWANG-BONG JUNGSAN-RI** ②
73 × 100 CM
ACRYLIC ON CANVAS
2011

지리산 오도재에서 ① AT JIRISAN (MT.) ODOJAE ①
91 × 116.5 CM
ACRYLIC ON CANVAS
2011

지리산 오도재에서 ② AT JIRISAN(MT.) ODOJAE ②
91 × 121 CM
ACRYLIC ON CANVAS
2011

성삼재 ① SEONGSAMJAE ①
80 × 100 CM
ACRYLIC ON CANVAS
2011

성삼재 ② SEONGSAMJAE ②
91 × 116.5 CM
ACRYLIC ON CANVAS
2011

지리산 칠선계곡 JIRISAN(MT.) CHILSEON GYEGOK VALLEY
45 × 45 CM
ACRYLIC ON CANVAS
2011

청계호 ① CHEONGGYEHO LAKE ①
60.8 × 91 CM
ACRYLIC ON CANVAS
2011

청계호 ② CHEONGGYEHO LAKE ②
73 × 100 CM
ACRYLIC ON CANVAS
2011

반야봉 BANYA-BONG
90.5 × 116.5 CM
ACRYLIC ON CANVAS
2011

저는 되도록 풍경이라는 말을 안 쓰려는 입장이어서
2009년의 전시 제목도 〈산·수〉라고 했는데, 우리에게는
풍경이라는 말보다 산수라는 표현이 더 맞다고 생각해요.
왜냐하면 풍경이라는 말은 19세기 후반, 일본인이 만든
신조어에요. 풍경을 영어로는 LANDSCAPE, 불어로는
PAYSAGE라고 하는데 어원적인 의미를 따져보면 대지를
조망하는 경치거든요. 그래서 저는 풍경화라는 말 대신
경치 그림이라든가 경관화라는 말을 쓰기도 하는데,
'풍경'에 익숙한 사람들은 아주 낯설어 하죠. 그렇다고
산수화라고 말하면 사람들은 동양화를 떠올려요. 뭔가 우리
정서에 더 어울리는 표현으로 정리할 필요가 있는 부분이라
생각해요.

이영희, 『화가 서용선과의 대화』(좋은땅, 2020),
52~53쪽.

I try not to use the word 'p'unggyŏng' (landscape),
and thus titled my 2009 exhibition San·Su
(mountain·water). I think the expression 'sansu'
is more appropriate for us than 'p'unggyŏng.' One
of the reasons is that p'unggyŏng is a term newly
coined by Japanese people in the late 19th century.
P'unggyŏng is 'landscape' in English and 'paysage'
in French, which etymologically signifies a scenery
that overlooks the earth. I therefore sometimes
use 'scenery painting' (kyŏngch'i kŭrim) or 'scenic
picture' (kyŏnggwanhwa) in place of 'landscape'
painting (p'unggyŏnghwa), but those familiar
with 'landscape' often take these as very odd. odd.
But if I use the term 'sansuhwa,' people think of
oriental paintings. I think something needs to be
done to settle for an expression that would be more
compatible to our sentiment.

웅석봉 ① UNGSEOK-BONG ①
116.5 × 91 CM
ACRYLIC ON CANVAS
2011

웅석봉 ② UNGSEOK-BONG ②
116.5 × 91 CM
ACRYLIC ON CANVAS
2011

형제봉(악양) ① HYEONGJAE-BONG (AKYANG) ①
121 × 91 CM
ACRYLIC ON CANVAS
2011

형제봉(악양) ② HYEONGJAE-BONG (AKYANG) ②
116.5 × 91 CM
ACRYLIC ON CANVAS
2011

청학동에서 (묵계저수지) ①
AT CHEONGHAK-DONG (**MUKGYE RESERVOIR**) ①
　121 × 91 CM
　ACRYLIC ON CANVAS
　2011

청학동에서 (묵계저수지) ②
AT CHEONGHAK-DONG (MUKGYE RESERVOIR) ②
116.5 × 91 CM
ACRYLIC ON CANVAS
2011

청학동에서 ① AT CHEONGHAK-DONG ①
130.2×162 CM
ACRYLIC ON CANVAS
2011

해인사 HAEINSA TEMPLE
50.3 × 60.8 CM
ACRYLIC ON CANVAS
2011

백령도 BAEKRYEONGDO ISLAND
132 × 162 CM
ACRYLIC ON CANVAS
2011

엄마의 전쟁기억 ① MOTHER'S MEMORIES OF THE WAR ①
38 × 29.8 × 15 CM
ACRYLIC ON CANVAS, STEEL BAR
2011

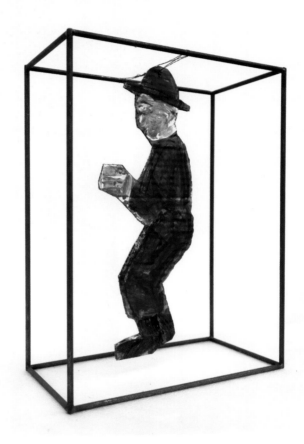

사열 ① **MILITARY REVIEW** ①
38 × 28 × 15.3 CM
ACRYLIC ON CORRUGATED PAPER, STEEL BAR
2011

사열 ② **MILITARY REVIEW** ②
38 × 28 × 15.3 CM
ACRYLIC ON CORRUGATED PAPER, STEEL BAR
2011

독가촌 DOKGACHON VILLAGE
VARIABLE INSTALLATION
LED SCREEN
2011

그림 숲의 야수

A BEAST IN THE PICTURE FOREST

백민석
소설가. 단편집『혀끝의 남자』『수림』『버스킹!』, 장편소설
『공포의 세기』『교양과 광기의 일기』『해피 아포칼립스!』,
에세이『리플릿』『아바나의 시민들』『헤밍웨이』『이해할 수
없는 아름다움』『과거는 어째서 자꾸 돌아오는가』등이 있다.

Baek Minsuk
Works: *Short stories Man on the Tip of the Tongue,
A Forest, Busking; novels A Century of Terror, Diary
of Prudence and Insanity, Happy Apocalypse!;
essays Leaflet, Citizens of Havana, Hemingway.*

1. 만첩산중 서용선

2021년 7월 말, 경기도 여주미술관으로 서용선 작가를 만나러 갔다. 그의 작품세계를 다룬 화집에 나도 원고를 싣기로 했고, 기왕 쓰는 것이면 작가를 만나 이야기도 한번 나눠보고 작업실도 구경하는 것이 원고를 다채롭게 하는 데 도움이 되리라는 생각이 들어서였다. 여주미술관에서는 《만첩산중서용선繪畵》전이 열리고 있었다. 풀어쓰면 '겹겹이 둘러싸인 산속(만첩산중)의 서용선 그림(회화)' 전시회가 될 텐데, 미술관의 위치가 야트막한 산을 등지고 수풀에 둘러싸여 있어 산중이고, 첩첩이 걸어놓은 그림들 사이를 헤치고 나아가듯 관람하게 되어 있어서 만첩인가 하는 생각이 들 만큼 규모가 큰 인상적인 전시였다.

《만첩산중서용선繪畵》전에서 관람객은 산속의 나무들처럼 빽빽이 설치된 그림과 조각 작품들 사이를, 좁다란 등산로를 다니듯 오가며 작품을 관람해야 한다. 보통의 전시회는 그처럼 작품을 전시하지 않는다. 그림과 그림 사이를 널찍널찍 떨어뜨려 놓고, 충분히 뒤로 물러나 감상할 수 있도록 관람 공간도 확보한다.

처음 전시장에 들어섰을 때 전시회 제목을 눈여겨보지 않았기에 나로서는 이런 전시 공간의 구성이 낯설고 이해할 수 없었다. 여주미술관이 크긴 했지만 작품이 공간에 비해 차고 넘친다는 느낌이었다. 뒤쪽에 공간이 없어서 〈얼굴2〉 같은 대형 작품은 앞에 딱 붙듯이 서서 올려다봐야 했다. 어떤 작품은 창문 가까이 걸려있어 여름 아침의 따가운 직사광선을 바로 받고 있었다. 글을 쓰려고 당시 찍어온 사진들을 뒤적이다가 전시회를 '만첩산중'에 비유한 포스터가 눈에 들어왔다. 그리고 한자어에 서툰 나는 사전을 찾아봤고, 비로소 전시회의 큐레이터가 무슨 의도로 공간 구성을 그렇게 했는지 어렴풋하게나마 짐작을 할 수 있었다.

큐레이터는 전시회가, 서용선 작가의 작품세계를 밀도 있게 재구성한 하나의 울창한 숲이 되기를 바랐던 것 같다. 실제로 전시회에는 작가의 습작기 시절의 작품부터 최근의 작품들까지 망라한 백여 점이 전시되었고, 그것들 한 점 한 점이 이제 고희를 맞은 작가의 지나온 인생을 말해주고 있었다. 나이를 먹을수록 삶은 울창한 숲을 닮아가기 마련이다. 처음엔 갓 솟아난 민둥산이었다가 차츰 나이를 먹으며 기쁘고 슬픈 일들을 겪고, 인연을 맺고 끊고, 멀리 떠났다가 돌아오기도 하고, 일에서 성공과 실패를 맛보기도 하면서 깊고 울창해지는 삶이라는 숲을 형성한다. 그 삶의 주인이 화가라면 숲은 그의 작품 세계일 것이고, 숲의 울창한 나무들은 그가 작업해온 그림들이 될 것이다. 작가가 걸어온 삶의 역정은 굳이 캐묻지 않아도 숲의 형상에, 나무들의 형상에 배어 은은히 드러나기 마련이다. 전시회에는 한 귀퉁이를 쥐가 쏠아놓은 듯한 대학 시절 습작품도 있었다. 《만첩산중서용선繪畵》전은 서용선이 작가로서 살아온 오십 년의 궤적을 숲의 형태로 빼곡히 정리해놓은 회고전이라고 할 수 있었다.

전시회를 보는 날에 여주역에 아침 일찍 도착했다. 역에서 일행을 만나 미술관까지 함께 차를 타고 가기로 했었다. 일행과 역 밖으로 나가는데 반백의 머리에 고동색 티셔츠와 면바지를 입은 수수한 차림의 노년의 신사가 나를 기다리고 있었다. 서용선 작가였다. 마중 나올 것이라고는 기대하지 않았기에 나는 깜짝 놀랐다. 나는 그가 나를 알 리 없다고 생각하고 있었다. 내가 이번 화집 출간에 글을 쓰는 여러 작가 중 하나이고, 오늘 인터뷰가 예정되어 있다는 정도만 들어서 알고 있으리라 짐작했다. 언젠가 그에 대해 글을 쓰긴 했다. 하지만 그에 대해 얼마나 많은 작가론과 작품론이 쓰였는지 생각하면 나는 거의 아무것도 쓰지 않은 것이나 마찬가지였다. 그래서 이 뜨거운 여름날 그가 역까지 나왔다는 사실이 놀랍기만 했다.

나는 인간으로서의 창작자가 궁금했던 적이 없다. 나는 소설가지만 같이 소설을 쓰는 동료 문인들이 어떻게 생겼고 나이는 몇이고 뭘 하며 먹고사는지, 최근에 무슨 작품을 썼는지 궁금해하지 않는다. 미학 에세이를 두 권이나 썼지만, 그 책들에 등장하는 미술인이나 영화인에 대해 인간적인 관심은 없었다. 어떻게 생겼고 나이는 얼마이고 어느 나라 사람인지 모른다. 내가 다른 창작자의 삶에 관심을 가질 때는, 그의 삶의 어느 한순간이 명백히 그의 작품에 영향을 주었을 때다. 이런 경우엔 작품을 제대로 읽기 위해 작가 삶의 어느 한 특정 지점을 참고해야 한다.

서용선 작가에 대해서도 그랬다. 나는 여주역 앞에서 그를 만나기 직전까지 그가 어떻게 생겼는지(어쩌다 사진을 봤겠지만 나는 작가 사진을 눈여겨보지 않는다), 그의 머리가 세었는지 아닌지, 그렇게 연세가 드셨는지(작품에 넘치는 힘을 생각하면 그가 늙었다는 사실이 믿기지 않는다) 전혀 몰랐고, 그래서 멀찍이서 나와 눈을 맞추며 걸어오는 그를 알아보지 못했다. 이는 내가 그 전날까지 그의 화집과 그에 대한 글들을 뒤적이며 그의 작품세계를 공부했다는 사실과는 무관한 일이다.

나는 어느 분야든, 창작자와 그의 작품은 다르고 다를 수밖에 없다고 생각한다. 그러지 않다면 작품을 읽어내면서 작품 분석에 대한 내 입장을 유지할 수가 없다. 작품을 알기 위해 창작자를 알아야 할 필요는 없다. 이 글에서도 서용선 작가의 삶은 작품을 설명하기 위해 꼭 필요한 경우가 아니라면 다루지 않을 생각이다. 여주미술관이 문을 열자마자 입장했기에, 나는 작가 본인의 설명을 들으며 편한 마음으로 전체 작품을 느긋하게 둘러볼 수 있었다.

2. 〈얼굴2〉

여주미술관 로비에는 서용선 작가를 다룬 책들이 비치되어 있었다. 나는 커피를 마시며 그중 한 권을 펼쳤다. 올봄에 소마미술관에서 있었던 한국-스페인 특별전 《마주하는

1. *Mancheop Sanjung* and Suh Yongsun

At the end of July in 2021, I visited Yeoju Art Museum in Gyeonggido to meet Suh Yongsun. I was scheduled to write for an art book on the artist's oeuvre, and I thought, if I must write, I'd better meet with him in person, have a chat and walk through his studio for more diverse stories. At the museum was the exhibition *Mancheop Sanjung Suh Yongsun Paintings*. If one translates the title literally, it would be an exhibition of 'Suh Yongsun's paintings deep in ten thousand layers of a mountain range.' The museum's location with a low mountain at the back surrounded by the woods indeed conjured up an image of being 'in the mountains' (*sanjung*). And paintings that ranged close to one another so as to cause the audience to wedge their way through made one wonder whether this was what 'ten thousand layers' (*mancheop*) meant. It was an impressive exhibition of scale that evoked various responses.

The audience of *Mancheop Sanjung* had to walk through the dense forest of paintings and sculptural works as if hiking on a narrow trail. This is obviously not a general method of display. Many exhibitions make sure that one artwork is hung faraway from another, and secure enough space for a viewer to take a step backward and view the work from a broader perspective.

Because I had not paid close attention to the exhibition title, such design of exhibition space was something unfamiliar and I felt somewhat confused as I entered the venue. Although the museum was large enough, the great number of artworks seemed to overwhelm the gallery space. For large-scale works like *Face 2*, I had to stand right in front of the work and look up as there was not enough space to step back. Another painting hung right by the window, directly receiving the hot sunlight of a summer morning. Rummaging through photographs I took of the exhibition for this essay, I came across a poster that likened the exhibition to '*mancheop sanjung*.' As I am not very versed in Chinese characters, I looked these four letters up in a dictionary, and found out that they together signified 'ten thousand layers of a mountain range.' And at last, I could at least faintly understand the curator's intention for such an arrangement.

It seems that the curator of the exhibition hoped for it to become a thick forest that densely reconstructed Suh Yongsun's oeuvre. The exhibition in practice presented around a hundred works of Suh that ranged from those of his student years to more recent ones. Each individual work told a story of the artist, who would soon celebrate his seventieth birthday, and of the life he chose to live. As one ages, the person's life comes to resemble a dense forest. It is at first close to a bare mountain that just emerged, but as one ages—as one experiences things happy and sad, forms and

breaks relationships, leaves faraway and returns, goes through ups and downs—their forest gradually becomes deep and exuberant. In case of an artist, the forest would be his oeuvre, and the trees in that thick forest would be the works he painted all his life. It is thus not necessary to probe into his life's journey, as it is already dimly reflected in the shape of the forest and its trees. At the exhibition was also one of Suh's studies from his college years, the corner of which looked as if gnawed by a rat. *Mancheop Sanjung Suh Yongsun Paintings*, in short, was an exhibition close to a retrospective that scrupulously retraced Suh Yongsun's fifty years of life as an artist through the metaphor of a forest.

On the day I saw the exhibition, I arrived at the Yeoju Station early in the morning. I planned to meet with a company there and together set out for the museum by car. As I walked outside the station, I came across an aged gentleman waiting for me. This man of gray hair in modest clothes of maroon-colored t-shirt and cotton pants turned out to be the artist himself. I was surprised by this unexpected encounter. I had not expected him to recognize me. I assumed that he would simply know me as one of the writers of his art book that was to be published with whom he had an interview scheduled for that day. I had once written on the artist. But considering how many people have written on Suh Yongsun and his works, my contribution was close to none. And therefore, that unexpected encounter at the station on a hot summer day was of a pure astonishment.

To confess, I have never been curious about an artist as a human being. I am a writer myself, but I have never wondered about my fellow writers— what they look like, how old they are, how they make a living of, or even what work they recently wrote. I published two books on aesthetics, but I have never had any personal interest in artists and movie makers I wrote about. I do not know of their appearances, ages, or nationalities. It is only when a moment in a creator's life has clearly affected the work that I start paying attention to the artist's personal life. And I do so solely because it is inevitable for a proper understanding of the work.

I took the same approach for Suh Yongsun. Right until I met him in front of the Yeoju Station, I had no idea of his appearance (I probably have seen a photo of him before, but I usually do not pay close attention to artist photos.), whether his hair got gray or not, or how aged he was (considering his paintings' exploding energy, it is still difficult to believe that he is that old). And therefore, I did not recognize the man who walked toward my direction exchanging glances with me. This is something that has nothing to do with the fact that until the night before, I had studied his oeuvre by scrutinizing art books and writings on the artist.

I believe that in every field, there is and there

풍경, 일상의 시선》의 도록이었다. 두 나라의 여섯 작가가
참여한 그 도록을 쭉 훑다 보니, 역시나 서용선의 작품들이
눈에 확 띄었다. 여섯 작가 중 그가 가장 뛰어났다는
뜻이 아니다. 작가들의 우열을 내가 가릴 수 없다. 다만
도록의 모든 페이지에서, 그의 작품들이 시각적으로 가장
강렬했다는 의미다.

　　서용선 작가의 작품은 강렬함에 있어 다른 작가들을
압도하는 일면이 있다. 작품의 사이즈는 대체로 대형이고,
선은 굵고 거칠며 색은 오방색을 연상시킬 만큼 원색을 쓰고,
그러면서 농도의 변화랄 것이 없어 색채의 회색지대가 없다.
그는 과감하게 세부를 생략하고 선 몇 다발과 색 몇 가지로
형상을 표현한다. 〈얼굴2〉(2009)가 좋은 예다. 크기는
249.5×200 CM로 성인의 키를 훌쩍 넘어서고, 다듬어지지
않은 선들이 얼굴 윤곽을 거칠게 누빈다. 원색의 노랑이
주를 이루는 가운데 검정과 빨강이 어우러져 있다. 얼굴
골격의 입체를 나타내기 위해 노랑에 농도 변화를 주는 대신
빨강으로 골격의 그늘을 표현했다. 세부를 생략한 만큼
보통의 자화상에서 볼 수 있는 표정의 섬세한 묘사는 없다.
[1]

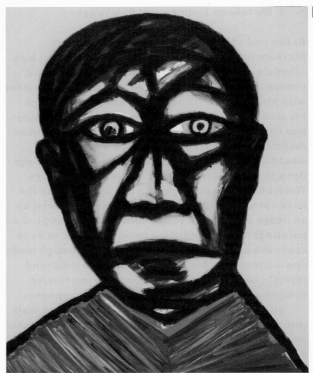

　　표정이 있어야 할 자리에 놓인 것은 그 자신의 내면을
드러내는 단호하고 직설적인 인상이다. 그는 자기 얼굴에
나타난 표정을 그린 게 아니라, 자화상을 그릴 때 쓰는
거울(문호리 작업실 사진에서 찾아볼 수 있다)을 통해
그 자신이 받은 자신의 인상을 그린 것만 같다. [2] 그리고
그 인상은 보는 이에게 결코 편한 인상은 아니다. 내가
인터뷰에서 뉴욕 연작을 예로 들면서 "사람들 표정이
사납다, 유머가 안 느껴진다."라고 감상을 이야기하자 그는
"나 스스로는 유머가 있다고 생각해요, 내가 좀 낙천적으로
보는 면도 있고 웃기는 면이 있다고 생각해요."라고
답했다. 물론 대머리 통기타 가수가 등장하는 〈알렉산더
플라츠〉(2012~15) 같은 작품은 웃기고 유머가 느껴진다.
보고 있으면 슬며시 미소가 지어진다. 하지만 그런 작품은
드물고, 〈알렉산더 플라츠〉 역시 가수 자신이 웃고 있지는
않다. [3]

　　어쩌면 서용선에게 겉으로 드러나는 표정은 의미
있는 게 아닐지도 모른다. 이영주 큐레이터도 나와 비슷한
생각을 한 모양인지 이렇게 썼다. "그에 따르면 자화상은
그의 모습을 그린다기보다는 내부에 감춰진 불편함을 찾는
행위이다. 때문에 자화상 드로잉은 그의 예민한 촉수로부터
발생되는 삶의 정신과의 긴밀한 작용으로서, 풍화와 견딤의
연속이다."① 그는 자화상에서조차 생김새에, 겉 표정에
집중하지 않는다. 〈얼굴2〉에서도 눈에 먼저 들어오는 것은
어쩌면 화난 듯하고 사나운 듯하고 불편해 보이는 인상이다.
눈동자는 관람객의 눈을 똑바로 마주 바라보는 듯이
정중앙에 자리했고, 입술은 굳게 다물었다. 그를 만난 날

내가 순간순간 받곤 했던 작가의 인상 그대로다. 그렇지만
그의 인물들에게서는, 보는 이를 진정으로 억압하고 정말로
불편하게 하는 근엄함이나 엄숙함, 권위 의식 같은 건
느껴지지 않는다. 그의 사나움, 불편함은 수평적 관계에서
느껴질 법한 불편함이다.

　　서용선의 작품은 근작일수록, 선은 더 거칠 것 없이
쭉쭉 뻗어나가고 원색의 존재감은 더 그럴 수 없을 듯이
선명하다. 보는 이의 마음을 놓이게 하는 부드러운 힘은
느껴지지 않는다. 그러니 한국-스페인 특별전에 나온 다른
작가들보다 눈에 더 잘 띌 수밖에. 《마주하는 풍경, 일상의
시선》 도록의 다른 작가들은 색은 파스텔 톤이거나 수채화
톤으로 쓰고, 부드럽고 매끄럽게 물결치는 선을 그렸다.
인물들은 함박웃음을 짓고 있고, 풍경은 아기자기하고,
묘사는 극사실주의처럼 충실하다. 이런 작가들 사이에
섞어놓은 서용선은, 그림들로 이뤄진 종이 숲에 풀려난
원색의 야수처럼 보인다.

①　　이영주, 「기획의 글」, 『확장하는 선, 서용선 드로잉』,
　　　한국문화예술위원회 시각예술부, 2016년, 9쪽.

cannot be but a gap between a creator and his work. If not, it would not be possible for me to maintain my original stance as I read and analyze a work. It is not a must to know about the author in order to understand a work. For this reason, I am not planning to write about Suh Yongsun's life in this essay unless it is inevitable. As I entered the Yeoju Art Museum at the opening hour, I could look through all the exhibited works at ease, guided by the artist himself.

2. *Face 2*

In the museum lobby, there were a number of books on the artist. I picked one of them up and turned the pages as I took a sip of coffee. It was an exhibition catalogue of *The Scenery We Face, Our Daily Gaze*, a special exhibition organized by Seoul Olympic Museum of Art (SOMA) this spring that presented works by six artists from Korea and Spain. As I skimmed through the catalogue, the works of Suh Yongsun, as expected, caught my eyes. It is not that his was the best among others. It is not my place to judge who is better than who. It was only that from every pages of the catalogue, ones that displayed the images of Suh's works were visually the most powerful.

There is an aspect of Suh Yongsun's paintings that overwhelms the works of other artists. His works are mostly of large scale, and their lines are bold and wild. The colors are vivid to remind one of five cardinal colors of *obangsaek*, and there is no gray zone of colors as there is not much change in density. The artist often omits details and depicts a shape only with a couple of lines and a few colors. His self-portrait *Face 2* (2009) is a good example. This work is as large as 249.5 × 200 cm, taller than an adult man. The outline of the face depicted is roughly rendered by unrefined brushstrokes. A vivid yellow hue fills most of the canvas, in harmony with black and red. In order to add volume to the facial skeleton, Suh made a choice to express facial shades with a new color red rather than adjusting the density of yellow. As the artist had left out most of the details, a meticulous depiction of facial expressions common in most self-portraits is absent in this work. [1]

What came in place of a detailed facial expression is a resolute and forthright impression that reveals the artist's inner mind. It seems that what Suh Yongsun portrayed was not the look on his face, but the impression he received from his own reflection in the mirror—the mirror used for painting self-portraits (which can be found in the

artist's studio at Munho-ri). [2] And for the viewer, that impression is never a comfortable one to look at. In an interview with the artist, I took his New York series as an example to talk about how "the look on people's faces are somewhat fierce. I cannot discern a sense of humor." To this, Suh responded, "I actually think of myself as equipped with a sense of humor. There is a side of me that is quite optimistic and funny." Of course, there are works like *Alexander Platz* (2012–15) presenting a bald headed guitar singer that are indeed funny and humorous. A smile naturally forms as one takes a time to look at these paintings. However, such works are rare, and even in *Alexander Platz*, the singer himself is not smiling. [3]

It may be that for Suh Yongsun, facial expressions that are externally revealed are not very significant. This view has been elaborated by curator Lee Yeongju. She writes, "According to the artist, self-portraits are less something that portrays his appearance but more of an act of searching for some discomfort hidden inside. In that way, Suh's self-portrait drawings are an embodiment of intimate interactions between his life and mind generated from his keen tentacles, or a continuation of weathering and tolerance."① Even in his self-portraits, Suh Yongsun does not focus on resemblance or external appearance. What one encounters first in *Face 2* is also a more general impression of a person who seems somewhat

3

① Lee Yeongju, "On the Exhibition," *Expanding Lines: Suh Yongsun Drawing*, Seoul: Visual Arts Department, Arts Council Korea, 2016, 9.

서용선의 그림을 야수처럼 보이게 하는 데 큰 역할을
하는 것이 그의 선들이다. 〈얼굴2〉에서 보듯 그의 선들은
얼굴의 부드러운 윤곽을 나타내면서도 곡선보다는 직선을
닮았고, 날카롭게 각이 져 있고, 선 하나로 끝나지 않는다.
그는 굵은 붓으로 반복해 선을 긋는다. 그래서 그의 선은
선이라기보다는 선의 묶음, 선의 다발로 보인다. 김경운
학예연구사는 그가 형상을 "지표적인 선묘를 쌓아나가
만들어"[2]낸다고 말한다. 그도 한 인터뷰에서 그림을
시작할 때 일단 선을 그어본다고 말한다. "우선 보이는 대로
선을 그어놔요…… 자기가 선 하나를 이렇게 잘못 그어도
절대로 이건 잘못 그어지는 게 아니에요. 왜냐면 이게
기준이 되는 거예요. 나중에라도 이 선이 다른 선과 만나서
어떤 역할을 하게 되어 있어요."[3]

캔버스에 선을 하나 그어놓는 행위는 많은 작가들에게
한 작품의 시작이겠지만, 서용선에게 선 긋기는 시작일뿐
아니라 완성이기도 하다. 〈얼굴2〉에서처럼 그는 선을
다발처럼 묶어 채색면처럼 사용하고 선에도 색을 싣는다.
그에게 드로잉이란 선과 색이 결합되어 있는 하나의 완성된
작품이다(그는 드로잉 작품만 모아 따로 전시회를 열기도
했다). 그래서 이선영 미술평론가처럼 "그에게 선은 동시에
색"이라고 하면서, 그의 작품에서 "색은 선으로 인해 힘을
받으며, 선은 색으로 인해 풍요로워진다."[4]고 말하는 것이
가능해진다.

선은 서용선의 작품 세계로 들어가는 열쇠다. 2007년에
집중적으로 그려진 그의 드로잉 자화상 연작을 보면 선은
얼굴의 윤곽을 나타내기 위해 쓰였다기보다는, 선으로
얼굴 자체를 빚었다는 느낌을 받는다. 검정 단색으로
그려진 드로잉 자화상에서 그는 선으로 색을 칠했다.[4]
이런 특징은 드로잉뿐만 아니라 대부분의 자화상과 인물
그림에서 두루 나타난다. 2007년에 검정 단색으로 그려졌던
그의 자화상은 2021년에는 빨강의 선들로 그려졌다(그에게
자화상은 상당히 중요하다. 작업실에도 작업 중인 자화상이
한 점 있었고, 자화상만 따로 모아 전시회를 열기도 했다).
바탕에 색이 있긴 하지만 그는 빨강의 선들로 자신의 형상을
채워 넣었다.[5] 이선영 평론가의 말처럼 그의 그림에서
선은 동시에 색이다.

서용선에게 선은 단순히 기능적 측면만 갖는 게 아니다.
그는 선에 자신의 감정을, 직설적인 어떤 감정적 메시지를
담는 듯이 보인다. 그의 그림을 보고 있으면 선이 말하고
있는 듯하다. 선이 곧 메시지가 되어 마음에 와닿는 듯한

② 　김경운, 「서용선 작품세계의 사려 깊은 매력」, 『올해의 작가
2009 서용선』, 국립현대미술관, 2009년, 17쪽.

③ 　임흥, 〈이해와 오해〉(작가 서용선 다큐멘터리), 2006년.
『올해의 작가 2009 서용선』(17쪽)에서 재인용.

④ 　이선영, 「근대를 관통해온 주체, 그리고 도시와 역사」,
『확장하는 선, 서용선 드로잉』, 한국문화예술위원회
시각예술부, 2016년, 14쪽.

4

4

angry, ferocious, and ill at ease. The figure's pupils are located at the center of the canvas as if looking straight into the viewer's eyes, and his lips are tightened. The impression of this painting in fact is exactly the one I received of the artist himself moment to moment on the day I met him. Nevertheless, no actual austerity, solemnity, or any sense of authority that could truly cause discomfort is sensed from Suh's figures. Rather, the fierceness and discomfort of the man in *Face 2* are those of a horizontal relationship.

Suh Yongsun's works, particularly more recent ones, present lines that boldly stretch out and primary colors that display a high degree of presence. No wonder his paintings were most noticeable in the Korea-Spain joint exhibition. From what I observed from the exhibition catalogue of *The Scenery We Face, Our Daily Gaze*, the works of other artists display quite different features, using colors of pastel or watercolor tones, and lines that ripple in gentle and smooth waves. Their figures all smile brightly, feature adorable sceneries, and depict objects in great detail as in hyperrealist works. Suh Yongsun, blended within these painters, appears like a beast of primary colors unleashed in a paper forest of pictures.

What contributes the most to the beastly look of Suh Yongsun's paintings are his lines. As in *Face 2*, his lines are mostly straight rather than curved, even when depicting the smooth outline of a face. They are sharply angled, and do not operate individually. Suh repetitively draws multiple lines with a thick brush. And thus, his lines become more like a collection, or a bundle of lines. Curator Kim Kyung-woon once described how Suh Yongsun creates an image "through the accumulation of indexical line drawings."② The artist himself once mentioned in an interview that when he begins a work, he just goes ahead and draw a line. "First of all, I just make a line as I see it. (...) Even if you make a wrong line, it is not wrong at all. Because that becomes a starting point. This line would eventually come to perform a certain role when it meets another line."③

Making a line on a canvas would be the beginning of a long process to come for many artists. But for Suh Yongsun, this is not only an act

of starting but also of completion. As in *Face 2*, Suh often groups multiple lines in bundles and uses them like a colored 'surface,' and in addition give colors to individual lines. To Suh, a drawing is itself a completed and independent art work where lines and colors are unified into a singular whole (he once held an exhibition composed only of his drawings). And therefore, it becomes possible to say that, as in art critic Lee Seon-young's words, "to the artist, a line is at the same time a color," and that in Suh's paintings, "colors are enforced by lines, and lines are enriched by colors."④

Lines are a key for entering Suh Youngsun's oeuvre. If one takes a closer look at his series of self-portrait drawings intensively worked on in 2007, lines do not just 'depict' a face, but rather 'shape' the face itself. In his self-portrait drawing in black monochrome, the artist colored the surface with his lines. [4] Such a feature is displayed not only in his drawings but also in most of his self-portraits and figure paintings. The self-portrait of black monochrome from 2007 turns into that of red lines in 2021 (to the artist, self-portraits are of considerable importance. There was one in progress in his studio, and Suh also held an exhibition only of his self-portraits). There are other colors in the background, but it is red lines that mainly fill in the surface to form a shape. [5] As in the words of Lee Seon-young, the line is at the same time also the color in Suh's paintings.

To Suh Yongsun, lines are not merely functional. It seems like the artist is embodying his feelings, some forthright messages of emotion, in his lines. When I look at Suh Yongsun's paintings, I sometimes feel like his lines are speaking to me. That the lines immediately become a message that reach my heart. I would explain again later, but such characteristics of Suh Yongsun's lines could be aesthetically connected to the 1980s *minjung* art of Korea.

Suh Yongsun's lines did not display such

5

② Kim Kyung-woon "The Discreet Charm of Suh Yong-sun's Art," in *Suh Yong-sun: Artist of the Year 2009*, National Museum of Modern and Contemporary Art, 2009, 17.

③ An interview from *Understanding & Misunderstanding*, a documentary film on the artist. Directed by Lim Hong, 2006, quoted in *Suh Yong-sun: Artist of the Year 2009*, 17.

④ Lee Sun-young, "A Subject That Has Penetrated the Modern, And the City and History," *Expanding Lines: Suh Yongsun Drawing*, Seoul: Visual Arts Department, Arts Council Korea, 2016, 14.

느낌을 받는다. 뒤에 다시 말하겠지만, 이런 선의 특징에서
그와 1980년대 민중미술의 미학적 연계점을 찾을 수 있다.
　　서용선의 선이 처음부터 지금과 같았던 건 아니다.
그의 초기작들에서 선은 보통의 기능적 측면만을 지녔던
것으로 보인다. 《만첩산중서용선繪畵》전에는 그가 삼십 대에
그렸던 그림들이 있었다. 〈도시의 사람들〉(1987~8)로
자화상 못지않게 중요한 그의 또 다른 테마인 현대 도시인을
그린 작품이다.[6] 그에게는 작가 인생 내내 끌고 온
몇 가지 테마가 있다. 자화상이 그렇고 현대 도시인 테마가
있다. 그리고 역사 속 인물과 사건을 그린 역사 테마와
우리네 설화 테마도 있다. 작가로 살아오면서 직접 길어
올린 테마들이 하나씩 더해지면서, 그의 작품세계는 이제
만첩산중을 이루고 있다. 그는 나이가 들수록 세계가
풍요로워지는 작가다.
　　〈도시의 사람들〉의 선은 〈얼굴2〉의 선과 확연히
다르다. 초기작의 선은 형상의 윤곽을 표현하고 명암을
드러내는 보통의, 단순한 기능에 머무는 듯이 보인다.
얼굴의 주름을 나타내고 옷의 주름을 나타낸다. 원색이
아니라 연한 색을 쓰고 있고 훨씬 가늘고 섬세하다. 아직
그의 그림에서 선이 말하고 있지는 않다. 그의 초기작들에선
선은 아직 선이다. 때문에 본격적으로 그의 화풍이 무르익은
다음의 작품들에 비해 메시지성이 약해 보인다. 그는 많은
뛰어난 작가들이 그렇듯 초기작에선 평범한 모습을 보인다.
　　평범하긴 하지만 〈도시의 사람들〉에도 선은 놀랍도록
많이 쓰였다. 초기작에서도 서용선은 색을 칠해 면을
만들기보다는 선을 긋고 또 그어 채색면을 만들었다. 그의
작품은 선들의 향연이다.

　　3. 〈도시에서〉

한국-스페인 특별전이 그랬듯이, 서용선은 개인전보다는
기획전이나 단체전일 때 더욱 도드라져 보이는 작가라고
할 수 있다. 나는 이 글을 쓰기 전부터 그의 전시회를 봐왔다.
글도 썼다. 2015년, 『리플릿』(2017)에서였는데 1995년에
서용선이 서미갤러리에서 연 개인전에 관한 글이었다.
내가 그 글을 쓸 수 있었던 것은 1995년 전시회의 리플릿을
그때까지 보관하고 있었기 때문이고, 무려 20년이나
서미갤러리에서 받았던 인상을 내가 잃어버리지 않은
덕분이었다.
　　내가 한 해에 보는 전시회의 수를 생각하면, 그리고
20년이 지나도록 서용선에 대한 인상을 잊지 않았다는
점을 생각하면, 그가 가진 힘을 긍정하지 않을 수 없다.
그의 그림들은 내가 20년 동안 본 그 모든 전시회를 대부분
망각하는 동안에도 살아남을 만큼 평범하지 않다. 그의
작품 세계는 늘 뭔가 아직 의미가 덜 캐내어진 듯한, 아직
이해가 완결되지 않은 세계 같다. 그에겐 직관적으로 한눈에
파악되지 않는 것이 있다.

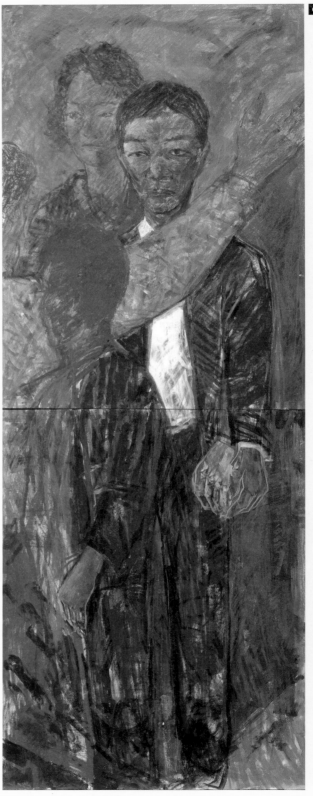

　　내가 『리플릿』에서 서용선에 대해 썼던 글이 「공허라는
두렵고 낯선 그림자」였다. 다룬 작품은 서미갤러리에
전시됐던 〈도시에서〉다.[7] 도시의 흔한 거리 풍경을
묘사한 이 그림은 도상만 보면 하나도 어렵지 않다. 바탕의

features from the beginning. In the artist's earlier works, lines only served an ordinary function. An example could be found from Suh's work from his thirties displayed in the *Mancheop Sanjung* exhibition. The painting titled *People of the City* (1987–88) depicts contemporary people of the city, another main theme of Suh Yongsun of great significance as his self-portraits. [**6**] Suh has a number of themes that are continued throughout his artistic life. One is the self-portrait and another is contemporary urbanites. And there is also that of history depicting historical figures and events, as well as that of Korean myths. These themes the artist himself drew up from his life are aggregated to compose Suh Yongsun's oeuvre of 'ten thousand layers.' He is an artist whose world enriches as he ages.

The lines displayed in *People in the City* are clearly distinguished from those of *Face 2*. The lines of his earlier works seem to be bounded to their more general and simple roles of outlining and expressing light and shade. They express creases in faces and clothes. They are of lighter tone rather than in primary colors, and are much thinner and delicate. These lines yet appear to be speaking. In Suh's earlier works, lines are just lines. And therefore, they display only a subtle message compared to his later works in more established style. Like many other extraordinary artists, Suh Yongsun produced yet ordinary works in his earlier days.

Lines in *People in the City* are ordinary, but they are already used to a surprising degree. Even in Suh's earlier works, surfaces are rendered not in colors but in repeated lines. And in this way, Suh Yongsun's works display a feast of lines.

3. *In the City*

Suh Yongsun could be described as an artist who becomes more conspicuous in special exhibitions and group exhibitions—as in Korea-Spain joint exhibition—than in his solo shows. I have seen his exhibitions long before writing this essay. I have also already written about him. It was in 2015 for the book *Leaflet* (published in 2017), and it was about Suh's solo exhibition at Gallery Seomi in 1995. I could write the essay as I had preserved the leaflet (a thin booklet that explained about the exhibition) from the 1995's show, and as I still had not lost the impression I received at the Gallery for over twenty years.

Considering the number of exhibitions I see every year, and how I have never forgotten the impression I received of the artist for more than two decades, I cannot but acknowledge his power. Suh Yongsun's paintings are by no means ordinary so to survive my forgetting of most of the exhibitions

I have visited over the past twenty years. His oeuvre is always like a world the meaning of which is yet to be excavated, the understanding of which is yet to be completed. There is something about the artist that cannot be intuitively grasped at a glance.

The essay I wrote on the artist in *Leaflet* was titled "A Fearful and Unknown Shadow Called Voidness." It focused on the painting *In the City* (1994) exhibited at Gallery Seomi. [**7**] This work's iconography is not at all difficult to understand, as it presents an everyday scenery of a city. The grid in the background depicts pavement blocks, while the other side of the work with a traffic lane implies a roadway. The men in suit and shirt walk on the sidewalk. Only with such description, no other work in the world could be as ordinary as this one. There seems to be nothing that could not be grasped at one glance. However, such plain subject matter is intervened by Suh Yongsun's characteristic aesthetics, for instance, his way of employing lines and colors. The pavement and roadway are all colored in vivid dark blue, and figures are colored in red and yellow. Pedestrians are painted flatly lacking any sense of space, lying on the ground like shadows.

There is thus something additional to this work *In the City* than a simple portrayal of four men walking on the sidewalk. What that something is that is difficult to be captured through an iconographical analysis would differ from person to person. For me, it is Freudian "uncanny." The four men on the pavement are indeed of human forms but are placed on the ground like shadows without any hint of three dimensionality. Furthermore, there is something absent in these men that is crucial for a realistic depiction—the shadow. In short, *In the City*, through four men without shadow lying on the ground like shadows, depict the most ordinary scenery in the most extraordinary way.

그리드는 보도블록이고 차선 표시가 있는 한편은 차도고, 그 위를 셔츠와 정장 차림의 남자들이 걷고 있다. 만약 이 설명만 읽는다면 세상에 이처럼 평범한 그림은 없을 것이다. 한눈에 파악하지 못할 것이 없어 보인다. 하지만 평범한 풍경에 선과 색의 운용 같은, 그의 특징적인 미학이 끼어든다. 보도와 차도의 색깔은 온통 짙은 파랑이고, 그 위의 행인들은 빨강과 노랑만으로 칠해졌고 공간감을 무시하고 이차원 평면으로 그림자처럼 바닥에 깔려있다.

〈도시에서〉에는 보도 위를 걷는 네 사람이라고 쉽게 말할 수 없는 무엇이 더 있다. 단순히 도상적 해석만으로는 이해되지 않는 그것이 무엇일지는 보는 사람마다 다르겠으나, 내 경우엔 그걸 프로이트가 말한 '언캐니(UNCANNY)'라고 봤다. 보도의 네 사람은 분명 인간의 형상이지만 입체감 없이 그림자처럼 바닥에 깔려있다. 그러면서 동시에 네 사람에게는 사실적인 묘사에서라면 있어야 할 것, 그림자가 없다. 〈도시에서〉는 그림자 없는 네 사람이 그림자처럼 누워있는, 가장 평범한 일상적 풍경을 조금도 평범하지 않게 표현한 그림이다.

프로이트는 1919년의 논문 「두려운 낯섦」에서 언캐니를 "공포감의 한 특이한 변종"으로 소개하고 있다. 바닥의 그림자처럼 흔하고 낯익은 것이 어떤 계기에 의해 "이상하게 불안감을 주고 공포감을 주는 것으로 변"⑤할 때 느껴지는 감정이다. 〈도시에서〉를 1995년에 갤러리에서 볼 때나 2015년에 『리플릿』을 쓰며 볼 때나 지금 다시 볼 때나, 그 이상한 낯선 느낌에서는 큰 차이가 없다. 작품에서 무엇보다 언캐니한 감정은 이차원 평면으로 구현된 세계에서 비롯된다. 보도블록이나 노면에 표시된 차선처럼 사람들 역시 평면이다. 이 공간이 왜곡된 세계에서 사람은 평면화되고 획일화된다. 〈도시에서〉의 네 사람은 몰개성의 평면적 존재라는 점에서, 부피도 깊이도 없는 그림자와 다름없다.

색 역시 서용선의 작품세계로 들어가는 열쇠다. 〈도시에서〉가 주는 두려운 낯섦은 왜곡된 공간감에만 그치지 않는다. 색도 그런 효과를 내는데, 그가 사용한 파랑과 빨강의 원색은 선이 그렇듯, 그 자신의 내면의 어떤 메시지를 담고 있는 듯 보인다. 그의 그림에선 색도 대상을 재현하는 기능적 역할을 넘어 메시지가 된다. 선이 말을 하듯 색도 말을 한다. 〈도시에서〉에서 빨강과 파랑이 말하고 있는 바는 언어만큼 명확하지는 않지만, 원색의 강렬함만큼이나 강렬한 감정적 메시지를 보는 이의 마음에 전달한다.

〈도시에서〉의 이차원적 사람들은 육체를 잃고 희미한

⑤ 지그문트 프로이트, 『예술, 문학, 정신분석』, 정장진 옮김, 열린책들, 2004년, 405~6쪽.
⑥ 같은 책, 434~5쪽.
⑦ 백민석, 『리플릿』, 한겨레출판, 2017년, 115쪽.

존재감만이 남은 유령처럼 보이기도 한다. 프로이트에 의하면 "가장 강렬하게 두려운 낯섦의 감정을 불러일으키는 것은 죽음, 시체, 죽은 자의 생환이나 귀신과 유령 등에 관련된 것이다." 독일어 단어 운하임리히(UNHEIMLICH)는 '집과 같은(HEIMLICH)'의 반의어로, 영어로는 언캐니(UNCANNY)라고도 옮겨진다. "UNHEIMLICH한 집은 우리가 흔히 귀신 들린 집이라는 말로 표현하는 집보다 훨씬 더 강력한 표현이다."⑥ 〈도시에서〉의 빨강과 파랑은 거의 유령이나 다름없이 된 사람들이 내지르는 한낮의 비명처럼 느껴진다. 〈도시에서〉의 그림자나 다름없이 비인간화된 현대인의 초상에서, 이상하리만치 격렬한 생명력이 느껴진다면 그것은 비명 같은 원색 때문이다. 그림자에 입은 없지만 나는 색이 비명을 지르는 듯한 언캐니한 느낌을 받는다. 색을 통해 우리 현대인들의 비명을, 비언어적인 구조 신호를 듣는 것 같다.

나는 「공허라는 두렵고 낯선 그림자」의 결말에서 〈도시에서〉에서 들리는 구조 신호를 이렇게 해석했다. "그림자가 실체가 '없는' 광학적 현상에 불과한 것처럼, 공허 역시 무엇인가 결여되고 결핍된 '없는' 것을 뜻한다. 세상에 귀신이 있다고 믿기는 어렵고, 그 두렵고 낯선 그림자의 정체는 우리 인생의 밑바닥에 가로놓인 공허가 아닐까. 공허라는 절대적인 결여와 결핍. 그 없음의 있음을 불현듯 깨달을 때 찾아오는 감정이 두려운 낯섦 아닐까."⑦

나는 인터뷰에서 이 특이한 이차원 평면의 세계에 대해 물었다. 서용선은 자신의 미적 경험이 어떻게 시작됐는지부터 현대 회화의 흐름에 대해서까지 재밌는 이야기를 들려줬다. 정리하면,

"평면적인 요소들은 정확히 얘기하면 인쇄물에 대한 반응인 것 같아요. 저희 세대 같은 경우는 그림 원작을 거의 못 보고 미술대학에 들어갔어요. (인쇄된 그림 말고) 진짜 그림을 본 거는 중학교 때 미술 선생님이 미술실에서 그린 그림을 그냥 지나치듯 두세 점을 본 정도고, 갤러리 한번 가본 적이 없고 미술관 한번 가본 적이 없고, 이발소 같은 데 걸려있는 거는 무심코 봤겠죠. 그렇지만 회화 작품이라고 생각하고 본 건 없어요.
물론 예술이라는 것에 끌리는 점은 좀 있었겠죠. 대학 가기 전까지 제가 이해한 회화라면 화집 같은 인쇄물을 통해 본 것들이었어요. 미술대학도 화집으로 공부하고 들어갔죠. 대학에 입학해서 여러 작가의 그림, 원작을 봤죠. 당시 들어온 게 팝아트 같은 것들, 마티스 같은 것도 들어왔는데, 그것은 정말 평면적이거든요. 그런데 원근법적 공간보다 더 세련된 느낌을 주는 거예요.
회화에서의 재현적 깊이감이라고 하는 것이, 현실에서 느껴지는 그런 공간감에 비해서는 굉장히 인위적이라는 게 본능적으로 느껴지거든요. (평면성을

In his 1919 article "The Uncanny" (Das Unheimliche), Freud introduced the term as a marginal form that "belongs to the realm of the frightening, of what evokes fear and dread."⑤ It is such a feeling triggered when something that was "once well known and had long been familiar" as a shadow on the ground, by some chance, transforms into something that strangely arouses "uneasy, fearful horror."⑥ Looking at *In the City* in a gallery space in 1995, or in 2014 as I wrote for the book *Leaflet*, or at this time as I write this essay, the painting's strange and unfamiliar feeling remains unchanged. The work's uncanniness originates from the two dimensionality of the depicted world. Like the pavement blocks or the traffic lanes, people are also flat. In this world of distorted spatiality, people are flattened and uniformized. In that they are deindividuated and flattened beings, the four men in *In the City* are not much different from shadows without any sense of volume or depth.

Colors are also one key for entering Suh Yongsun's oeuvre. The frightening unfamiliarity of *In the City* does not end with distorted spatiality. Colors also display such effect. Primary colors of blue and red, as in Suh's lines, seem to embody a message of the artist's inner mind. In Suh Yongsun's paintings, colors also operate beyond its general role of representation and become a message. Like lines that speak for themselves, colors also speak their own words. What red and blue in *In the City* are trying to communicate is not as clear as those of actual words, but they are still capable of delivering a powerful emotional message, as strong as that of primary colors, to the viewer's heart.

Two dimensional figures in *In the City*, in a way, resemble ghosts that lost their body and display only a faint presence. According to Freud, those that represent "the acme of the uncanny" are those that has "to do with death, dead bodies, revenants, spirits and ghosts."⑦ The German word "unheimlich" is an antonym of "heimlich" which means "familiar," "native," or "belonging to the home," and is translated into "uncanny" in English. The German phrase of "ein unheimliches Haus ['an uncanny house']" is an expression much stronger than its usual periphrasis of "a haunted house."⑧ In a similar way, *In the City*'s red and blue hues come across as a scream under the daylight of those ghost-like figures. If one senses some vitality that is peculiarly intense from the work's portrayal of contemporary men dehumanized like shadows, it would be because

of the scream-like vividness of primary colors. There is no mouth in the shadows, but I discern an uncanny feeling from screaming colors. Through colors, I hear the screams of us contemporary men, our nonverbal signal calling for rescue.

In the final section of my essay "A Fearful and Unknown Shadow of Voidness," I interpreted that sign for help heard from *In the City* in the following way: "Like a shadow that is nothing but an optical phenomenon 'without' substance, voidness also signifies something that is lacking and deprived, something that is 'without.' As it is difficult to believe that there are ghosts in the world, wouldn't it be more reasonable to identify that frightening and unfamiliar shadow as voidness situated deep under our lives? That absolute lack and deficiency called voidness. Wouldn't the frightening sense of the uncanny be something that is triggered by a sudden recognition of such absence and presence?"⑨

In an interview, I asked the artist about this peculiar world of two dimensionality. In response, Suh Yongsun recalled an interesting story of how his aesthetic experience began, and of the course of contemporary painting. Below are the summary of his words:

"To put it accurately, flat elements probably came in response to printed media. Most art students of my generation entered college without actually having seen an original artwork. The only experience of me seeing an actual painting (that was not printed) was in middle school, passing by two or three paintings by my art teacher in the classroom. I had never been to a gallery, or an art museum. I may have unconsciously seen some paintings hanging in a barbershop. But there was nothing that I consciously saw as a work of art.
Of course there were things that attracted me to the things we call art. Before I went to college, I understood paintings through printed images as in art books. In fact, I studied for art college with art books. It was after I entered college that I got to see the original works of various artists. What came into vogue in Korea at the time were the works of pop art, or of Matisse, and they were all very two-dimensional. However, they appeared more sophisticated than those of perspectival space.
In paintings, there is something called representational depth. Compared to the spatiality of reality, such depth cannot be but instinctively perceived as greatly artificial. After the paintings of Impressionists (that emphasized two-dimensionality) became well known, that artificially rendered depth came to appear outdated. Or somewhat contrived. For example, paintings like that of Rembrandt's

⑤ Sigmund Freud, "The Uncanny," Translated by David
 Mclintock, London: Penguin Books, 2003, 123.
⑥ Ibid., 131.
⑦ Ibid., 148.
⑧ Ibid., 148.
⑨ Baek Minsuk, *Leaflet*, Seoul: Hankyoreh Publishing,
 2017, 115.

강조한) 인상파 이후의 그림이 나온 순간, 인위적으로
만들어낸 깊이감이 뒤떨어져 보이는 거죠. 작위적으로
보이는 거죠. 예를 들면 렘브란트 그림은 억지로
그늘이나 빛으로 깊이감을 만들어가고, 인위적으로
원근감을 강조하잖아요. 고전도 나름대로 보는
즐거움이 있지만, 인위적이라는 점에서 고전보다
오히려 현대 그림이 더 자연스러운 면이 있어요.
그림은 원래 평면이었어요. 현대 회화가 평면적으로
되어가는 데는 유리한 점이 있어서예요.
인쇄물이라는 것. 현대사회에서 인쇄물이 차지하는
비중이 크고, 인쇄물이 지적인 환경이 돼버린 거고,
시각적으로. 그래서 그런 평면성을 제가
감각적으로다가 받아들인 거예요. (……) 그런데
현실은 원근법 같은 공간감을 무시할 수가 없고, 하지만
평면적인 것도 진실이라고 할 수 있죠. 원근법도 하나의
표현 방법이고 평면적인 것도 하나의 표현 방법이고.
둘을 얼마나 잘 섞느냐가 문제인 거 같아요."

나는 서용선의 작품 세계를 간단히 설명할 용어를
아직 모른다. 누군가에게 어울리는 적절한 미학 용어가
없다는 의미는 그만큼 그의 작업이 독창적이라는 말도
된다. 과거와 현재의 어느 흐름에도 딱히 욱여넣을 수 없는
독창적인 작가들은 어디에나 꼭 있다. 서용선 역시 기존의
알려진 유파의 화풍이나 스타일로 설명되지 않는다. 내가
인터뷰에서 "백색 모노크롬이 한국의 화단만이 아니라
미술대학에서 미적 판단 기준을 넘어 하나의 명령같이
지배하던 시절"⑧에, 그러니까 1970년대 후반 추상회화가
화단의 주류이던 시절에 선생님은 상당히 다른 길을 가시지
않았나, 그러려면 용기가 상당히 필요하지 않았냐고 묻자
그가 짓던 미소가 떠오른다. 그는 빙 둘러 대답하면서
이렇게 덧붙였다.

"저를 지도하신 선생님들조차 너무 서사적이다, 너무
이야기가 많다, 고 하셨으니까. 그림에 너무 형상이
있으면, 미술 쪽에서는 문학적이다, 이렇게 볼 수 있는
거죠. 이 그림에 무슨 이야기가 필요하냐, 이런 얘기를
들었어요. 설명적이다, 라고. 왜냐하면 형상이 있으면
설명적인 게 되는 거죠."

이선영 평론가도 서용선이 당시의 주류와 다른 길을
갔다는 데 주목했다. "작가가 미술대학을 다니던 시기인
1970~80년대(에) (……) 사대부의 화풍과 근대의
예술을 위한 예술이 미묘하게 결합된 듯한 고상하고

⑧ 이인범, 『서용선의 도시 그리기: 유토피즘과 그 현실 사이』,
 학고재, 2015년, 7쪽.
⑨ 이선영, 앞의 책, 15쪽.

관념적인 화풍 속에 특히 억압된 것은 색이었다. (……)
우리의 장구한 역사적 전통 속에서 극히 일시적인 시기의
특징에 지나지 않는 백의민족과 백자, 그리고 수묵화 등을
운운하면서 색은 천시되거나 금기시되었다. 반면 서용선의
작품에는 생경하리만치 강렬한 색선이 지배적이다."⑨

이해하는 일이 힘들수록 책을 쌓아놓고 과거의 사례를
뒤적이게 된다. 하지만 과거는 참고만 할 뿐이다. 작가는
독창적일수록 과거를 배반한다. 미학이나 미술사를
다룬 책에 이름을 올리는 작가들은 과거 어느 한 시점의
유행을 가장 잘 설명할 수 있는 지표종으로, 후대의
비평가들에 의해 의미가 주어지고 추인된 사람들일
뿐이다. 그저 그뿐이다. 모든 시대의 미학이나 미술사에는
결코 그들 몇몇만 있었던 게 아니다. 과거의 현실이든,
현재의 현실이든, 현실은 그렇게 단순하게 형성되고
빈약하게 흘러가지 않는다. 현실은 몇몇 작가에 의해 과잉
대표될 만큼 앙상하지 않다. 지표종이 되지 않는, 유행을
따라가기를 거절하고 제 길을 간 숱한 작가들이 현실의
풍부하고 진실한 육체를 형성한다.

서용선의 작품에서 눈에 띄는 것은 굵고 거친 직설적인
선과 단호함이 느껴지는 원색의 채색면이다. 부드러운
맛이 없이 여러 차례 오간 붓질의 흔적이 그대로 남아있는
직선적인 드로잉 선들은 1980~90년대의 한국 민중미술의
선들을 떠올리게 한다. 민중미술에서 선은 단순히 인물의
윤곽을 나타내는 기능적인 역할만 했던 게 아니라, 역사를
일궈나가는 민중의 힘과 한, 의지 같은 정신적 가치를
상징하는 역할을 했다. 그래서 민중미술에서 선들은,
나약하지 않은 거칠고 직설적인 느낌을 주는 선들이 즐겨
자주 쓰였다. 서용선의 선들도 그렇다. 하지만 그의 작품
목록에서 딱히 민중미술의 미학적 전형성이 엿보이는
작품은 없다. 민중미술이 한창이던 시기에 그는 역사화를
그렸고 현대 도시인의 모습을 그렸다(어쩌면 이 두 가지
테마가 그가 나름대로 생각했던 민중미술이었을지 모른다).
국립현대미술관 과천관에서 열린 〈시대를 보는 눈:
한국근현대미술〉전에는 그가 1984년에 그린 〈소나무〉가
걸려 있었다. [8] "한국 미술의 흐름을 미술 내적인
면모보다는 시대 사회적 관점에서 접근하고자" 했다는 전시
취지를 봐도 알 수 있듯이, 1980년대에 그려진 그의 소나무
연작은 당대의 현실을 간접적으로, 상징적으로 표현하고
있는 것이었다. 〈소나무〉의 선들 역시 직선적이고 다발로
그어져 있다. 뾰족뾰족한 소나무의 솔잎을 묘사하는 데 그의
선 긋기만큼 적절한 화법이 또 있을까.

한편 원색의 채색면을 큼지막 큼지막하게 나누는
스타일은 언뜻 몬드리안 식의 신조형주의를 떠올리게
한다. 물론 서용선의 작품은 누가 봐도 구상회화다. 그의
작품세계는 리얼리즘에서 멀리 떨어져 있기는 하지만
추상회화와는 더 거리가 멀다. 하지만 몬드리안의
그림들이 "구성적 추상"회화라는 조주연의 설명을 읽으면
꼭 서용선을 두고 한 말 같다. "길이, 면적, 색채의 모든

factitiously create a sense of depth with light and shade and unnaturally stress perspective. There is indeed a pleasure in viewing such classical works, but in that they are artificial, modern paintings tend to offer more natural aspects.

Pictures were originally flat. The reason for modern painting's inclination to become increasingly two-dimensional is because there is a clear advantage to it. Namely, that they are or would be printed. Printed media plays a big role in contemporary society, and printed works have become an intellectual environment in their own right. Visually. And now, I have reinterpreted that two-dimensionality in a more sensual way. (…) In reality, I cannot ignore perspectival spatiality, but flatness is also of the truth. Perspectival laws are one form of expression, and two-dimensionality is another form of expression. And thus, it becomes an issue of how to aptly blend the two."

I still do not have the right words to simply summarize Suh Yongsun's oeuvre. That there is no aesthetical term to properly describe an artist implies that his works are of great originality. There is always an artist of such originality that it is impossible to aptly position him into any trends of the past and the present. Suh Yongsun is also an artist who cannot be described in terms of previously-known schools of painters or artistic styles. I remember the smile that came up on the artist's face when I asked him in an interview how he came to choose a path quite different from the majority "in the period when white monochrome dominated the Korean art market and became an aesthetic order and standard in academics as well,"⑩ or, in the late 1970s when abstract paintings were the major trend of the art circle, and had it not require a quite lot of courage to do so. Instead giving a direct answer, Suh added as follows:

"Even the professors who instructed me commented that my works were too narrative, with too many stories. If a painting is too figurative, those in the art field would call it literary. I heard comments like 'What story is necessary in this picture?' That it would be too explanatory. To them, if there is a form, it becomes explanatory by default."

Art critic Lee Sun-young also focused on how Suh Yongsun took a different path from the main trend of the time. "In the 1970s and '80s when the artist

studied in art college (…) what was particularly oppressed within the elegant and conceptual artistic style—where the styles of scholar-gentry and modernism's 'art for art's sake' were subtly blended—was color. (…) Colors were disdained and considered a taboo based on things like 'white-clad people,' white porcelain, ink-and-wash paintings, and the like—trends that were only transient in our long historical tradition. On the other hand, Suh Yongsun's paintings display an unconventional domination of powerful lines of color."⑪

As things become more difficult to understand, I come to stack a number of books and rummage through them for past examples. But I just refer to them. The more original an artist is, the more he betrays his past. Those artists whose names appear in the books of aesthetics or art history are like index species who can most well explain the trend of a particular point, who have been made significant and ratified by critics of later generations. It is only that and nothing else. In every era, there existed many others than those few in aesthetics and art history. Whether it is the reality of the past, or that of the present, reality does not form that simply or pass by so poorly. The reality is not so scanty to be over represented by a few artists. Those great numbers of artists who refused to follow the trend and chose their own path, who resisted becoming an index specimen, creating the ample and honest body of reality.

What catches one's eyes in Suh Yongsun's paintings are thick and rough lines and a somewhat determined color field of primary colors. Straight lines of his drawing that lack smoothness and where traces of repeated brush strokes remain remind one of the lines seen in *minjung* art of the 1980s and '90s. In *minjung* art, lines not only delineated a figure, but symbolized spiritual values of power, sorrow, and the will of the people cultivating their own history. And therefore, the lines of these works were never weak but often rough and forthright. The same is true for Suh Yongsun's lines. However,

⑩⑩ Lee Ihn Bum, *Suh Yongsun's City Drawing: Between Utopism and Its Reality*, Seoul: Hakgojae, 2015, 7.
⑪⑪ Lee Sun-young, ibid., 15.

면에서 서로 다른 조형 요소들이 각자의 차이를 온전히
유지한 채 역동적 긴장 관계를 구성하는"⑩이라는 구성적
추상회화의 설명에서, 〈도시에서〉의 거친 선과 채색면
사이의 강렬한 대비, 긴장이 만들어내는 힘이 넘치는 역동적
구성이 떠오른다. 말레비치나 몬드리안 같은 현대적인
작가들은 "색채와 선을 묘사의 기능에서 분리시켜 양자의
고유한 미학적 가치와 기능을 강조했"⑪고 결과적으로
추상회화로 나아갔다. 추상회화엔 캔버스 바깥 외부 세계를
모사한 형상은 없다. 모더니즘 작가들에게 의미 있었던 건
외부의 대상이 아니라 선과 색채, 캔버스라는 평면 공간
같은 회화의 물질적인 요소들이었다.

　　서용선 역시 회화의 물질적 요소들이 가지는 효과를
알고 적극적으로 활용한다. 조인수 교수는 그가 어떻게
회화의 물질성을 다루는지 설명한다. "화면 전체를 가득
채운 색채는 화폭을 하나의 물질로 결속시킨다. 물질적
평면성으로 입체적 공간감을 붕괴시켰다. 이로써 서용선의
그림은 (……) 그 자체로서 독립된 물체로 우리 앞에
존재한다. (……) 결국 두드러지는 것은 자기 완결적인
회화의 평면성이다. (……) 색이 양적으로 증가하면서 면을
이루고 색채 간의 긴장감이 증폭되며 높은 채도는 이것을
북돋운다. 형태뿐만 아니라 색채의 충돌로 인하여 거대한
울림이 퍼져 나온다."⑫ 그가 형상을 따라 색에 농도
변화를 주지 않는 이유가 여기에 있다. 인터뷰에서 말했듯이
그는 그림에 입체감을 주어 대상을 충실히 모사하는 대신,
기꺼이 평면의 세계를 향해 나아간다. 일부러 대상의
색과 형상을 왜곡시킨다. 대신 그가 자신의 작업을 통해
보여주려는 것은, 선과 색이 드러내는 정확히 언어화할 수는
없는 강렬한 느낌의 그 자신의 메시지다.

　　회화는 이미지로 이뤄졌지 언어로 이뤄지지 않았다.
하지만 해석 가능한 상징적 이미지를 써서 메시지를 전달할
수는 있는데, 이건 해몽, 꿈의 해석처럼 너무 쉽다. 회화로
할 수 있는 더 고차원적 소통은 회화 고유의 물질적 성질을
활용하는 것이다. 서용선은 자신의 감정이 드러나는
직설적인 선들로 캔버스를 구획하고 그 안을 단호하게
원색으로 채우는 방식으로 자기 메시지를 전한다. 이는
말레비치가 그의 절대주의 회화에서 시도했던 바다. "회화는
언어가 아니므로 명확하고 분절적인 방식으로 의미작용을
할 수 없는데, 이런 회화가 의사소통을 할 수 있는 가장
확실한 방법 중 하나는 안료가 가득 칠해진 분할되지 않은
평면들의 확장, 즉 색채라는 것이 그의 생각이었다."⑬

　　서용선의 메시지가 무엇인지는 언어로 이뤄지지
않았으니 보는 이마다 해석이 분분하겠지만, 선과 색의

⑩　조주연, 『현대미술 강의 - 순수미술의 탄생과 죽음』, 글항아리,
　　2017년, 133쪽.
⑪　같은 책, 74쪽.
⑫　조인수, 「서용선의 역사 그리기: 비극의 도상학」, 『올해의 작가
　　2009 서용선』, 국립현대미술관, 2009년, 119쪽.
⑬　조주연, 앞 책, 122쪽.

운용 방식에서 느껴지는 특징은 있다. 그의 선은 직설적이고
색은 단호하다. 때론 선도 단호하고 색도 직설적이다.

4. 〈SEEING〉(2013)

〈얼굴2〉와 〈도시에서〉에 이어 내가 가장 좋아하는 서용선의
작품이 〈SEEING〉(2013)이다. [9] 그러고 보니 나는 지금
누구의 잔소리도 듣지 않고 내가 좋아하는 그의 작품들에
대해 마음껏 글을 쓰고 있다. 〈얼굴2〉를 여주미술관에서
보고 〈도시에서〉를 서미갤러리에서 봤듯이, 〈SEEING〉은
2015년 학고재갤러리에서 봤다(이 전시는 학고재갤러리와
금호미술관에서 연계해 진행했던 것으로 기억한다). 전시를
언제 어디서 봤는지 관람객이 좀처럼 잊지 못하게 하는 것도
그의 작품이 가진 놀라운 힘이다. 학고재갤러리 전시장
중앙의 넓고 흰 기둥에 홀로 걸려있던 〈SEEING〉의 빨강
바탕이 아직도 기억에 선명하다. 그의 다른 그림들에 비하면

his list of works do not include any that display aesthetics typical of *minjung* art. At the time when *minjung* art was at its peak, Suh painted historical paintings and depicted contemporary people in the city (although it may be that these two themes were Suh's own subjects of minjung art.) Exhibited in *Artists in Their Times: Korean Modern and Contemporary Art* held in MMCA Gwacheon was Suh's painting from 1984 titled *Pine Tree*.[8] As could be assumed from the exhibition's intention to "approach the course of Korean art history not from inside the art world itself, but from a periodic and social perspective," Suh Yongsun's *Pine Tree* series from the 1980s indirectly and symbolically expressed the time's reality. The work's lines are also straight and of bundles. Would there be any other method more appropriate than Suh's lines for depicting the pine's pointed needles?

Suh Yongsun's bold division of pictorial planes with color fields of primary colors reminds one of Mondrian's neoplasticism. Of course Suh's paintings are apparently figurative. Although his oeuvre is far from realism, it is even farther removed from abstract paintings. However, Cho Ju-yeon's description of Mondrian's paintings as "figurative abstraction" could also be applied to Suh Yongsun's works. From her description of figurative abstract paintings that "in every aspect of length, area, and color, individual formative elements retain their own distinguishing characteristics intact but together form a dynamic relationship of tension,"[12] I am reminded of the work *In the City* and its dynamic composition of abundant energy created by the strong contrast and tension between rough lines and colored surfaces. Modern painters like Malevich and Mondrian "separated colors and lines from their descriptive role to emphasize their own aesthetic value and function,"[13] and eventually came to pursue abstraction. In abstract paintings, there is no form that imitates the world outside the canvas. What was significant to the modernist painters was not the object outside but physical elements of the painting itself such as lines, colors, and the flat surface of the canvas.

Suh Yongsun also understood the effect of painting's physical elements and used them enthusiastically. Professor Cho Insoo explains how the artist deals with painting's materiality: "Colors that fill the entire surface unite the pictorial plane as one material. Such materialistic flatness

⑫ Jo Juyoun, *A Lecture on Contemporary Art: Birth and Death of Fine Art*, Seoul: Geulhangari, 2017, 133.
⑬ Ibid, 74.
⑭ Cho Insoo, "Picturing History: Suh Yong-sun's King Danjong Series," in *Suh Yong-sun: Artist of the Year 2009*, Gwacheon: National Museum of Contemporary Art, Korea, 119.
⑮ Jo Juyoun, ibid, 122.

collapses the three-dimensional spatiality. And therefore, Suh Yongsun's painting (...) itself come to exist in front of us as an independent object. (...) What then predominates is the painting's flatness that is completed in itself. (...) As the color increases in quantity, it comes to form a surface, and the tension between colors becomes amplified, enhanced by higher saturation. Not only the forms but the collision of colors produce a huge reverberation."[14] Here is the reason that Suh does not change the density of color according to shapes. As he mentioned in an interview, instead of faithfully imitating an object by adding a sense of volume, he willingly walks toward the world of flatness. He deliberately distorts the object's color and form. What the artist tries to show through his works instead is his own message of intense emotion that could not be translated into exact words, but is instead revealed through his lines and colors.

Paintings are composed of images and not words. It is still possible to deliver a message by using interpretable symbolic images, but this is too easy like reading a dream. More advanced communication that can be done through paintings utilizes the material quality of painting itself. Suh Yongsun divides the canvas with straightforward lines that reveal his emotions and fill in each space with resolute primary colors to deliver his own message. This is what has been attempted by Malevich in his Suprematist paintings. "Because paintings are not language, they cannot operate as a signifier in a clear and segmented way, and therefore, for the artist, the most definite way for a painting to communicate was to expand non-divisible surfaces that are fully painted, in other words, colors."[15]

Suh Yongsun's messages are delivered in non-verbal way and thus yield various interpretations for different viewers, but there are clear characteristics in his employment of lines and colors. Suh's lines are forthright and his colors resolute. Sometimes, his lines are also resolute and his colors also frank.

4. *Seeing* (2013)

Another favorite work of mine in addition to *Face 2* and *In the City* is *Seeing* (2013).[9] As I come to think of it, I am writing about the artist's works that I like without paying heed to anyone's nitpicking. Just as I encountered *Face 2* in Yeoju Art Museum and *In the City* in Gallery Seomi, I first saw *Seeing* in 2015 at Hakgojae Gallery (if I am remembering correctly, the exhibition was jointly organized by Hakgojae Gallery and Keumho Museum of Art). It is also the great strength of Suh Yongsun's works that make it difficult for the audience to forget about when and where they saw the exhibition. I still remember clearly the red

비교적 작은 사이즈(그래도 55.5×30.5 CM다)라서 더 눈에 띄기도 했었다.

〈SEEING〉은 〈얼굴2〉와 〈도시에서〉가 그런 것처럼 강렬한 원색 바탕에 그려졌다. 〈얼굴2〉가 노랑이고 〈도시에서〉가 파랑인 반면 〈SEEING〉은 빨강이라는 차이가 있을 뿐이다. 이 원색 바탕 위에 황색과 짙은 녹색, 빨강이 거친 붓질로 사람의 형상을 만들고 있다. 언뜻 자화상인가 싶지만 서용선 자신의 모습은 아니다. 웃통을 벗고 있는 것으로 봐서 우리가 현실에서 쉽게 마주칠 수 있는 인물도 아니다. 사실 이런 사람은 존재하지 않는다. 노랑에 가까운 황색과 진록의 피부를 가진 사람은 상상하기도 쉽지 않다. 〈얼굴2〉도 피부가 노랑이지만 제목이 지시하는 것이 '얼굴'이기에, 관람객은 사람의 얼굴을 그린 것이라고 받아들이고 이해할 수 있다. 하지만 〈SEEING〉의 경우엔 이해의 전제 역할을 하는 제목이 '봄, 보기'이기에 눈 이외의 부분은 부차적이고, 사람이 아닐 수도 있다.

흥미롭게도 시각을 그린 이 작품에는 눈동자가 없다. 흰자위만이 희번덕거릴 뿐이다. 사물을 볼 수 있게 하는 건 흰자가 아니라 눈동자다. 눈동자가 없으면 보는 행위(SEEING)도 없다. 그렇다면 이 그림은 무엇을 그린 것일까. 눈동자 없는 사람의 보는 행위의 불가능함을 그린 것일까. 아니면 눈동자 없는 사람의 시선이 존재하지 않는 보는 행위를 그린 걸까. 그도 아니면 내면의 어떤 강력한 감정적 힘이 번뜩이는 눈빛이 되어 밖으로 쏘아지는 것일 수도 있다. 〈SEEING〉에 대한 내 첫인상은 무섭다는 것이었다. 악몽의 한 장면 같았다. 악몽에서라면 눈동자가 없이도 보는 일이 가능하다.

앞서 말했듯, 서용선의 화법에서는 캔버스 바깥의 대상을 모사하는 일은 그다지 중요하지 않다. 그는 도심 거리를 걷는 사람들을 그대로 따라 그리기보다는, 그들 현대인의 내면적 실존을 선과 채색면으로, 색채 간의 증폭되는 긴장감으로 표현하려 했다. 그는 채색면과 채색면의 충돌과, 그 사이를 가르는 직설적이고 단호한 선으로 격렬한 비언어적 메시지를 만들어냈다.

회화가 가진 물질성을 적극적으로 강조하는 이러한 화풍에 영향을 준 것이 앙리 마티스의 야수주의(FAUVISM)였다. 인터뷰에서 서용선이 대학에 들어가서 인상적으로 봤던 작가로 마티스를 꼽은 것을 보면, 색의 운용에 있어서 야수주의로부터 힌트를 얻었던 것으로 보인다. 마티스로부터의 영향이 있었다고 할 수는 없다. 둘의 차이는 많은데, 무엇보다 마티스의 율동미 넘치는 윤곽선과 서용선의 그 자체로 형상이 되는 굵고 거친 선들은 차이가 너무 확연하다.

아무튼 회화의 물질성을 탐구하던 마티스도 사람의 피부를 있는 그대로 재현하지 않았다. 그의 대표작 〈청색 누드〉에서 누워있는 인물의 피부색은 제목처럼 청색이다. 피부색이 사실과 다르다고 비난이 쏟아지자 "만약 내가 이런 여성을 길에서 만났다면 두려움에 차 도망갔을 것"이라고 했다고 한다. 마티스는 그러면서 "나는 인간을 창조한 것이 아니라 그림을 그린 것이다"①④ 라고 덧붙였다고 한다. 서용선도 인간을 창조한 것이 아니라 그림을 그린 것이다. 그도 마티스 같은 현대 작가들처럼 색을, 대상의 묘사와 분리해 자의적으로 운용한다. 그는 대상에 맞는 색을 칠한 것이 아니라 자신이 표현하고자 하는 색을 칠한다. 〈얼굴2〉는 얼굴을 그린 것이 아니라 〈얼굴2〉라는 그림을 그린 것이고 〈도시에서〉도 행인들을 묘사한 것이 아니라 〈도시에서〉라는 그림을 그린 것이다. 〈SEEING〉도 마찬가지다. 그는 피부가 황색과 진록인 인물을 그린 것이 아니라 〈SEEING〉이라는 그림을 그린 것이다.

만약 내가 길을 가다 노랑 얼굴의 사람이나 진록 피부의 사람이나 온통 파랗게 칠해진 길을 만나게 되면 정신이 아뜩해질 것이다. 깜짝 놀라 도망칠지도 모른다. 그런 상황은 우리가 일상에서 접할 수 없기에, 우리의 평온한 마음을 깨뜨리고 익숙한 감각적 세계에 충격을 주고 의문을 품게 한다. 서용선의 작품세계는 고전적인 미학의 기준에서는 결코 아름답고 할 수 없다(반면 산수나 〈소나무〉처럼 자연을 그린 풍경화는 또 아름답다). 그가 그린 인물들은 〈도시의 사람들〉 같은 초기작들을 제외하면, 그가 인터뷰에서 말한 렘브란트의 인물들과는 어디 한구석 미학적으로 공유하는 지점이 없다. 렘브란트는 고전 미학을 되살린 르네상스 시기의 대표적인 화가다. 이는 그의 작품세계가 고전 미학에서 얼마나 멀리 떠내려온, 항해해온 현대미학의 결과인지를 말해준다.

미학은 아름다움의 기준을 제시하기도 하지만, 반대로 추함의 기준을 제시하기도 한다. 추함의 기준은 대체로 아름다움의 기준을 거꾸로 뒤집은 것이다. 비대칭, 부조화, 부정확성, 형태의 파괴 같은. 서용선의 그림을 보자. 몸의 비례나 원근법이 맞지 않거나 피부 색깔이 사실과 다르거나 형상의 자유분방함 같은 특징을 보면, 그가 그린 인물들은 고전 미학의 관점에서 추한 인물들이다. 19세기 독일의 카를 로젠크란츠는 『추의 미학』이라는 독보적인 책에서 추함에 대해 이렇게 말한다. 추함의 영역은 드물거나 낯설지 않다.

추의 제국은 우리가 보다시피 감각적 현상의 제국만큼이나 광대하다. 감각적 현상이라고 한 까닭은 악과 정신의 불행한 자기소외가 외형적 표현이라는 중개를 통해서 비로소 미적 대상이 되기 때문이다. 추는 미에 근거를 두고 있기 때문에 모든 미의 형태의 부정인 추는 자연의 필연성과 정신의 자유를 수단으로 스스로를 생산해낼 수 있다.①⑤

그렇다면 추가 어떻게 예술이 될 수 있단 걸까.

①④ 조주연, 앞 책, 86쪽.
①⑤ 카를 로젠크란츠, 『추의 미학』, 조경식 옮김, 나남출판, 2008년, 53쪽.

background of Seeing that was hanging by itself on a white column in the center of the gallery space. Its relatively small size compared to Suh's other works (but it is still 55.5 × 30.5 cm) most certainly caused it to stand out.

Seeing, as in Face 2 and In the City, was painted upon the background of strong primary color. The only difference is that the background is yellow in Face 2, blue in In the City, and red in Seeing. Upon the setting of such vivid color, rough brushstrokes of yellow, dark green, and red create a human form. One might wonder whether this is a self-portrait, but it is not what the artist looks like. As the man is bare-chested, it is also not a figure that we can easily encounter in reality. In fact, such a person does not exist. It is not easy even to just imagine a man with skin of yellow and dark green color. The face in Face 2 is also of yellowish tone, but as the subject matter matches the work's title, it is easier for the audience to receive the work as it is, as a portrayal of a human face. However, in case of Seeing, the title that acts as a premise of understand is 'seeing.' It might be that elements other than the eyes are only secondary, or even be that the depicted figure is not a human being.

Interestingly, despite the work's theme of 'vision,' there is no pupils in the eyes. Only the whites glare at the viewer. What allows one to see things are not the whites but pupils. Without them, there could be no valid act of 'seeing.' If so, then what is it that this painting is representing? The impossibility of 'seeing' for a person without pupils? Or the act of seeing of a person without pupils that lacks vision? If neither is true, it might be about some powerful emotional inner strength that transforms into the glare of the eyes and shoot out externally. My first impression of the work was 'fear.' It was like a scene from a nightmare. In a nightmare, it is possible to see without pupils.

As has been mentioned above, representing objects existing outside the canvas is not particularly important in Suh Yongsun's paintings. Rather than simply representing the landscape of people walking along the street downtown, Suh tries to express the internal existentiality of contemporary men with lines and colored surfaces, through amplified tensions between colors. Through a collision of different colored surfaces, and through cold and determined lines that transgress those surfaces, the artist created an intense nonverbal message.

Such artistic style that enthusiastically emphasizes the materiality of painting could be traced back to the influence of Henri Matisse's

Fauvism. As can be assumed from how Suh Yongsun brought up the artist's name as one of the most memorable painters he came to know in college, he probably have acquired some hint from the Fauvist use of colors. One however cannot say that there was a direct influence of Matisse on Suh. The two artists are different in many ways, and the biggest difference could be found in the contrast of Matisse's rhythmical outlines and Suh Yongsun's thick and rough lines that themselves become a form.

At any rate, Matisse who explored the materiality of paintings also did not represent people's skin color as it is. His well-known work Blue Nude displays a lying figure in blue skin as the title indicates. To a hurling criticism on such unrealistic skin color, Matisse responded, "If I met such women in the street, I should run away in terror."[16] And he added "Above all, I do not create a woman, I make a picture."[17] Suh Yongsun also does not create a man but paints a picture. Like modern painters like Matisse, he separates color from its descriptive function and employs it arbitrarily. He does not consider what color is proper for a certain object, but rather paint the color as he wishes to express. In the same vein, Face 2 is not a depiction of face but a painting of a picture called Face 2, and In the City is not a depiction of pedestrians but a painting of In the City. It is the same for Seeing. It is not that the artist had painted a figure with skin of yellow and deep green color, but simply painted a picture titled Seeing.

I might just be stunned if I come to approach a person with yellow face or skin of deep green color, or the street colored entirely in blue. I might even run away in horror. There is a slim chance that such thing would actually happen, and thus if it happens, it would break our serenity, shock our familiar world of senses, and cause us to question. According to the standards of classical aesthetics, Suh Yongsun's oeuvre could never be described as beautiful (although his mountain and water paintings of sansu and his paintings of nature like Pine Tree could be recognized as beautiful). Except for in his earlier works like People in the City, Suh Yongsun's figures do not share any aesthetical common ground with those of Rembrandt, the artist Suh mentioned in the interview. Rembrandt is a representative painter of the Renaissance who revived classical aesthetics. And in this respect, such contrast of the two artists' figures suggests how much Suh Youngsun's oeuvre strayed from classical aesthetics and instead sailed a long way toward a contemporary one.

Aesthetics set a standard of beauty, but also of the ugly. The criteria of ugliness is usually a negation of that of beauty: shapelessness, asymmetry, imperfection, destruction of forms, and the like. Let's take these standards to look at Suh Yongsun's paintings. His bodies are not accurate

16 Henri Matisse (1939), "Notes of a Painter on His Drawing," Jack Flam. Ed., Matisse on Art (New York: E.P. Dutton, 1978), 82.
17 Ibid., 82.

서용선의 인물들을 추하다고 단정지으면, 그의 작품들은 예술이 아니라는 말이 되는 것일까. 분명 그의 전시회를 찾았던 관람객이나 이 글에서 인용한 그림들을 본 독자 가운데에는 이런 게 무슨 예술이야, 하고 물었던 분들도 있었을 것이다. 로젠크란츠도 추함이 어떻게 예술이 될 수 있는지 물었다.

예술의 과업이 미를 생산하는 것이라면 예술이 추 역시 생산해내고 있음을 우리가 볼 때, 그것은 가장 큰 모순이 아닐까? 이런 질문에 대해 예술은 추를 생산하지만 아름답게 생산한다고 대답하고자 (한다.)⑯

예술은 추함도 생산한다. 왜냐하면 예술이 우리가 살아가는 세상을 반영하는 것이라고 했을 때, 이 세상에는 아름다움만 있지 않기 때문이다. 아름다움 못지않게 추함도 많이 눈에 띌 것이다. 예술이 아름다움을 추구하게 된 까닭도, 애초에 현실에 너무 많은 추함이 있기 때문이 아니었을까. 예술은 아름다움만을 추구할 수 없다. 만약 그렇다면 현실을 왜곡하고 외면한, 기만적인 작품이 나올 것이다. 따라서 로젠크란츠는 "미라는 이념의 현상을 총체적으로 묘사하는 한, 예술은 추의 형상화를 피해갈 수 없다."⑰ 라고 단정한다. 세상의 미를 묘사하고 싶다면, 세상의 추함 역시 외면할 수 없다는 의미다.

예술이 추를 생산하지만 아름답게 생산한다는 말은, 예술가가 추를 다룰 때는 "미를 다루는 방식이기도 한 그런 이상적 방식으로 그렇게 해야 한다."⑱ 는 의미다. 서용선이 바로 추함을 미학적으로 다룬다. 그가 그린 인물들은 일반적인 아름다움이라는 관념에 반하지만, 그 인물들이 포함된 그림 전체는 여러 미학적 양식들에 의해 조화를 이루어 하나의 총체적인 아름다움, 미학적 세계를 완성하게 된다. 내가 지금까지 이야기한 선과 색의 독창적인 운용, 왜곡된 형상으로 현대 도시인의 내면 드러내기 등등이 그 미학적 양식들이라고 할 수 있다. 그의 추함은 그렇게 해서 아름다움이 된다. 그의 작품이 예술이 아니라면, 그가 그렇게 많은 전시회를 열었을 리 없고, 내가 또 이런 글을 쓰고 있을 리 없다.

로젠크란츠는 기원전에 살았던 고대 그리스 조각가인 프락시텔레스의 이야기를 들려준다. 프락시텔레스가 미의 여신 아프로디테를 조각할 때, 절대 여러 모델의 아름다운 부분들을 취해 조각으로 옮기지 않았을 것이라는 주장이다.

그(프락시텔레스)는 여성적인 미의 승리를 자신의 내면에서 생산해내었음에 틀림없다. (……) 예술은 정확해야 하고, 자연적이고 정신적인 현실의 본질을 자신 내에 받아들여야 한다. 그러나 실물을 그대로 옮기는 방식으로 해서는 안 되고 잘못된 초월성의 의미로 이상화해서도 안 된다. 우리는 예술가에게 단순한 올바름을 상대적으로 변형시키는 자유를 부여해야 한다.⑲ (강조는 필자)

서용선의 작품들은 로젠크란츠의 말처럼 그가 선과 색을, 형상을 자유롭게 다룬 결과다. 그는 예술과 예술가의 비밀을 이른 나이에 깨달았다. 그런 점만으로도 그는 매우 특별하고 행복한 작가인 것이다.

⑯ 앞 책, 53쪽.
⑰ 같은 책, 57쪽.
⑱ 같은 책, 62쪽.
⑲ 같은 책, 137 - 8쪽.

1 〈얼굴2〉, 249.5 × 200 CM, 캔버스에 아크릴, 2009
2 서용선 작업실 사진(촬영: 백민석)
3 〈알렉산더 플라츠〉, 295 × 205 CM, 캔버스에 아크릴, 2012 ~ 2015
4 〈자화상〉, 109 × 80 CM, 종이에 아크릴, 2007
5 〈자화상1〉 30.3 × 30.5 CM, 캔버스에 아크릴, 2019, 2021
6 〈도시의 사람들〉, 209 × 70 CM, 종이에 혼합매체, 1987, 1988
7 〈도시에서〉, 200 × 200 CM, 캔버스에 유채, 1994
8 〈소나무〉, 180 × 150 CM, 캔버스에 유채, 1984
9 〈SEEING〉, 55.5 × 30.5 CM, 캔버스에 아크릴, 2013

in their proportion or perspective, skin colors lack reality, and forms are freewheeling. Basing on the criteria of classical aesthetics, such features of Suh's figures only point to ugliness. Karl Rosenkranz of the 19th century Germany elaborates on ugliness in his book *Aesthetics of Ugliness*. The area of the ugly is not rare or unfamiliar.

> The realm of ugliness is, as we can see, as large as the realm of sensible appearance itself; of sensible appearance, because evil and the unfortunate self-estrangement of the spirit only become aesthetic objects through the mediation of exterior representation. Because ugliness comes only through beauty, it can generate itself as the negation of each of its forms, making use of the necessity of nature just as well as of the freedom of mind.[18]

Then, how can the ugly becomes art? If one concludes that Suh Yongsun's figures are ugly, then would it be that his works are not art? It must be that among the viewers of Suh's exhibitions or readers of this essay who have seen the quoted works, there were those who have asked, "How can such a thing be art?" Rosenkranz also asked how the ugly could become art.

> If making beauty is the task of art, must it not appear as the greatest contradiction when we notice that art also produces ugliness? (…) we wish to answer here that art does produce ugliness, but as something beautiful (…).[19]

Art also produces ugliness. This is especially true if one considers art as a reflection of the world we are living in, as the world is not only consisted of beautiful things. One can easily discern ugly things just as one finds beautiful ones. The reason why art came to pursue beauty might be that from the beginning, there was too much ugliness in reality. Art cannot only pursue beauty. If so, it would end up producing deceptive works that distort and disregard reality. Thus, Rosenkranz concludes that "for this reason of rendering the appearance of the idea in its totality, then, art cannot avoid making ugliness."[20] It means that if one wishes to describe the world's beauty, one cannot disregard the world's ugliness.

What it means by saying that art produces ugliness but in a beautiful way is that when an artist deals with ugliness, one must "treat it according to the general laws of beauty, (…) it should form it, its truth intact, according to the parameters of its aesthetic significance."[21] Suh Yongsun deals with ugliness in such an aesthetic way. The figures he painted go against the general concept of beauty, but the work on the whole where figures belong to presents a harmony rendered by a number of aesthetic elements to create and complete one sole beauty, one world of aesthetics. The artist's original way of employing lines and colors, or his revealing of contemporary urbanites' inner mind through distorted forms are some of these aesthetic elements. And through them, Suh Yongsun's ugliness becomes beauty. If his works are not art, then there is no way he could have had so many exhibitions, and there would be no reason for me to write this essay.

In his book, Rosenkranz talks about a story of an ancient Greek sculptor Praxiteles. It is that when Praxiteles sculpted his ideal statue of Aphrodite, the goddess of beauty, he would never have eclectically compiled elements of excellent beauty from each of his models and put them together at his discretion.

> From his own interior thoughts he had to conceive the triumph of female beauty. (…) To be correct, art should adopt the essence of natural and mental reality, but it should not naturalize any more than it should idealize in the service of a false transcendence. We shall have to concede to the artist a relative remodeling of mere rightness, insofar as he needs it for the production of the objective truth of the idea, (…).[22] (emphasis added)

Suh Yongsun's works, as in the words of Rosenkranz, are the result of free rendering of lines, colors, and forms. He realized the secret of the arts and artists at an earlier age. By this fact alone, he is indeed a very special and happy artist.

[18] Karl Rosenkranz, 2015, *Aesthetics of Ugliness: A Critical Edition*, edited and translated by Andrei Pop and Mechtild Widrich, London: Bloomsbury Academic, 46.
[19] Ibid., 46.
[20] Ibid., 48.
[21] Ibid., 50.
[22] Ibid., 91–92.

색인　　　　　　　　　　　　INDEX

자화상 SELF-PORTRAIT
53×41 CM
ACRYLIC ON CANVAS
2008

2008·8·27 → 9·9 〈서용선〉 갤러리고도, 서울
2009·5·11 → 5·30 〈徐庸宣, 顔たち(얼굴들)〉 GALLERY FUKUZUMI, 오사카

자화상 SELF-PORTRAIT
53×41 CM
ACRYLIC ON CANVAS
2008

2008·8·27 → 9·9 〈서용선〉 갤러리고도, 서울
2009·5·11 → 5·30 〈徐庸宣, 顔たち(얼굴들)〉 GALLERY FUKUZUMI, 오사카

자화상 SELF-PORTRAIT
73×60.5 CM
ACRYLIC ON CANVAS
2007, 2008

2009·5·11 → 5·30 〈徐庸宣, 顔たち(얼굴들)〉 GALLERY FUKUZUMI, 오사카
2014·5·30 → 6·15 〈소밥 후원전〉 갤러리 소밥, 양평
2018·11·2 → 12·22 〈서용선의 자화상, REFLECTION〉 갤러리JJ, 서울

자화상 SELF-PORTRAIT
73×60.5 CM
ACRYLIC ON CANVAS
2007, 2008

2009·11·18 → 12·6 〈서용선〉 통인옥션갤러리, 서울

자화상 SELF-PORTRAIT
73×60.5 CM
ACRYLIC ON CANVAS
2007, 2008

2008·4·2 → 4·15 〈자화상〉 갤러리고도, 서울

자화상 SELF-PORTRAIT
73×60.5 CM
ACRYLIC ON CANVAS
2007, 2008

2009·5·11 → 5·30 〈徐庸宣, 顔たち(얼굴들)〉 GALLERY FUKUZUMI, 오사카
2018·11·2 → 12·22 〈서용선의 자화상, REFLECTION〉 갤러리JJ, 서울

자화상 SELF-PORTRAIT
73×60.5 CM
ACRYLIC ON CANVAS
2007, 2008

자화상 SELF-PORTRAIT
73×60.5 CM
ACRYLIC ON CANVAS
2007, 2008

2009·5·11 → 5·30 〈徐庸宣, 顔たち(얼굴들)〉 GALLERY FUKUZUMI, 오사카
2009·11·18 → 12·6 〈서용선〉 통인옥션갤러리, 서울

자화상 SELF-PORTRAIT
73×60.5 CM
ACRYLIC ON CANVAS
2007, 2008

2009·5·11 → 5·30 〈徐庸宣, 顔たち(얼굴들)〉 GALLERY FUKUZUMI, 오사카
2009·11·18 → 12·6 〈서용선〉 통인옥션갤러리, 서울

자화상 SELF-PORTRAIT
89×130 CM
ACRYLIC ON CANVAS
2007, 2008

2008·4·2 → 4·15 〈자화상〉 갤러리고도, 서울

자화상 SELF-PORTRAIT
89 × 146 CM
ACRYLIC ON CANVAS
2007, 2008

2008·5·1 → 5·28 〈SUH YONGSUN RECENT PAINTINGS〉 A-STORY, 부산 / 서울
2019·9·17 → 9·27 〈나는 누구인가〉 인디프레스, 서울

자화상 SELF-PORTRAIT
89 × 146 CM
ACRYLIC ON CANVAS
2007, 2008

2008·5·1 → 5·28 〈SUH YONGSUN RECENT PAINTINGS〉 A-STORY, 부산 / 서울

자화상 SELF-PORTRAIT
163 × 130 CM
OIL ON CANVAS
2008

2008·8·27 → 9·9 〈서용선〉 갤러리고도, 서울
2013·8·23 → 10·1 〈SUH YONGSUN〉 베를린 한국문화원, 베를린

자화상 SELF-PORTRAIT
163 × 130 CM
OIL ON CANVAS
2008

2008·8·27 → 9·9 〈서용선〉 갤러리고도, 서울
2013·8·23 → 10·1 〈SUH YONGSUN〉 베를린 한국문화원, 베를린

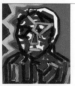

생각하는 사람 PERSON WHO
THINKS
73 × 60.5 CM
ACRYLIC ON CANVAS
2008

2008·8·27 → 9·9 〈서용선〉 갤러리고도, 서울

느끼는 사람 PERSON WHO FEELS
73 × 60.5 CM
ACRYLIC ON CANVAS
2008

2008·5·1 → 5·28 〈SUH YONGSUN RECENT PAINTINGS〉 A-STORY, 부산 / 서울
2008·8·27 → 9·9 〈서용선〉 갤러리고도, 서울

기다리는 사람 PERSON WHO WAITS
91 × 72.5 CM
ACRYLIC, PAPERBOARD BOX
COLLAGE ON CANVAS
2008

2008·8·27 → 9·9 〈서용선〉 갤러리고도, 서울

소리치는 사람 PERSON WHO
SHOUTS
131 × 90 CM
ACRYLIC ON CANVAS
2008

2008·5·1 → 5·28 〈SUH YONGSUN RECENT PAINTINGS〉 A-STORY, 부산 / 서울

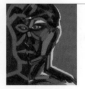

이중성격 DUAL PERSONALITY
53 × 45.7 CM
OIL ON CANVAS
2008

2008·5·1 → 5·28 〈SUH YONGSUN RECENT PAINTINGS〉 A-STORY, 부산 / 서울
2008·8·27 → 9·9 〈서용선〉 갤러리고도, 서울
2009·5·11 → 5·29 〈徐庸宣, 顔たち(얼굴들)〉 GALLERY FUKUZUMI, 오사카

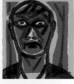

얼굴 THE FACE
54 × 45.4 CM
OIL ON CANVAS
2008

2008·5·1 → 5·28 〈SUH YONGSUN RECENT PAINTINGS〉 A-STORY, 부산 / 서울

남자 ① MAN ①
116.7 × 90 CM
OIL ON CANVAS
2008

2008·5·1 → 5·28 〈SUH YONGSUN RECENT PAINTINGS〉 A-STORY, 부산 / 서울
2013·8·23 → 10·1 〈SUH YONGSUN〉 베를린 한국문화원, 베를린

남자 ② MAN ②
116.7 × 90 CM
OIL ON CANVAS
2008

2008·5·1→5·28 〈SUH YONGSUN RECENT PAINTINGS〉 A-STORY, 부산 / 서울
2013·8·23→10·1 〈SUH YONGSUN〉 베를린 한국문화원, 베를린

개사람 ① GAESARAM（CANINE
MAN）①
163 × 130 CM
ACRYLIC ON CANVAS
2008

2008·8·27→9·9 〈서용선〉 갤러리고도, 서울
2013·8·23→10·1 〈SUH YONGSUN〉 베를린 한국문화원, 베를린
2017·3·7→5·15 〈예술만큼 추한〉 서울대학교미술관, 서울

개사람 ② GAESARAM（CANINE
MAN）②
163 × 130 CM
ACRYLIC ON CANVAS
2008

2008·8·27→9·9 〈서용선〉 갤러리고도, 서울
2012·1·5→1·21 〈나, 화가〉 아트포럼뉴게이트, 서울
2017·3·7→5·15 〈예술만큼 추한〉 서울대학교미술관, 서울

관계 RELATION
130 × 89 CM
OIL ON CANVAS
2008

2008·5·1→5·28 〈SUH YONGSUN RECENT PAINTINGS〉 A-STORY, 부산 / 서울

사람들 PEOPLE
131 × 90 CM
OIL ON CANVAS
2008

2008·5·1→5·28 〈SUH YONGSUN RECENT PAINTINGS〉 A-STORY, 부산 / 서울

생각 THINKING
73 × 60.5 CM
OIL ON CANVAS
2007, 2008

2008·8·27→9·9 〈서용선〉 갤러리고도, 서울
2012·1·5→1·21 〈나, 화가〉 아트포럼뉴게이트, 서울

깊은 생각 DEEP THINKING
91 × 117 CM
ACRYLIC ON CANVAS
2008

2008·5·1→5·28 〈SUH YONGSUN RECENT PAINTINGS〉 A-STORY, 부산 / 서울

작업 중 41번지 AT WORK #41
91 × 117 CM
ACRYLIC ON CANVAS
2008

2008·8·27→9·9 〈서용선〉 갤러리고도, 서울
2010·4·7→5·1 〈서용선〉 갤러리이마주, 서울
2019·1·9·2·10 〈SUH YONGSUN, UTOPIA'S DELAY THE PAINTER AND
THE METROPOLIS〉 MIZUMA, KIPS & WADA ART, 뉴욕
2021·2·14→6·30 〈만첩산중 서용선회화〉 여주미술관, 여주

34가 작업 중 AT WORK 34TH ST.
168.5 × 153 CM
ACRYLIC ON CANVAS
2006, 2007, 2008

2008·5·1→5·28 〈SUH YONGSUN RECENT PAINTINGS〉 A-STORY, 부산 / 서울
2008·8·27→9·9 〈서용선〉 갤러리고도, 서울
2022·1·20→2·24 〈THE HIDDEN MASTERPIECE〉 GALLERY BK, 서울

들여다보는 개 A DOG PEEKING INTO
THE ROOM
259 × 194 CM
ACRYLIC ON CANVAS
2008

2008·5·1→5·28 〈SUH YONGSUN RECENT PAINTINGS〉 A-STORY, 부산 / 서울
2011·10·12→2012·2·12 〈삶과 풍토〉 대구미술관, 대구
2014·12·27→2015·2·12 〈상처난 색채〉 아트센터 쿠, 대전

소리치다 SHOUTING
194 × 259 CM
OIL ON CANVAS
2008

2008·5·1→5·28 〈SUH YONGSUN RECENT PAINTINGS〉 A-STORY, 부산 / 서울
2012·3·6→7·29 〈민성（民性）〉 대구미술관, 대구
2014·3·21→5·11 〈바람을 흔들다-（역）사적 그림을 위하여〉 부산시립미술관, 부산
2020·2·19→5·16 〈새로운 시의 시대〉 경남도립미술관, 창원

카페에서 AT CAFÉ
72.7 × 60.6 CM
OIL ON CANVAS
2008

2008·8·27 → 9·9 〈서용선〉 갤러리고도, 서울

엘리베이터 ELEVATOR
117 × 91 CM
ACRYLIC ON CANVAS
2008

2008·5·1 → 5·28 〈SUH YONGSUN RECENT PAINTINGS〉 A-STORY, 부산 / 서울
2012·2·15 → 2·27 〈세 개의 시선 - 서용선 조병왕 이재원〉 갤러리그림손, 서울
2019·4·6 → 6·30 〈2019 남북한특별전 - 평화, 하나되다〉 오두산 통일전망대, 파주

기다림 WAITING
100 × 80 CM
OIL ON CANVAS
2008

2008·5·1 → 5·28 〈SUH YONGSUN RECENT PAINTINGS〉 A-STORY, 부산 / 서울
2008·8·27 → 9·9 〈서용선〉 갤러리고도, 서울

대화 CONVERSATION
100 × 80 CM
ACRYLIC ON CANVAS
2008

2008·5·1 → 5·28 〈SUH YONGSUN RECENT PAINTINGS〉 A-STORY, 부산 / 서울

선거 ELECTION
259 × 194 CM
OIL ON CANVAS
2008

2009·7·3 → 9·20 〈올해의 작가〉 국립현대미술관, 과천
2011·10·12 → 2012·2·12 〈삶과 풍토〉 대구미술관, 대구
2020·2·19 → 5·16 〈새로운 시의 시대〉 경남도립미술관, 창원

화합 UNITY
220 × 360 CM
OIL ON CANVAS
2008

2008·5·1 → 5·28 〈SUH YONGSUN RECENT PAINTINGS〉 A-STORY, 부산 / 서울
2012·3·6 → 7·29 〈민성(民性)〉, 대구미술관, 대구
2013·7·5 → 7·28 〈정전 60주년 특별전 - 잃어버린 시간을 찾아서〉 OCI 미술관, 서울

버티기 HOLDING ON
145 × 89.5 CM
OIL ON CANVAS
2008

2008·5·1 → 5·28 〈SUH YONGSUN RECENT PAINTINGS〉 A-STORY, 부산 / 서울
2013·8·23 → 10·1 〈SUH YONGSUN〉 베를린 한국문화원, 베를린
2019·1·9 → 2·10 〈SUH YONGSUN, UTOPIA'S DELAY THE PAINTER AND
THE METROPOLIS〉 MIZUMA, KIPS & WADA ART, 뉴욕
2021·2·14 → 6·30 〈만첩산중 서용선회화〉 여주미술관, 여주

광차 MINECART
116.5 × 91 CM
OIL ON CANVAS
2008

2008·8·27 → 9·9 〈서용선〉 갤러리고도, 서울
2010·10·22 → 12·12 〈IN AND WITH: CONTEMPORARY KOREAN ART〉
CANTOR FITZGERALD GALLERY, HAVERFORD COLLEGE, 필라델피아
2013·8·23 → 10·1 〈SUH YONGSUN〉 베를린 한국문화원, 베를린

건축가 주소장 ARCHITECT JU
54.5 × 41 CM
OIL ON CANVAS
1997, 2008

2008·5·1 → 5·28 〈SUH YONGSUN RECENT PAINTINGS〉 A-STORY, 부산 / 서울
2009·5·11 → 5·30 〈徐庸宣, 顔たち(얼굴들)〉 GALLERY FUKUZUMI, 오사카

장성아 JANG SUNGAH
116.5 × 91 CM
ACRYLIC ON CANVAS
2008

2008·5·1 → 5·28 〈SUH YONGSUN RECENT PAINTINGS〉 A-STORY, 부산 / 서울
2021·2·14 → 6·30 〈만첩산중 서용선회화〉 여주미술관, 여주

앉아 있는 사람 SITTING MAN
162 × 130 CM
OIL ON CANVAS
2008

2008·5·1 → 5·28 〈SUH YONGSUN RECENT PAINTINGS〉 A-STORY, 부산 / 서울
2008·8·27 → 9·9 〈서용선〉 갤러리고도, 서울
2010·10·6 → 12·31 〈트라이앵글〉 류미재갤러리하우스, 가평
2012·1·5 → 1·21 〈나, 화가〉 아트포럼뉴게이트, 서울

스튜어디스 FLIGHT ATTENDANT
91×60.5 CM
ACRYLIC ON CANVAS
2008

2008·5·1→5·28 〈SUH YONGSUN RECENT PAINTINGS〉 A-STORY, 부산／서울
2019·5·1→5·11 〈서용선-속도의 도시〉 NICHE GALLERY, 도쿄

검투사 GLADIATOR
163×130 CM
ACRYLIC ON CANVAS
2008

2008·8·27→9·9 〈서용선〉 갤러리고도, 서울
2013·8·23→10·1 〈SUH YONGSUN〉 베를린 한국문화원, 베를린

베를린 지하철 BERLIN SUBWAY
73×154 CM
ACRYLIC ON CANVAS
2006, 2007, 2008

2008·5·1→5·28 〈SUH YONGSUN RECENT PAINTINGS〉 A-STORY, 부산／서울
2014·12·27→2015·2·12 〈상처난 색채〉 아트센터 쿠, 대전
2019·1·9→2·10 〈SUH YONGSUN, UTOPIA'S DELAY THE PAINTER AND
 THE METROPOLIS〉 MIZUMA, KIPS & WADA ART, 뉴욕
2021·2·14→6·30 〈만첩산중 서용선회화〉 여주미술관, 여주

S-BAHN, 베를린 S-BAHN, BERLIN
200×200 CM
ACRYLIC ON CANVAS
2008

2008·5·1→5·28 〈SUH YONGSUN RECENT PAINTINGS〉 A-STORY, 부산／서울
2009·5·7→5·19 〈MY WAY WORKS〉 빛갤러리, 서울
2021·2·14→6·30 〈만첩산중 서용선회화〉 여주미술관, 여주

베를린 레오폴드플라츠 정거장
LEOPOLDPLATZ STATION,
BERLIN
205×415 CM
ACRYLIC ON CANVAS
2006, 2007, 2008

2008·5·1→5·28 〈SUH YONGSUN RECENT PAINTINGS〉 A-STORY, 부산／서울
2011·7·15→9·18 〈이미지 수사학〉 서울시립미술관, 서울
2021·2·14→6·30 〈만첩산중 서용선회화〉 여주미술관, 여주

비스마르크 BISMARCK
408×447 CM
ACRYLIC ON LINEN
2006, 2008

2008·5·1→5·28 〈SUH YONGSUN RECENT PAINTINGS〉 A-STORY, 부산／서울
2012·3·6→7·29 〈민성(民性)〉 대구미술관, 대구
2013·8·23→10·1 〈SUH YONGSUN〉 베를린 한국문화원, 베를린

퇴근-추이거좡(崔各庄)에서
LEAVING WORK-FROM
CUIGEZHUANGXIANG
200×200 CM
ACRYLIC ON CANVAS
2007, 2008

2010·4·7→5·1 〈서용선〉 갤러리이마주, 서울
2012·1·5→1·21 〈나, 화가〉 아트포럼뉴게이트, 서울
2014·3·21→5·11 〈바람을 흔들다-(역)사적 그림을 위하여〉 부산시립미술관, 부산

라이광잉(來廣管) LAIGUANGYING
200×200 CM
ACRYLIC ON CANVAS
2007, 2008

자전거 타는 사람 MAN ON BICYCLE
200×150 CM
ACRYLIC ON CANVAS
2007, 2008

2009·7·8→8·14 〈THE THREE 하종현 이강소 서용선〉 갤러리이마주, 서울

아버지-엄마의 이야기 FATHER-
MOM'S STORY
117×91 CM
ACRYLIC ON CANVAS
2008

2008·8·27→9·9 〈서용선〉 갤러리고도, 서울
2009·11·14→12·13 〈미래의 기억〉 박수근미술관, 양구
2013·6·25→8·25 〈기억·재현 서용선과 6·25〉 고려대학교박물관, 서울
2017·9·22→11·13 〈청년의 초상〉 대한민국역사박물관, 서울
2019·2·22→5·12 〈불멸사랑〉 일민미술관, 서울

동학, 승천 DONGHAK UPRISING,
ASCENSION
200×150 CM
ACRYLIC ON CANVAS
2008

2008·7·30→9·30 〈찾아가는 미술관-국립현대미술관, 누군들 따뜻한 남쪽마을이
 그립지 않으랴〉 장흥문화예술회관, 장흥

동학, 미륵의 달 DONGHAK
UPRISING, MOON OF
MAITREYA
99×99 CM
ACRYLIC ON CANVAS
2008

2008·7·30 → 9·30 〈찾아가는 미술관 - 국립현대미술관, 누군들 따뜻한 남쪽마을이
그립지 않으랴〉 장흥문화예술회관, 장흥
2013·8·23 → 10·1 〈SUH YONGSUN〉 베를린 한국문화원, 베를린

계유년 GYEYUNYEON
193×130 CM
ACRYLIC ON CANVAS
1992, 2008

2010·10·22 → 12·12 〈IN AND WITH : CONTEMPORARY KOREAN ART〉
CANTOR FITZGERALD GALLERY, HAVERFORD COLLEGE, 필라델피아

시 쓰는 매월당 MAEWEOLDANG
WRITING POETRY
130×97 CM
OIL ON CANVAS
2008

2008·8·27 → 9·9 〈서용선〉 갤러리고도, 서울
2015·9·18 → 9·30 〈김시습〉 겸재정선미술관, 서울

노산군, 세조 NOSANGUN,
KING SEJO
60.6×72.7 CM
OIL ON CANVAS
2008

2008·8·27 → 9·9 〈서용선〉 갤러리고도, 서울
2008·9·17 → 10·9 〈자기만의 방〉 스페이스 함, 서울
2013·1·9 → 2·4 〈박물관 IMAGE〉 동덕여자대학교박물관·동덕아트갤러리, 서울

추악한 손 UGLY HANDS
60.6×72.7 CM
OIL ON CANVAS
2008

2008·8·27 → 9·9 〈서용선〉 갤러리고도, 서울

전등사 ① JEONDEUNGSA
TEMPLE ①
71.4×54 CM
ACRYLIC ON KOREAN PAPER
2008

2008·10·3 → 10·12 〈정족산 삼랑성〉 전등사 정족산사고 전시장, 인천

전등사 ② JEONDEUNGSA
TEMPLE ②
71.4×54 CM
ACRYLIC ON KOREAN PAPER
2008

2008·10·3 → 10·12 〈정족산 삼랑성〉 전등사 정족산사고 전시장, 인천

신화 MYTH
119.7×110 CM
ACRYLIC WRAPPING
PAPERBOARD COLLAGE ON
CANVAS
2008

천제 RITUAL TO HEAVENLY GODS
182×227.5 CM
ACRYLIC ON CANVAS
2008

2008·12·6 → 12·22 〈TAEBAEK DISCOURSE〉 CASO, 오사카
2013·10·18 → 2014·3·2 〈신화와 전설 - 평화의 도시, 고양600년 기념특별전 잃어버린
세계로의 여행〉 아람누리 아람미술관, 고양
2014·11·6 → 11·16 〈26회 이중섭미술상 - 신화, 또 하나의 장소〉 조선일보미술관, 서울
2021·4·2 → 9·26 〈시대와 개성〉 해든뮤지엄, 인천

구와우 GUWAWU VILLAGE
45.5×53 CM
ACRYLIC ON CANVAS
2008

금강골 GEUMGANGGOL
45.7×54 CM
ACRYLIC ON CANVAS
2008

명달리 ② MYEONGDAL-RI ②
60.8×91 CM
ACRYLIC ON CANVAS
2008

팔당 ① PALDANG ①
80×100 CM
OIL ON CANVAS
2004, 2008

2012·6·13 → 7·22 〈풍경남북(風景南北)〉 아람누리 아람미술관, 고양
2021·2·14 → 6·30 〈만첩산중 서용선회화〉 여주미술관, 여주

서 있는 사람들 ① STANDING
PEOPLE ①
277.5×56×57 CM
ACRYLIC ON WOOD BOARD
2008

2008·12·20 → 2009·11·30 〈거울아 거울아 – 그림 속 사람들 이야기〉 국립현대미술관
어린이미술관, 과천
2011·3·9 → 4·10 〈시선의 정치〉 학고재갤러리, 서울
2012·3·6 → 7·29 〈민성(民性)〉 대구미술관, 대구

서 있는 사람들 ② STANDING
PEOPLE ②
273×58×61.5 CM
ACRYLIC ON WOOD BOARD
2008

2011·3·9 → 4·10 〈시선의 정치〉 학고재갤러리, 서울
2011·7·5 → 10·2 〈김강용 서용선〉 류미재갤러리하우스, 가평
2012·3·6 → 7·29 〈민성(民性)〉 대구미술관, 대구
2012·9·1 → 10·31 〈트라이앵글〉 고생대자연사박물관, 태백

서 있는 사람들 ③ STANDING
PEOPLE ③
273×58×85 CM
ACRYLIC ON WOOD BOARD
2008

2008·12·20 → 2009·11·30 〈거울아 거울아 – 그림 속 사람들 이야기〉 국립현대미술관
어린이미술관, 과천
2011·3·9 → 4·10 〈시선의 정치〉 학고재갤러리, 서울
2011·7·5 → 10·2 〈김강용 서용선〉 류미재갤러리, 양평
2012·3·6 → 7·29 〈민성(民性)〉 대구미술관, 대구
2012·9·1 → 10·31 〈트라이앵글〉 고생대자연사박물관, 태백

서 있는 사람들 ④ STANDING
PEOPLE ④
168.5×55×25 CM
ACRYLIC ON WOOD BOARD
2008

2012·3·6 → 7·29 〈민성(民性)〉 대구미술관, 대구

서 있는 사람들 STANDING PEOPLE
158×44×64 CM
ACRYLIC ON WOOD BOARD
2008

2011·3·9 → 4·10 〈시선의 정치〉 학고재갤러리, 서울
2011·7·5 → 10·2 〈김강용 서용선〉 류미재갤러리하우스, 가평

여자들 WOMEN
168.5×38×49 CM
ACRYLIC ON WOOD BOARD
2008

2008·12·20 → 2009·11·30 〈거울아 거울아 – 그림 속 사람들 이야기〉 국립현대미술관
어린이미술관, 과천
2011·3·9 → 4·10 〈시선의 정치〉 학고재갤러리, 서울
2012·3·6 → 7·29 〈민성(民性)〉 대구미술관, 대구

서 있는 사람들 STANDING PEOPLE
449×80×70 CM
ACRYLIC ON WOOD BOARD
2008

2011·3·9 → 4·10 〈시선의 정치〉 학고재갤러리, 서울

팔 들고 있는 사람 PERSON RAISING
AN ARM
458×87×68 CM
ACRYLIC ON WOOD BOARD
2008

2011·3·9 → 4·10 〈시선의 정치〉 학고재갤러리, 서울

갇힌 사람들 THE CONFINED MEN
247×243×19 CM
WIRE NET, ACRYLIC ON WOOD
BOARD
2008

2009·7·3 → 9·20 〈올해의 작가〉 국립현대미술관, 과천

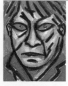

빨간 눈의 자화상 SELF-PORTRAIT
WITH RED EYES
259 × 194 CM
ACRYLIC ON CANVAS
2009

2009·7·3 → 9·20 〈올해의 작가〉 국립현대미술관, 과천
2014·12·27 → 2015·2·12 〈상처난 색채〉 아트센터 쿠, 대전

자화상 SELF-PORTRAIT
89 × 145 CM
ACRYLIC ON CANVAS
2009

2009·5·7 → 5·19 〈MY WAY, MY WORKS〉 빛 갤러리, 서울
2009·7·8 → 8·14 〈THE THREE – 하종현 이강소 서용선〉 갤러리이마주, 서울

자화상 SELF-PORTRAIT
26 × 18 CM
ACRYLIC ON CANVAS
2009

자화상 SELF-PORTRAIT
200 × 150 CM
ACRYLIC ON CANVAS
2009

2009·7·8 → 8·14 〈THE THREE – 하종현 이강소 서용선〉 갤러리이마주, 서울
2012·2·15 → 2·27 〈세 개의 시선 – 서용선 조병왕 이재현〉 갤러리그림손, 서울

그림 그리는 남자 THE MAN WHO
PAINTS
161.6 × 116.6 CM
ACRYLIC ON CANVAS
2009

2009·7·8 → 8·14 〈THE THREE – 하종현 이강소 서용선〉 갤러리이마주, 서울
2012·2·15 → 2·27 〈세 개의 시선 – 서용선 조병왕 이재현〉 갤러리그림손, 서울

겨울 WINTER
134 × 117 CM
ACRYLIC ON CANVAS
2009

2009·11·18 → 12·6 〈서용선〉 통인옥션갤러리, 서울

남자 ONE MAN
60 × 50 CM
ACRYLIC ON CANVAS
2009

2009·5·11 → 5·30 〈徐庸宣, 顔たち（얼굴들）〉 GALLERY FUKUZUMI, 오사카

앉아 있는 남자 SITTING MAN
100 × 80 CM
ACRYLIC ON KOREAN PAPER
2000, 2009

2010·6·23 → 8·31 〈WORK ON PAPER〉 리씨갤러리, 서울

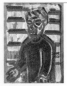

남자 ONE MAN
100 × 80 CM
ACRYLIC ON KOREAN PAPER
2000, 2009

2010·6·23 → 8·31 〈WORK ON PAPER〉 리씨갤러리, 서울
2013·6·19 → 7·2 〈2013년 현대작가〉 동덕여자대학교박물관·동덕아트갤러리, 서울

얼굴 ① THE FACE ①
259 × 194 CM
ACRYLIC ON CANVAS
2009

2009·7·3 → 9·20 〈올해의 작가〉 국립현대미술관, 과천
2011·12·17 → 2012·2·17 〈예술과 환경〉 고생대자연사박물관, 태백
2012·3·6 → 7·29 〈민성（民性）〉 대구미술관, 대구

얼굴 ② THE FACE ②
249.5×200 CM
ACRYLIC ON CANVAS
2009

2009·7·3→9·20 〈올해의 작가〉 국립현대미술관, 과천
2011·12·17→2012·2·17 〈예술과 환경〉 고생대자연사박물관, 태백
2012·3·6→7·29 〈민성(民性)〉 대구미술관, 대구
2021·2·14→6·30 〈만첩산중 서용선회화〉 여주미술관, 여주

광부 ① MINER ①
259×194 CM
ACRYLIC ON CANVAS
2009

2009·7·3→9·20 〈올해의 작가〉 국립현대미술관, 과천
2011·12·17→2012·2·17 〈예술과 환경〉 고생대자연사박물관, 태백

광부 ② MINER ②
259×194 CM
ACRYLIC ON CANVAS
2009

2009·7·3→9·20 〈올해의 작가〉 국립현대미술관, 과천
2011·12·17→2012·2·17 〈예술과 환경〉 고생대자연사박물관, 태백

수줍음 SHYNESS
117×91 CM
ACRYLIC ON CANVAS
2007, 2009

2009·11·18→12·6 〈서용선〉 통인옥션갤러리, 서울

진예 JINYE
53×41 CM
ACRYLIC ON CANVAS
2009

2009·5·11→5·30 〈徐庸宣, 顔たち(얼굴들)〉 GALLERY FUKUZUMI, 오사카

김진희 ① KIM JINHEE ①
117×91 CM
ACRYLIC ON CANVAS
2009

2009·11·18→12·6 〈서용선〉 통인옥션갤러리, 서울
2013·10·22→11·5 〈일상의 사유적 치유〉 갤러리인데코, 서울

김진희 ② KIM JINHEE ②
117×91 CM
ACRYLIC ON CANVAS
2009

2009·11·18→12·6 〈서용선〉 통인옥션갤러리, 서울
2013·10·22→11·5 〈일상의 사유적 치유〉 갤러리인데코, 서울

주대관 JU DAEGWAN
53×41 CM
OIL ON CANVAS
1997, 2008, 2009

2009·5·11→5·30 〈徐庸宣, 顔たち(얼굴들)〉 GALLERY FUKUZUMI, 오사카

주대관 ② JU DAEGWAN ②
53×41 CM
OIL ON CANVAS
1997, 2008, 2009

2009·5·11→5·30 〈徐庸宣, 顔たち(얼굴들)〉 GALLERY FUKUZUMI, 오사카

한승호 HAN SEUNGHO
53×41 CM
ACRYLIC ON CANVAS
2009

2009·5·11→5·30 〈徐庸宣, 顔たち(얼굴들)〉 GALLERY FUKUZUMI, 오사카

황종수 HWANG JONGSOO
53×41 CM
ACRYLIC ON CANVAS
2009

2009·5·11→5·30 〈徐庸宣, 顔たち(얼굴들)〉 GALLERY FUKUZUMI, 오사카

류광운 RYU GWANGWOON
333 × 218 CM
ACRYLIC ON CANVAS
2008, 2009

2009·7·3 → 9·20 〈올해의 작가〉 국립현대미술관, 과천

이가영 LEE GAYOUNG
200 × 150 CM
ACRYLIC ON CANVAS
2009

2010·4·7 → 5·1 〈서용선〉 갤러리이마주, 서울

의자 CHAIR
162 × 97 CM
ACRYLIC ON CANVAS
2009

2009·5·7 → 5·19 〈MY WAY, MY WORKS〉 빛갤러리, 서울

베이징 ① BEIJING ①
200 × 300 CM
ACRYLIC ON CANVAS
2007, 2008, 2009

2009·7·3 → 9·20 〈올해의 작가〉 국립현대미술관, 과천
2018·12·19 → 2019·3·24 〈예술가의 책장〉 아람누리 아람미술관, 고양

베이징 ② BEIJING ②
200 × 300 CM
ACRYLIC ON CANVAS
2007, 2008, 2009

2009·7·3 → 9·20 〈올해의 작가〉 국립현대미술관, 과천
2022·4·28 → 7·18 〈한중 수교30주년기념전〉 주중한국문화원, 베이징

베이징 ③ BEIJING ③
200 × 300 CM
ACRYLIC ON CANVAS
2007, 2008, 2009

2009·7·3 → 9·20 〈올해의 작가〉 국립현대미술관, 과천
2018·12·19 → 2019·3·24 〈예술가의 책장〉 아람누리 아람미술관, 고양

베이징 ④ BEIJING ④
200 × 300 CM
ACRYLIC ON CANVAS
2007, 2008, 2009

2009·7·3 → 9·20 〈올해의 작가〉 국립현대미술관, 과천
2018·12·19 → 2019·3·24 〈예술가의 책장〉 아람누리 아람미술관, 고양
2022·4·28 → 7·18 〈한중 수교30주년기념전〉 주중한국문화원, 베이징

걸어가는 남자-라이광잉(來廣營)
WALKING MAN -
LAIGUANGYING
200 × 150 CM
ACRYLIC ON CANVAS
2007, 2009

2009·7·8 → 8·14 〈THE THREE-하종현 이강소 서용선〉 갤러리이마주, 서울
2010·4·7 → 5·1 〈서용선〉 갤러리이마주, 서울

北京 버스, 라이광잉(來廣營)
BEIJING BUS, LAIGUANGYING
300 × 200 CM
ACRYLIC ON CANVAS
2008, 2009

2009·7·3 → 9·20 〈올해의 작가〉 국립현대미술관, 과천
2012·2·15 → 2·27 〈세 개의 시선-서용선 조병왕 이재현〉 갤러리그림손, 서울
2021·2·14 → 6·30 〈만첩산중 서용선회화〉 여주미술관, 여주

베이징 버스 ① BEIJING BUS ①
300 × 200 CM
ACRYLIC ON CANVAS
2008, 2009

2009·7·3 → 9·20 〈올해의 작가〉 국립현대미술관, 과천

베이징 버스 ② BEIJING BUS ②
300 × 200 CM
ACRYLIC ON CANVAS
2008, 2009

2009·7·3 → 9·20 〈올해의 작가〉 국립현대미술관, 과천
2021·2·14 → 6·30 〈만첩산중 서용선회화〉 여주미술관, 여주

베이징 버스 ③ BEIJING BUS ③
300×200 CM
ACRYLIC ON CANVAS
2008, 2009

2009·7·3 → 9·20 〈올해의 작가〉 국립현대미술관, 과천
2014·3·21 → 5·11 〈바람을 흔들다-(역)사적 그림을 위하여〉 부산시립미술관, 부산
2021·2·14 → 6·30 〈만첩산중 서용선회화〉 여주미술관, 여주

베이징 버스 ④ BEIJING BUS ④
300×200 CM
ACRYLIC ON CANVAS
2008, 2009

남녘 사람, 북녘 사람 MEN FROM
 THE SOUTH, MEN FROM THE
 NORTH
80.4×130 CM
ACRYLIC ON CANVAS
2009

2009·11·14 → 12·13 〈미래의 기억〉 박수근미술관, 양구
2010·12·23 → 2011·2·6 〈눈꽃 위에 피는 꽃-분단미술〉 대전시립미술관, 대전
2013·6·25 → 8·25 〈기억·재현 서용선과 6·25〉 고려대학교박물관, 서울
2021·7·1 → 9·5 〈한국근현대미술명작전〉 용인 포은아트갤러리

수용소 PRISON CAMP
300×500 CM
ACRYLIC ON CANVAS
2009

2009·7·3 → 9·20 〈올해의 작가〉 국립현대미술관, 과천

희생 CASUALTIES OF WAR
260×580.5 CM (3P)
OIL ON CANVAS
2009

2009·7·3 → 9·20 〈올해의 작가〉 국립현대미술관, 과천
2013·6·25 → 8·25 〈기억·재현 서용선과 6·25〉 고려대학교박물관, 서울
2014·10·3 → 11·2 〈지리산 프로젝트 2014, 우주예술집〉 성심원, 산청 / 실상사, 남원 /
 삼화에코하우스, 하동

계유년 GYEYUNYEON
330×500 CM
ACRYLIC ON CANVAS
2009

2009·7·3 → 9·20 〈올해의 작가〉 국립현대미술관, 과천
2012·3·6 → 7·29 〈민성(民性)〉 대구미술관, 대구
2021·2·14 → 6·30 〈만첩산중 서용선회화〉 여주미술관, 여주

마고성 사람들 THE PEOPLE OF
 MAGO CASTLE
300×500 CM
ACRYLIC ON CANVAS
2009

2009·7·3 → 9·20 〈올해의 작가〉 국립현대미술관, 과천
2013·10·18 → 2014·3·2 〈신화와 전설-평화의 도시, 고양600년 기념특별전 잃어버린
 세계로의 여행〉 아람누리 아람미술관, 고양

마고성 사람들 THE PEOPLE OF
 MAGO CASTLE
800×30 CM
ACRYLIC ON WOOD AND STEEL
 SUPPORT
2009

2009·7·3 → 9·20 〈올해의 작가〉 국립현대미술관, 과천
2014·10·3 → 11·2 〈지리산 프로젝트 2014, 우주예술집〉 성심원, 산청 / 실상사, 남원 /
 삼화에코하우스, 하동

마고 ① MAGO ①
800×500×330 CM
STEEL
2009

2009·7·3 → 9·20 〈올해의 작가〉 국립현대미술관, 과천
2013·10·18 → 2014·3·2 〈신화와 전설-평화의 도시, 고양600년 기념특별전 잃어버린
 세계로의 여행〉 아람누리 아람미술관, 고양

마고 ② MAGO ②
420×243×212 CM
STEEL
2009

2009·7·3 → 9·20 〈올해의 작가〉 국립현대미술관, 과천

마고 ③ MAGO ③
203×122×130 CM
STEEL
2009

2009·7·3 → 9·20 〈올해의 작가〉 국립현대미술관, 과천
2013·10·18 → 2014·3·2 〈신화와 전설-평화의 도시, 고양600년 기념특별전 잃어버린
 세계로의 여행〉 아람누리 아람미술관, 고양

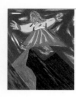

마고 MAGO
162.5×130.5 CM
ACRYLIC ON CANVAS
2009

2010·4·7 → 5·1 〈서용선〉 갤러리이마주, 서울
2013·10·18 → 2014·3·2 〈신화와 전설 – 평화의 도시, 고양600년 기념특별전 잃어버린
　　세계로의 여행〉 아람누리 아람미술관, 고양
2014·11·6 → 11·16 〈26회 이중섭미술상 – 신화, 또 하나의 장소〉 조선일보미술관, 서울
2019·2·22 → 5·12 〈불멸사랑〉 일민미술관, 서울
2021·10·15 → 2022·1·28 〈우리 안의 여신을 찾아서 – 서용선의 마고 이야기〉
　　여성역사문화공간 서울여담재, 서울

마고 ① MAGO ①
54×72 CM
ACRYLIC ON KOREAN PAPER
2009

2009·10·10 → 10·18 〈강화의 가을바람〉 전등사 정족산사고, 인천

마고 ② MAGO ②
54×72 CM
ACRYLIC ON KOREAN PAPER
2009

2009·10·10 → 10·18 〈강화의 가을바람〉 전등사 정족산사고, 인천

지리산 원묵계 ① JIRISAN (MT.)
　　WONMUKGYE ①
91×117 CM
ACRYLIC ON CANVAS
2009

2009·9·2 → 10·10 〈산·수(山·水)〉 리씨갤러리, 서울
2011·7·5 → 10·2 〈김강용 서용선〉, 류미재갤러리하우스, 가평
2014·10·3 → 11·2 〈지리산 프로젝트 2014, 우주예술집〉 성심원, 산청 / 실상사, 남원 /
　　삼화에코하우스, 하동
2015·5·13 → 6·7 〈겸재 정선, 오늘에 다시 태어나다〉 겸재 정선미술관, 서울

지리산 원묵계 ② JIRISAN (MT.)
　　WONMUKGYE ②
60.5×72.5 CM
ACRYLIC ON CANVAS
2009

2009·9·2 → 10·10 〈산·수(山·水)〉 리씨갤러리, 서울

지리산 원묵계 ③ JIRISAN (MT.)
　　WONMUKGYE ③
60.5×72.5 CM
ACRYLIC ON CANVAS
2009

2009·9·2 → 10·10 〈산·수(山·水)〉 리씨갤러리, 서울
2009·11·18 → 12·6 〈서용선〉 통인옥션갤러리, 서울

지리산 성삼재 JIRISAN (MT.)
　　SEONGSAMJAE
50×72.5 CM
ACRYLIC ON CANVAS
2009

2009·9·2 → 10·10 〈산·수(山·水)〉 리씨갤러리, 서울

지리산 상월 JIRISAN (MT.)
　　SANGWOL
50×72.5 CM
ACRYLIC ON CANVAS
2009

2009·9·2 → 10·10 〈산·수(山·水)〉 리씨갤러리, 서울

쌍계사 ① SSANGGYESA TEMPLE ①
72.5×116.5 CM
ACRYLIC ON CANVAS
2009

2009·9·4 → 9·20 〈지리산 – 남도문화의 보고〉 신세계갤러리, 광주 / 센텀시티, 부산

쌍계사 ② SSANGGYESA TEMPLE ②
50×72.5 CM
ACRYLIC ON CANVAS
2009

2009·9·4 → 9·20 〈지리산 – 남도문화의 보고〉 신세계갤러리, 광주 / 센텀시티, 부산
2011·4·6 → 4·22 〈TOUCH〉 GALLERY FUKUZUMI, 오사카

화엄사 연기암 HWAEOMSA TEMPLE
 YEONGIAM
60.5×72.5 CM
ACRYLIC ON CANVAS
2009

2009·9·2→10·10 〈산·수(山·水)〉 리씨갤러리, 서울

하동 평사리 PYEONGSA-RI,
 HADONG
50×73 CM
ACRYLIC ON CANVAS
2009

2009·9·2→10·10 〈산·수(山·水)〉 리씨갤러리, 서울

낙산사 ① NAKSANSA TEMPLE ①
45.5×53 CM
ACRYLIC ON CANVAS
2008, 2009

2009·9·2→10·10 〈산·수(山·水)〉 리씨갤러리, 서울

낙산사 ② NAKSANSA TEMPLE ②
72.5×91 CM
ACRYLIC ON CANVAS
2009

2009·11·18→12·6 〈서용선〉 통인옥션갤러리, 서울
2011·5·24→6·21 〈THE MAN WHO PAINTS〉 SHINHWA GALLERY, 홍콩

낙산사 ③ NAKSANSA TEMPLE ③
72.5×91 CM
ACRYLIC ON CANVAS
2009

2009·11·18→12·6 〈서용선〉 통인옥션갤러리, 서울

정선 JEONGSEON
53×45.5 CM
ACRYLIC ON CANVAS
2008, 2009

2009·9·2→10·10 〈산·수(山·水)〉 리씨갤러리, 서울

굴암리 GYULAM-RI
45.5×53 CM
ACRYLIC ON CANVAS
2008, 2009

2009·9·2→10·10 〈산·수(山·水)〉 리씨갤러리, 서울
2019·4·5→5·3 〈서용선, 산을 넘은 시간들〉 누크갤러리, 서울

정선군 고한 ① GOHAN,
 JEONGSEON-GUN ①
50×73 CM
ACRYLIC ON CANVAS
2008, 2009

2009·9·2→10·10 〈산·수(山·水)〉 리씨갤러리, 서울

정선군 고한 ② GOHAN,
 JEONGSEON-GUN ②
50×73 CM
ACRYLIC ON CANVAS
2009

2009·9·2→10·10 〈산·수(山·水)〉 리씨갤러리, 서울

구와우 ① GUWAWU VILLAGE ①
72.5×117.5 CM
ACRYLIC ON CANVAS
2008, 2009

2009·9·2→10·10 〈산·수(山·水)〉 리씨갤러리, 서울

구와우 ② GUWAWU VILLAGE ②
116.5×72.5 CM
ACRYLIC ON CANVAS
2008, 2009

2009·9·2→10·10 〈산·수(山·水)〉 리씨갤러리, 서울

구와우 ③ GUWAWU VILLAGE ③
53×72 CM
ACRYLIC ON CANVAS
2008, 2009

2009·9·2→10·10 〈산·수(山·水)〉 리씨갤러리, 서울

구와우 ④ GUWAWU VILLAGE ④
61×72.5 CM
ACRYLIC ON CANVAS
2007, 2009

2009·9·2→10·10 〈산·수(山·水)〉 리씨갤러리, 서울

구와우 ⑤ GUWAWU VILLAGE ⑤
61×72.5 CM
ACRYLIC ON CANVAS
2007, 2009

2009·9·2→10·10 〈산·수(山·水)〉 리씨갤러리, 서울

명달리, 양평 MYEONGDAL-RI,
YANGPYEONG
60.8×91 CM
ACRYLIC ON CANVAS
2008, 2009

2009·9·2→10·10 〈산·수(山·水)〉 리씨갤러리, 서울

다릿골 ① DARIGOL ①
50×60.8 CM
ACRYLIC ON CANVAS
2008, 2009

2009·9·2→10·10 〈산·수(山·水)〉 리씨갤러리, 서울

다릿골 ② DARIGOL ②
61×72.5 CM
ACRYLIC ON CANVAS
2008, 2009

2009·9·2→10·10 〈산·수(山·水)〉 리씨갤러리, 서울

다릿골 닥나무 ① DARIGOL
MULBERRY ①
130.5×162.5 CM
ACRYLIC ON CANVAS
2009

2009·9·2→10·10 〈산·수(山·水)〉 리씨갤러리, 서울

다릿골 닥나무 ② DARIGOL
MULBERRY ②
130.5×162.5 CM
ACRYLIC ON CANVAS
2009

2009·9·2→10·10 〈산·수(山·水)〉 리씨갤러리, 서울
2012·6·13→7·22 〈풍경남북(風景南北)〉 아람누리 아람미술관, 고양

금강골 GEUMGANGGOL
60.7×50 CM
ACRYLIC ON CANVAS
2009

2021·2·14→6·30 〈만첩산중 서용선회화〉 여주미술관, 여주

용소골(덕풍계곡) YONGSOGOL
(DEOKPUNG VALLEY)
53×72 CM
ACRYLIC ON CANVAS
2009

2009·9·2→10·10 〈산·수(山·水)〉 리씨갤러리, 서울

소나무 풍경 LANDSCAPE WITH
PINE TREES
60.5×72 CM
ACRYLIC ON CANVAS
2009

2009·12·4→2010·1·9. 〈서용선 오원배 황주리〉 리씨갤러리, 서울

소나무 PINE TREES
117 × 91 CM
ACRYLIC ON CANVAS
2009

2009·9·2 → 10·10 〈산·수(山·水)〉 리씨갤러리, 서울
2009·11·18 → 12·6 〈서용선〉 통인옥션갤러리, 서울
2011·7·6 → 7·19 〈10 MASTERS〉 고도갤러리, 서울
2021·2·14 → 6·30 〈만첩산중 서용선회화〉 여주미술관, 여주

해운대 HAEUNDAE
60.5 × 91 CM
ACRYLIC ON CANVAS
2006, 2009

2009·12·4 → 2010·1·9 〈서용선 오원배 황주리〉 리씨갤러리, 서울

태종대 신선바위 TAEJONGDAE
SINSEON BAWI ROCK
60.5 × 91 CM
ACRYLIC ON CANVAS
2006, 2009

2009·12·4 → 2010·1·9 〈서용선 오원배 황주리〉 리씨갤러리, 서울

둔황 가는 길-섬서성 ① ROAD TO
DUNHUANG-SHAANXI ①
132 × 162 CM
ACRYLIC ON CANVAS
2009

2009·9·2 → 10·10 〈산·수(山·水)〉 리씨갤러리, 서울

둔황 가는 길-섬서성 ② ROAD TO
DUNHUANG-SHAANXI ②
132 × 162 CM
ACRYLIC ON CANVAS
2009

2009·9·2 → 10·10 〈산·수(山·水)〉 리씨갤러리, 서울

뭉치 MOONGCHI
130 × 89.3 CM
ACRYLIC ON CANVAS
2006, 2009

2009·11·18 → 12·6 〈서용선〉 통인옥션갤러리, 서울

주시 KEEPING AN EYE
550 × 200 × 20 CM
STEEL, 2009

2009·9·23 → 11·1 〈2009 청주국제공예비엔날레-OUTSIDE THE BOX〉
청주예술의전당 / 상단산성 / 중흥공원 주변, 청주

체포된 사람들 ARRESTED 1, 2, 3, 6, 7
약 122.5 × 54.5 × 55 CM
ACRYLIC ON WOOD PANEL, BOLT
2009

2009·10·21 → 11·20 〈신호탄〉 기무사 터(현 국립현대미술관 서울관), 서울

감시 SURVEILLANCE
250 × 120 × 40 CM
REINFORCED STYROFOAM
2009

2009·9·6 → 11·9 〈베를린 장벽붕괴20주년 기념 프로젝트〉 브란덴부르크 문 주변,
베를린

화엄사 HWAEOMSA TEMPLE
60.5 × 90.5 CM
ACRYLIC ON CANVAS
2009

억불산 UKBULSAN (MT.)
97 × 130.5 CM
ACRYLIC ON CANVAS
2008, 2009

2010

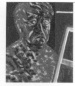

자화상 SELF-PORTRAIT
91 × 73 CM
ACRYLIC ON CANVAS
2010

2010·2·4 → 2·16 〈ENCOUNTER : 서용선 & 장 야훈〉 갤러리고도, 서울

그림 그리는 남자 THE MAN WHO
　　　　PAINTS
96 × 62.5 CM
ACRYLIC ON DAKPAPER
2010

2011·3·9 → 4·10 〈시선의 정치〉 학고재갤러리, 서울
2019·5·22 → 7·21 〈전신(傳神), 인간을 바라보다 : 서용선 안창홍 정원철〉 갤러리 세줄, 서울

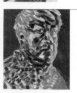

자화상 SELF-PORTRAIT
91 × 73 CM
ACRYLIC ON CANVAS
2009, 2010

2010·2·4 → 2·16 〈ENCOUNTER : 서용선 & 장 야훈〉 갤러리고도, 서울

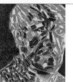

자화상 SELF-PORTRAIT
91 × 73 CM
ACRYLIC ON CANVAS
2009, 2010

2010·2·4 → 2·16 〈ENCOUNTER : 서용선 & 장 야훈〉 갤러리고도, 서울
2014·12·27 → 2015·2·12 〈상처난 색채〉 아트센터 쿠, 대전

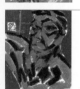

자화상 SELF-PORTRAIT
91 × 73 CM
ACRYLIC ON CANVAS
2009, 2010

2010·2·4 → 2·16 〈ENCOUNTER : 서용선 & 장 야훈〉 갤러리고도, 서울

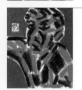

자화상 SELF-PORTRAIT
91 × 73 CM
ACRYLIC ON CANVAS
2009, 2010

2010·2·4 → 2·16 〈ENCOUNTER : 서용선 & 장 야훈〉 갤러리고도, 서울
2012·1·5 → 1·21 〈나, 화가〉 아트포럼뉴게이트, 서울

그림 그리는 남자 ① THE MAN WHO
　　　　PAINTS ①
91 × 116·5 CM
ACRYLIC ON CANVAS
2009, 2010

2010·3·10 → 4·2 〈ART BEACON 2010〉 비콘갤러리, 서울

그림 그리는 남자 ② THE MAN WHO
　　　　PAINTS ②
91 × 116·5 CM
ACRYLIC ON CANVAS
2009, 2010

2010·3·10 → 4·2 〈ART BEACON 2010〉 비콘갤러리, 서울
2011·5·24 → 6·21 〈THE MAN WHO PAINTS〉 SHINHWA GALLERY, 홍콩
2019·4·6 → 6·30 〈2019 남북한특별전－평화, 하나되다〉 오두산 통일전망대, 파주

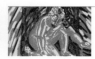

그림 그리는 남자 THE MAN WHO
　　　　PAINTS
89 × 145.5 CM
ACRYLIC ON CANVAS
2007, 2010

2010·2·4 → 2·16 〈ENCOUNTER : 서용선 & 장 야훈〉 갤러리고도, 서울
2011·5·24 → 6·21 〈THE MAN WHO PAINTS〉 SHINHWA GALLERY, 홍콩
2017·3·7 → 5·14 〈예술만큼 추한〉 서울대학교미술관, 서울
2019·8·23 → 9·15 〈나는 누구인가〉 인디프레스, 서울

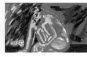

잠에서 깨어나기 WAKING UP
89 × 145 CM
ACRYLIC ON CANVAS
2009, 2010

2010·2·4 → 2·16 〈ENCOUNTER : 서용선 & 장 야훈〉 갤러리고도, 서울
2011·7·5 → 10·2 〈김강용 서용선〉 류미재갤러리하우스, 가평

그림 - 아침 PAINTING IN THE
MORNING
130.5×162 CM
ACRYLIC ON CANVAS
2010

2010·2·4 → 2·16 〈ENCOUNTER : 서용선 & 장 야훈〉 갤러리고도, 서울
2013·8·23 → 10·1 〈SUH YONGSUN〉 베를린 한국문화원, 베를린
2014·2·7 → 4·4 〈SUH YONGSUN〉 DAAD, 본

그림 그리는 남자 ① THE MAN WHO
PAINTS ①
96×62.5 CM
ACRYLIC ON DAKPAPER
2010

2011·3·9 → 4·10 〈시선의 정치〉 학고재갤러리, 서울
2011·4·29 → 7·30 〈KÜNSTLER SUH YONGSUN〉 GALERIE SON, 베를린
2014·12·27 → 2015·2·12 〈상처난 색채〉 아트센터 쿠, 대전

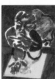

그림 그리는 남자 ② THE MAN WHO
PAINTS ②
96×62.5 CM
ACRYLIC ON DAKPAPER
2010

2011·3·9 → 4·10 〈시선의 정치〉 학고재갤러리, 서울
2011·4·29 → 7·30 〈KÜNSTLER SUH YONGSUN〉 GALERIE SON, 베를린
2018·11·2 → 12·22 〈서용선의 자화상, REFLECTION〉 갤러리JJ, 서울

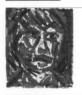

자화상 SELF PORTRAIT
31.5×21 CM
MONOPRINT
2010

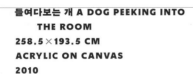

들여다보는 개 A DOG PEEKING INTO
THE ROOM
258.5×193.5 CM
ACRYLIC ON CANVAS
2010

2011·3·9 → 4·10 〈시선의 정치〉 학고재갤러리, 서울
2011·10·12 → 2012·2·12 〈삶과 풍토〉 대구미술관, 대구

남자 ONE MAN
51×40.5 CM
ACRYLIC ON PAPER
2010

2010·7·9 → 7·25 〈소밥 1주년 기념전〉 갤러리 소밥, 양평

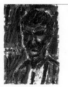

이상(李箱) ① LEE SANG ①
82×54 CM
ACRYLIC ON PAPER
2010

머리 ① ONE HEAD ①
65×45.5 CM
ACRYLIC ON CANVAS
2010

2010·4·7 → 5·1 〈서용선〉 갤러리이마주, 서울
2011·4·6 → 4·22 〈TOUCH〉 GALLERY FUKUZUMI, 오사카

머리 ② ONE HEAD ②
65×45.5 CM
ACRYLIC ON CANVAS
2010

2010·4·7 → 5·1 〈서용선〉 갤러리이마주, 서울
2011·4·6 → 4·22 〈TOUCH〉 GALLERY FUKUZUMI, 오사카

흑인 남자 BLACK MAN
53×45.5 CM
OIL ON CANVAS
2010

2011·4·6 → 4·22 〈TOUCH〉 GALLERY FUKUZUMI, 오사카

여자 ONE WOMAN
50×45 CM
OIL ON CANVAS
2010

김진희 ① KIM JINHEE ①
162×130 CM
ACRYLIC ON CANVAS
2010

2010·4·7 → 5·1 〈서용선〉 갤러리이마주, 서울

김진희 ② KIM JINHEE ②
116×90.5 CM
ACRYLIC ON CANVAS
2010

2010·4·7 → 5·1 〈서용선〉 갤러리이마주, 서울

거리의 사람들 ② PEOPLE ON THE
STREET ②
141.5×76.5 CM
ACRYLIC ON DAKPAPER
2010

2011·3·9 → 4·10 〈시선의 정치〉 학고재갤러리, 서울

두 여자 TWO WOMEN
96×62.5 CM
ACRYLIC ON DAKPAPER
2010

2011·3·9 → 4·10 〈시선의 정치〉 학고재갤러리, 서울

거리, 자전거 타는 사람 STREET,
MAN ON BICYCLE
200×150 CM
ACRYLIC ON CANVAS
2007, 2010

2010·4·7 → 5·1 〈서용선〉 갤러리이마주, 서울
2011·7·5 → 10·2 〈김강용 서용선〉 류미재갤러리하우스, 가평

23가 출구 23RD ST. EXIT
197×124.7 CM
ACRYLIC ON CANVAS
2010

2011·3·9 → 4·10 〈시선의 정치〉 학고재갤러리, 서울
2013·8·23 → 10·1 〈SUH YONGSUN〉 베를린 한국문화원, 베를린

34가 34TH ST.
200×175 CM
ACRYLIC ON CANVAS
2010

2011·3·9 → 4·10 〈시선의 정치〉 학고재갤러리, 서울

지하철-다운타운행 SUBWAY TO
DOWNTOWN
163×138 CM
ACRYLIC ON CANVAS
2010

2010·3·4 → 3·13 〈6 DOWNTOWN〉 KIPS GALLERY, 뉴욕
2011·3·9 → 4·10 〈시선의 정치〉 학고재갤러리, 서울
2012·3·6 → 7·29 〈민성(民性)〉 대구미술관, 대구

지하철-다운타운행 SUBWAY TO
DOWNTOWN
172×140 CM
ACRYLIC ON CANVAS
2010

2010·3·4 → 3·13 〈6 DOWNTOWN〉 KIPS GALLERY, 뉴욕
2011·3·9 → 4·10 〈시선의 정치〉 학고재갤러리, 서울

14가 지하철 정류장, 기다리는 사람
14TH ST. STATION, PEOPLE
WAITING
143.5×230.5 CM
ACRYLIC ON CANVAS
2010

2011·3·9 → 4·10 〈시선의 정치〉 학고재갤러리, 서울

14가 출구 14TH ST. EXIT
172×141 CM
ACRYLIC ON CANVAS
2010

2010·3·4 → 3·13 〈6 DOWNTOWN〉 KIPS GALLERY, 뉴욕
2010·4·7 → 5·1 〈서용선〉 갤러리이마주, 서울
2011·4·29 → 7·30 〈KÜNSTLER SUH YONGSUN〉 GALERIE SON, 베를린

14가 출구 14TH ST. EXIT
213×175 CM
ACRYLIC ON CANVAS
2010

2011·3·9 → 4·10 〈시선의 정치〉 학고재갤러리, 서울
2019·4·5 → 5·3 〈서용선, 산을 넘은 시간들〉 누크갤러리, 서울
2021·2·14 → 6·30 〈만첩산중 서용선회화〉 여주미술관, 여주

지하철 표 찾는 여자 WOMAN
　　　LOOKING FOR SUBWAY
　　　TICKET
140×97 CM
ACRYLIC ON CANVAS
2010

2010·3·4 → 3·13 〈6 DOWNTOWN〉 KIPS GALLERY, 뉴욕
2010·4·7 → 5·1 〈서용선〉 갤러리이마주, 서울
2011·4·29 → 7·30 〈KÜNSTLER SUH YONGSUN〉 GALERIE SON, 베를린

지하철 정거장 SUBWAY STATION
142.5×69.5 CM
ACRYLIC ON CANVAS
2010

2011·3·9 → 4·10 〈시선의 정치〉 학고재갤러리, 서울

25가 출구 코너 CORNER OF THE
　　　25TH ST. EXIT
215×175 CM
ACRYLIC ON CANVAS
2010

2011·3·9 → 4·10 〈시선의 정치〉 학고재갤러리, 서울
2021·2·14 → 6·30 〈만첩산중 서용선회화〉 여주미술관, 여주

지하철 문 NY SUBWAY DOOR
179×90 CM
ACRYLIC ON CANVAS
2010

2011·3·9 → 4·10 〈시선의 정치〉 학고재갤러리, 서울
2021·2·14 → 6·30 〈만첩산중 서용선회화〉 여주미술관, 여주

코니 아일랜드 행 TO CONEY ISLAND
145.5×89.3 CM
ACRYLIC ON CANVAS
2010

2010·3·4 → 3·13 〈6 DOWNTOWN〉 KIPS GALLERY, 뉴욕
2010·4·7 → 5·1 〈서용선〉 갤러리이마주, 서울
2011·4·29 → 7·30 〈KÜNSTLER SUH YONGSUN〉 GALERIE SON, 베를린

NY 지하철 NY SUBWAY
41×51 CM
ACRYLIC ON PAPER
2010

2010·6·23 → 8·31 〈WORK ON PAPER〉 리씨갤러리, 서울
2012·2·15 → 2·27 〈세 개의 시선 - 서용선 조병왕 이재현〉 갤러리그림손, 서울

스완슨 지하철 SWANSON METRO
141.5×76.5 CM
ACRYLIC ON DAKPAPER
2010

2011·3·9 → 4·10 〈시선의 정치〉 학고재갤러리, 서울
2011·7·5 → 7·15 〈SUHYONGSUN〉 RMIT SCHOOL OF ART GALLERY, 멜버른
2012·7·23 → 8·12 〈예술의 힘_사람〉 두만강문화전시관, 도문

스완슨 거리 ① SWANSON
　　　STREET ①
141.5×76.5 CM
ACRYLIC ON DAKPAPER
2010

2011·3·9 → 4·10 〈시선의 정치〉 학고재갤러리, 서울
2011·7·5 → 7·15 〈SUHYONGSUN〉 RMIT SCHOOL OF ART GALLERY, 멜버른
2012·4·18 → 6·29 〈THROUGH YOUR EYES〉 시드니 한국문화원, 시드니

스완슨 거리 ② SWANSON
　　　STREET ③
141.5×76.5 CM
ACRYLIC ON DAKPAPER
2010

2011·3·9 → 4·10 〈시선의 정치〉 학고재갤러리, 서울
2011·7·5 → 7·15 〈SHUYONGSUN〉 RMIT SCHOOL OF ART GALLERY, 멜버른
2012·4·18 → 6·29 〈THROUGH YOUR EYES〉 시드니 한국문화원, 시드니

스완슨 거리 ③ SWANSON
　　　STREET ③
141.5×76.5 CM
ACRYLIC ON DAKPAPER
2010

2011·3·9 → 4·10 〈시선의 정치〉 학고재갤러리, 서울
2011·7·5 → 7·15 〈SHUYONGSUN〉 RMIT SCHOOL OF ART GALLERY, 멜버른
2012·7·23 → 8·12 〈예술의 힘_사람〉 두만강문화전시관, 도문

케이크 고르는 남자 A MAN
CHOOSING CAKES
141.5×76.5 CM
ACRYLIC ON DAKPAPER
2010

2011·3·9 → 4·10 〈시선의 정치〉 학고재갤러리, 서울
2011·7·5 → 7·15 〈SUHYONGSUN〉 RMIT SCHOOL OF ART GALLERY, 멜버른
2012·4·18 → 6·29 〈THROUGH YOUR EYES〉 시드니 한국문화원, 시드니

남미계 식당 HISPANIC
RESTAURANT
141.5×76.5 CM
ACRYLIC ON DAKPAPER
2010

2011·3·9 → 4·10 〈시선의 정치〉 학고재갤러리, 서울
2011·7·5 → 7·15 〈SUHYONGSUN〉 RMIT SCHOOL OF ART GALLERY, 멜버른

카페에서 AT THE CAFÉ
141.5×76.5 CM
ACRYLIC ON DAKPAPER
2010

2011·3·9 → 4·10 〈시선의 정치〉 학고재갤러리, 서울
2011·7·5 → 7·15 〈SUHYONGSUN〉 RMIT SCHOOL OF ART GALLERY, 멜버른

호텔 앞 IN FRONT OF THE HOTEL
141.5×76.5 CM
ACRYLIC ON DAKPAPER
2010

2011·3·9 → 4·10 〈시선의 정치〉 학고재갤러리, 서울
2011·7·5 → 7·15 〈SUHYONGSUN〉 RMIT SCHOOL OF ART GALLERY, 멜버른
2012·7·23 → 8·12 〈예술의 힘_사람〉 두만강문화전시관, 도문

포스터 POSTER
141.5×76.5 CM
ACRYLIC ON DAKPAPER
2010

2011·3·9 → 4·10 〈시선의 정치〉 학고재갤러리, 서울
2011·7·5 → 7·15 〈SUHYONGSUN〉 RMIT SCHOOL OF ART GALLERY, 멜버른
2012·4·18 → 6·29 〈THROUGH YOUR EYES〉 시드니 한국문화원, 시드니
2018·11·2 → 12·22 〈서용선의 자화상, REFLECTION〉 갤러리JJ, 서울

시장 입구 – 라이광잉(來廣管) 베이징
MARKET ENTRANCE –
LAIGUANGYING BEIJING
200×300 CM
ACRYLIC ON CANVAS
2008, 2010

2010·4·7 → 5·1 〈서용선〉 갤러리이마주, 서울

엄금비법(嚴禁非法) PROHIBITING
ILLEGAL ACTIVITIES
200×200 CM
ACRYLIC ON CANVAS
2007, 2010

2010·4·7 → 5·1 〈서용선〉 갤러리이마주, 서울

전기의자 ELECTRIC CHAIR
160×130 CM
ACRYLIC ON CANVAS
2010

2010·4·7 → 5·1 〈서용선〉 갤러리이마주, 서울
2011·5·24 → 6·21 〈THE MAN WHO PAINTS〉 SHINHWA GALLERY, 홍콩
2012·3·6 → 7·29 〈민성(民性)〉 대구미술관, 대구
2017·12·15 → 2018·2·18 〈열정〉 양평군립미술관, 양평

이름 없는 죽음들 NAMELESS DEATHS
131×162 CM
ACRYLIC ON CANVAS
2010

2010·5·19 → 5·30 〈노란 선을 넘어서〉 경향갤러리, 서울
2010·12·23 → 2011·2·6 〈눈꽃 위에 피는 꽃 – 분단미술〉 대전시립미술관, 대전
2013·6·25 → 8·25 〈기억·재현 서용선과 6·25〉 고려대학교박물관, 서울

전쟁과 여인 A WOMAN IN THE WAR
130.3×161.7 CM
ACRYLIC ON CANVAS
2010

2010·5·19 → 5·30 〈노란 선을 넘어서〉 경향갤러리, 서울
2010·10·22 → 12·12 〈KOREAN ART FESTIVAL IN AND WITH: CONTEMPORARY
KOREAN ART〉 CANTOR FITZGERALD GALLERY, HAVERFORD COLLEGE,
필라델피아
2013·6·25 → 8·25 〈기억·재현 서용선과 6·25〉 고려대학교박물관, 서울

한글 만들기 MAKING HANGEUL
162×130 CM
ACRYLIC ON CANVAS
2010

2010·6·12 → 6·30 〈MEN IN THE HISTORY〉 604 GALLERY, 부산
2013·1·9 → 2·4 〈박물관 IMAGE〉 동덕여자대학교박물관·동덕아트갤러리, 서울

고명(顧命) KING'S TESTAMENT
162×130 CM
OIL ON CANVAS
2010

2010·6·12→6·30 〈MEN IN THE HISTORY〉 604 GALLERY, 부산

단종 KING DANJONG
51.5×41 CM
ACRYLIC ON PAPER
2010

2010·3·4→3·13 〈6 DOWNTOWN〉 KIPS GALLERY, 뉴욕
2010·10·14→11·30 〈서용선의 풍경화〉 리씨갤러리, 서울

단종 KING DANJONG
175×143 CM
OIL ON CANVAS
2010

2010·6·12→6·30 〈MEN IN THE HISTORY〉 604 GALLERY, 부산
2013·8·23→10·1 〈SUH YONGSUN〉 베를린 한국문화원, 베를린

밀담 SECRET CONVERSATION
160×130 CM
ACRYLIC ON CANVAS
2010

2010·6·12→6·30 〈MEN IN THE HISTORY〉 604 GALLERY, 부산
2011·5·24→6·21 〈THE MAN WHO PAINTS〉 SHINHWA GALLERY, 홍콩
2012·3·2→4·22 〈맛의 나라〉 양평군립미술관, 양평

선위 ABDICATION
162×130 CM
ACRYLIC ON CANVAS
2010

2010·6·12→6·30 〈MEN IN THE HISTORY〉 604 GALLERY, 부산
2012·3·2→4·22 〈맛의 나라〉 양평군립미술관, 양평
2013·1·9→2·4 〈박물관 IMAGE〉 동덕여자대학교박물관·동덕아트갤러리, 서울

상황 SITUATION
219.5×210 CM
OIL ON CANVAS
2010

2010·6·12→6·30 〈MEN IN THE HISTORY〉 604 GALLERY, 부산

노산군 PRINCE NOSANGUN
259×193.5 CM
OIL ON CANVAS
2010

2010·6·12→6·30 〈MEN IN THE HISTORY〉 604 GALLERY, 부산
2011·9·3→9·17 〈양평환경미술제〉 양평군립미술관, 양평

백성들의 생각, 노산군 THOUGHTS OF
THE PEOPLE, NOSANGUN
259×193.5 CM
OIL ON CANVAS
2010

2010·6·12→6·30 〈MEN IN THE HISTORY〉 604 GALLERY, 부산
2011·9·3→9·17 〈양평환경미술제〉 양평군립미술관, 양평

모의 CONSPIRACY
330.3×218 CM
ACRYLIC ON CANVAS
2010

2014·3·21→5·11 〈바람을 흔들다_(역)사적 그림을 위하여〉 부산시립미술관, 부산

세조 KING SEJO
193.5×259 CM
ACRYLIC ON CANVAS
2010

2010·6·12→6·30 〈MEN IN THE HISTORY〉 604 GALLERY, 부산

청령포, 송씨부인 CHEONGNYEONG-
PO, MADAME SONG
162×130 CM
ACRYLIC ON CANVAS
2010

2010·6·12→6·30 〈MEN IN THE HISTORY〉 604 GALLERY, 부산

매월당 MAEWEOLDANG
218 × 330.3 CM
ACRYLIC ON CANVAS
2010

2010·6·12 → 6·30 〈MEN IN THE HISTORY〉 604 GALLERY, 부산
2014·3·21 → 5·11 〈바람을 흔들다_(역)사적 그림을 위하여〉 부산시립미술관, 부산
2015·9·18 → 9·30 〈김시습〉 겸재 정선 미술관, 서울

매월당 MAEWEOLDANG
172 × 140 CM
ACRYLIC ON CANVAS
2010

2010·6·12 → 6·30 〈MEN IN THE HISTORY〉 604 GALLERY, 부산
2011·9·3 → 9·17 〈양평환경미술제〉 양평군립미술관, 양평
2015·9·18 → 9·30 〈김시습〉 겸재정선미술관, 서울
2018·2·5 → 2·25 〈강원, THE STORY〉 강릉아트센터, 강릉

청령포 CHEONGNYEONGPO
91 × 116.7 CM
OIL ON CANVAS
2010

2010·6·11 → 6·30 〈MEN IN THE HISTORY〉 스페이스홍지, 서울

청령포 CHEONGNYEONGPO
91 × 116.7 CM
OIL ON CANVAS
2010

2010·6·12 → 6·30 〈MEN IN THE HISTORY〉 604 GALLERY, 부산

청령포 CHEONGNYEONGPO
90 × 116 CM
OIL ON CANVAS
2010

2010·10·14 → 11·30 〈서용선의 풍경화〉 리씨갤러리, 서울
2014·5·2 → 7·27 〈역사적 상상 – 서용선의 단종실록〉 화이트블럭, 파주

청령포 CHEONGNYEONGPO
90 × 116 CM
OIL ON CANVAS
2010

청령포 CHEONGNYEONGPO
91 × 60.8 CM
OIL ON CANVAS
2010

2011·7·5 → 10·2 〈김강용 서용선〉 류미재갤러리, 양평
2016·10·7 → 11·20 〈서용선〉 류미재갤러리하우스, 가평

청령포 CHEONGNYEONGPO
131.5 × 162 CM
ACRYLIC ON CANVAS
2010

2010·10·14 → 11·30 〈서용선의 풍경화〉 리씨갤러리, 서울
2011·5·24 → 6·21 〈THE MAN WHO PAINTS〉 SHINHWA GALLERY, 홍콩

청령포 CHEONGNYEONGPO
130.5 × 162 CM
ACRYLIC ON CANVAS
2010

2010·10·14 → 11·30 〈서용선의 풍경화〉 리씨갤러리, 서울

출항 ① SETTING SAIL ①
259 × 194 CM
ACRYLIC ON CANVAS
2010

2010·8·7 → 11·30 〈CELADON ART PROJECT 2010 강진에서 청자를 만나다〉
강진청자박물관, 강진
2013·12·17 → 2014·1·31 〈한국 현대회화 33인〉 강동아트센터, 서울

출항 ② SETTING SAIL ②
259 × 194 CM
ACRYLIC ON CANVAS
2010

2010·8·7 → 11·30 〈CELADON ART PROJECT 2010 강진에서 청자를 만나다〉
강진청자박물관, 강진
2013·12·17 → 2014·1·31 〈한국 현대회화 33인〉 강동아트센터, 서울

이동, 마고 사람 MOVING, PEOPLE
OF MAGO
116.5×91 CM
ACRYLIC ON CANVAS
2010

2010·2·4 → 2·16 〈ENCOUNTER: 서용선 & 장 야훈〉 갤러리고도, 서울
2014·11·6 → 11·16 〈26회 이중섭미술상 – 신화, 또 하나의 장소〉 조선일보미술관, 서울
2021·10·15 → 2022·1·21 〈우리 안의 여신을 찾아서 – 서용선의 마고 이야기〉
　　　여성역사문화공간 서울여담재, 서울

철암천변 ① CHEORAM
RIVERSIDE ①
45.5×53 CM
ACRYLIC ON CANVAS
2008, 2010

철암천변 ② CHEORAM
RIVERSIDE ②
45.5×53 CM
ACRYLIC ON CANVAS
2010

2010·10·14 → 11·30 〈서용선의 풍경화〉 리씨갤러리, 서울
2013·8·23 → 10·1 〈SUH YONGSUN〉 베를린 한국문화원, 베를린

철암 삼방동에서 AT SAMBANG-
DONG, CHEORAM
45.5×50 CM
ACRYLIC ON CANVAS
2008, 2010

철암 삼방동 SAMBANG-DONG,
CHEORAM
45.5×53 CM
ACRYLIC ON CANVAS
2007, 2010

2011·7·16 → 8·21 〈트라이앵글 프로젝트, 철암〉 철암역 갤러리 등, 태백

철암 석탄공사 입구 CHEORAM COAL
CORPORATION ENTRANCE
46×53 CM
ACRYLIC ON CANVAS
2007, 2010

2013·8·23 → 10·1 〈SUH YONGSUN〉 베를린 한국문화원, 베를린
2014·2·7 → 4·4 〈SUH YONGSUN〉 DAAD, 본

태백 황지동 HWANGJI-DONG,
TAEBAEK
50.3×61 CM
ACRYLIC ON CANVAS
2010

2011·4·6 → 4·22 〈TOUCH〉 GALLERY FUKUZUMI, 오사카

구와우 GUWAWU VILLAGE
61×91 CM
ACRYLIC ON CANVAS
2010

2010·10·14 → 11·30 〈서용선의 풍경화〉 리씨갤러리, 서울

도계 DOGYE
130×162 CM
ACRYLIC ON CANVAS
2010

2010·10·14 → 11·30 〈서용선의 풍경화〉 리씨갤러리, 서울
2011·5·24 → 6·21 〈THE MAN WHO PAINTS〉 SHINHWA GALLERY, 홍콩
2014·5·31 → 7·31 〈아르스 악티바 2014_예술과 삶의 공동체〉 강릉시립미술관, 강릉

태백산맥 도계 TAEBAEK
MOUNTAINS, DOGYE
61×91 CM
ACRYLIC ON CANVAS
2009, 2010

2010·10·14 → 11·30 〈서용선의 풍경화〉 리씨갤러리, 서울

만항재에서 AT MANHANGJAE
60.8×91 CM
ACRYLIC ON CANVAS
2010

2014·5·31 → 7·31 〈아르스 악티바 2014_예술과 삶의 공동체〉 강릉시립미술관, 강릉

청송 CHEONGSONG
91×117 CM
ACRYLIC ON CANVAS
2010

2010·10·14 → 11·30 〈서용선의 풍경화〉 리씨갤러리, 서울

청송 주산지 CHEONGSONG JUSANJI
91×117 CM
ACRYLIC ON CANVAS
2010

2010·10·14 → 11·30 〈서용선의 풍경화〉 리씨갤러리, 서울

주왕산 JUWANGSAN (MT.)
116.5×91 CM
ACRYLIC ON CANVAS
2010

2010·10·14 → 11·30 〈서용선의 풍경화〉 리씨갤러리, 서울

숭어바위 SUNGEO BAWI (MULLET
 ROCK)
91×60.5 CM
ACRYLIC ON CANVAS
2007, 2010

2015·5·13 → 6·7 〈겸재 정선 오늘에 다시 태어나다〉 겸재정선미술관, 서울

동해 EAST SEA
45×53 CM
ACRYLIC ON CANVAS
2010

목포 거리 STREET IN MOKPO
162×130.5 CM
ACRYLIC ON CANVAS
2010

2010·11·13 → 11·27 〈목포 그리기 3·근대화의 명암〉 종합예술갤러리 전시장, 목포
2012·6·13 → 7·22 〈풍경남북(風景南北)〉 아람누리 아람미술관, 고양
2013·6·19 → 7·2 〈2013년 현대작가〉 동덕여자대학교박물관·동덕아트갤러리, 서울
2018·12·19 → 2019·3·24 〈예술가의 책장〉 아람누리 아람미술관, 고양

강진 도암면 DOAM-MYEON,
 GANGJIN
61×73 CM
ACRYLIC ON CANVAS
2010

2010·10·14 → 11·30 〈서용선의 풍경화〉 리씨갤러리, 서울

백련사에서 AT BAEKRYEONSA
 TEMPLE
60.8×73 CM
ACRYLIC ON CANVAS
2010

2010·10·14 → 11·30 〈서용선의 풍경화〉 리씨갤러리, 서울

강진만 GANGJINMAN BAY
130×162 CM
ACRYLIC ON CANVAS
2010

2010·10·14 → 11·30 〈서용선의 풍경화〉 리씨갤러리, 서울

강진 백련사 동백꽃 CAMELLIA
 FLOWER IN BAEKRYEONSA
 TEMPLE, GANGJIN
130×162 CM
ACRYLIC ON CANVAS
2010

2010·10·14 → 11·30 〈서용선의 풍경화〉 리씨갤러리, 서울

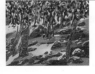
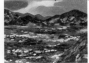

거제 ① GEOJE ①
91×117 CM
ACRYLIC ON CANVAS
2010

2010·10·20 → 11·8 〈우리는 거제도로 갔다〉 거제문화예술회관, 거제

거제 ② GEOJE ②
91×117 CM
ACRYLIC ON CANVAS
2010

2010·10·20 → 11·8 〈우리는 거제도로 갔다〉 거제문화예술회관, 거제

거제도 GEOJEDO ISLAND
23.5×31.5 CM
OIL PASTEL ON PAPER
2010

2014·3·1 → 4·30 〈류미재 봄 파머스가든 개관전〉 류미재갤러리, 양평

제주, 현대미술관에서
AT JEJU MUSEUM OF
CONTEMPORARY ART
23.5×31.5 CM
OIL PASTEL ON PAPER
2010

2010·8·14 → 8·31 〈6회 녹색 문학미술 기행〉 제주현대미술관, 제주

다릿골 치과집 DARIGOL DENTIST'S
HOUSE
53.5×65 CM
ACRYLIC ON CANVAS
2008, 2009, 2010

2010·10·14 → 11·30 〈서용선의 풍경화〉 리씨갤러리, 서울

다릿골 치과집 DARIGOL DENTIST'S
HOUSE
53×65 CM
ACRYLIC ON CANVAS
2008, 2009, 2010

다릿골 DARIGOL
50.3×61 CM
ACRYLIC ON CANVAS
2008, 2010

2010·10·14 → 11·30 〈서용선의 풍경화〉 리씨갤러리, 서울
2011·4·6 → 4·22 〈TOUCH〉 GALLERY FUKUZUMI, 오사카

41번지 #41
61×93 CM
ACRYLIC ON CANVAS
2008, 2010

2010·10·14 → 11·30 〈서용선의 풍경화〉 리씨갤러리, 서울

호랑이 ① TIGER ①
53×45 CM
ACRYLIC ON CANVAS
2010

2010·1·27 → 2·26 〈2010 신년맞이 가가호호(佳家好虎) - 호랑이 연가〉 우림화랑, 서울

호랑이 ② TIGER ②
53×45 CM
ACRYLIC ON CANVAS
2010

2010·1·27 → 2·26 〈2010 신년맞이 가가호호(佳家好虎) - 호랑이 연가〉 우림화랑, 서울
2015·4·29 → 6·21 〈호시탐탐〉 고려대학교박물관, 서울

이와미 사람들 IWAMI'S PEOPLE
ACRYLIC ON WOOD
2010

2010·3·6 → 3·14 〈이와미 국제 미술전 - 톳토리현의 사람과 자연〉
톳토리현 이와미사무소 / 이와미온천구 STUDIO 652 / 이와미역 / 톳토리

자화상 SELF-PORTRAIT
30×30 CM
PORCELAIN, COBALT, BLACK
OXIDE, 1250°C
2010

2010·9·10 → 2011·2·27 〈OFF THE WALL: 건축도자, 경계에서〉 김해클레이아크
미술관, 김해

인터넷하는 남자 ① MAN SURFING
 THE INTERNET ①
30×30 CM (2 PIECE)
PORCELAIN, COLOR GLAZE,
 BLACK OXIDE, 1250°C
2010

2010·9·10 → 2011·2·27 〈OFF THE WALL: 건축도자, 경계에서〉 김해클레이아크
 미술관, 김해

인터넷하는 남자 ② MAN SURFING
 THE INTERNET ②
30×30 CM (2 PIECE)
PORCELAIN, COLOR GLAZE,
 BLACK OXIDE, 1250°C
2010

2010·9·10 → 2011·2·27 〈OFF THE WALL: 건축도자, 경계에서〉 김해클레이아크
 미술관, 김해

남자 MAN
25.5×25.5 CM
PORCELAIN, 1250°C
2010

바라보다 SEEING
27×27 CM
PORCELAIN, 1250°C
2010

섬 ISLAND
25.5×25.5 CM
PORCELAIN, 1250°C
2010

세 사람 THREE MEN
30 CM (∅)
PORCELAIN, 1250°C
2010

마고성 MAGO CASTLE
44×33 CM (2 PIECE)
STONEWARE, COBALT, IRON &
 BLACK OXIDE, 1250°C
2010

2010·9·10 → 2011·2·27 〈OFF THE WALL: 건축도자, 경계에서〉 김해클레이아크
 미술관, 김해

마고 MAGO
30×30 CM (2 PIECE)
PORCELAIN, RED GLAZE, COBALT,
 1250°C
2010

2010·9·10 → 2011·2·27 〈OFF THE WALL: 건축도자, 경계에서〉 김해클레이아크
 미술관, 김해

집으로 GOING HOME
80×60 CM (4 PIECE)
PORCELAIN, COLOR GLAZE,
 1250°C
2010

2010·9·10 → 2011·2·27 〈OFF THE WALL: 건축도자, 경계에서〉 김해클레이아크
 미술관, 김해

관계 RELATIONSHIP
33×43.5 CM
PORCELAIN, 1250°C
2010

관계 RELATIONSHIP
180×180×288 CM (37 PIECE)
STONEWARE, COLOR GLAZE,
 CERAMIC CRAYON, 1250°C
2010

2010·9·10 → 2011·2·27 〈OFF THE WALL: 건축도자, 경계에서〉 김해클레이아크
 미술관, 김해

2011

	자화상 ② SELF-PORTRAIT ② 96 × 62.5 CM ACRYLIC ON DAKPAPER 2011	2016·8·23→10·2 〈2016 아르코미술관 대표작가_서용선 드로잉, 확장하는 선〉 아르코미술관, 서울
	자화상 ③ SELF-PORTRAIT ③ 96 × 62.5 CM ACRYLIC ON DAKPAPER 2011	2016·8·23→10·2 〈2016 아르코미술관 대표작가_서용선 드로잉, 확장하는 선〉 아르코미술관, 서울
	자화상 ④ SELF-PORTRAIT ④ 96 × 62.5 CM ACRYLIC ON DAKPAPER 2011	2012·1·5→1·21 〈나, 화가〉 아트포럼뉴게이트, 서울 2018·11·2→12·22 〈서용선의 자화상, REFLECTION〉 갤러리JJ, 서울
	자화상 ⑤ SELF-PORTRAIT ⑤ 96 × 62.5 CM ACRYLIC ON DAKPAPER 2011	2016·8·23→10·2 〈2016 아르코미술관 대표작가_서용선 드로잉, 확장하는 선〉 아르코미술관, 서울
	시애틀 자화상 SEATTLE, SELF-PORTRAIT 96 × 62.5 CM ACRYLIC ON DAKPAPER 2011	
	자화상 SELF-PORTRAIT 53.5 × 43 CM OIL PASTEL ON ACRYLIC PANEL 2011	2011·6·10→7·3 〈텅빈 도시가 내 방 안에 맨발로 서 있다〉 갤러리 소밥, 양평
	그림 그리는 남자 ① THE MAN WHO PAINTS ① 96 × 62.5 CM ACRYLIC ON DAKPAPER 2011	2013·3·27→4·20 〈움직이는, 움직이지 않는〉 갤러리이마주, 서울 2021·2·14→6·30 〈만첩산중 서용선회화〉 여주미술관, 여주
	그림 그리는 남자 ② THE MAN WHO PAINTS ② 96 × 62.5 CM ACRYLIC ON DAKPAPER 2011	2013·3·27→4·20 〈움직이는, 움직이지 않는〉 갤러리이마주, 서울 2020·9·25→11·6 〈VARIATION OF ARCHI RHYTHM 원형의 변주〉 JNO GALLLERY, 서울
	그림 그리는 남자 ③ THE MAN WHO PAINTS ③ 96 × 62.5 CM ACRYLIC ON DAKPAPER 2011	2011·11·25→12·1 〈트라이앵글 프로젝트-목포 그리기〉 목포문화예술회관, 목포 2013·3·27→4·20 〈움직이는, 움직이지 않는〉 갤러리이마주, 서울 2021·2·14→6·30 〈만첩산중 서용선회화〉 여주미술관, 여주
	머리 ③ ONE HEAD ③ 60.7 × 50.2 CM OIL ON CANVAS 2009, 2011	2011·4·6→4·22 〈TOUCH〉 GALLERY FUKUZUMI, 오사카 2011·7·5→10·2 〈김강용 서용선〉 류미재갤러리하우스, 가평

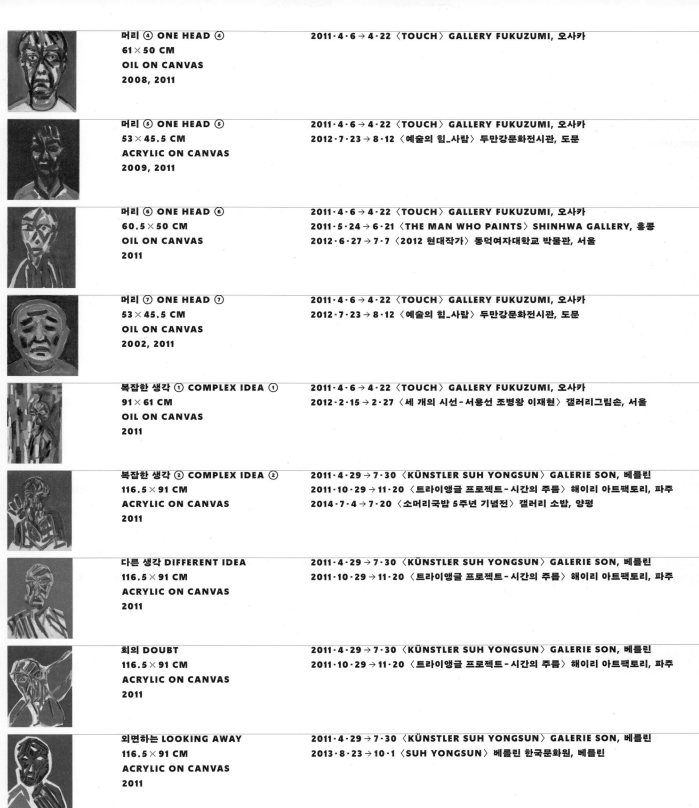

머리 ④ ONE HEAD ④
61×50 CM
OIL ON CANVAS
2008, 2011

2011·4·6 → 4·22 〈TOUCH〉 GALLERY FUKUZUMI, 오사카

머리 ⑤ ONE HEAD ⑤
53×45.5 CM
ACRYLIC ON CANVAS
2009, 2011

2011·4·6 → 4·22 〈TOUCH〉 GALLERY FUKUZUMI, 오사카
2012·7·23 → 8·12 〈예술의 힘_사람〉 두만강문화전시관, 도문

머리 ⑥ ONE HEAD ⑥
60.5×50 CM
OIL ON CANVAS
2011

2011·4·6 → 4·22 〈TOUCH〉 GALLERY FUKUZUMI, 오사카
2011·5·24 → 6·21 〈THE MAN WHO PAINTS〉 SHINHWA GALLERY, 홍콩
2012·6·27 → 7·7 〈2012 현대작가〉 동덕여자대학교 박물관, 서울

머리 ⑦ ONE HEAD ⑦
53×45.5 CM
OIL ON CANVAS
2002, 2011

2011·4·6 → 4·22 〈TOUCH〉 GALLERY FUKUZUMI, 오사카
2012·7·23 → 8·12 〈예술의 힘_사람〉 두만강문화전시관, 도문

복잡한 생각 ① COMPLEX IDEA ①
91×61 CM
OIL ON CANVAS
2011

2011·4·6 → 4·22 〈TOUCH〉 GALLERY FUKUZUMI, 오사카
2012·2·15 → 2·27 〈세 개의 시선 - 서용선 조병왕 이재현〉 갤러리그림손, 서울

복잡한 생각 ② COMPLEX IDEA ②
116.5×91 CM
ACRYLIC ON CANVAS
2011

2011·4·29 → 7·30 〈KÜNSTLER SUH YONGSUN〉 GALERIE SON, 베를린
2011·10·29 → 11·20 〈트라이앵글 프로젝트 - 시간의 주름〉 해이리 아트팩토리, 파주
2014·7·4 → 7·20 〈소머리국밥 5주년 기념전〉 갤러리 소밥, 양평

다른 생각 DIFFERENT IDEA
116.5×91 CM
ACRYLIC ON CANVAS
2011

2011·4·29 → 7·30 〈KÜNSTLER SUH YONGSUN〉 GALERIE SON, 베를린
2011·10·29 → 11·20 〈트라이앵글 프로젝트 - 시간의 주름〉 해이리 아트팩토리, 파주

회의 DOUBT
116.5×91 CM
ACRYLIC ON CANVAS
2011

2011·4·29 → 7·30 〈KÜNSTLER SUH YONGSUN〉 GALERIE SON, 베를린
2011·10·29 → 11·20 〈트라이앵글 프로젝트 - 시간의 주름〉 해이리 아트팩토리, 파주

외면하는 LOOKING AWAY
116.5×91 CM
ACRYLIC ON CANVAS
2011

2011·4·29 → 7·30 〈KÜNSTLER SUH YONGSUN〉 GALERIE SON, 베를린
2013·8·23 → 10·1 〈SUH YONGSUN〉 베를린 한국문화원, 베를린

힘 빠진 남자 DEPRESSED MAN
90.8×60.8 CM
OIL ON CANVAS
2011

2011·4·6 → 4·22 〈TOUCH〉 GALLERY FUKUZUMI, 오사카
2011·7·5 → 10·2 〈김강용 서용선〉 류미재갤러리하우스, 가평

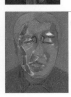

주대관 ① JU DAEGWAN ①
53×41 CM
OIL ON CANVAS
1997, 2008, 2011

2011·4·6 → 4·22 〈TOUCH〉 GALLERY FUKUZUMI, 오사카

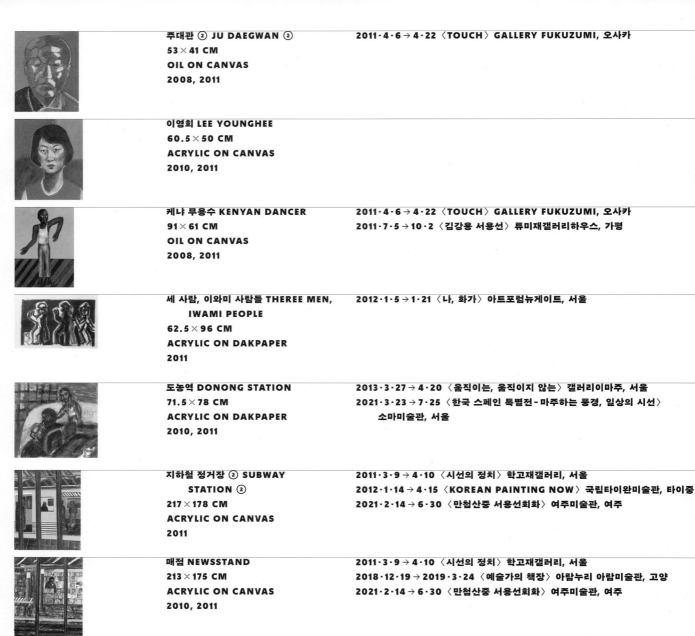

주대관 ② JU DAEGWAN ②
53 × 41 CM
OIL ON CANVAS
2008, 2011

2011·4·6 → 4·22 〈TOUCH〉 GALLERY FUKUZUMI, 오사카

이영희 LEE YOUNGHEE
60.5 × 50 CM
ACRYLIC ON CANVAS
2010, 2011

케냐 무용수 KENYAN DANCER
91 × 61 CM
OIL ON CANVAS
2008, 2011

2011·4·6 → 4·22 〈TOUCH〉 GALLERY FUKUZUMI, 오사카
2011·7·5 → 10·2 〈김강용 서용선〉 류미재갤러리하우스, 가평

세 사람, 이와미 사람들 THEREE MEN,
　　IWAMI PEOPLE
62.5 × 96 CM
ACRYLIC ON DAKPAPER
2011

2012·1·5 → 1·21 〈나, 화가〉 아트포럼뉴게이트, 서울

도농역 DONONG STATION
71.5 × 78 CM
ACRYLIC ON DAKPAPER
2010, 2011

2013·3·27 → 4·20 〈움직이는, 움직이지 않는〉 갤러리이마주, 서울
2021·3·23 → 7·25 〈한국 스페인 특별전 – 마주하는 풍경, 일상의 시선〉
　　소마미술관, 서울

지하철 정거장 ② SUBWAY
　　STATION ②
217 × 178 CM
ACRYLIC ON CANVAS
2011

2011·3·9 → 4·10 〈시선의 정치〉 학고재갤러리, 서울
2012·1·14 → 4·15 〈KOREAN PAINTING NOW〉 국립타이완미술관, 타이중
2021·2·14 → 6·30 〈만첩산중 서용선회화〉 여주미술관, 여주

매점 NEWSSTAND
213 × 175 CM
ACRYLIC ON CANVAS
2010, 2011

2011·3·9 → 4·10 〈시선의 정치〉 학고재갤러리, 서울
2018·12·19 → 2019·3·24 〈예술가의 책장〉 아람누리 아람미술관, 고양
2021·2·14 → 6·30 〈만첩산중 서용선회화〉 여주미술관, 여주

뉴욕 지하철 NEW YORK SUBWAY
244 × 600 CM
ACRYLIC ON CANVAS
2010, 2011

2011·3·9 → 4·10 〈시선의 정치〉 학고재갤러리, 서울
2011·4·29 → 7·30 〈KÜNSTLER SUH YONGSUN〉 GALERIE SON, 베를린

펜 스테이션 PENN STATION
193.5 × 259 CM
ACRYLIC ON CANVAS
2011

2012·2·15 → 2·27 〈세 개의 시선 – 서용선 조병왕 이재현〉 캘러리그림손, 서울

베를린 성당 BERLIN CATHEDRAL
400 × 500 CM
ACRYLIC ON LINEN
2006, 2011

2011·3·9 → 4·10 〈시선의 정치〉 학고재갤러리, 서울
2012·2·9 → 3·3 〈TERRITORY〉 KIPS GALLERY, 뉴욕

후퇴 THE REFUGEES
121 × 91 CM
ACRYLIC ON CANVAS
2011

2012·2·9 → 3·3 〈TERRITORY〉 KIPS GALLERY, 뉴욕

선물 – 사가모어 힐 GIFT – SAGAMORE HILL
175 × 214 CM
ACRYLIC ON CANVAS
2011

2012·2·9 → 3·3 〈TERRITORY〉 KIPS GALLERY, 뉴욕
2012·9·19 → 11·25 〈DMZ 평화미술프로젝트_겨울 겨울 겨울, 봄〉 경기도미술관, 안산
2013·6·25 → 8·25 〈기억·재현 서용선과 6·25〉 고려대학교박물관, 서울

금대암에서 AT GEUMDAEAM
60.6 × 72.7 CM
ACRYLIC ON CANVAS
2011

2011·10·27 → 11·18 〈서용선의 지리산〉 리씨갤러리, 서울

지리산 금대암 JIRISAN (MT.) GEUMDAEAM
71 × 71 CM
ACRYLIC ON CANVAS
2011

2011·10·27 → 11·18 〈서용선의 지리산〉 리씨갤러리, 서울

세진대에서 AT SEJINDAE
72.3 × 91 CM
ACRYLIC ON CANVAS
2011

2011·10·27 → 11·18 〈서용선의 지리산〉 리씨갤러리, 서울

세진대 SEJINDAE
42.6 × 64 CM
ACRYLIC ON CANVAS
2011

2011·10·27 → 11·18 〈서용선의 지리산〉 리씨갤러리, 서울

천왕봉 중산리에서 ① IN CHEON-WANG-BONG JUNGSAN-RI ①
72.5 × 90.7 CM
ACRYLIC ON CANVAS
2011

2011·10·27 → 11·18 〈서용선의 지리산〉 리씨갤러리, 서울

천왕봉 중산리에서 ② IN CHEON-WANG-BONG JUNGSAN-RI ②
73 × 100 CM
ACRYLIC ON CANVAS
2011

2011·10·27 → 11·18 〈서용선의 지리산〉 리씨갤러리, 서울

지리산 오도재에서 ① AT JIRISAN (MT.) ODOJAE ①
91 × 116.5 CM
ACRYLIC ON CANVAS
2011

2011·10·27 → 11·18 〈서용선의 지리산〉 리씨갤러리, 서울
2021·2·14 → 6·30 〈만첩산중 서용선회화〉 여주미술관, 여주

지리산 오도재에서 ② AT JIRISAN (MT.) ODOJAE ②
91 × 121 CM
ACRYLIC ON CANVAS
2011

2011·10·27 → 11·18 〈서용선의 지리산〉 리씨갤러리, 서울
2014·10·3 → 11·2 〈지리산 프로젝트 2014: 우주예술집〉 성심원, 산청 / 실상사, 남원 / 삼화에코하우스, 하동

성삼재 ① SEONGSAMJAE ①
80 × 100 CM
ACRYLIC ON CANVAS
2011

2011·10·27 → 11·18 〈서용선의 지리산〉 리씨갤러리, 서울

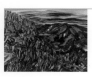

성삼재 ② SEONGSAMJAE ②
91 × 116.5 CM
ACRYLIC ON CANVAS
2011

2011·10·27 → 11·18 〈서용선의 지리산〉 리씨갤러리, 서울

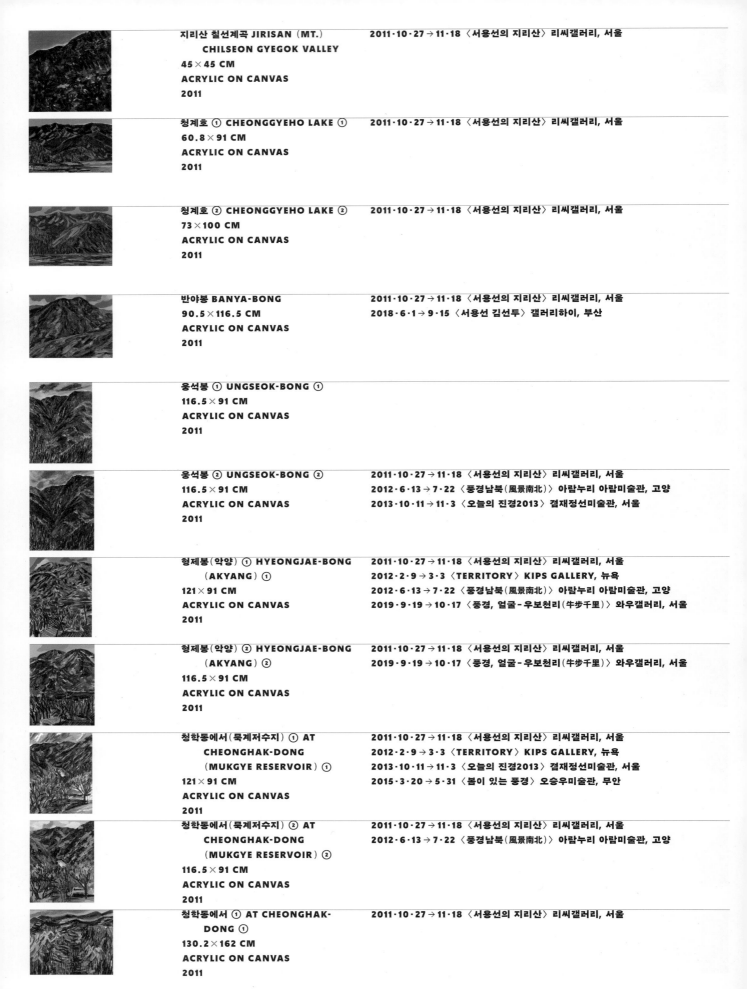

지리산 칠선계곡 JIRISAN (MT.)
CHILSEON GYEGOK VALLEY
45×45 CM
ACRYLIC ON CANVAS
2011

2011·10·27 → 11·18 〈서용선의 지리산〉 리씨갤러리, 서울

청계호 ① CHEONGGYEHO LAKE ①
60.8×91 CM
ACRYLIC ON CANVAS
2011

2011·10·27 → 11·18 〈서용선의 지리산〉 리씨갤러리, 서울

청계호 ② CHEONGGYEHO LAKE ②
73×100 CM
ACRYLIC ON CANVAS
2011

2011·10·27 → 11·18 〈서용선의 지리산〉 리씨갤러리, 서울

반야봉 BANYA-BONG
90.5×116.5 CM
ACRYLIC ON CANVAS
2011

2011·10·27 → 11·18 〈서용선의 지리산〉 리씨갤러리, 서울
2018·6·1 → 9·15 〈서용선 김선두〉 갤러리하이, 부산

웅석봉 ① UNGSEOK-BONG ①
116.5×91 CM
ACRYLIC ON CANVAS
2011

웅석봉 ② UNGSEOK-BONG ②
116.5×91 CM
ACRYLIC ON CANVAS
2011

2011·10·27 → 11·18 〈서용선의 지리산〉 리씨갤러리, 서울
2012·6·13 → 7·22 〈풍경남북(風景南北)〉 아람누리 아람미술관, 고양
2013·10·11 → 11·3 〈오늘의 진경2013〉 겸재정선미술관, 서울

형제봉(악양) ① HYEONGJAE-BONG
(AKYANG) ①
121×91 CM
ACRYLIC ON CANVAS
2011

2011·10·27 → 11·18 〈서용선의 지리산〉 리씨갤러리, 서울
2012·2·9 → 3·3 〈TERRITORY〉 KIPS GALLERY, 뉴욕
2012·6·13 → 7·22 〈풍경남북(風景南北)〉 아람누리 아람미술관, 고양
2019·9·19 → 10·17 〈풍경, 얼굴 – 우보천리(牛步千里)〉 와우갤러리, 서울

형제봉(악양) ② HYEONGJAE-BONG
(AKYANG) ②
116.5×91 CM
ACRYLIC ON CANVAS
2011

2011·10·27 → 11·18 〈서용선의 지리산〉 리씨갤러리, 서울
2019·9·19 → 10·17 〈풍경, 얼굴 – 우보천리(牛步千里)〉 와우갤러리, 서울

청학동에서(묵계저수지) ① AT
CHEONGHAK-DONG
(MUKGYE RESERVOIR) ①
121×91 CM
ACRYLIC ON CANVAS
2011

2011·10·27 → 11·18 〈서용선의 지리산〉 리씨갤러리, 서울
2012·2·9 → 3·3 〈TERRITORY〉 KIPS GALLERY, 뉴욕
2013·10·11 → 11·3 〈오늘의 진경2013〉 겸재정선미술관, 서울
2015·3·20 → 5·31 〈봄이 있는 풍경〉 오승우미술관, 무안

청학동에서(묵계저수지) ② AT
CHEONGHAK-DONG
(MUKGYE RESERVOIR) ②
116.5×91 CM
ACRYLIC ON CANVAS
2011

2011·10·27 → 11·18 〈서용선의 지리산〉 리씨갤러리, 서울
2012·6·13 → 7·22 〈풍경남북(風景南北)〉 아람누리 아람미술관, 고양

청학동에서 ① AT CHEONGHAK-
DONG ①
130.2×162 CM
ACRYLIC ON CANVAS
2011

2011·10·27 → 11·18 〈서용선의 지리산〉 리씨갤러리, 서울

해인사 HAEINSA TEMPLE
50.3×60.8 CM
ACRYLIC ON CANVAS
2011

백령도 BAEKRYEONGDO ISLAND
132×162 CM
ACRYLIC ON CANVAS
2011

2011·7·22 → 8·22 〈분쟁의 바다 화해의 바다, 제 1회 인천 평화 미술 프로젝트〉
　　　　　　　　 인천아트플랫폼, 인천
2013·6·25 → 8·25 〈기억·재현 서용선과 6·25〉 고려대학교박물관, 서울
2019·2·22 → 5·12 〈불멸사랑〉 일민미술관, 서울

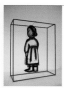

엄마의 전쟁 기억 ① MOTHER'S
　　　　　 MEMORIES OF THE WAR ①
38×29.8×15 CM
ACRYLIC ON CANVAS, STEEL BAR
2011

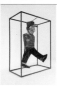

사열 ① MILITARY REVIEW ①
38×28×15.3 CM
ACRYLIC ON CORRUGATED
　　　 PAPER, STEEL BAR
2011

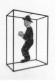

사열 ② MILITARY REVIEW ②
38×28×15.3 CM
ACRYLIC ON CORRUGATED
　　　 PAPER, STEEL BAR
2011

독가촌 DOKGACHON VILLAGE
VARIABLE INSTALLATION,
　　　 LED SCREEN
2011

2011·6·17 → 7·24 〈강호가도 – 서호미술관 10주년 기념전〉 서호미술관, 남양주

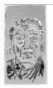

자화상 SELF-PORTRAIT
51×25.2 CM
OIL PASTEL ON MIRROR
2011

2011·6·10 → 7·3 〈텅빈 도시가 내 방 안에 맨발로 서 있다〉 갤러리 소밥, 양평

자화상 SELF-PORTRAIT
사이즈 불명 SIZE UNKNOWN
OIL PASTEL ON MIRROR
2011

자화상 SELF-PORTRAIT
사이즈 불명 SIZE UNKNOWN
OIL PASTEL ON MIRROR
2011

엄마의 전쟁 기억 ② MOTHER'S
　　　　　 MEMORIES OF THE WAR ②
45×35×15 CM
ACRYLIC ON CANVAS, STEEL BAR
2011

엄마의 전쟁기억 ③ MOTHER'S
　　　　　 MEMORIES OF THE WAR ③
49.5×40.3×15.5 CM
ACRYLIC ON CANVAS, STEEL BAR
2011

2013·6·25 → 8·25 〈기억·재현 서용선과 6·25〉 고려대학교박물관, 서울

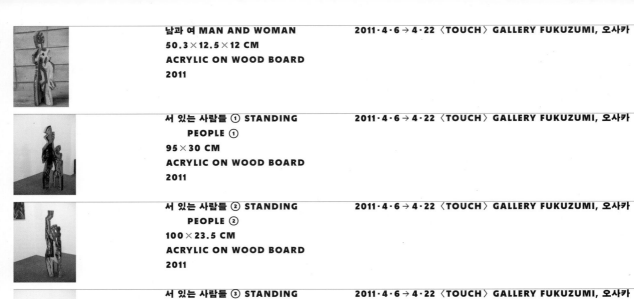

남과 여 MAN AND WOMAN
50.3×12.5×12 CM
ACRYLIC ON WOOD BOARD
2011

2011·4·6 → 4·22 〈TOUCH〉 GALLERY FUKUZUMI, 오사카

서 있는 사람들 ① STANDING
PEOPLE ①
95×30 CM
ACRYLIC ON WOOD BOARD
2011

2011·4·6 → 4·22 〈TOUCH〉 GALLERY FUKUZUMI, 오사카

서 있는 사람들 ② STANDING
PEOPLE ②
100×23.5 CM
ACRYLIC ON WOOD BOARD
2011

2011·4·6 → 4·22 〈TOUCH〉 GALLERY FUKUZUMI, 오사카

서 있는 사람들 ③ STANDING
PEOPLE ③
53×30 CM
ACRYLIC ON WOOD BOARD
2011

2011·4·6 → 4·22 〈TOUCH〉 GALLERY FUKUZUMI, 오사카

약력

ARTIST
BIOGRAPHY

서용선 (1951~)

학력
1982 서울대학교 대학원 서양화과 졸업(M.F.A)
1979 서울대학교 미술대학 회화과 졸업(B.F.A)

교육 경력
2016~ 서울대학교 미술대학 명예교수
1986~2008 서울대학교 미술대학 교수

개인전
2021 〈서용선의 마고 이야기, 우리 안의 여신을 찾아서〉여성역사공유공간 서울여담재, 서울
 〈서용선의 자화상〉갤러리하이, 부산
 〈MAGO, THE MYTH_SUH YONGSUN〉JNO 갤러리, 서울
 〈만첩산중萬疊山中 서용선회화〉여주미술관, 여주
 〈서용선의 생각, 가루개 프로젝트〉갤러리 JJ, 서울

2020 〈직관적 사유로서의 선_서용선 종이그림〉올미아트스페이스, 서울
 〈고구려, 산수〉갤러리이마주, 서울

2019 〈서용선의 머리_갈등〉갤러리 JJ, 서울
 〈통증·징후·증세_서용선의 역사 그리기〉아트센터화이트블럭, 파주
 〈ソ·ヨンソン, 速度の都市(서용선, 속도의 도시)〉NICHE GALLERY, 도쿄
 〈서용선, 산을 넘은 시간들〉누크갤러리, 서울
 〈SUH YONGSUN: UTOPIA'S DELAY THE PAINTER AND THE METROPOLIS〉MIZUMA, KIPS & WADA ART, 뉴욕

2018 〈서용선의 자화상_REFLECTION〉갤러리 JJ, 서울
 〈도시를 향한 현상학적 시선〉신라갤러리, 대구
 〈SUH YONGSUN: CITY AND HISTORY OF LANDSCAPE〉MK GALLERY, VIENNA, 버지니아

2017 〈MY PLACE〉GALLERY FUKUZUMI, 오사카
 〈SUH YONGSUN: 37 RUE DE MONTREUIL PARIS / 222 MAIN STREET NEWJERSEY〉LA GALERIE LA VILLE
 A DES ARTS, 파리
 〈SUH YONGSUN: CROSSING WORLDS〉ART MORA, 뉴욕
 〈생각이 그려지는〉봉산문화회관, 대구

2016 〈서용선〉류미재갤러리, 양평
 〈색色과 공空_서용선〉김종영미술관, 서울
 〈서용선의 인왕산〉누크갤러리, 서울
 〈2016 아르코미술관 대표작가: 확장하는 선_서용선 드로잉〉아르코미술관, 서울
 〈서용선의 마산〉마산청과시장 아트스튜디오, 창원

2015 〈서용선_자화상〉갤러리이마주, 서울
 〈서용선의 도시그리기_유토피즘과 그 현실 사이〉금호미술관 / 학고재갤러리, 서울

2014 〈상처난 색채〉아트센터 쿠, 대전
 〈서용선〉이유진갤러리, 서울
 〈제26회 이중섭미술상_신화, 또 하나의 장소〉조선일보미술관, 서울
 〈徐庸宣ソ·ヨンソン, EMBODIED AND EMBEDDED THINGS_SELF PORTRAITS AND SCENE〉GALLERY FUKUZUMI,
 오사카
 〈역사적 상상_서용선의 단종실록〉아트센터화이트블럭, 파주
 〈SUH YONGSUN〉DAAD(독일학술교류처), 본

2013 〈SUH YONGSUN〉KIPS GALLERY, 뉴욕
 〈SUH YONGSUN〉베를린 한국문화원, 베를린
 〈기억·재현_서용선과 6·25〉고려대학교박물관, 서울
 〈움직이는, 움직이지 않는〉갤러리이마주, 서울

2012 〈서용선 풍경_오대산〉동산방화랑 / 리씨갤러리, 서울
 〈TERRITORY〉KIPS GALLERY, 뉴욕

SUH YONGSUN
b.1951, Seoul, South Korea

<u>EDUCATION</u>
1982 Master in Fine Arts, Seoul National University, Seoul, Korea
1979 Bachelor of Fine Arts, Seoul National University, Seoul, Korea
 Currently lives and works in Yangpyeong, near Seoul

TEACHING
2016–Present Emeritus Professor at Seoul National University
1986–2008 Professor at College of Fine Arts, Seoul National University

<u>SOLO EXHIBITIONS</u>
2021 *Suh Yongsun's Mago, Searching for Goddess in Our Minds* : Seoul Herstory House Yeodamjae, Seoul
 Suh Yongsun's Self-Portrait : Gallery Hi, Busan, Korea
 Mago, The Myth : JNO Gallery, Seoul
 Mancheobsanjoong(萬疊山中), *Suh Yongsun Painting* : Yeoju Museum, Yeouju, Korea
 Suh Yongsun's Thoughts, Garugae project : Gallery JJ, Seoul

2020 *Paper Painting by Suh Yongsun* : Allme Artspace, Seoul
 Goguryeo, Scenery by Suh Yongsun : Gallery Imazoo, Seoul

2019 *Head by Suh Yongsun_Conflict* : Gallery JJ, Seoul
 Pain · Symptoms · Signs, The Remaking of History in Suh Yongsun's Painting : Art Center WhiteBlock, Paju, Korea
 Suh Yongsun, City of Velocity : Niche Gallery, Tokyo
 Suh Yongsun, Time passing with mountains : Nook Gallery, Seoul
 Suh Yongsun, Utopia's delay – The Painter and The Metropolis : Mizuma, Kips & Wada Art, New York, USA

2018 *Self-Portrait by Suh Yongsun_Reflection* : Gallery JJ, Seoul
 Suh Yongsun, A Phenomenological View Toward the City : Gallery Shilla, Daegu, Korea
 Suh Yongsun, City and History of Landscape : MK Gallery, Vienna, VA, USA

2017 *My Place* : Gallery Fukuzumi, Osaka, Japan
 Suh Yongsun – 37 rue de Montreuil Paris / 222 Main Street New Jersey : La Galerie La Ville A des Arts, Paris
 Suh Yongsun – Crossing Worlds : Art Mora Gallery, New York, USA
 Drawn by the Thought- Suh Yongsun : Bongsan Cultural Center, Daegu, Korea

2016 *Suh Yongsun* : Ryumijae Gallery, Yangpyeong, Korea
 Color色 and Void空 – Suh Yongsun : Kim Chong Yung Museum, Seoul
 Suh Yongsun – Mt. Inwangsan : Nook gallery, Seoul
 Expanding Lines – Suh Yongsun Drawing, 2016 Representative Artist : Arko Art Center, Seoul
 Suh Yongsun and Masan : Masan Art Studio, Changwon, Korea

2015 *Suh Yongsun – Self Portrait* : Gallery Imazoo, Seoul
 Utopia's Delay – the Painter and the Metropolis : Kumho Museum of Art, Seoul / Hakgojae Gallery, Seoul

2014 *Broken Color* : Art Center KUH, Daejeon, Korea
 Suh Yongsun : Lee Eugean Gallery, Seoul
 Suh Yongsun's Heterotopia The Forfeiture of Myth – the 26th Lee Jungseop Award Recipient Show : Chosun Ilbo Art
 Gallery, Seoul
 Embodied and Embeded Things Self Portraits and Scenes : Gallery Fukuzumi, Osaka, Japan
 Historical Imagination – The King Danjong Stories by Suh Yongsun : Art Center White Block, Paju, Korea
 Suh Yongsun : DAAD(Deutscher Akademischer Austauschdienst), Bonn, Germany

2013 *Suh Yongsun* : Kips Gallery, New York, USA
 Suh Yongsun : Koreanisches Kulturzentrum, Berlin
 Memory, Representation_Suh Yongsun and 6.25 : Korea University Museum, Seoul
 Moving, Unmoving : Gallery Imazoo, Seoul

2012 *Mt. Odaesan Landscape* : Dongsanbang Gallery, Seoul / Lee C Gallery, Seoul
 Territory : Kips Gallery, New York, USA

2011 *Mt. Jirisan Landscape* : Lee C gallery, Seoul
 Suh Yongsun : RMIT(Royal Melbourne Institute of Technology) School of Art Gallery, Melbourne, Australia

2011	〈서용선의 지리산〉리씨갤러리, 서울
	〈SUH YONGSUN〉RMIT(로열멜버른공과대학) SCHOOL OF ART GALLERY, 멜버른
	〈THE MAN WHO PAINTS〉SHINWHA 갤러리, 홍콩
	〈KÜNSTLER SUH YONGSUN〉GALERIE SON, 베를린
	〈TOUCH〉GALLERY FUKUZUMI, 오사카
	〈시선의 정치〉학고재갤러리, 서울
2010	〈서용선의 풍경화〉리씨갤러리, 서울
	〈MEN IN THE HISTORY〉604J 갤러리 / 604H 갤러리, 부산
	〈MEN IN THE HISTORY〉스페이스홍지, 서울
	〈서용선〉갤러리이마주, 서울
	〈6 DOWNTOWN〉KIPS GALLERY, 뉴욕
2009	〈서용선〉통인옥션 갤러리, 서울
	〈미래의 기억〉박수근미술관, 양구
	〈산·수山·水〉리씨 갤러리, 서울
	〈2009 올해의 작가_서용선〉국립현대미술관, 과천
	〈徐庸宣, 顔たち(얼굴들)〉GALLERY FUKUZUMI, 오사카
2008	〈서용선〉갤러리고도, 서울
	〈SUH YONGSUN, RECENT PAINTINGS〉갤러리 A-STORY, 부산 / 서울
2007	〈매월당梅月堂 김시습金時習〉갤러리고도, 서울
	〈노산군 일지 III〉오스갤러리, 전주
	〈徐庸宣 魯山君日誌 III(서용선 노산군일지 III)〉GALLERY FUKUZUMI, 오사카
2006	〈이념과 현장들〉갤러리고도, 서울
	〈서용선〉철암역갤러리, 태백
	〈SUH YONGSUN NEW WORKS〉CRECLOO ART GALLERY, 뉴욕
2004	〈태백, 철암〉수가화랑, 부산
	〈서용선〉노화랑, 서울
	〈미래의 기억〉일민미술관, 서울
2002	〈서용선_만들기와 그리기〉노화랑, 서울
1999	〈서용선 1993-1999, 노산군(단종)일지〉영월문화원, 영월
1998	〈서용선〉노화랑, 서울
1997	〈서용선〉이콘갤러리, 서울
1996	〈서용선, 자화상 소묘·드로잉〉이콘갤러리, 서울
	〈서용선〉조현갤러리, 서울
1995	〈SUH YONGSUN, SELF PORTRAIT〉GALLERY SWAN, 뉴욕
	〈서용선〉갤러리서미, 서울
1994	〈서용선〉이콘갤러리, 서울
1993	〈서용선 1987-1993, 노산군(단종)일기〉신세계갤러리, 서울
1992	〈서용선〉이콘갤러리, 서울
1991	〈서용선〉신세계미술관, 서울
	〈서용선〉갤러리서미, 서울
1990	〈서용선〉공간미술관, 서울
1989	〈서용선〉문예진흥원미술회관(아르코미술관), 서울
1988	〈서용선〉갤러리P&P, 서울

The Man Who Paints : Shin Wha Gallery, Hong Kong
Künstler Suh Yongsun : Galerie Son, Berlin
Touch : Gallery Fukuzumi, Osaka, Japan
Politics of Gaze : Hakgojae Gallery, Seoul

2010 *Landscapes by Suh Yongsun* : Lee C Gallery, Seoul
Men in the History : Gallery 604J ; 604H, Busan, Korea
Men in the History : Space Hongji (curated by 604 gallery), Seoul
Suh Yongsun : Gallery Imazoo, Seoul
6 Downtown : Kips Gallery, New York, USA

2009 *Suh Yongsun* : Tong-In Auction Gallery, Seoul
Memories of the Future : Park Soo Keun Museum of Art, Yanggoo, Korea
Mountain and Water : Lee C gallery, Seoul
Artist of the Year 2009 : National Museum of Modern and Contemporary Art Korea, Gwacheon, Korea
Suh Yongsun, Figures : Gallery Fukuzumi, Osaka, Japan

2008 *Self Portrait* : Gallery Godo, Seoul
Suh Yongsun : Gallery A-story, Seoul / Busan, Korea

2007 *Maeweoldang Kim Siseup* : Gallery Godo, Seoul
The Diary of Nosangun (III) : O's Gallery, Jeonju, Korea
Suh Yongsun (The Diary of Nosangun III) : Gallery Fukuzumi, Osaka, Japan

2006 *Ideology and Places* : Gallery Godo, Seoul
Suh Yongsun : Cheoram Railroad Station, Taebaek, Korea
Suh Yongsun New Works : Crecloo Art Gallery, New York, USA

2004 *Taebaek, Cheoram* : Suga Art Space, Busan, Korea
Suh Yongsun : Rho Gallery, Seoul
The Memories of the Future : Ilmin Museum of Art, Seoul

2002 *Suh Yongsun, Solid & Drawing* : Rho Gallery, Seoul

1999 *Suh Yongsun 1993–1999, The Diary of Nosangun (King Danjong)* : Yeongwol Culture Center, Yeongwol, Korea

1998 *Suh Yongsun* : Rho Gallery, Seoul

1997 *Suh Yongsun* : Gallery Icon, Seoul

1996 *Suh Yongsun, Self Portrait Drawing* : Gallery Icon, Seoul
Suh Yongsun : Johyun Gallery, Busan, Korea

1995 *Yongsun-Suh Drawings, Self-Portrait* : Gallery Swan, New York, USA
Suh Yongsun : Seomi Gallery, Seoul

1994 *Suh Yongsun* : Gallery Icon, Seoul

1993 *Suh Yongsun 1987–1993, The Diary of Nosangun (King Danjong)* : Shinsegae Gallery, Seoul

1992 *Suh Yongsun* : Gallery Icon, Seoul

1991 *Suh Yongsun* : Shinsegae Gallery, Seoul
Suh Yongsun : Gallery Seomi, Seoul

1990 *Suh Yongsun* : Space Museum, Seoul

1989 *Suh Yongsun* : Korean Culture and Arts Foundation Fine Arts Center (Arko Art Center), Seoul

1988 *Suh Yongsun* : P&P Gallery, Seoul

간추린 기획전 / 단체전

2022 〈한중수교 30주년 기념전 공감_한국현대미술을 바라보다〉 주중한국문화원, 베이징
〈정진국의 건축과 서용선 박인혁의 그림〉 토포하우스, 서울
〈미니멀리즘 - 맥시멀리즘 - 메커니즈즈즘(1막 - 2막)〉 아트선재센터, 서울

2021 〈달빛이 연못을 뚫어도〉 난계로 로얄빌딩 팝업전시장, 서울
〈할아텍 철암그리기 20주년 기념전〉 태백석탄박물관 기념전시실, 태백 / 목포문화예술회관, 목포
〈여수국제미술제: 흐르는 것은 멈추길 거부한다〉 엑스포컨벤션센터, 여수
〈전방前方, 20인의 예술가가 전하는 한반도 평화이야기〉 오두산통일전망대, 파주
〈약속의 땅〉 더 그레이트 컬렉션, 서울
〈시대와 개성〉 해든뮤지움, 인천
〈한국·스페인 특별전_마주하는 풍경, 일상의 시선〉 소마미술관, 서울
〈신자연주의: 리좀이 화엄을 만날때〉 전북도립미술관, 완주

2020 〈ㄱ의 순간〉 예술의전당 서예박물관, 서울
〈인간과 도시_권순철 서용선〉 와우갤러리, 서울
〈2020부산비엔날레_열 장의 이야기와 다섯 편의 시〉 부산현대미술관 외, 부산
〈평화, 바람이 불다_남북한 특별전시회〉 오두산통일전망대, 파주
〈회화와 서사〉 뮤지엄 산, 원주
〈진달래 꽃 피고 지고〉 전북도립미술관, 완주
〈새로운 시의 시대〉 경남도립미술관, 창원
〈이른 봄나들이 - 예술가의 집〉 여주미술관, 여주
〈TRAHERE 화가의 자화상〉 고양어울림누리 어울림미술관, 고양
〈SUH YONGSUN & KATHLEEN J GRAVES〉 MK GALLERY, VIENNA, 버지니아

2019 〈한국의 바다와 섬〉 이탈리아 한국문화원, 로마
〈몽유인왕夢遊仁王, 안평의 꿈_인왕산으로부터〉 안산예술의전당, 안산
〈신자연주의 26주년 기념, 당신의 몸이 신자연이다!〉 담빛예술창고, 담양
〈우보천리牛步千里_풍경, 얼굴〉 와우갤러리, 서울
〈수원화성프로젝트 성城_판타스틱 시티〉 수원시립아이파크미술관, 수원
〈인왕산 아회첩_유서산기遊西山記〉 보안여관, 서울
〈恭齋, 그리고 화가의 자화상〉 행촌미술관, 해남
〈전신傳神, 인간을 바라보다〉 갤러리세줄, 서울
〈소화素畵, 한국 근현대드로잉〉 소마미술관, 서울
〈평화, 하나되다_2019 남북한특별전〉 오두산통일전망대, 파주
〈불멸사랑〉 일민미술관, 서울
〈VISIONI DI PAESAGGI CONTEMPORANEI DAL MONDO〉 MUSEO DI PALAZZO DORIA PAMPHILJ, VALMOTONE, 로마
〈평화의 시대, 평화로운 땅〉 인천문화예술회관, 인천

2018 〈바다와 섬〉 상하이한국문화원, 상하이
〈예술가의 책장〉 아람누리 아람미술관, 고양
〈BG MUHN & SUH YONGSUN〉 MK GALLERY, VIENNA, 버지니아
〈독도미학〉 세종문화회관미술관, 서울
〈몽유인왕夢遊仁王〉 자하미술관, 서울 / 춘천문화예술회관, 춘천
〈장소를 품다 - 부강〉 스페이스몸미술관 / 세종부강리고택, 세종
〈붉은 땅, 푸른 강, 검은 갯벌_무안문화의 원류〉 오승우미술관, 무안
〈경기 아카이브, 지금〉 경기상상캠퍼스, 수원
〈2018 창원 국제조각비엔날레_불각不刻의 균형均衡〉 성산아트홀, 창원
〈A NEW ERA OF PEACE AND A PEACEFUL LAND〉 GREBEL GALLERY(CONRAD GREBEL UNIVERSITY COLLEGE, WATERLOO), 온타리오
〈WE THE PEOPLE〉 OZANEAUX ART SPACE, 뉴욕
〈베트남에서 베를린까지〉 국립아시아문화전당, 광주
〈TRAHERE_화가의 자화상〉 아트센터화이트블럭, 파주
〈강원, THE STORY〉 강릉아트센터, 강릉
〈접점개화接點開花〉 홍콩한국문화원, 홍콩

2017 〈TWO REFLECTIONS: SUH YONGSUN & DON KIMES, KOREAN AND AMERICAN ARTISTS CONFRONT HUMANITY AND NATURE〉 워싱턴한국문화원, 워싱턴 DC
〈미황사〉 학고재갤러리, 서울
〈안평대군의 비밀정원〉 자하미술관, 서울
〈회화에서 회화로〉 시안미술관, 영천
〈풍경 표현〉 대구미술관, 대구
〈ART AND VIMUKTI〉 산타루지(三澤寺), 시즈오카
〈내가 나를 바라보니 - 서용선 제 5회 붓다아트페스티벌 특별전〉 SETEC, 서울

SELECTED EXHIBITIONS

2022
Sympathy – Looking at Korean Contemporary Art, Commemorating the 30th Anniversary of Diplomatic Relations between Korea and China : Korean Cultural Center, Beijing, China
Chung Jinguk Architecture and Suh Yongsun, Park Inhyuk Paintings : Topohouse, Seoul
Minimalism-Maximalism-Mechanissmmm Act1–Act 2 : Art Sonje Center, Seoul

2021
Pop-up Show – Though Moonlight Penetrates the River : Nangyero Royal Building, Seoul
Commemorating the 20th Anniversary of Halartec Cheoram Grigi : Taebaek Coal Museum, Taebaek / Mokpo Cultural Center, Mokpo, Korea
Yeosu International Art Festival – Flowing refuses to stop : Yeosu Expo Convention Center, Yeosu, Korea
20 Artists' Stories of the Korean Peninsula : Odusan Unification Tower Gallery, Paju, Korea
The Promised Land : The Great Collection, Seoul
The Era and Individuality : Headen Museum, Incheon, Korea
The Scenary We Face, Our Daily Gaze : Seoul Olympic Museum of Art, Seoul
Shinjayeon Art Movement, The Rhizomes Entangled with the Indra's Net : Jeonbuk Museum of Art, Wanju, Korea

2020
The Moment of "Giyeok (Korean Alphabet ㄱ)" : Seoul Calligraphy Art Museum, Seoul
Human and City_Kwon Suncheol, Suh Yongsun : Wow Gallery, Seoul
2020 Busan Biennale, Words at an Exhibition_ an exhibition in ten chapters and five poems : Museum of Contemporary Art, Busan, and other venues, Busan, Korea
Peace, The Wind Blows : Odusan Unification Tower Gallery, Paju, Korea
The Painting & Narrative : Museum San, Wonju, Korea
Azalea Flowers Bloom and Fall : Jeonbuk Museum of Art, Wanju, Korea
Rewriting Poetry : Gyeongnam Art Museum, Changwon, Korea
Early Spring Outing – The House of Artists : Yeoju Art Museum, Yeoju, Korea
Trahere, Self-portrait : Aram Nuri Arts Center, Goyang, Korea
Suh Yongsun & Kathleen J Graves_Midtown & Beyond : MK Gallery, Vienna, VA., USA

2019
The Sea and The Island : Korean Cultural Center, Rome
Mongyu Inwang (Dream Journey to Mt. Inwang), Dream of Prince Anpyung : Ansan Arts Center Gallery, Ansan, Korea
Your Body is the Shinjayeon (新自然)! : Dambit Arts Cargo, Damyang, Korea
UboChunRi (牛步千里), Landscape and Figure : Wow Gallery, Seoul
2019 SUNG (城), Fantastic City – Suwon Hwaseong Project : Suwon Ipark Museum of Art, Suwon, Korea
Inwangsan Project_Yuseosangi (遊西山記) : Art Space Boan, Seoul
Gongjae (恭齋) and Self-portrait of Painters : Haengchon Museum, Haenam, Korea
Transmitting the Spirit, Looking at Human : Gallery Sejul, Seoul
SoWha (素畫), Drawing – Korean Modern and Contemporary Drawings : SOMA Museum of Art, Seoul
Peace, We are One : Odusan Unification Tower Gallery, Paju, Korea
Immortality in the Cloud : Ilmin Museum of Art, Seoul
Visioni di Paesaggi Contemporanei dal Mondo : Museo di Palazzo Doria Pamphilj, Valmotone, Rome
Art Era of Peace, A Peaceful Land : Incheon Culture & Arts Center, Incheon, Korea

2018
The Sea and The Island : Shanghai Korean Cultural Center, Shanghai, China
The Bookshelves of the Artists : Aramnuri Aram Art Museum, Goyang, Korea
BG Muhn & Suh Yongsun : MK Gallery, Vienna, VA., USA
The Aesthetics of Dokdo : Sejong Center for the Performing Arts, Seoul
Mongyu Inwang (夢遊仁王) : Zaha Museum, Seoul / Chuncheon Cultural Center, Chuncheon, Korea
Hold the Place – Bugang : Space Mom Museum / Sejong Bugangri Old House, Sejong, Korea
Red Earth, Blue River, Black Tideland_Origin of Muan Culture : Seungwoo Oh Museum of Art, Muan, Korea
Gyeonggi Archive – Now : Gyeonggi Sangsang Campus, Suwon, Korea
2018 Changwon Sculpture Biennale : Seongsan Art Hall, Changwon, Korea
A New Era of Peace and A Peaceful Land : Grebel Gallery at Conrad Grebel University College, Waterloo, Ontario, Canada
We the People : Ozaneaux Art Space, New York, USA
From Vietnam to Berlin : Asia Culture Center, Gwangju, Korea
Trahere – Self-portrait of Painters : Art Center White Block, Paju, Korea
Gangweon, The Story : Gangneung Art Center, Gangneung, Korea
Blooming at the Junction (接點開花) : Hong Kong Korean Cultural Center, Hong Kong

2017
Two Reflections_Suh Yongsun & Don Kimes, Korean and American Artists Confront Humanity and Nature : Korean Cultural Art Center, Washington, D.C.
Miwhangsa-temple : Hakgojae Gallery, Seoul
The Secret Garden of Prince Anpyeong : Zaha Museum, Seoul
Revisiting Painting Arts – Modern Figurative Paintings by Korean Artists : Cyan Art Museum, Yeongcheon, Korea
Expression of Landscape : Daegu Art Museum, Daegu, Korea
Art and Vimukti : Santaku-ji Temple, Shizuoka, Japan
Buddha Art Festival – Seoul International Buddhism Expo : SETEC, Seoul
Commodity & Ideology : Queens College, Klapper Art Gallery, New York, USA
The Portrait of Youth : National Museum of Korean Contemporary History, Seoul

〈COMMODITY & IDEOLOGY〉 KLAPPER HALL ART GALLERY(QUEENS COLLEGE), 뉴욕
〈청년의 초상〉 대한민국역사박물관, 서울
〈색채의 재발견〉 뮤지엄 산, 원주
〈예술만큼 추한〉 서울대학교미술관, 서울
〈그림, 사람, 학교-서울대학교 미술대학 아카이브, 서양화〉 서울대학교미술관, 서울

2016 〈동학〉 전북도립미술관, 완주
〈CONNECT-日韓現代美術交流展(한일현대미술교류전)〉 JARFO京都畫廊, 교토
〈풍경을 보는 여섯 가지의 시선〉 오승우미술관, 무안
〈광주비엔날레특별전_0상 공화국〉 국립아시아문화전당, 광주
〈국립현대미술관 과천 30년 특별전_달은, 차고, 이지러진다〉 국립현대미술관, 과천
〈SOUTH KOREAN ART : EXAMINING LIFE THROUGH SOCIAL REALITIES(한반도의 사실주의)〉 AMERICAN
 UNIVERSITY MUSEUM AT THE KATZEN ARTS CENTER, 워싱턴 DC
〈사월의 동행_세월호 희생자 추념전〉 경기도미술관, 안산
〈통일아!〉 예술의 전당, 서울
〈안평의 시대-두 번째〉 류미재갤러리, 양평
〈문화적 대화〉 호주 한국문화원, 시드니 / 갤러리 LVS, 서울

2015 〈백제의 재발견〉 전북도립미술관, 완주
〈김시습〉 겸재정선미술관, 서울
〈고야산高野山 개창 1200년 특별기획전: 생명의 교향〉 곤고부지金剛峯寺개창1200년갤러리, 와카야마
〈2015 풍류남도 만화방창〉 행촌미술관 / 해남종합병원 / 고산윤선도유물전시관 외, 해남
〈세계유산 IN 안동, 문하전회文河傳回〉 안동문화예술의 전당, 안동 / 울산문화예술회관, 울산
〈풍류남도 아트프로젝트〉 행촌미술관, 해남
〈몽중애상夢中哀傷〉 자하미술관, 서울
〈봄이 있는 풍경〉 오승우미술관, 무안
〈안평의 시대〉 류미재갤러리, 양평

2014 〈지리산프로젝트 2014 우주예술집〉 성심원, 산청 / 실상사,남원 / 삼화에코하우스, 하동
〈사유로서의 형식_드로잉의 재발견〉 뮤지엄 산, 원주
〈미안합니다 잊지 않겠습니다〉 미테-우그로, 광주
〈겸재 정선과 아름다운 비해당 정원〉 겸재정선미술관, 서울
〈최치원 풍류탄생〉 예술의전당 서예박물관, 서울
〈아르스 악티바 2014_예술과 삶의 공동체〉 강릉시립미술관, 강릉
〈바람을 흔들다_(역)사적 그림을 위하여〉 부산시립미술관, 부산
〈다시 그리기〉 갤러리 3, 서울
〈미술관 이미지〉 동덕여자대학교박물관 / 동덕아트갤러리, 서울

2013 〈한국 현대회화 33인〉 강동아트센터, 서울
〈일상의 사유적 치유〉 갤러리인데코, 서울
〈고양600년 기념특별전 잃어버린 세계로의 여행_신화와 전설, 평화의 도시〉 아람누리 아람미술관, 고양
〈2013 평화미술 프로젝트 백령도-525,600시간과의 인터뷰〉 인천아트플랫폼, 인천
〈정전 60주년 특별전_잃어버린 시간을 찾아서〉 OCI미술관, 서울
〈2013년 현대작가〉 동덕여자대학교박물관 / 동덕아트갤러리, 서울
〈인물로 시대를 읽다_인물 파노라마〉 전북도립미술관, 완주

2012 〈THE POWER OF ART_PEOPLE〉 두만강문화전시관, 도문
〈풍경남북風景南北〉 아람누리 아람미술관, 고양
〈THROUGH YOUR EYES〉 호주한국문화원, 시드니
〈민성民性〉 대구미술관, 대구
〈세 개의 시선_서용선 조병왕 이재현〉 갤러리그림손
〈KOREAN PAINTING NOW〉 국립타이완미술관, 타이중

2011 〈예술과 환경〉 고생대자연사박물관, 태백
〈삶과 풍토〉 대구미술관, 대구
〈올해의 작가 23인의 이야기 1995-2010〉 국립현대미술관, 과천
〈제1회 평화미술 프로젝트_분쟁의 바다, 화해의 바다〉 인천아트플랫폼, 인천
〈트라이앵글 프로젝트 2011〉 구와우전시공간 할 외, 태백
〈이미지 수사학〉 서울시립미술관, 서울
〈서울, 도시탐색〉 서울시립미술관, 서울
〈FESTART OSAKA2011〉 GALLERY FUKUZUMI, 오사카
〈코리안 랩소디_역사와 기억의 몽타주〉 삼성미술관 리움, 서울

2010 〈눈꽃 위에 피는 꽃_분단미술〉 대전시립미술관, 대전
〈IN AND WITH : CONTEMPORARY KOREAN ART〉 CANTOR FITZGERALD GALLERY, HAVERFORD COLLEGE,

Rediscovery of Colors : Museum San, Wonju, Korea
Ugly As Art : Seoul National University Museum of Art, Seoul
Paintings, People, University – Archive of College of Fine Arts : Seoul National University Museum of Art, Seoul

2016 *Donghak* : Jeonbuk Museum of Art, Wanju, Korea
 2016-Connect : JARFO Kyoto Gallery, Kyoto, Japan
 Six Perspectives Looking at the Landscape : Seungwoo Oh Museum of Art, Muan, Korea
 Republic on 0-sang Gwangju Biennale Special Exhibition : Asia Cuture Center, Gwangju, Korea
 As the Moon Waxes and Wanes – MMCA Gwacheon 30 Years 1986-2006 : National Museum of Modern and
 Contemporary Art, Korea, Gwacheon, Korea
 South Korean Art_Examining Life Through Social Realities : American University Museum, Washington D.C.
 April the Eternal Voyage – MV Sewol-Memorial Exhibition : Gyeonggi Museum of Modern Art, Ansan, Korea
 A! Unification : Seoul Arts Center, Seoul
 The 2nd Prince Anpyeong Era : Ryumijae Gallery, Yangpyeong, Korea
 Cultural Conversations : Gallery LVS, Seoul / Korean Cultural Centre, Sydney, Australia

2015 *Rediscovery of Baekje Dynasty – Reported by Contemporary Art* : Jeonbuk Museum of Art, Wanju, Korea
 Kim Siseup（金時習）: Gyeomjae Jeongseon Art Museum, Seoul
 Symphony of Lives – The special exhibition for the 1200th anniversary of Mountain Koya's Founding : Kongobuji KAISO
 1200th Gallery, Wakayama, Japan
 2015 The World Heritage in Andong, Munhajeonhoe（文河傳回）: Andong Culture & Arts Center, Andong, Korea / Ulsan
 Culture Art Center, Ulsan, Korea
 2015 Pungryunamdo（風流南道）*Art Project* : Haengchon Museum, Haenam, Korea
 The Scenery of Spring : Muan Seungu Oh Museum, Muan, Korea
 Prince Anpyung era : Bom Farmers Garden, Ryumijae Gallery, Yangpyeong, Korea
 2015 PyungryuNamdo（風流南道）*Manwhabangchang*（萬化方暢）: Haengchon Art Museum, Henam
 Mongjungesang（夢中哀傷）: Zaha Museum, Seoul
 Hositamtam（虎視眈眈）: Korea University Museum, Seoul

2014 *Jirisan Project, Universe·Art·Zip* : Sungsimwon, Sancheong / Silsangsa temple, Namwon / Samwha EcoHouse, Hadong,
 Korea
 A Form as Thinking – Rediscovery of Drawing : Museum San, Wonju, Korea
 We are Sorry, We Won't Forget : Mitte-Ugro, Gwangju, Korea
 Gyeomjae Jeongseon and Beautiful Bihaedang Garden : Gyeomjae Jeongseon Museum, Seoul
 Choe Chiwon – Poongryu（風流）: Calligraphy Museum of Seoul Arts Center, Seoul
 Ars Activa 2014 – Arts & Their Communities : Gangneung Museum of Art, Gangneung, Korea
 What Makes the Wind Sway : Busan Art Museum, Busan, Korea
 Redrawing : Gallery 3, Seoul
 Museum Image : Dongduk Women's University Museum, Seoul / Dongduk Art Gallery, Seoul

2013 *33 Korean Contemporary Painters* : Gangdong Art Center, Seoul
 Thinkable Cure of Daily Life : Gallery Indeco, Seoul
 Myth and Legend : Aramnuri Art Center, Goyang, Korea
 The 3rd IRAP Sea of Peace, Baekryeongdo – interview '525,600 hours : Incheon Art Platform, Incheon, Korea
 The 60th Anniversary of Ceasefire Exhibition – Remembrance of Things Past : OCI Museum, Seoul
 2013 Artists : Dongduk Women's University Museum / Dongduk Art Gallery, Seoul
 Figures Panorama : Jeonbuk Museum of Art, Wanju, Korea
 Today's JinKyung（眞境）*2013* : Gyeomjae Jeongseon Art Museum, Seoul

2012 *The Power of Art – People* : The Tumen River Art Center, Tumen, China
 Landscape of South and North Korea : Aramnuri Art Center, Goyang, Korea
 Through Your Eyes : Korean Cultural Center, Sydney, Australia
 Korean Archetype : Daegu Art Museum, Daegu, Korea
 Three Views_Suh Yongsun, Cho Byungwang, Lee Jaehyun : Gallery Grimson, Seoul
 Korean Painting Now : Taiwan National Museum of Fine Arts, Taichung, Taiwan

2011 *Art and Environment* : Taebaek Paleozoic Museum, Taebaek, Korea
 Nature, Life, Human : Daegu Art Museum, Daegu, Korea
 Artist of the Year 1995-2010 : National Museum of Contemporary Art Korea, Gwacheon, Korea
 Sea of Conflict, Sea of Reconciliation, The 1st IPAP Sea of the Peace : Incheon Art Platform, Incheon, Korea
 Triangle Project 2011 – Cheoram : Cheoram Gallery, Taebaek, Korea
 Rhetoric of the Images : Seoul Museum of Art, Seoul
 Seoul, City Exploration : Seoul Museum of Art, Seoul
 Festart Osaka 2011 (with Gallery Fukuzumi) : Osaka, Japan
 Korean Rhapsody – A Montage of History and Memory : Leeum Samsung Museum of Art, Seoul

2010 *The Flower on the Snow – Art of National Division* : Daejeon Museum of Art, Daejeon, Korea
 Korean Art Festival – In and With : Contemporary Korean Art : Cantor Fitzgerald Gallery, Haverford College,

필라델피아

〈우리는 거제도로 갔다〉 거제 문화예술회관미술관, 거제

〈한국 드로잉 30년_1970~2000〉 소마미술관, 서울

〈OFF THE WALL : 건축 도자 경계에서〉 클레이아크김해 미술관, 김해

〈CELADON ART PROJECT 2010_강진에서 청자를 만나다〉 강진청자미술관, 강진

〈젊은모색 30〉 국립현대미술관, 과천

〈岩美國際現代美術展 鳥取の人と自然(이와미국제현대미술전 돗토리현의 사람과 자연)〉 돗토리현이와미초 사무소 / 이와미온천지구 STUDIO 652 / 이와미역, 돗토리

〈철암 그리기 100회 기념전_거기 철암 그리고 태백〉 철암갤러리 외, 태백

〈WORK ON PAPER〉 리씨갤러리, 서울

〈겸재 화혼華婚 - 개관1주년기념 현대작가 53인초대전〉 겸재정선기념관, 서울

2009 〈신호탄〉 기무사 강당 및 기무사 내 부지(현 국립현대미술관 서울관), 서울

〈2009 청주국제공예비엔날레: OUTSIDE THE BOX〉 청주예술의전당 / 상당산성 / 중흥공원 주변, 청주

〈갤러리 소머리국밥 개관전〉 갤러리소머리국밥, 양평

〈베를린 장벽붕괴 20주년 기념〉 브란덴부르크 게이트 외, 베를린

〈7080 청춘예찬_한국현대미술 추억사〉 조선일보미술관, 서울

〈MY WAY, MY WORKS〉 빛갤러리, 서울

〈THE TREE 하종현 이강소 서용선〉 갤러리이마주, 서울

〈지리산_남도 문화의 보고〉 신세계갤러리, 광주 / 센텀시티, 부산

2008 〈그림, 문학을 그리다〉 국립청주박물관 외, 청주

〈1970년대 한국미술_국전과 민전〉 예술의전당 한가람미술관, 서울

2007 〈ART FAIR 21_COLOGNE - 고도갤러리〉 EXPO XXI, 쾰른

2006 〈우리 시대의 얼굴〉 윤슬미술관, 김해

〈독섬, 독도〉 전북도립미술관, 완주

〈예술과 교육〉 서울대학교미술관, 서울

〈BERLIN PAINTINGS DIALOG BERLIN - KOREA〉 KOMMUNALE GALERIE, 베를린

2005 〈베를린에서 DMZ까지_광복60주년기념 문화사업〉 서울올림픽미술관(소마미술관), 서울

〈서울미술대전 - 회화〉 서울시립미술관, 서울

〈한국미술 100년〉 국립현대미술관, 과천

2004 〈한국현대작가전〉 서울시립미술관 남서울분관, 서울

〈평화선언 2004 세계 100인 미술가〉 국립현대미술관, 과천

〈暗-示(암-시) UMBRA〉 성곡미술관 외, 서울

2003 〈빛과 색채의 탐험〉 예술의전당 한가람미술관, 서울

〈역사와 의식, 독도진경 판화전〉 서울대학교박물관, 서울

〈2인전_드로잉 페인팅〉 독일한국대사관 홍보문화관, 베를린

〈서울미술대전〉 서울시립미술관, 서울

〈깊은_그림〉 대안공간 풀, 서울

〈아이 유 어스〉 성곡미술관, 서울

2002 〈역사와 의식, 독도진경판화전〉 천안독립기념관특별전시장, 천안

〈한국미술의 자화상〉 세종문화회관 미술관, 서울

〈광주비엔날레_P_A_U_S_E, 프로젝트 3_집행유예〉 5.18자유공원 내 헌병대모형관 영창, 광주

2001 〈한국미술2001_회화의 복권〉 광동미술관, 광저우 / 국립현대미술관, 과천

〈제1회 철암그리기〉 석탄박물관, 태백

〈사불산 윤필암_꽃보다 아름다운 스님들의 도량전〉 인사동 학고재화랑, 서울

〈2001 서울미술대전〉 서울시립미술관, 서울

〈한국미술대상전〉 국립현대미술관, 과천

2000 〈한국화가 33인전〉 갤러리 맥, 서울

〈작은 담론_80년대 소그룹 미술운동〉 문화예술진흥원미술회관(아르코미술관), 서울

〈시대의 표현_눈과 손〉 예술의전당 한가람미술관, 서울

〈CONTEMPORARY ART FROM KOREA〉 DAR AL FUNOON GALLERY, AL ASIMAH GOVERNATE, 쿠웨이트 / UNESCO PALACE, 베이루트

1999 〈양평군립미술관 개관기념전〉 양평군립미술관, 양평

〈새천년 특별기획_인물로 보는 한국미술〉 호암미술관, 서울

〈'99 서울미술대전〉 서울시립미술관, 서울

Philadelphia, USA

We Went to Geoje Island : Geoje Art Center, Geoje, Korea

Korean Avant-Garde Drawing 1970-2000 : Seoul Olympic Museum of Art, Seoul

OFF the Wall – Boundary between Architecture and Ceramics : Clayarch Gimhae Museum, Gimhae, Korea

Gangjin Celadon Art Project 2010 : GangJin Celadon Museum, Gangjin, Korea

The 30th Anniversary of the Young Korean Artists : National Museum of Contemporary Art Korea, Gwacheon, Korea

People and Nature in Tottori – Iwami International Exhibition of Contemporary Art : Iwami Studio 652 & Iwami Station, Iwami, Japan

Over the Yellow Line : Kyunghyang Gallery, Seoul

Gyeomjae Hwahon (華婚) *Commemorating the 1st Anniversary of Gyeomjae Jeongseon Art Musueum* : Gyeomjae Jeongseon Art Museum, Seoul

The Age of Innocence : Topohouse, Seoul

Commemorating The 100th Anniversary of Halartec Cheoram Grigi : Taebaek Art Center, Taebaek, Korea

2009 *Beginning of New Era* : Defense Security Command (the present, National Museum of Modern and Contemporary Art Korea), Seoul

2009 Cheongju International Craft Biennale – Outside the Box : Cheongju Art Center, Sangdansansung, Jungheung Park, Cheongju, Korea

Commemorating Gallery Sobab Inaugural : Gallery Sobab, Yangpyeong, Korea

The 20th Anniversary Fall of the Wall in Berlin : Organizing Committee, Brandenburg Gate etc., Berlin

70, 80 Ode to Youth – History of Contemporary Korean Art : Chosun Ilbo Art Museum, Seoul

My Way, My Works : Vit Gallery, Seoul

The Three_Lee Gangso, Suh Yongsun, Ha Jonghyun : Gallery Imazoo, Seoul

Mt. Jirisan, Repository of Youngnam and Honam Region : Shinsegae Gallery, Gwangju / Centum City, Busan, Korea

2008 *Painting, Illustrating Literature* : Cheongju National Museum, Cheongju, Korea

In 1970s, Korean Art – National Art Exhibition and Private Art Exhibition : Seoul Arts Center, Seoul

2007 *Art Fair 21_Cologne (with Gallery Godo)* : Cologne, Germany

2006 *Faces of Our Era* : Gimhae Cultural Center and Yunseul Museum, Gimhae, Korea

Dok Island, Dokdo : Jeonbuk Museum of Art, Wanju, Korea

Art & Education : Contemporary Museum of Seoul National University, Seoul, Korea

Berlin Paintings Dialog Berlin–Korea : Kommunale Galerie, Berlin

2005 *Berlin to DMZ* : Seoul Olympic Museum of Art, Seoul

Seoul Grand Art : Seoul Museum of Art, Seoul

Korean Art 100 years : National Museum of Modern and Contemporary Art, Gwacheon, Korea

2004 *Contemporary Korean Artists* : Nam Seoul Museum of Art, Seoul

Declaration : National Museum of Modern and Contemporary Art, Korea, Gwacheon, Korea

Umbra : Sungkok Museum etc, Seoul

2003 *Exploration for Light & Color* : Seoul Arts Center, Seoul

Landscape Prints of Dokdo : Seoul National University Museum, Seoul

2 Artists : Press and Culture Department Embassy of the Republic of Korea, Berlin

Seoul Art : Seoul Museum of Art, Seoul

Deep-Painting : Alternative Space Pool, Seoul

I, You, Us : Sungkok Museum, Seoul

2002 *History and Consciousness, Dokdo JinGyeong Print* : The Independence Hall of Korea, Cheonan, Korea

Landscape of Dokdo JinGyeong : Seoul National University Museum, Seoul

Self-Portrait of Contemporary Korean Art : Sejong Center, Seoul

Gwangju International Biennale P_A_U_S_E, Project 3 – Stay of Execution : 5.18 Memorial Park, Gwangju, Korea

2001 *Korean Art 2001 – Reinstatement of Painting* : National Museum of Contemporary and Modern Art, Korea, Gwacheon, Korea / Guangzhou, China

The 1st Cheoram Grigi : Taebaek Coal Museum, Taebaek, Korea

Sabulsan Yunpilam – The Road for the Cultural Society : Hakgojae Gallery, Seoul

2001 Seoul Art Festival : Seoul Museum of Art, Seoul

Korean Art Prize (Hankuk libo) : National Museum of Modern and Contemporary Art, Korea Gwacheon, Korea

2000 *33 Korea Artists* : Gallery Mac, Seoul

Little Narrative – Artists in the 80's Small Groups : the Korean Culture & Arts Foundation Seoul Arts Center (Arko Museum), Seoul

Contemporary Art from Korea : Unesco Palace, Kuwait / Beirut, Lebanon / Israel, etc.

Expression of Era – Eyes and Hands : Seoul Arts Center, Seoul

〈SOUND OF NATURE: CONTEMPORARY ART FROM KOREA_CALGARY〉 TRIANGLE GALLERY, 앨버타
〈제2회 황해예술제_밥과 미술〉 인천종합문화예술회관, 인천
〈포비아_무의식의 욕망〉 일민미술관, 서울

1998 〈회화 속의 몸〉 한림미술관, 대전
 〈드로잉 횡단〉 금호미술관, 서울
 〈새로운 천년 앞에서〉 광주시립미술관, 광주

1997 〈'97 서양화 100인 초대전〉 서울신문갤러리, 서울
 〈한국미술 '97 인간 동물 기계〉 국립현대미술관, 과천

1996 〈동시대작가〉 아라리오갤러리, 서울
 〈도시와 미술〉 서울시립미술관, 서울
 〈KOREAANSE SCHILDERKUNST NU〉 RIJKSMUSEUM VOOR VOLKENKUNDE(국립민족학박물관), 레이든
 〈'96 서울미술대전〉 서울시립미술관, 서울
 〈정치와 미술〉 신세계갤러리, 광주 / 보다갤러리, 서울

1995 〈세계현대미술제〉 국립현대미술관, 서울
 〈한국, 100개의 자화상_조선에서 현대까지〉 국립청주박물관, 청주 / 서울미술관, 서울
 〈서울신문 창간 50주년기념_한국 현대회화 50년 조망〉 서울갤러리, 서울

1994 〈서울정도 600주년기념 국제현대미술제〉 국립현대미술관, 과천
 〈'94 서울 문화읽기〉 한원미술관, 서울
 〈'94 서울미술대전〉 서울시립미술관, 서울

1993 〈'93 한국적 구상성을 위한 제언〉 롯데화랑, 서울
 〈인물화, 삶의 표정〉 현대아트갤러리, 서울

1992 〈'92 한국현대미술_한중예술연합회〉 예술의전당, 서울
 〈'92 현대미술초대〉 국립현대미술관, 서울
 〈한국현대회화_표현, 현상〉 ART CORE ANEXE GALLERY, 로스앤젤레스 / 신세계 동방플라자 미술관, 서울
 〈금호미술관 3주년기념전_오늘의 삶, 오늘의 미술〉 금호미술관, 서울

1991 〈PEINTURE CORÉENNE MODERNE〉 미건갤러리, 서울 / FOUNDATION VASARELY(바젤리재단), 엑상프로방스
 〈한국현대미술의 한국성 모색 III_갈등과 대결의 시대〉 한원갤러리, 서울
 〈1991 세기말 인상〉 신세계미술관, 서울

1990 〈'90 현대미술동우회〉 국립현대미술관, 서울
 〈예술의 전당 개관기념〉 예술의전당, 서울
 〈신형상 6인〉 모란미술관, 남양주
 〈판화 18인〉 갤러리서미, 서울
 〈금호미술관 3주년기념전 사람들_이 땅(土)에서〉 금호미술관, 서울

1989 〈인간·생각·오늘〉 온다라미술관, 전주
 〈인간-7인의 시각〉 나우갤러리, 서울
 〈한국현대미술_80년대의 정황〉 동숭아트센터, 서울

1988 〈갤러리서미 개관기념전_한국성, 현대성, 표현성〉 갤러리서미, 서울
 〈형상_7인의 작업〉 바탕골미술관, 서울
 〈현,상_그 변용과 가늠〉 녹색갤러리, 서울
 〈한국현대미술 신세대 16인〉 신세계미술관, 서울
 〈제2회 레알리떼 서울〉 그로리치화랑, 서울

1987 〈제19회 까뉴 국제 회화제〉 CHÂTEAU MUSÉE GRIMMALDI(샤토 그리말디 미술관), 카뉴쉬르메르
 〈오늘의 회화_14인의 시각〉 한국화랑, 서울
 〈새로운 조형〉 신세계미술관, 서울

1986 〈현·상〉 관훈미술관, 서울
 〈SEOUL IN SEOUL〉 大阪府立現代美術センタ(오사카부립현대미술센터), 오사카

1985 〈在韓國作家 3人(한국작가 3인)〉 スルガ台画廊(스루가다이화랑), 도쿄
 〈'85 청년작가〉 국립현대미술관, 과천

1984 〈제7회 중앙미술대상전〉 국립현대미술관, 서울

1999	*Yangpyeong Museum inaugural show* : Yangpyeung Art Museum, Yangpyeong, Korea

1999 *Yangpyeong Museum inaugural show* : Yangpyeung Art Museum, Yangpyeong, Korea
New Millennium Korean Arts by Korean Portraits from Prehistory to Modern Times : Hoam Art Museum, Seoul
'99 Seoul Art Exhibition : Seoul Museum of Art, Seoul
Sound of Nature, Contemporary Art from Korea : Triangle Gallery, Alverta, Canada
The 2nd Hwanghae Art – Bob and Art : Incheon Art Center Exhibition Hall, Incheon, Korea
Phobia_ Unconscious Desire : Ilmin Museum of Art, Seoul

1998 *Body in Painting* : Hanlim Museum of Art, Daejeon, Korea
Crossing Drawing : Kumho Museum of Art, Seoul
In Front of New Millennium : Gwangju Museum of Art, Gwangju, Korea

1997 *100 Western Style Painters* : Seoul Shinmun Gallery, Seoul
Korean Art '97 – Humanism · Animalism · Mechanism : National Museum of Modern and Contemporary Art, Gwacheon, Korea

1996 *Contemporary Artists* : Arario Gallery, Seoul
City and Art : Seoul Museum of Art, Seoul
Korean Painting Now : Volkenkunde Museum, Leiden, Netherlands
'96 Seoul : Seoul Museum of Art, Seoul
Politics and Art : Shinsegae Gallery, Gwangju / Boda Gallery, Seoul

1995 *World Contemporary Art* : National Museum of Modern and Contemporary Art, Gwacheon, Korea
100 Self-Portraits in Korea, From Chosun Dynasy Period to Present : Cheongju National Museum, Cheongju / Seoul Museum of Art, Seoul
View of the 50years Korean Contemporary Art : Seoul Shinmun Gallery, Seoul

1994 *600 Years of City Seoul, International Art Festival* : National Museum of Modern and Contemporary Art, Gwacheon, Korea
Exploration The Seoul Culture : Hanwon Gallery, Seoul
'94 Seoul Art Exhibition : Seoul Museum of Art, Seoul

1993 *'93 for the Expected Concreteness* : Lotte Gallery, Seoul
Figure, Expression of Life : Hyundai Art Gallery, Seoul

1992 *'92 Korean Contemporary Art* : Seoul Arts Center, Seoul
'92 Contemporary Art : National Museum of Modern and Contemporary Art, Korea, Gwacheon, Korea
Korean Contemporary Paintings Exhibition, Expression–Figuration : Dongbang Museum of Art, Seoul / La Artcore Brewery Annex, Los Angeles, USA
Today's Life, Today's Arts : Kumho Museum of Art, Seoul

1991 *Korean Contemporary Art* : Vasarely Gallery, Aix-en Provence, France / Migun Gallery, Seoul
A Grouping for the Identity of Contemporary Korean Art – A Period of Conflict and Confrontation : Hanwon Gallery, Seoul
Expression of The End of a Century : Shinsegae Gallery, Seoul

1990 *'90 Contemporary Artists Association* : National Museum of Modern and Contemporary Art, Gwacheon, Korea
The 1st Seoul Arts Center Show : Seoul Arts Center, Seoul
6 New Figurative Artists : Moran Museum of Art, Namyangju, Korea
18 Print Artists : Seomi Gallery, Seoul
People – from This Land : Kumho Museum of Art, Seoul

1989 *Human · Thinking · Today* : Ondara Museum, Jeonju, Korea
Human Being – 7 Artists Sight : Now Gallery, Seoul
Korea Contemporary Art – Under 80s Circumstance : Dongsoong Art Center, Seoul

1988 *Korean Character, Contemporary, Expression* : Seomi Gallery, Seoul
Figuration – 7 Artist's Works : Batanggol Art Gallery, Seoul
Present · Image – Transforming and Taking Aim : Gallery Noksaek, Seoul
Korean Contemporary Art, 16 New Generation Artists : Shinsegae Gallery, Seoul
The 2nd Réalité Seoul : Grorich Gallery, Seoul

1987 *The 19th International Painting Festival* : Grimaldi Castle Museum, Cagnes-sur-Mer, France
Today's Painting, The 14 Artists Gaze : Hankook Gallery, Seoul
New Figuration : Shinsegae Gallery, Seoul

1986 *Present · Image* : Gwanhoon Gallery, Seoul
Seoul In Seoul : Osaka Contemporary Art Center, Osaka, Japan

1983	〈DRAWING '83 SEOUL〉 SCOPE GALLERY, 로스엔젤레스
	〈'82문제작가 작품전〉 서울미술관, 서울
1982	〈동아미술제〉 국립현대미술관, 서울
	〈'82 현대회화〉 미술회관, 서울 / 롯데갤러리, 대구
	〈서울신문 창간 38주년기념 정예작가 초대전〉 서울신문사 서울갤러리 / 롯데미술관, 서울
1980	〈서울80_WORK WITH PHOTO 창립전〉 공간미술관, 서울
1978	〈45-51〉 출판문화회관, 서울
	〈제1회 중앙미술대상전(중앙일보사)〉 국립현대미술관, 서울
	〈제8회 한국미술대상전(한국일보사)〉 국립현대미술관, 서울

공공미술 프로젝트

2001-	공공미술 프로젝트 〈할아텍(HALARTEC) 철암그리기〉

레지던시 프로그램 및 기타 경력

2018	ARTIST TALK : YORK UNIVERSITY, YORK CENTRE FOR ASIAN RESEARCH 초청, TORONTO, 캐나다
	KAAF(KOREA-AUSTRALIA ARTS FOUNDATION 한-호문화재단) ART PRIZE 심사위원장 초청, SYDNEY, 오스트레일리아
2017	TORPEDO FACTORY ART CENTER 레지던시 프로그램, VIRGINIA, 미국
2016	ART MORA 레지던시 프로그램, NEW JERSEY, 미국
	마산청과시장 마산아트스튜디오 레지던시 프로그램, 창원
2015	이마도 레지던시 프로그램, 행촌문화재단 및 행촌미술관, 임하도, 해남
2012	SYDNEY UNIVERSITY 레지던시 프로그램, SYDNEY, 오스트레일리아
2010	RMIT UNIVERSITY 레지던시 프로그램, MELBOURNE, 오스트레일리아
2009	베를린 장벽붕괴 20주년기념 도미노 프로그램, BRANDENBURG GATE, BERLIN, 독일
2006	MONASH UNIVERSITY 방문교수/작가 프로그램, MELBOURNE, 오스트레일리아
2004	CITÉ INTERNATIONAL PROGRAM - 가나갤러리, PARIS, 프랑스
	ASEM재단 후원 파리 1대학방문교수 - 서울 대학교환프로그램, PARIS, 프랑스
2002	HAMBURG INTERNATIONAL ART WORKSHOP 초청작가(교수), HAMBURG, 독일
1995	VERMONT 레지던시 프로그램 참가, VERMONT, 미국

작품 소장

국립현대미술관, 과천
국립현대미술관 미술은행, 과천
서울시립미술관, 서울
부산시립미술관, 부산
대구미술관, 대구
수원시립미술관, 수원
고려대학교박물관, 서울
서울대학교, 서울
서울대학교미술관, 서울
서울대학교 공과대학, 서울
충청대학교, 청주
모란미술관, 남양주
OCI 미술관, 서울
국방대학원박물관, 경기도
동서문학, 서울
모나쉬대학, 멜버른(오스트레일리아)
우관중미술관 갤러리, 싱가포르
블루힐백화점(현 롯데백화점), 성남
이와미초 사무소, 돗토리현(일본)
양평군립미술관, 양평
인천문화재단 인천아트플랫폼, 인천
포스코, 서울
아트센터화이트블럭, 파주
행촌문화재단, 해남
경남도립미술관, 창원
대한보증보험(현 SGI 서울보증)

1985	'85 The Korean Young Artists Biennial : National Museum of Modern and Contemporary Art, Seoul
	3 Korean Artists Group Show : Surugadai Gallery, Tokyo
1984	The 7th JoongAng Grand Prix Exhibition (Joongang Ilbo) : National Museum of Modern and Contemporary Art, Seoul
1983	Drawing '83 Seoul : Scope Gallery, Los Angeles, USA
	'82 Selected Artists Works (by 12 Art Critics) : Seoul Museum of Art, Seoul
1982	Dong-A Art Festival (Dong-A Ilbo) : National Museum of Modern and Contemporary Art, Seoul
	Drawings & Prints by Korean Artists by 4 Art Critics : Gwanhoon Gallery / Koryo Gallery, Seoul
	Today's Artists : Seoul Shinmun Gallery, Seoul / Lotte Gallery, Seoul
1980	The 1st Seoul '80 – Work with Photo-Group : Space Gallery, Seoul
1978	45–51 : Publication & Culture Center, Seoul
	The 1st JoongAng Grand Prix Show (JoongAng Ilbo) : National Museum of Modern and Contemporary Art, Seoul
	The 8th Hankook Art (Hankook Ilbo) : National Museum of Modern and Contemporary Art, Seoul

PUBLIC ART PROJECTS

2001–	Artist group Halartec (Hal Art and Technology)

RESIDENCY PROGRAMS AND OTHERS

2018	Artist Talk, invited by York Centre for Asian Research, York University, Toronto, Canada
	The Jury president, KAAF (Korea-Australia Arts Foundation) Art Prize, Sydney, Australia
2017	Torpedo Factory Art Center, Alexandria, VA, USA
2016	Art Mora, New Jersey, USA
	Masan Art Studio, Changwon, Korea
2015	Haengchon Museum and Foundation for Arts and Culture, Imhado, Haenam, Korea
2012	Sydney University, Sydney, Australia
2010	RMIT University, Melbourne, Australia
2009	Invited Artist / The 20th Anniversary Fall of the Wall in Berlin Committee, Berlin
2006	Visiting Professor / Artist Program at Monash University, Melbourne, Australia
2004	Exchange Professor / University Sorbonne / Gana Art Gallery, Cité International Program, Paris
2001	Invited Professor / International Artist Workshop Program, Hamburg, Germany
1995	Vermont Studio Center, Vermont, USA

COLLECTIONS

National Museum of Modern and Contemporary of Art, Korea, Gwacheon
ArtBank, National Museum of Modern and Contemporary of Art, Korea, Gwacheon
Seoul Museum of Art, Seoul
Busan Museum of Art, Busan
Daegu Art Museum, Daegu
Suwon Museum of Art, Suwon
Korea University Museum, Seoul
Seoul National University, Seoul
Seoul National University Museum of Art, Seoul
College of Engineering, Seoul National University, Seoul
Chungcheong University, Cheongju
Moran Museum, Namyangju
OCI Museum, Seoul
Korea National Defense University Museum, Nonsan
Dongseo Literature Publishing Co., Seoul
Monash University, Melbourne, Australia
Wu Guanzhong Museum annexed Gallery, Singapore
Blueheel Department Store (Lotte Department Store), Seongnam
Iwami office, Tottori, Japan
Yangpyeong Art Museum, Yangpyeong
Incheon Art Platform, Incheon
Posco, Seoul
Art Center White Block, Paju
Haengchon Cultural Foundation, Haenam
Gyeongnam Art Museum, Changwon
Dehan Guarantee Insurance Company

SELECTED AS

SELECTED AS

2016	**Representative Artist, Arko Art Center, Seoul**
2009	**Artist of the Year, National Museum of Modern and Contemporary Art, Korea**

AWARDS

2014	**Lee Jung Seop Art Award, Chosun Ilbo Art Museum, Seoul**
1984	**The 6th JoongAng Special Art Award, JoongAng Ilbo, Seoul**
1982	**Dong-A Art Fair, Dong-A Art Award, Dong-A Ilbo, Seoul**
1978	**The 1st JoongAng Special Art Award, JoongAng Ilbo, Seoul**

서용선 2008 → 2011

초판 1쇄 발행 2022년 7월 30일

지은이	서용선
글	백민석
번역	배연경
편집	박현정, 최재혁
자료제공	서용선아카이브
디자인	이기준
제작	두리기획

ISBN	979-11-977586-2-1 03650
정가	70,000원

펴낸이	박현정
펴낸곳	연립서가
출판등록	2021년 7월 21일 (제2021-000012호)
주소	서울시 강동구 상암로 225, 3동 903호

전자우편	YEONRIP@NAVER.COM
페이스북	YEONRIPSEOGA
인스타그램	YEONRIP_SEOGA